The Art of
Understanding Art

The Art of Understanding Art

Irina D. Costache

WILEY-BLACKWELL

A John Wiley & Sons, Ltd., Publication

Library of Congress Cataloging-in-Publication Data

Costache, Irina Dana.
 The art of understanding art / Irina D. Costache.
 p. cm.
 Includes bibliographical references and index.
 ISBN 978-0-470-65832-1 (hardcover : alk. paper) – ISBN 978-0-470-65834-5 (pbk. : alk. paper)
 1. Art–Textbooks. I. Title.
 N7425.C67 2011
 701'.1–dc23
 2011036426

A catalogue record for this book is available from the British Library.

Set in 11/13pt on Dante by Toppan Best-set Premedia Limited
Printed and bound in Singapore by Markono Print Media Pte Ltd

1 2012

To all unknown "Van Goghs"

Contents

Acknowledgments

This book derives from reflections generated by years of teaching, analyzing, making, and enjoying art. *The Art of Understanding Art* outlines a new path of introducing readers to art based on "behind-the-scenes" information and critical visual inquiry.

For the author the book is the conclusion of a long journey. Many individuals have contributed to its completion. I am very grateful to all of them. I would like first to thank the Wiley-Blackwell team. Jayne Fargnoli, the executive editor, was immediately interested in a view "outside the box," and her enthusiasm for and confidence in this project were essential to making this book possible. Her outstanding professionalism, extraordinary efficiency, and sensitive understanding throughout the publication process have been remarkable. I would also like to thank Allison Kostka, editorial assistant, for her valuable work on this project; Lisa Eaton, production manager; Annette Abel, for her careful evaluation of the material submitted; Juanita Bullough, an excellent copy editor, for her thorough, attentive, and insightful editing; the designers, for a great cover; and other individuals who have been involved in the publication of this book. I am profoundly grateful to the reviewers: Bruce Robertson, Professor of Art History at the University of California at Santa Barbara; Laura Ruby, Professor of Art at the University of Hawaii; Anne Swartz, Professor of Art History at Savannah College of Art and Design, and other anonymous commentators for their attentive reading, valuable suggestions, and overall interest in my innovative approach. Their support of this new perspective contributed to the publication of this manuscript. I have been very fortunate to teach in many environments where I was able to develop innovative teaching approaches. At California State University Channel Islands (CSUCI), where I have been a faculty member since the university opened its doors in 2002, I would like to thank President Richard R. Rush, for his extraordinary support for faculty and forward-looking vision for education; Jack Reilly, chair of the CSUCI Art Program, for his continuous support of my work; and my colleagues, faculty, staff, and administration for encouraging innovation and providing a collegial atmosphere conducive to learning and research. I would also like

to thank Jody Baral, Chair of the Art Department and gallery director at Mount
St. Mary's College in Los Angeles, where I previously taught, for his enthusiastic
interest in innovative ways of teaching art history. I am also grateful to many col-
leagues, including Michael Aurbach, Nina Berson, Kathleen Desmond, Constance
Moffatt, Margarita Nieto, and Jeanne Willette, for the numerous formal and infor-
mal discussions about art and its history. Obtaining permissions for illustrations
was not an easy task and I would also like to thank Pam Moffat for her very pro-
fessional and efficient work in this process, and Dominique Loder for recommend-
ing her. I would like also to thank the institutions and individuals who granted
their permission to reproduce the copyright material in this book and acknowl-
edge the following galleries and artists: Sikkema Jenkins & Co., New York for Kara
Walker; the Jack Shainman Gallery, New York for El Anatsui; the Marian Goodman
Gallery, New York for Thomas Struth; and the Pace Gallery, New York for Fred
Wilson, who graciously provided the images and permission to reproduce them
free of charge. I would also like to acknowledge Nathalia Morales, who assisted
me with checking names, dates, and titles, and Lynda Bunting for recommending
her, and my colleague, Professor Liz King, for her work and creativity in designing
the website for this book. I would also like to acknowledge and thank the many
students I have had over the years whose views, questions, doubts, and desire to
know more about art prompted me to write this book and shaped its content.

My profound gratitude goes to my family for supporting and encouraging me
in pursuing this project, my husband in particular, who read many versions of the
manuscript and made valuable comments and suggestions.

Thank you all.

Irina D. Costache
September 2011

Why Should Art Matter to *You*? A Message to Art Beginners

Art is everywhere: on street corners and buses, in parks and restaurants, on your computer and cell-phone screens. Art is a visual story of what being human is all about, told in many forms and with many voices. Understanding art will teach you to react constructively to new ideas and divergent perspectives and value diverse cultures and various customs. It will stimulate your mind and your eyes: you will look more attentively and think more creatively. Art will inspire you to pursue your visions, dreams, and hopes in your personal life and professional path.

Art is important and gratifying. This book gives you the information, tools, and methods that will empower you to appreciate and enjoy art long after you have finished reading the text. Certain ideas and works of art will confirm and enhance what you know. Others will teach you to look beyond the superficial layers to discover unexpected meanings. You will like some artworks and dislike others. Some will shock you; others will leave you indifferent. But don't reject art or ideas before you find out more about them!

Introduction: What Is Art?

Pictures must be miraculous . . .
a revelation, an unexpected
and unprecedented resolution of an eternally familiar need.

Mark Rothko[1]

What is art? Art is defined in dictionaries and encyclopedias as "works resulting from creative activities which communicate forms, ideas, and emotions and bring about reactions from viewers." This broad and generic meaning gives an elusive answer to the clichéd question. Based on this explanation the term *art* can be applied to a wide range of visual expressions, establishing parity among works with significant visual, conceptual, cultural, and chronological differences. Gian Lorenzo Bernini's (1598–1680) *Four Rivers Fountain* in the Piazza Navona in Rome (1648–1651; Figure 0.1) and Marcel Duchamp's (1887–1968) *Fountain* (1917; Figure 0.2) are both considered art.

What are the common denominators, besides their titles, that qualify these works to be included the same category? Visual elements cannot be the determining criteria. Do they both provoke emotions or communicate ideas? Are they the result of human creativity? Most viewers appreciate Bernini's dramatic sculptural shapes. However, few would call Duchamp's *Fountain* "art." What distinguishes a bathroom fixture from a sculpture? How does a common object become "art"? Who and what is involved in this process?

Even though visual expressions can be traced back to prehistoric times, the meaning of the term "art" is defined by more recent and mostly Western values. In today's society a work of art is considered special and distinct from ordinary occurrences. It is displayed in museums, reproduced in books, and discussed in lectures. It is admired and protected. A wide range of individuals, institutions, and factors contribute to establishing the guidelines that set art apart from commonplace manifestations. Museums are among the most authoritative, influential, and trusted forums. The artistic standards of these institutions are shaped by the opinions, research, and interpretations of art historians, theorists, critics,

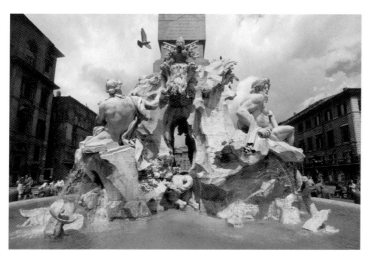

0.1. Gian Lorenzo Bernini, *Four Rivers Fountain*, 1648–1651. Piazza Navona, Rome. *Photo:* Vanni / Art Resource, New York.

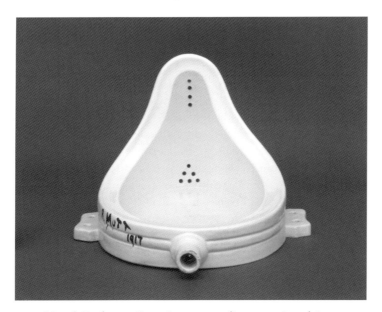

0.2. Marcel Duchamp, *Fountain*, 1917, replica 1964. Porcelain, unconfirmed: 360 × 480 × 610 mm. Tate Gallery, London. *Photo:* Tate, London / Art Resource, New York; © 2011 Artists Rights Society (ARS), New York / ADAGP, Paris / Succession Marcel Duchamp

collectors, and other experts. These specialists communicate their views to both their peers and the public through exhibitions, books, articles, catalogues, reviews, and presentations.

Until recently *art* was explained and exemplified by a hierarchic index of Western landmarks linked together by an inherent, yet mysterious greatness.

"Masterpieces" and "geniuses" of the Renaissance, the Baroque, and Impression-ism were at the top of this list. With the exception of Ancient Egypt and Meso-potamia, artistic traditions outside the West have been included only sporadically and often in a subordinated role. The influences of Japanese prints and African sculpture in modern art are a case in point. The concern with reiterating the value of validated works of art and familiar names has also marginalized, and even excluded many Western developments. Gender, materials, subject matter, and geographical location have been among the criteria used for this segregation. These omissions have created the impression that no art was produced in Greece after the first century CE and there were no women artists until the nineteenth century. Although the founding principles of the selection processes may be problematic, these lists made art a clear and stable category, which shaped the audience's taste.

The interest in cross-cultural traditions and novel modes of communication of the late twentieth century has facilitated broader artistic dialogues. Access to diverse past and present visual expressions has prompted the revision of land-marks. Mayan monuments, Japanese calligraphy, and African textiles are now valuable contributors to the history of art alongside Renaissance architecture, Baroque sculptures and Impressionist paintings. The last name Gentileschi means to many Artemisia, not Orazio. These new voices and values have substantially expanded the definition of art.

But what specialists are noticing exactly in these works, after ignoring them for centuries, is not obvious to the audience. Why do some experts consider Artemi-sia's art more interesting than her father's? Why has no one seen this until now?

Contemporary art has increased the difficulty of looking at, understanding, and enjoying art. Unexpected materials, unusual subject matter, and unpredictable formats have challenged familiar values and norms and in the process have puzzled, even alienated spectators. Popular culture has been more effective in connecting art with the public. *Mona Lisa* T-shirts and *David* tote bags, along with numerous other reproductions of mostly renowned masterpieces, have spread art in informal ways and to unexpected places. However, it takes more to understand art than wearing a T-shirt. But where to start? To discern what defines art in today's vibrant and ever-changing context may be exciting for experts, but it is downright frustrat-ing for the audience.

The fear of making "incorrect" statements about art has prompted spectators to rely on basic and measurable values. Realism, artists' skills, historical signifi-cance, and familiar phrases such as "I know what I like" and "seeing is believing" are among them. They are all valuable criteria, but they also make the comfort of recognizing art overpower the curiosity of discovering new visual possibilities. For most viewers art has to be a confirmation rather than a "revelation."

The anxiety many spectators experience when looking at and responding to art is well justified. Art is typically seen in its final resting place, in museums and gal-leries, disconnected from its original context. These passive displays conceal most of the history and processes that have determined the creation, meaning, and

value of the work. The mandatory distance between viewers and art, rightfully observed by institutions, further heightens the mystery of art. Labels, statements, and other material are useful aids. However, the information, presented as concluding statements rather than a starting point for critical inquiry, leaves many viewers with unanswered questions. How was the art made? Why is it so expensive? Why is it in a museum?

What is the role of artists in the process of defining art? As creators they obviously have a vital function. But not everything they produce is called art. Even though artists have assumed more active positions in the art world, specialists and institutions are still key to designating what is art.

Unlike viewers, experts examine art up close, removed from frames and display cases. Before reaching a conclusion, they research numerous visual and textual resources. Their analyses focus on diverse issues including, but not limited to, the materials used, studio practices, subject matter, historical context, financial support, stylistic concerns, moral values, literary sources, and artistic norms. Some experts are concerned with style and formal elements. Others consider patronage and contextual factors essential to understanding a work of art. Still other specialists believe that contemporary values are central to the meaning of art. There are many more views about how to look at, analyze, and interpret art.

The multilayered interpretations and lack of consensus make art an engaging and dynamic field of inquiry. These divergent positions, however, confuse and discomfort viewers. Changes in artistic and financial values further complicate the process of understanding art. Over a century ago a group of artists decided to paint new subjects using a novel style. They were ridiculed and pejoratively called "impressionists" to point out that their paintings were mere "impressions," not art. *The rest is history.* Impressionism is now recognized, appreciated, and enjoyed worldwide. How can values vary so drastically? What triggers these reversals? How can anyone outside the discipline understand art when even experts seem to disagree and change their views?

"It is not enough to believe what you see," argued Leonardo da Vinci (1452–1519), "you must also understand what you see."[2] How can viewers develop a meaningful personal appreciation of art? Where and how does the process of understanding art begin?

This book proposes a novel approach that aims to answer these and many other questions about art. At the core of this new view are two interrelated notions. First, that art is a changing concept defined within specific cultural, historical, and geographical contexts by numerous individuals, institutions, and factors. Second, that understanding art is an active and critical process that engages the eye and the mind. For these reasons, this book transforms the customary statement, "This a valuable work of art," into the inquiry, "How does an object become valued as art?"

The text provides a novel and solid foundation based on a meticulous assessment of what makes art possible and meaningful. The chapters uncover the "behind-the-scenes" activities, methods, and tools that affect the creation, dissemination, analysis, and interpretation of art. In lay terms this book is not offering

"a fish," an inventory of masterpieces to last on only one occasion. Rather, it teaches "how to fish" or, in this case, how to understand art, which will last a lifetime. The text avoids endorsing particular artists, styles, or methods. Instead, its purpose is to empower readers with the knowledge necessary to look at art with confidence and curiosity.

Which *Fountain* is the best sculpture: Bernini's or Duchamp's? Should they both be considered art? The information acquired from this book will guide spectators to form personal responses. Many may continue to admire Bernini's art, while others will begin to understand and maybe even value Duchamp's work. These divergent views and taste will, however, no longer be distressing. Readers will no longer be concerned with having the "correct" opinion. Rather, they will have discovered that understanding art requires attentive looking and critical thinking, supported by knowledge and information. From patronage to deconstruction and from climate to provenance, this book is an invitation to look at and think about art beyond familiar catchphrases, comfortable superlatives, and impressive accolades. *The Art of Understanding Art* will uncover an exciting world of art, which will prompt readers to revisit renowned masterpieces and discover new artistic expressions.

Enjoy!

Notes

1. Mark Rothko, "The Romantics Were Prompted," 1947, quoted in Chipp, *Theories*, p. 549.
2. Leonardo da Vinci, quoted in Kelen, *Leonardo da Vinci's Advice to Artists*, p. 23.

Navigating the Book:
A User's Guide

The Art of Understanding Art has been conceived to make the encounter with art exciting, memorable, and enduring. Multicultural views, art-historical methods, studio practices, theoretical issues, and classroom dialogues have been crucial in shaping the format and content of the text. The book has adapted both its narrative and format to contemporary practices. It makes the most effective use of the material presented, avoiding the duplication of basic information abundantly available online and in print. Therefore, while terms and concepts are explained in diagrams and a Glossary section, readers are also directed to other print or electronic sources if further clarification is needed. Moreover, additional visual and textual material, including links to images discussed in the text, has been included in the companion website, which will be periodically updated. This hybrid format is an effective method of using novel means of communication and keeping the material current. The financial benefits are an additional valuable component.

The book is organized into four parts: *Making Art*, *Disseminating Art*, *Analyzing Art*, and *Interpreting Art*. This arrangement has an underlying, yet not mandatory, sequential order. It identifies four phases in the "life" of a work of art. The text starts with the genesis of art, continues with its dissemination and analysis, and ends with the processes of interpretation. The parts and chapters are not written as a continuous narrative, however. Readers can select the order without jeopardizing the knowledge they will acquire. Flexibility is an important aspect of this book; it aims to emphasize that art can be approached from various perspectives and with different concerns. Factors, circumstances, and elements with broad influences are discussed in one chapter and cross-referenced to the others. Within chapters, specific topics are often arranged alphabetically to avoid the suggestion of a ranking system.

The works of art reproduced in the book have been selected to support the major analyses and reflect the diversity of art available today. The other artworks discussed are available on the book's website. Readers can easily find them online by using the information provided.

The introductory material includes a note to art beginners, an introduction, a guide to using the book, and a section reflecting on the multiple purposes of art. This section ends with Anatomy of a Work of Art, which presents the conceptual layout of the book in diagram form.

Part One, Making Art (Chapters 1–3), examines the multiple factors involved in the creation of a work of art. The first chapter, Artists and Patrons, focuses on the definition of artists, their creative processes, and the role of patronage in art. The second chapter, Environment, Materials, and Other Resources, presents the impact many practical issues have on the outcome of art. The discussion reflects on the role climate, tools, knowledge, and other elements have on the creation and definition of art. Chapter 3, Context, discusses a wide range of contextual elements that affect artists and their creativity. The analysis underlines specific aspects that have substantial influence on the art-making process and work of art. This chapter is also relevant to Chapter 7 and can be used in connection with the section on Original Context.

Part Two, Disseminating Art (Chapters 4 and 5), analyzes the methods of spreading art in modern culture and reflects on the impact these processes have on viewers' responses to art. Chapter 4, The Dissemination of Original Art, exposes the ways in which original art is made available to the public. The analysis also discusses museums, galleries, and other venues and highlights their role in defining and understanding art. This chapter ends with a section on art and business. The next chapter, The Dissemination of Art through Reproductions, and Other Issues, presents the implications of art circulating in the form of print and digital reproductions. This chapter concludes with a discussion of the art world.

Part Three, Analyzing Art (Chapters 6–8), is concerned with the tools and processes used to analyze art. Chapter 6, Visual Resources Used to Analyze Art, examines the main visual resources relevant to this process. In addition to formal elements, this chapter also explains how provenance, conservation, and symbols may add valuable information to research. The next chapter, Textual and Other Resources Used to Analyze Art, considers a wide range of textual resources that inform art historical research. It concludes with a discussion of comparisons and their role in art examination. Chapter 8, A Critical Examination of Art Classification, exposes the roots of art categories and the criteria used in this process. The second part of this chapter outlines the specificity of various categories and reflects on their role in art analysis and appreciation.

Part Four, Interpreting Art (Chapters 9–10 and Conclusion), discusses a wide range of issues pertinent to understanding the meaning of art. Chapter 9, Interpreting Art: Criteria and Values, examines preconceived ideas about art, artistic standards, and values. It then considers the main characteristics of Modernism and Postmodernism and outlines their role in defining art. The chapter concludes with an introduction to interpreting images. Chapter 10, Methodologies of Art, presents the specificity of various methodologies. The chapter ends with a case study. This exercise exposes how different methodologies affect the interpretation and subsequent understanding of art. The Conclusion is a brief reflection on the significance of art and ends with the same quote which begins the Introduction, creating a full circle.

The book aims, within the limits of the medium, to establish a dialogue. Questions, quotes, and cross-references prompt reflections about the issues discussed.

Their purpose is twofold: first to establish a more direct dialogue with the reader, and second, to initiate a personal critical inquiry. Consequently, some questions are intentionally left unanswered. Furthermore, in some cases the quotes support the analysis, while in others they bring a slightly different point of view to prompt viewers to reflect on the issues. The text uses a concise format, with short sections and even outlines whenever possible. Cross-references to artists, concepts, terms, illustrations, websites, and other material are used throughout the book to emphasize the multifaceted aspects of art. The symbol is used throughout the text to direct the reader to a web link or information/illustration on the website, and terms used in the text can be found in the Glossary.

Notes can be found at the end of each chapter, and a Bibliography and List of Illustrations are included at the end of the text. The Bibliography includes print and new-media sources about the topics discussed.

Appendix 1, The Art World, is an overview of the individuals and institutions involved in the process of defining art. Presented as a "laundry list," this easily readable information reveals the roles these entities play in the validation and definition of art.

Appendix 2 provides creative assignments and writing projects which mix acquired knowledge with creative thinking. They can be used as written or studio projects, or a combination of both. They can also be a valuable starting point for discussions. Additional projects and other class-related material are posted on the website.

Appendix 3 is a Glossary which provides brief explanations about artists, time periods, and concepts mentioned in the book.

Appendix 4, Tools of the Trade, uses several diagrams to explain basic visual language. It includes: Elements of Design (Diagrams 2–3), Principles of Design (Diagram 4), Content/Subject Matter (Diagram 5), and Art Media (Diagrams 6–8).

The website matches the conceptual and formal layout of the book. The chapters have links to illustrations and additional material. The web address is: http://faculty.csuci.edu/irina.costache/book. The online material also includes references to art-history timelines and resources for the Tools of the Trade.

The book is written at an introductory level. It has been designed for today's audiences accustomed to concise information expanded through links. Cross-cultural and chronological examples underline the wealth of visual expressions in the world today. Although complex concepts, ideas, and issues are discussed, they are presented in a basic format. *The Art of Understanding Art*, while inclusive and wide-ranging, is conceived as a foundation for future discoveries and a starting point for further learning, not a conclusive finality. There is, purposely, no direct answer to the question, *What is art?* posed at the beginning of the text. Reading this book will make it clear that the journey to finding an adequate reply is far more enlightening and rewarding than the one-line response readers sought at the beginning.

Why Is Art Made? The Purposes of Art: A Brief Overview from A to Z

There is an astonishing amount of art in the world today: millions, maybe even billions, of works. Nobody can either count or see them all. Yet art continues to be produced. Why is it made? Art is created to communicate about and reflect on a wide range of feelings, ideas, concerns, and thoughts. Across time and cultures artists, patrons, viewers, institutions, and multiple other factors discussed in this book have influenced and determined why and how art is made, viewed, displayed, and interpreted. Over time, the initial artistic intentions and original functions may be altered by new contexts, values, and tastes. Art, however, continues to connect with new audiences beyond chronological restrictions, cultural identities, geographical limitations, and language barriers.

The following discussion is an overview of the different purposes of art. The criteria for these categories include the intentions of the artist and the original functions and later reception of the work. Many works of art have been, and continue to be, created for more than one purpose. The list is both incomplete and overwhelming, intentionally emphasizing the multiple functions of art. It is organized alphabetically to avoid a ranking system based on value or importance.

Art for Art's Sake

The notion of "art for art's sake" implies that art is a self-referential entity with no ties to its environment and should be appreciated for its own qualities. In modern times "art for art's sake" has been linked to artists' personal artistic quests, views, and expressions. Many works apparently detached from reality derive from or include subtle, but significant, references to specific ideas and emotions. Mark Rothko's (1903–1970) abstract paintings, for example, have a profound spiritual component.

Art as Biography

In the past artists have documented their professional and personal concerns in self-portraits. Today artists include in their art more private issues and moments,

ranging from aging to fighting cancer, often presented with voyeuristic qualities that make audiences uncomfortable.

Should artists expose the intimacy of their lives?

Art as Commentary on Contemporary Times and Issues

Many works of art have reflected, directly or indirectly, on their own times. As, in the modern era, artists became more independent, they were also able to use art to express their views and concerns about contemporary issues. The *Aids Memorial Quilt* (1996–) project, for example, is an ongoing project created to raise awareness of the devastating disease of Aids.

Do you know a work of art whose main purpose is to comment on contemporary issues?

Art as Commentary on the Past

Art has often been created to contemplate the past. The most familiar examples in Western art are subjects related to Greek and Roman civilizations. Classicism was at the core of the Italian Renaissance. It was also essential for the late eighteenth-century Neoclassical period, which favored the virtues of classical antiquity over present-day issues. Contemporary artists use the past as inspiration, but also to critique previous artistic and cultural practices.

Art Commenting about Art

Artists have commented in some of their works on the meanings and purposes of art. These views have been presented mostly in self-portraits and allegories. Contemporary artists have developed innovative ways of presenting their thoughts about these issues. *Erased de Kooning Drawing* (1953), by Robert Rauschenberg (1925–2008), is one of many examples. The work is what the title suggests: an erased drawing by the Abstract Expressionist artist Willem de Kooning (1904–1997). By attaching his name to the work, Rauschenberg intended to question a wide range of artistic norms, including the significance of originality and authorship.

Art and the Community/Public Art

Many works of art have been created for public viewing. Murals, sculptures, and scores of ornaments made for religious, political, and aesthetic purposes are

displayed publicly, often outdoors and independent of art institutions. A contemporary example is *CowParade*, hosted by over fifty cities around the world since 1999. This project, comprising multiple sculptures displayed in parks, at bus stops, and in front of shops, aims to ignite a meaningful dialogue between art, the community, and the urban environment. While the form of the sculptures remains essentially the same (different shapes of cows), artists paint them in a novel and unique style in each city. The project also benefits various international charities.

Art for Commemorative Purposes

An important function of art is to commemorate individuals and events. Works created for this purpose are usually commissioned by city, state, and other officials or influential patrons, and made mostly for public display. Scores of sculptures representing political, historical, and cultural figures celebrate and recognize their contributions to the national and international community.

Have you seen works of art made to commemorate a person or an event?

Art as Decoration

Many works of art have been created, both in the past and today, to embellish a space. In some cases decorative arts and objects have been integrated with paintings and sculptures. For example, the nineteenth-century American artist James McNeill Whistler (1834–1903) blended interior design with painting, sculpture, and furniture in his famous *Peacock Room* (1876–1877).

Should art be made only for decorative purposes, or should it have other functions?

Art as Documentation

There are many instances when art has either been created to document events or could be used as visual documentation. Cave paintings provide modern audiences with valuable information about the period in which they were created. The beauty of medieval manuscripts is equaled by the wealth of information they preserve. Similarly, the complicated writing on Egyptian paintings and sculptures adds documentary value to these works.

Should art created for documentary purposes be considered artistically less valuable than other works?

Art and Emotions

Art has often been created to express artists' feelings or to produce an emotional response from viewers. There are multiple examples of soft, tender, and warm moments as well as raw, graphic, and violent scenes. The viewer's connection to art is often mainly on an emotional level.

Art as Enjoyment

Many experts and viewers disagree with the idea that art can be created solely for enjoyment; such works are often perceived to be superficial. The French twentieth-century artist Henri Matisse (1869–1954) eloquently refuted this view. He said that he dreamt of a serene art that would be "like a good armchair in which to rest."[1]

Can a work of art simply be enjoyed?

Art and Everyday Life

In some cultures art has been closely intertwined with life. In the West, daily life has been reflected in views of interiors, family portraits, hunting scenes, and still life. In many ancient cultures the representation of everyday life is also connected to funeral rituals. For example, the paintings and sculptures in ancient Etruscan and Egyptian tombs reveal the customs of these ancient civilizations.

Art for Functional Purposes

Masks, articles of clothing, baskets, and other functional objects were created in many cultures to be both used and admired. In the modern Western tradition art is considered an object to be looked at but not touched, let alone used. Many artists and art movements have tried to breach this gap. The twentieth-century Bauhaus School established strong connections between art and everyday objects.

What do you think: should the utilitarian purposes of art diminish its artistic value?

Art and History

Before the invention of photography, art was the only visual record, and many works were created to illustrate specific historical events. These images are valuable sources for understanding the past. However, they represent a point of view,

not an objective account. History painting, a favored genre of the French Art Academy, is a term used to define artworks concerned with representing classical subjects, religious narratives, and major events from the past, adding, at times, fictional or moralizing components.

Art and Human Nature/Psychology

The individual has been central to many traditions and cultures, but the subtleties of inner life have not been widely explored in art until the modern era. This interest, evident since the late eighteenth century, is linked to other scientific, social, and sociological changes. (It was also during this period, in 1818, that the novel *Frankenstein* was published.)

Art as Ideas and Thought Process

The notion that art is created for conceptual rather than visual purposes is widely debated among both experts and viewers. While descriptive elements remain the mechanism through which art communicates, many artists, particularly in recent times, have given priority to the conceptual aspect of their art.

Should art be about visual elements or ideas? What should viewers do in front of a work of art: look at the art or think about it?

Art and Ideals

Many artworks have been created to expose the ideals of a society. For example, the sculptures created in ancient Greece during the fifth century BCE embodied this culture's idealized representation of a man. When these statues are compared to later works with the same subject, either in Greek or other traditions, it becomes evident that ideal forms differ across time and cultures.

Art as Information

Some works of art are created specifically to inform us of various events and products. Posters and signs and, more recently, web and other graphic designs have this primary function. Since the beginning of the twenty-first century art institutions have recognized the value of art created for these purposes by organizing major exhibitions of film posters, advertisements, and graphic design.

Art and Knowledge

Knowledge is used by artists in the creative process, but it can also be the reason art is made. Studies of nature, anatomy, optics, medical practices, engineering, and astronomy were based on and reflected the knowledge of the time. A good example is the painting by Benjamin West (1738–1820), *Benjamin Franklin Drawing Electricity from the Sky* (ca.1816). A digital reproduction of this work is on the homepage of the Franklin Electric Co.

Do you know works of art created specifically for this purpose?

Art and Life/Nature

Many cultures have thought of art as a continuum of life. In the Western tradition art has mostly been created to reflect on life and nature rather than being inter-twined with them. Contemporary artists, however, including Walter De Maria and Christo (both b. 1935), have established innovative dialogues with nature and life.

Art as Memory

Art has often been created in the past as a visual record. Portraits have served as personal and public memories. Landscapes and urban scenes have preserved images of the past. Although their initial purpose might have been different, these works have become valuable visual testimonies of their times.

Art and Philosophy

Philosophy and art have always been strongly interconnected. Throughout history artists have been influenced by philosophical views. Daoism and Confucianism are reflected in Chinese landscape paintings. In Western art, the philosophies of the ancient Greeks Plato (429–347 BCE) and Aristotle (384–322 BCE) and the eighteenth-century German Immanuel Kant (1724–1804) have affected many artis-tic views and developments. Jacques Lacan (1901–1981), Jacques Derrida (1930–2004), and Jean-François Lyotard (1924–1998) are some of the philosophers and theorists who have influenced contemporary art.

Art and Politics

For centuries and across the globe political life has been closely intertwined with art. In certain circumstances, both in modern times and in the past, art has been

created for propaganda purposes. Since the mid-nineteenth century artists have had more opportunities and freedom to express personal political views in their works.

Art and Reality

Art has reflected the surrounding environment and, at times, confirmed the identity of the space in which we live. New media – photography, film and, more recently, video and virtual reality – have continued to offer images that parallel the coherence of the world. For many viewers, realism (the imitation of reality) is an important criterion in art appreciation.

Art and Religion and Spirituality

A great deal of art has been created, particularly in the past, for religious purposes. Many such works are now displayed in museums and admired solely for their artistic qualities. Modern artists have reflected about religion and spirituality from a more personal angle.

Art as Self-Expression and Personal Statement

The most widely held belief is that art is a form of self-expression. The link between the creative act and the work of art has important and complex ramifications. Sometimes, if this relationship is too intimate, the audience has difficulties understanding the meaning of the art. Artists have also made visual statements about identity, race, and gender. Some of these artworks are self-reflective, while others critique values and expose stereotypes.

If you were to create a work of art, what statement would you like to make, and how would you present it?

Art as Social Statement

Artists have reflected and exposed a wide range of social issues in their art.

Do artists have an obligation to be involved in social issues? What social issue should artists focus on today? What would you focus on if you were an artist?

Art as "Truth"

The notion that art has changeable meanings and values is uncomfortable to many. In the modern Western tradition, where science and provable truths have

been at the core of most disciplines, there are expectations for art to also be "truth." Picasso reflected on this issue, stating, "Art is a lie that makes us realize truth."[2] The artists may be true to themselves, but even this is not always possible. Personal interpretations, views, and feelings are at the core of both making and understanding art.

Can you think of other purposes and functions of art? For example, art as therapy.

Why is art made? The multiple and diverse purposes of art are evident. Art is a visual journal of our past, present, and future. But art is hardly an open book. Many works, even when familiar, intrigue audiences. This mystery is not threatening, but it is intimidating. Some of the mystique of art will be uncovered in the following chapters. The issues presented will clarify what makes art both powerful and necessary. Some of these elements are awe-inspiring, others banal; some are visible, others invisible; and some are familiar, others unknown. They all, however, confirm that art is an indispensable ingredient of life, culture, and society. Art makes the ordinary *extra*ordinary.

> " Art is not about art. Art is about life, and that sums it up. "
>
> **Louise Bourgeois**[3]

Notes

1. Henri Matisse, *Notes of a Painter*, quoted in Chipp, *Theories*, p. 135.
2. Pablo Picasso, "Statement, 1923," quoted in Chipp, *Theories*, p. 264.
3. Louise Bourgeois, "Interview with Donald Kuspit, 1988," quoted in Harrison and Wood (eds), *Art in Theory*, p. 1089.

The Anatomy of a Work of Art

Van Gogh's *The Starry Night* (1889) needs no introduction. Ignored when it was created more than a century ago, this painting is now one of the most famous works of art, recognized and admired by scores of viewers. Many factors, elements, and individuals affected the creation of this work of art, influenced its unexpected journey, and determined its contemporary meaning, value, and interpretation. Using this specific example, the diagram presents the four major elements in the "anatomy" of a work of art: making, disseminating, analyzing, and interpreting. These components form the conceptual layout of the book.

Making Art

Originality, authorship, and authenticity are at the core of van Gogh's unique style. Broad and diverse factors influenced his creativity and art: financial issues, the materials available, the cultural milieu and artistic context, Japanese prints, his education, health, friendships, family ties, interest in nature, and geographic location are among them. They have all contributed to the creation of art.

Disseminating Art

The Starry Night is now displayed in the Museum of Modern Art in New York. The painting is more often seen in the form of a print or digital reproduction. Since the mid-twentieth century this work has broadly circulated in culture in a variety of formats, including a wide range of objects such as totes and mugs. The book and film *Lust for Life* (1956) and the 1972 song about this painting have added to van Gogh's popularity and *The Starry Night*'s fame.

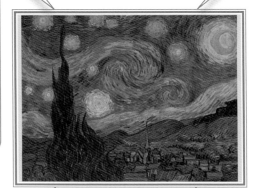

Analyzing Art

Many visual and textual sources inform the analysis of this painting. They include the examination of form and content, comparisons to other works by the artist and from the period, provenance, van Gogh's letters, and art-historical writings by experts about his work and art of the period. Art-market information, exhibitions, art conservation, and current views about his work also contribute to a comprehensive analysis of this painting.

Interpreting Art

What is the meaning of *The Starry Night*? There are many ways this painting could be interpreted. To some, this painting is a vivid documentation of the artist's personal thoughts and dreams. To others, it is an intense visualizing of a cosmic event. Some viewers are more interested in understanding how artistic values change, while others focus on the effect reproductions have on the appreciation of this painting and art in general.

1.0. Vincent van Gogh, *The Starry Night*, 1889. Oil on canvas, 29 × 36¼ in. Museum of Modern Art, New York. *Photo:* Digital Image © The Museum of Modern Art / Licensed by SCALA / Art Resource, New York.

Part One

Making Art

Viewers come into contact with art decades, even centuries, after its creation, in cultural and geographical contexts substantially different from the original ones. How art is made is largely a mystery for the audience. The creators, the artists, are essential to this process. Multiple other individuals, entities, and procedures are also involved in the creation of art. Their roles are mostly concealed in the finished work, but they are, however, relevant to understanding art. The following chapters examine a series of important elements and factors that affect artists, their creativity, and the outcome of their art. The discussions include an analysis of the definition of an "artist" and the role of patronage, as well as the impact the environment, materials, and context have on the making of art.

The Art of Understanding Art, First Edition. Irina D. Costache.
© 2012 Blackwell Publishing Ltd. Published 2012 by Blackwell Publishing Ltd.

1
Artists and Patrons

The painting *Las Meninas* (The Maids of Honor, 1656; Figure 1.1), by Diego Velázquez (1599–1660), is a comprehensive commentary about artists and their art-making skills, needs, and practices. The artist's presence confirms his seminal role in the creative process. As a court painter, however, Velázquez had also to fulfill the requests of his patron, the king of Spain. The paintings on the walls, barely visible in reproductions, make references to other artists, including Peter Paul Rubens (1577–1640), a seventeenth-century Flemish painter who had met Velázquez while working for the king of Spain. The inclusion of the art is a subtle commentary on artists' training, education and influences. The elaborate definition of space reveals Velázquez's keen knowledge of perspective and the contemporary scientific concerns with light. Beyond the apparent subject, a royal portrait, the painting reveals many factors and individuals that affect the process of making art. These issues are discussed in this chapter.

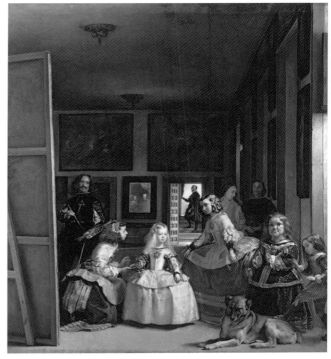

1.1. Diego Rodríguez de Silva y Velázquez, *Las Meninas* (The Maids of Honor) (also known as *The Family of Philip IV*), *ca.*1656. Oil on canvas, 316 × 276 cm. Prado, Madrid. *Photo:* Giraudon / The Bridgeman Art Library International.

Artists and Creators

The term "artist" designates individuals who can communicate through their works, often long after their death, with wide and

The Art of Understanding Art, First Edition. Irina D. Costache.
© 2012 Blackwell Publishing Ltd. Published 2012 by Blackwell Publishing Ltd.

diverse audiences. This extraordinary ability has enhanced the belief that artists have qualities that set them apart from average persons. Artists are generally perceived to be emotional, creative, and sensitive individuals. Gender, upbringing, education, and many other internal and external factors influence the development and views of artists.

The characteristics of an artist vary greatly across cultures and time. The modern meaning of this term did not exist in many traditions. In ancient Egypt and medieval Europe, for example, artists were skilled craftsmen who worked mostly anonymously and in groups. In contrast, in later centuries, European and Asian artists were acclaimed professionals who often interacted with high officials and royalty. The roles and positions of individuals who created art also fluctuated. In some cultures they fulfilled civic tasks, while in others they were perceived to have magical powers. Some artists were celebrated by their contemporaries and others were ignored.

Today the term artist is used to designate a broad range of creative individuals across the globe from both past and present. This generic usage erroneously suggests that the concept or word "artist" existed in the original contexts. Contradictory to the diversity it is applied to, the meaning of this term continues to be mostly based on Western views and values. Since the fifteenth century this tradition has been concerned with recognizing individual achievements. Inventions, ideas, and discoveries have been credited to the persons who originated them. This view is also at the core of the definition of an "artist." Artists are perceived to establish a strong bond with their art to the point of merging into one "entity." Art history has reinforced this oneness: A painting by Pablo Picasso (1881–1973) is called "a Picasso." This union between artists and their work has determined the essential qualities of an artist: originality, authorship, and authenticity.

Originality, Authorship, Authenticity

In the modern Western context, artists are thought to be individuals with identifiable, unique, and visible involvement in the art-making process. The close relationship between artists and their art is expected to produce tangible objects with a consistent style and, if possible, a signature. The key characteristics of an artist and work of art, derived from these expectations, are, as stated above, originality, authorship, and authenticity. *Originality* refers to the "one of a kind" ideas and style specific to one artist. *Authorship* confirms the individual creativity of the artist. *Authenticity* recognizes the work of art as the genuine creation by, preferably, a known artist. Their opposites are copy, forgery, and fake. These concepts have been, and continue to be, in many circumstances, the main criteria used to confirm artists' merit. Their influential role is underscored by the answer to this question:

Who would you consider a better artist: Van Gogh or someone who paints copies of his famous The Starry Night (1889)?

The validation of an artist based on these elements is rooted in the Renaissance. This period, which started in fifteenth-century Italy, is known, among other things, for the revival of ideals from ancient Greek and Roman civilizations. In art history this entire era, spanning from approximately 500 BCE to the fourth century CE, is often called *classical*. Two classical ideals were particularly relevant to Renaissance art: individualism and *mimesis* (the notion that art should imitate, or "mimic," reality). Before the Renaissance, during the several centuries of the medieval period (also called the Middle Ages), artists were craftsmen who belonged to guilds and worked, like other individuals involved in trades, anonymously as team-mates. The raise of individualism in the Renaissance created the need, or perhaps desire, for personal and professional acclaim in many fields, including art. In fact, in his influential book *On Painting* (1436), the Italian architect and theorist Leon Battista Alberti (1404–1472) explicitly encouraged artists to seek "fame and fortune." As artists' names and identities merged with personalized styles, recognizable authorship and originality became measurements of their artistic worth.

The demand for an art that mirrors reality further advanced artists' individualism and status in society. The fifteenth-century invention of mathematical perspective made it possible to create spatial illusions on two-dimensional surfaces. Until the discovery of photography four centuries later, persuasive, lifelike paintings were unique visual documents. Despite the appearances of objectivity, perspective is a codification of perception. It is therefore an interpretation, not an impartial account. There are, however, no other visual sources to verify the accuracy of these convincing imitations of reality. How empowered artists must have felt! The bold inclusion of self-representation in religious or secular compositions throughout this period corroborates artists' sense of importance.

The painting *Las Meninas* (1656; Figure 1.1), by the Baroque artist Diego Velázquez, is a case in point. This large canvas represents, in the center, the monarch's daughter, the *infanta* (a title similar to "princess") Margarita, and her entourage. To the left, and somewhat obscure at first, is the artist's self-portrait. Velázquez's assertive view of himself within the royal household, higher than everybody else in this picture, confirms his self-worth. Even the king and queen, his patrons, are just a faint reflection, barely visible in the mirror on the back wall. The artist is at ease and actively engaged in his profession. The palette and brush in his hand authenticate the originality of the work. The artist's focused gaze underlines his meticulous scrutiny of reality.

This painting is based on and defined by Velázquez's observations and interpretation. Its truthfulness, aside from historical facts, exists however, in this image alone. Did this scene happen exactly as depicted? There is no way of knowing. To emphasize his control over visual representation, the artist conceals the canvas on which he paints. His presence in this royal portrait affirms the importance of artists and their profession: they, and they alone, can create visual documents. In addition, many artists, Velázquez included, have advised their patrons on art collecting and even diplomatic matters. Both Velázquez and Rubens were knighted for their services.

Nothing could be further from the image of modern artists. Rather than interacting with high officials, they have been generally perceived unable, or unwilling, to obey the norms of society. The diminished role of patronage and invention of photography in the nineteenth century, along with many other factors discussed in this book, opened the doors for greater self-expression. Many artists of the period, including Vincent van Gogh (1853–1890), searched for innovative ways to reflect their personal visions. These artists and their art are called *avant-garde*; a French military term referring to an elite force sent on ahead of the ordinary troops. It was first used to describe cultural developments in the nineteenth century. Since then, the term *avant-garde* has been widely employed to identify art and artists pushing the boundaries of the status quo. The idiosyncratic views of the avant-garde appeared outlandish to the public and even most experts, who dismiss them most of the time. Surprisingly, the defining criteria for the avant-garde continued to be originality, authorship, and authenticity. (See "Modernism" in Chapter 9 for a discussion of the avant-garde.)

Self Portrait as an Artist (1888; Color Plate 1), by Van Gogh, confirms this. The overt visual and historical differences between Velázquez and the modern artist overshadow the extraordinary connections between them. Van Gogh is in front of the easel. He is alone. Neither the obligation to fulfill a commission nor the need to imitate reality curtails his creativity. His personal artistic quests derived from his emotions, ideas, and views have transformed the realm he observes into a unique, personal vision. His surroundings are not a recognizable space, only a series of painterly and colorful marks. Van Gogh's intensely piercing gaze confronts the audience. Like Velázquez, he is in the midst of creation, his palette and brushes in his hand, but he denies viewers' access to the painting he is working on. The presence of the artist, recognizable brushstrokes and style confirm originality, authorship, and authenticity: This is a Van Gogh.

The term "artist" has not been an inclusive one. Prior to the modern period, women had limited opportunities to contribute to culture. Their public lives and interactions with influential figures were restricted by social norms. Even though there were several successful women artists in the seventeenth century, it would be hard to imagine any of them in Velázquez's authoritative position.

Women and Art

Women have had fewer possibilities than men to participate in the arts. Family obligations and lack of education have been two of the most significant barriers in their quest for successful careers in art and other fields. Some women, however, were able to overcome these difficult circumstances and became acclaimed artists. More women have been actively engaged in the arts in the later part of the nineteenth century. But the rebellious attitude of the avant-garde was perceived unsuitable for them. Even though the

number of women artists grew, their participation and contribution contin-
ued to be limited until the last decades of the twentieth century.

While their creative voices have been excluded or marginalized, women
have been widely represented in art. The female body, often unclothed, has
been used to symbolize important values and concepts such as liberty,
freedom, justice, and peace. Gender differences have also been visible in
patronage. In the past art was created mostly by male artists for male patrons.
This is an important issue to bear in mind when looking at art.

Today, women have become major players in the arts. Many of their
works reflect on the artistic marginalization and cultural isolation of
their history. There is an abundant literature on women in the arts. Studies
and research have unveiled women patrons and artists and have exposed
their innovative and idiosyncratic strategies.

Not only women, but also individuals with traditions, practices, and values
significantly different from Western views, have been marginalized. The inherent
biases of the term have made it necessary to use gender, ethnicity, or geography
to help define these artists.

Popular culture, and films in particular, have substantiated the public's belief
that artists are distinct in appearances and behavior from the rest of society. The
film *Lust for Life* (1956), depicting the life of Van Gogh, and the recent movie *Frida*
(2002), are good examples. The artists portrayed in these motion pictures had
complicated lives. The use of documentation effectively connects personal trag-
edies to creativity, but also enhances the mythical image of "tormented" artists.
At the same time, these films reinforce the value of originality, authorship, and
authenticity. Frida Kahlo's (1907–1954) recent popularity confirms that these core
values continue to be essential, regardless of gender or cultural environment. Her
recognition as an important artist is based on her original style, authentic ideas,
and visible authorship.

Kahlo's *Self-Portrait with Cropped Hair* (1940; Color Plate 2), whose genesis was
dramatically reenacted in the movie, visibly displays these qualities. Powerful self-
representations are the author's trademark. As in other portraits, this painting
reflects a specific event in Kahlo's life: her divorce due to her husband's infidelities.
The artist presents herself both vulnerable (she is alone in a generic, desolate
space) and empowered (the scissors in her hand suggest action). Her ambiguous
presence, dressed in a man's suit which is too big for her, further underlines a dual
identity. The cropped hair scattered on the floor is transformed into roots, a
symbol of growth and strength. The simple, almost monochromatic palette of
earthy colors is highlighted by a subtle contrast between the grayish suit she is
wearing and the yellow chair (reminiscent of the painting *Van Gogh's Chair*, 1888).
The musical score and text of the Mexican song inserted at the top add to the
story (but also its ambiguity, if one can't read the text or notes). The graphic lines,

flat surfaces, and bold colors are part of her original and authentic style. Her name, life, and art have been merged into one. This painting is unmistakably a "Kahlo."

How do you define an artist?

Appropriations

Originality, authorship, and authenticity confirm artists' physical and conceptual involvement in creating a work that is "new" and "unique." The absence of these three elements raises significant doubts about the merit and artistic value of artists. Using existing forms, ideas, and subject matter has been, however, a common practice in art. Identical classical subjects and religious themes have been repeatedly depicted by scores of artists. For example, many famous artists, including Donatello (1386–1466), Gian Lorenzo Bernini, and Michelangelo Buonarroti (1475–1564) have created sculptures representing the biblical hero David. (Michelangelo's work is discussed in Chapter 10.) No one would argue that these artists had no imagination. Their unique perspective and personal style overshadow the duplication of the subject and suffice as evidence of their original interpretation.

The reaction is quite different when modern artists use a similar approach. Andy Warhol's (1928–1987) *Campbell's Soup Cans* (1962) illustrates this point. "Lack of ideas," heightened by the banality of the objects, are among the main reasons for dismissing his work and discrediting him as an artist. His use of contemporary popular icons is, however, comparable to the repetitive use of religious themes, such as the statue of David discussed above. Warhol's appropriation of soup cans

also reflects on the still-life tradition, such as the painting *Still Life with Fish, Vegetables, Gougères, Pots, and Cruets on a Table* (1769), by the French painter Jean-Siméon Chardin (1699–1779) (J. Paul Getty Museum). The dishes, plates, jars, and utensils suggest a lavishly prepared meal. Both artists include manufactured objects and appropriate their shapes, forms, and designs. Each work comments on and celebrates its own time. The elaborate food preparation shown in much seventeenth- and eighteenth-century still life suggests a slow pace. In contrast, Warhol's condensed meal, further reinforced by the processes used, is symptomatic of modern times.

> The artist is a receptacle for emotions that come from all over the place: from the sky, from the earth, from a scrap of paper, from a passing shape, from a spider's web.
>
> **Pablo Picasso**[1]

Why do many viewers admire Chardin's paintings more than Warhol's work? Is it the modern object, or the process used? Chardin re-creates the objects and their intricate designs meticulously with oil paint and a brush. The time involved in producing this work, and the resulting accuracy, mesmerize viewers and confirm originality and authorship. In contrast, Warhol uses mechanical repetition and painting process (which included, in some versions, the silk-screen, a method also used to print on T-shirts). The rapidity of the technique, the simplicity of the image, and the artist's detachment intentionally highlight the efficiency of mass production. These modern features prompt audiences to question Warhol's originality and authorship.

Modern artists have also used appropriation to expose the central, and, in their view, arbitrary role originality plays in art. The French artist Marcel Duchamp selected everyday objects, and with little or no alterations designated them as *his* art. He emphatically called these works "ready made." His memorable *Fountain* (1917; Fig 0.2), is a real bathroom fixture. Duchamp's works suggest that originality is not inherent to the art object or the process of creation. Rather, it is generated by ideas, art theory, and the institutional environment, such as museums and galleries.

Several decades later artists took this practice to another level by appropriating works of art. The American artist Sherrie Levine (b. 1947) created a series based on the works of famous male artists. *Fountain (After Marcel Duchamp: A.P.)* (1991), is one of them. This bronze replica of the plumbing component made famous by Duchamp's sculpture surprises and even angers spectators. Audiences expect artists to *create*, not *select* everyday objects or, even worse, *copy* someone's work. Levine's appropriation is not gratuitous. She aims to expose the fallacy of using authenticity and authorship as dominant criteria for defining art. Why was this common utilitarian object considered art in the first place? Moreover, why is it attributed to Duchamp? The artist neither created this "fountain" nor signed his name on it. In addition, the process of bronze casting raises questions, discussed in the next section, about originality and authorship. Levine also critically reflects on possible gender biases inherent to originality. Would a woman artist of the period be recognized for a comparable work?

Appropriations raise very meaningful questions. This practice has numerous ramifications, including legal issues, and remains understandably controversial even when supported by theoretical analysis.

> Do you know examples of appropriations in art, everyday life, or popular culture?

Attributions and Studio Practices

Levine uses "After" in the title of her sculpture to point the creative origins of her work. Originality and authenticity are strongly linked to the author. The process of identifying the creator of an artwork is called attribution. However, it is not always possible to know the artist. When attributions are inconclusive or unknown, art historians use prefixes such as "follower of," "in the manner of," "copy after," "school of," "studio of," "circle of," and "attributed to" to establish authorship.

These qualifiers identify authors solely as offshoots of the "real thing": names, periods, and sources with proven originality, authenticity, and authorship. For example, a sculpture attributed to "follower of Michelangelo" shifts the credit from the author of the work to the renowned artist. In some cases attributions have been difficult to establish because it is unclear if an artwork was created in a studio, is a later copy, or is by an independent artist whose style is similar to his or her contemporaries. This hierarchic system has a significant impact on viewers' appreciation of art. Who would you consider a better artist: an artist called Reynolds, or one identified as "follower of Reynolds," "school of Reynolds," or "after Reynolds"?

Attributions, however, do not always accurately reflect artists' authorship. Many works of art have been created with substantial help from assistants. In the past, studios and workshops were the only places artists could get an art education. This practice, widespread in the Renaissance, continued for many centuries. It is still common for emerging artists today to work as studio assistants to learn more about the profession, and the works of art created in these circumstances are usually attributed only to the head of the studio. The paintings by the renowned seventeenth-century Dutch artist Rembrandt van Rijn (1606–1669) have been praised for their originality. Like many other artists of the period, Rembrandt had many assistants. The *Rembrandt/Not Rembrandt* exhibition, held at the Metropolitan Museum of Art in New York in 1996, revealed the ambiguous authorship of some works. As a result of the research for this show, several works were reattributed.

This is not an isolated case. Monumental sculptures and large projects in particular require substantial support from various professionals. The numerous works of art created by the seventeenth-century Italian artist Gian Lorenzo Bernini in Rome, including the famous fountains in the Piazza Navona (Figure 0.1), the tomb of the Barberini Pope and the colonnade in St. Peter's piazza, would have been impossible to complete without scores of highly skilled assistants. The bronze-casting process raises further questions about authorship and originality. Specialists perform this work often without the immediate supervision of the artist.

In some cases, as happened with some sculptures by the French artist Auguste Rodin (1840–1917), casting may even take place after the artist's death. Today, his sculpture *The Burghers of Calais* (1884–1889) is displayed in Calais, but also in Paris, New York, Washington, Los Angeles, and Tokyo. There are 12 casts (the limit allowed under French law): the first made in the late nineteenth century, and the last in 1995, for the Rodin Museum in Seoul, South Korea. Should all *Burghers of Calais* be called original and authentic? (See "Patronage," below, for an analysis of this work.)

What do you think: Are the contemporary practices any different from Rembrandt's or Bernini's studios?

Many contemporary artists, including Andy Warhol, Jeff Koons (b. 1955), and Damien Hirst (b. 1965), have, to the consternation of the public, openly admitted to using assistants. Warhol's studio was known as *The Factory*.

How can viewers be completely sure that art is original and authentic? Should artists claim sole authorship when using assistants to complete their work?

Collaborations

Collaborations are common in music, film, and theater. In the visual arts and literature, particularly in Western tradition, they are rare and seen with certain distrust. These disciplines link authorship to a single view, voice, and style. How can two or more artists fuse their vision into one and create together? The studio practices discussed earlier demonstrate that this can be done.

The collaboration between Peter Paul Rubens and Jan Brueghel the Elder (1568–1625), two celebrated seventeenth-century Flemish artists, is a good, but rare example. Rubens is known for a painterly style and dramatic, emotional scenes. Brueghel, on the other hand, has a more meticulous approach. Their artistic dialogues resulted in over twenty paintings. The two artists worked independently, but they were able to merge their distinctive styles and ideas into cohesive images. The painting *The Garden of Eden with the Fall of Man* (*ca.*1617), is one of their collaborative works. It was included in the 2006 exhibition *Rubens and Brueghel: A Working Friendship* organized by the J. Paul Getty Museum with the Royal Picture Gallery Mauritshuis, in The Hague. When looking at their art and other collaborative works there is an undeniable temptation to discover individual contributions. The museum was well aware of this. It developed a website that allowed viewers to see the sections each artist worked on in this and other paintings in the show.

How do you look at collaborative works: as a whole, or as the sum of individual contributions?

Contemporary artists have been aware of the preconceived expectation of single authorship. The French artists Christo (b. 1935) and his wife Jeanne-Claude (1935–2009) collaborated for decades. Until 1995, however, the art was attributed solely to Christo. The artists recently acknowledged that they had made this decision to avoid the suspicion associated with collaborative authorships. This disclosure revealed that Jeanne-Claude had a creative, not only administrative role in these projects, as previously assumed.

Some artists, such as the Los Angeles-based Chicano groups Los Four and Asco (Spanish for "nausea"), have more openly embraced collaborations. These artists' collectives, active mainly in the 1970s and early 1980s, were primarily concerned with exposing Chicano art to broad audiences. The artists collaborated on murals, performances and installations, but also worked independently. Carlos Almaraz (1941–1989), Gronk (b. 1954), Harry Gamboa, Jr. (b. 1951), and Patssi Valdez (b. 1951), who were part of these groups had, and continue to have, strong solo careers. Collaborations are essential to create certain works of art, particularly in new media and printmaking. Architects also rely extensively on collaborators,

assistants, and many specialists to finalize their projects. More recently, the web has opened innovative possibilities for collaborations. Determining the exact role of various contributors to art projects can be difficult.

What is your opinion: should everyone who participates in the creation of art be recognized?

Artists and Multiple Works

Modern technologies have made it possible to produce multiple identical images. These mechanical and electronic tools have disengaged artists from the hands-on intimacy of the creative process. They also have challenged the core principles that define art and artists. How can authenticity and authorship be demonstrated in a photograph? What is an "original" when millions of identical images can be made from a plate, negative, or e-file? Broad access to the equipment has further diminished the perceived merit of artists and art. Anyone can get a camera and take a picture, but there is only one Van Gogh! (See also "Materials, Tools, and Technology" in Chapter 2.)

These superficial assumptions have created a segregation in the arts, which, until not so long ago, was reinforced by art experts and the market. The marginalization of prints, photographs, and videos in art history and their consistently lower financial value has affected the taste and views of the public.

Who would you consider to have more artistic worth: An artist who paints a landscape or one who makes a video of the same subject?

An important novel component of multiples, and the potential problem, is their ability to reach wide audiences. In the past this has helped artists to gain recognition, but it has not been a decisive factor for their success. This is likely to change in the near future, as new technologies become an increasingly predominant force in culture. How would art made for electronic dissemination be evaluated? Could originality, authorship, and authenticity continue to be relevant?

Artists and Artisans

These very similar words have very different meanings. Artists are expected to *create* works of original and exceptional quality that affect and connect with broad audiences. Art is not intended to have a function. In contrast, artisans *make* objects, often for utilitarian purposes. Their works, called "artifacts," are perceived to have less artistic value than "art." Artisans, whose names are rarely known, are not expected to have the same level of originality, authorship, and authenticity as artists. The public's appreciation of art has been greatly influenced by these values and standards. Generally speaking, making a vase is considered artistically less valuable than making a painting of a vase. (See also Chapter 8.)

Anonymous Artists

A great number of works of art created around the world are anonymous. There are two main reasons for this: The artists' names were never known or the attributions were lost over time. Anonymity is valued differently across time and cultures. Because modern Western culture has put great emphasis on known authorship, anonymous works are perceived to be less valuable than even those labeled "after," "school of," and "follower." Outside this period, anonymous art is accepted without preconceived value judgments. These standards have influenced viewers' appreciation of art.

The mortuary mask of *Tutankhamun* (*ca.*1332–1323 BCE) is admired with the same, if not greater, sense of awe, as *Mona Lisa* (*ca.*1505). When looking at the Egyptian sculpture, the focus is on the extraordinary use of forms and the idealized facial representations. The exquisite materials used and the purpose of this portrait heighten the appreciation of the viewer. There is substantial information about Tutankhamen, an Egyptian pharaoh who ruled during the eighteenth Egyptian dynasty (*ca.*1336–1327 BCE), but not about the artist, or artists, who made this work. In contrast, *Mona Lisa*, a portrait shrouded in mystery, is by a renowned artist. Would this painting be as widely celebrated if it were by an anonymous artist? The answer is very likely to be no. Do you know a modern Western masterpiece by an unknown artist? (*Mona Lisa* is discussed in Chapter 7.)

Preference for clear authorship has prompted art specialists to "invent" names. These pseudonyms usually start with the word "master," followed by an identifiable criterion: the title of a work, a specific subject matter, the date, location, etc. For example: *Master of the Saint Ursula Legend* is the name given to a fifteenth-century Flemish artist best known for a work representing this subject. There is an extensive list of "masters."

The eclectic identities, different styles, and various concerns of contemporary artists have questioned originality, authorship, and authenticity as determining factors in defining the term "artist." Nonetheless they continue to be valued, recognized, and protected as integral to individual creativity, even in this rich and culturally diverse environment. Outside specific artistic strategies, copies, fakes, and appropriations have strong negative connotations and rules and laws developed to prevent and expose them are strictly enforced.

Artists fascinate viewers. They are often perceived as some sort of magicians who transform a blank canvas or an ordinary block of stone into haunting visual statements that affect spectators across time and cultures. Not all artists have the recognition necessary to communicate with audiences. Many have been marginalized or ignored by either their contemporaries or later generations. How many "Van Goghs" are still waiting to be discovered no one will ever know.

Who is your favorite artist? Why?

The Creative Process: Inspiration and Influences

The creative process is a complicated and mysterious journey. There is a cross-cultural belief that creativity is a special gift that comes from inner, even magical powers which are not possessed by everyone. In reality, artists' inspiration is influenced by multiple psychological, cognitive, and artistic elements. Creativity is a fluid and unpredictable development. The ideas, feelings, and intentions experienced at the moment of creation are unattainable to most, if not all viewers. They may even be difficult for artists to describe.

In some traditions, art is created as part of secular or spiritual performances and engages a collective, even if limited, participation. Navajo and Tibetan Buddhist sand paintings are such examples. Artists, however, work mostly in private spaces. Unfinished art or works in progress, which would provide a glimpse into the creative processes, are seldom displayed. The perpetual image of artists as "different" and the complicated skills necessary to make art further enhance the mystery of the creative act.

Momentary inspirations and emotional outbursts are not the sole determining elements. External factors and practical considerations also affect artists' creativity and their overall formations, visions, and careers.

" The moment of inspiration comes by itself, and brushes away all doubts and hesitancies. "

Shen Tsung-ch'ien[2]

Self-Reflections

Creation is an intimate and private occurrence. The "secret ingredients" of the creative process are neither evident nor overtly revealed by artists. However, artists acknowledge the strong emotional, conceptual and, at times, physical bond they establish with their work. "I finally arrived at a shape that existed *a priori* in my mind,"[3] comments the American sculptor Martin Puryear (b. 1941) in reference to the genesis of his sculpture *Self*. For Jackson Pollock (1912–1956), the creative act is a private moment evident only in traces left on the canvas. "When I am in painting," the artist wrote in 1951, "I have a general notion as to what I am about . . . I *can* control the flow of paint: there is no accident, just as there is no beginning and no end."[4] The Chinese artist Wen Cheng-ming (1470–1559) confirmed the intensity of the creative act, suggesting the artist needs to "capture it at once before it vanishes."[5]

In addition to letters, reflections, and notes, discussed in Chapter 7, self-portraits reveal with subtlety and candor artists' views of themselves and their profession. Women's self-portraits are particularly interesting because their artistic formations

were restricted by scores of cultural and social factors. A century before Velázquez, the sixteenth-century Italian Sofonisba Anguissola (*ca*.1532–1625), one of the earliest female artists recognized in modern art history, exposed the creative process with wit and ingenuity. In *Bernardino Campi Painting the Portrait of Sofonisba Anguissola* (*ca*.1550; Figure 1.2), she presents her teacher, Bernardino Campi (1522–1591), painting her portrait. While the canvas is exposed, the authorship is intentionally unclear and confusing. To viewers it appears that Campi is painting Anguissola's portrait. In reality, she is the author of both. The artist cleverly suppresses her creative process from public scrutiny and substitutes it with Campi's. This unusual arrangement is also a comment on women and art: Anguissola is portraying herself as a mere flat and passive image, while the male artist is lively and actively engaged in art-making.

What differences and similarities can you detect in the artists' self-representations discussed in this chapter?

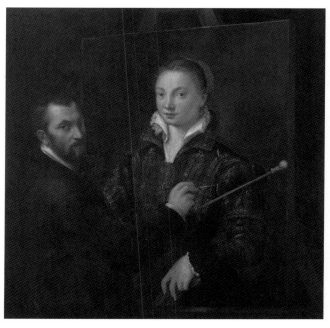

1.2. Sofonisba Anguissola, *Bernardino Campi Painting the Portrait of Sofonisba Anguissola*, *ca*.1550. Pinacoteca Nazionale, Siena. *Photo*: Scala / Ministero per i Beni e le Attività culturali / Art Resource, New York.

The creative process becomes even more complicated and difficult to understand when inspiration must be balanced with knowledge and practical issues. How much of a ceramic form is pre-planned by the artist and how much is altered while the potter's wheel is moving? New media artists constantly have to intertwine cognitive choices with unplanned processes. Random changes deriving from experimentation with tools and materials are part of the creative journey.

The Formative Years: Education, Family Life, and Personal Values

To create a work of art artists need a variety of skills, abilities, and qualifications. In general, individuals pursue an artistic career because they want to. There is an assumption that in addition to education to become artists individuals must possess special qualities, they must have a gift, a "talent." Today, most, but not all artists attend college for specialized training and career guidance. The MA and MFA have been the terminal art degrees, and recently a Ph.D. has become a growing trend.

Learning the skills needed to make art can take a significant amount of time. *How long did it take you to make this work?* is a question often asked of artists. The assumption that the longer it took the better the art is likely to be, completely ignores artists' education, training, and experience. Chinese artists can produce stunning calligraphy in a matter of minutes. But their ability to skillfully maneuver the ink and brushes on paper is the result of years of practice. The American artist James McNeill Whistler argued that the value of his painting *Nocturne in Black and Gold: the Falling Rocket* (1875) represents the knowledge he acquired over a long period, and cannot be judged merely on the amount of time it took him to create it.

Even though the curriculum of art education varies across time and cultures, there is a unifying model: master and apprentice or teacher and student. This system used with variations in America, Asia, Europe, and other continents continues to be the basic structure of today's art education. Art academies, even though they had significant restrictions, allowed artists to develop more freely than a master's studio. Art teachers and masters can have decisive influences on their students. Artists have been aware of this and found ways to overcome these confines. Jackson Pollock, famous for his abstract works, studied with Thomas Benton (1889–1975), an artist opposed to this type of art. Constantin Brancusi (1876–1957), an influential twentieth-century sculptor, left Rodin's studio because he understood the difficulty of establishing a personal artistic path while being an apprentice.

Until relatively recently, women were either excluded from or had limited access to education. Sculpture and architecture were considered for a long time "inappropriate" for them. In contrast, watercolor painting and crafts have been perceived fitting for their roles and position in society. These views made it very difficult for women to equally compete with men. As late as the 1880s, the American artist Thomas Eakins (1844–1916) was asked to resign from his teaching position at the Pennsylvania Academy because he had exposed female students to nude male models.

Women had very few role models. In the not-so-distant past, teachers and masters were mostly male. Anguissola's self-portrait, discussed earlier, reflects with wit on women's art education. On the one hand, this painting pays homage to Campi as a teacher; on the other, it aims to show that the student has surpassed the master. Education has also been a criterion for creating divisions and marginalizing artists. Terms such as "self-taught," "amateur," and "folk" emphasize a lack of academic training and suggest lower artistic values. These views can substantially influence viewers' opinions about art. (See Chapter 8.)

Texts and manuals are important educational resources for artists. They provide information about techniques, tools, styles, and many other art issues. Today the Internet has become a significant source of information for many fields, including the arts. The number of sites concerned with art issues is overwhelming and continues to grow.

Artists are also influenced in their creativity by their gender, ethnicity, and individual preoccupations. Upbringing, traditions, lifestyles, relationships, and

other elements inherent to their identity can substantially impact on their creative path. Happy moments, personal tragedies, illnesses, and scores of practical issues affect artists' views and their art. Sometimes these factors are visible in their works, while at other times they are hidden in complicated metaphors and symbols. Many artists choose not to make personal issues transparent in their art. Artists are also influenced by external contextual elements; these are discussed in Chapter 3.

Contemporary artists continue to seek "fame and fortune," and institutional values are generally still based on originality, authorship, and authenticity. Thus, even in today's global culture the notion of artist is still linked to the model established in the Renaissance.

Patronage

Art is often created at the request of individuals, institutions, or states. The entity commissioning the work is called a patron. A synonymous term used in contemporary culture is sponsor. Examples of patronage can be found across time and cultures and include a wide variety of projects that differ in size, medium, format, and purpose. Patronage had and continues to have a significant role in art.

Patrons can have a decisive role in the outcome of the art commissioned. They can not only influence and even determine the form and function of work, but their views can also significantly restrain creativity. In spite of these hindrances many artists established strong and productive dialogues with their patrons. Others had difficult, even humiliating working relationships with them, documented in letters and journals (See Chapter 7). Overall, artists, even those who disliked the contractual arrangements, were aware of the professional opportunities patronage offered them.

Most commissioned art had the approval of patrons. The fact that the work has been finished is a partial, but important, confirmation of this consent. Artists who disagreed with patrons had to either conceal their views in sophisticated allegories, or exclude them altogether. It is only in modern times, when the dependency on patronage subsided, that artists have been able to express their views more openly. These are important facts viewers should consider when examining art.

Private Patronage

Private commissions have generated the production of many works of art across time and cultures. They continue to be a relevant mode of supporting the creation of art. Private patrons are usually affluent people who commission art for personal use. These works are typically displayed in their residences and often inaccessible to the general audience. By and large portraits are the most common subject

matter of private commissions, particularly before the advent of photography. These works often reflect patrons' values.

The *Portrait of Giovanni (?) Arnolfini and his Wife* (1434; Color Plate 3), by Jan van Eyck (1385–1441), is one of the many such examples. As in other similar situations, the artist probably had to adjust his creativity to his patron's demands. The fancy clothes, elaborate interior, and complicated symbolism expose the social and financial status of the Italian banker Giovanni Arnolfini and his bride. The male figure looks at the viewer and his solemn and religious gesture underlines his sense of control. In contrast, his wife is looking down, passively placing her hand into his. Their gazes hint at social norms, gender roles, and family obligations. How much of this codified representation was defined by Arnolfini's request or the artist's vision is difficult, if not impossible, to know. Van Eyck, who appears to be a witness and painter of the event, was not shy about his dual role. On the back wall, above the mirror, an inscription states with boldness: "Jan van Eyck was here. 1434." The unusually large and legible signature documents and reflects on the relationship between patron and artist. (See Chapter 6 for a discussion of the symbols in this painting.)

Sometimes private patronage is closely intertwined with institutional support. (See the discussion about the Dia Art Foundation in "Today's Patronage," below.)

If you were an art patron, would you want the artist's vision or yours to be reflected in the portrait?

Religious Patronage

Religious patronage has been an important contributor to art around the world, but its primary aim was to disseminate faith. Therefore, artists had to observe strict visual rules and rigid symbolism, and their personal vision is often secondary. Religious works created across cultures reinforce this point. The familiar peaceful and meditative poses of Buddha, for example, speak intensely of the religious values involved, but reveal little about the artist. Many religious works are anonymous.

One of the best-known examples that illustrate the effects of religious patronage is Michelangelo's fresco in the Sistine Chapel. The artist's knowledge of anatomy, classical tradition, and Neoplatonic philosophy, in tune with the sixteenth-century Italian High Renaissance, permeates the scenes depicted on the ceiling (1508–1512). If the large, sculptural and realistic nudes painted with vibrant colors surprise viewers today, imagine how shocking they would have appeared to the clergy five centuries ago. In the scene *The Creation of Adam*, for example, Adam is a strong and confident individual. His reclining pose enhances and draws attention to his muscular, unclothed body. No one disputes that the fresco is Michelangelo's work. However, without the approval of his patron, Pope Julius II (1443–1513) this mural might have taken a completely different form.

The pivotal influence of the Pope was made even clearer three decades later. The religious environment of the period was no longer tolerant of classical motifs

and ideals. Michelangelo's *The Last Judgment* (1535–1541), painted in the same chapel, reflected some of these changes. The face of St. Bartholomew (a saint often represented with a knife and flayed skin, references to his traumatic death) is an intensely graphic self-portrait. Dramatic shapes and contorted bodies emphasize the religious significance of the subject. What a contrast between this work and the *Creation of Adam*. The representation of the nude was no longer acceptable. Michelangelo did not make any changes, but after his death the Pope commissioned another artist, Daniele da Volterra (1509–1566), to comply with the views of the Church. (These additions became an important issue for the recent conservation process.) Even though Michelangelo's style and originality are visible in both frescoes, patronage has played a decisive role in the final form.

Royal Patronage

Royal patronage has also been widespread in the past. This type of support, often connected to the political and religious context, has wide ramifications. The Taj Mahal (1630–1653) in India and the Egyptian pyramids (*ca.*2500 BCE), both commissioned by rulers, demonstrate its effect. Created centuries apart in completely different cultural, historical, and religious environments, these monuments reflect the patrons' views and overshadow, even conceal, those of the artists who created them. The pyramids, effectively immense tombstones, served a practical burial purpose, but were also indicative of the Pharaohs' power. The Taj Mahal was built to commemorate the death of the ruler's wife. These structures speak about the power, as well as personal and historical significance of each patron. The artists' views are absent.

Official portraits of rulers are commissioned works, and thus unfavorable images are rare. Leaders have been portrayed very similarly across time and cultures. Power, leadership, control, and wisdom are some of the core characteristics found in these works. In most cases, this art informs about the ruler, but reveal nothing about artists' feelings or political thoughts. Royal patronage can also be instrumental in supporting particular arts or styles. This has been the case, for example, in China, where ruling dynasties have played an important role in the development of painting. Royal patronage has also supported the construction of many architectural structures around the world. (See Chapter 3.)

If you were an art patron, would you want the artist's vision or yours to be reflected in the portrait?

Can you think of a work of art created with the support of a ruler or royalty? What specific elements reveal the views of the patron?

State, City, and Community Patronage

Art created under state or civic patronage tends to be more traditional. There are many reasons for this: The work of art has high public visibility, it has to please

diverse audiences, it uses public funds, and it aims to represent an official taste and position. Artists are aware that public projects are carefully scrutinized.

This was the case with August Rodin's *Burghers of Calais*. The artist was commissioned by the city of Calais to create a sculpture to commemorate six prominent local citizens willing to sacrifice their lives to save their city during the Hundred Years War (1336–1453). Rodin envisioned a project that was too innovative for the public space for which it was intended. Anticipating a negative reaction, he submitted a model that was in tune with the taste and style of the period: an imposing pedestal, which dwarfed the figures, a cohesive and massive sculptural group. The final sculpture bears little resemblance to the initial proposal. The six figures are independently defined. The Committee was shocked by the form of the sculpture and displeased with the portrayal of the heroes' distress. The work was accepted, but displayed on a high pedestal. In 1924 the sculpture was moved to a more prominent location and placed on a lower platform, as the artist had originally planned.

A well-known government art patronage in the United States during the 1930s was the Works Progress Administration (WPA). This program employed many artists who created a variety of works, including large public projects. Many of them were murals created for government structures such as post offices and public libraries. Since the latter part of the twentieth century, the National Endowment for the Arts (NEA), established in 1965, has supported the arts and artists with numerous and diverse grants and fellowships.

Today's Patronage: Corporations, Institutions, Foundations, and Grants

In contemporary culture patronage comes from a variety of sources. Institutions and corporations have commissioned works of art for their interior and outdoor spaces. Their support also includes developing art collections, giving grants to artists, and subsidizing exhibitions.

Grants, fellowships, and residencies are new forms of patronage. These opportunities are available through a system of applications and competitions reviewed and awarded usually by committees and juries. Owing to their high cost, many contemporary works such as environmental art, performances, and multimedia installations require institutional support. The Dia Art Foundation, based in New York, established in 1974 by Philippa de Menil and Heiner Friedrich, has been a major patron of art projects difficult to create and fund, including Walter De Maria's (b. 1935) *Lightning Field* (1977), and web projects such as *The New Five-Foot Shelf* (2004) by Allen Ruppersberg (b. 1944). (These works are discussed in Chapter 2.)

Museums can be patrons, too. They offer the space and financial support necessary to create large installations and other costly art projects. These works are included in temporary exhibitions and sometimes become part of the museums' permanent collection. (See the discussion on Tim Hawkinson in Chapter 2.)

Economic concerns and uncertainty about the value of visual innovation can prevent patrons from embarking on large or risky projects. Therefore bold changes are more rapidly made in fields less dependent on substantial financial support and where artists have greater control over the creative and production process. Many visionary projects in architecture and monumental sculpture remain on the drawing board for a long time, even forever.

Artists have always been aware that funding is an important component of art making. When sponsorship is not available, they have to find alternative means and sources. Some artists make sufficient money by selling their art. Those who do not, take art-related jobs, in education, design, or cultural institutions. Many artists have regular jobs in other fields. Others prefer to work as freelancers. Financial support affects not only the process of making art, but also its dissemination, analysis, and interpretation. (The dialogues between art and business are further discussed in Chapter 4.)

Summary

It becomes evident from the discussion in this chapter that making art is a long and complicated journey with many steps and components. Artists are the driving force in this process. They are influenced by many personal and external factors.

Which of these factors affect the way you look at, understand, and appreciate art?

What do you think has a more decisive influence in art-making: creativity, education, or patronage?

The process of making art is not limited to the elements discussed in this chapter. Velázquez's painting eloquently exposes many other issues essential to successfully completing a work of art. Practical matters such as studio space, art materials, knowledge, and skills can also have a decisive role. The impact these factors have on artists and their function in art making are discussed in Chapter 2.

Notes

1. Pablo Picasso, *Conversation* (1935), an interview with Daniel-Henry Kahnweiler, quoted in Chipp, *Theories of Modern Art*, p. 271.
2. Shen Tsung-ch'ien, quoted in Gayford and Wright, *Art Writing*, p. 48.
3. Martin Puryear, "Conversations with Hugh M. Davis and Helaine Posner, quoted in Stiles and Selz, *Theories and Documents*, p. 628.
4. Jackson Pollock, from the narration by the artist for the film *Jackson Pollock* (1951), quoted in Chipp, *Theories of Modern Art*, p. 548.
5. Wen Cheng-ming, quoted in Gayford and Wright, *Art Writing*, p. 47.

2
Environment, Materials, and Other Resources

2.1. James Luna, *Artifact Piece*, 1987. By courtesy of the artist.

Artifact Piece (1987; Figure 2.1), by the American artist James Luna (b. 1950), exposes many issues related to the process of making art. The artist presents himself in a display box filled with sand; the medium, artist, and subject overlap and are intentionally ambiguous. The artist reflects here on his Native American roots, and also questions conventional art materials and tools. Luna is not only the creator but also the medium. To the surprise of spectators, it is the artist's actual living body they are looking at, not its rendering in marble, wood, or bronze.

The Art of Understanding Art, First Edition. Irina D. Costache.
© 2012 Blackwell Publishing Ltd. Published 2012 by Blackwell Publishing Ltd.

Artifact Piece exposes, among other things, that to translate ideas into art, artists need to understand and consider many practical and cognitive issues. The environment and natural resources, location and studio, materials and tools, and technologies and knowledge have a significant impact on how art is made. These factors, as this case, may also affect the meaning of art.

Environment

Natural Resources

The environment and available resources can determine the form, shape, and even the content of art. However, their influential role is, most of the time, invisible or unknown to the viewer. Many art materials are made from natural resources. Wood has been used in sculpture, paintings, and papermaking, as well as for tools and implements. Cotton and linen have been used as a support for painting and other projects. Many pigments derive from plants, minerals, and other natural sources.

Nowhere is the role of natural resources more evident than in architecture. The Indian "cut rock" temples were carved in the natural rock. Equally difficult processes were needed to build the Egyptian pyramids. However, these awe-inspiring projects were also possible because stone was widely available in these regions. The astonishing innovations in Roman architecture are also directly connected to regional resources. The invention of concrete, which led to the design of famous and extraordinarily efficient building systems, is due, at least in part, to a natural material available in the area south of Rome. The much-admired marble in later Italian architecture and sculpture, which may appear lavish and extravagant was, and still is, copiously available and fairly inexpensive. The colorful marble used for the cathedrals in Pisa, Parma, and Florence was facilitated by the abundance of this material. Certainly, materials alone cannot account for the technical and artistic accomplishments of architecture.

The significant role of natural resources is evident in the desperate acts and even vandalism prompted by the scarcity of such materials. This has been the case with the Roman Colosseum, completed in 80 CE. Portions of the structure, including the marble that originally covered it, have been dismantled in subsequent centuries and used for other buildings. Metal, when in short supply, has been removed from this and many other ancient buildings. The natural environment has not only provided resources, but it has also been intertwined with architecture. The *Serpent Mound* in Ohio, an enigmatic Native American monument, was built within its natural setting. Its shape, reminiscent of a snake, from which it gets its name, is intimately connected with its surroundings. (See also "Comparisons" in Chapter 7.)

Modern technology, means of transportation, and global communications have diminished reliance on local resources. In the twentieth century many natural

materials were also replaced with artificial ones, with enhanced attributes. However, a heightened environmental consciousness has prompted contemporary artists to revert to natural products. Terms such as sustainability, green, and re-purposing have become important to contemporary art and architecture.

Location

Certain artworks are created for specific interior or exterior locations. The placement of a work of art influences and may even determine the choice of subject matter, materials, colors, and size. Artists working on such projects must consider how the surrounding environment relates to their work. Questions they may ask include: Is this a public or private space? What is the size of the area? Is it an outdoor or indoor project? What materials can be used? What should be the size of the work? What else is in that space? Is there an inappropriate subject matter?

If an art project were to be created for your college, what would be the best place for it on campus, and what restrictions or concerns would the artist(s) need to take into account?

Museums and galleries have recognized that many practical issues restrict the visions of artists. Therefore they support site-specific installations and other large projects which could not be created in a studio or would be difficult, even impossible to transport. The Überorgan (2007), by Tim Hawkinson (b. 1960), discussed later in this chapter, is such an example. (See also the textbox "The Artist's Studio" later in this chapter.)

Can you think of other practical issues that may be impediments for artists to create as they wish?

Climate

Weather and climate may appear unrelated to art, but in some instances they can be very influential factors. For example, fresco, a painting technique on wet plaster, requires a high temperature and low humidity when it is being painted. Once dry, frescoes are very resistant to variations in weather conditions. Architecture and outdoor statues are directly affected by climate. Heat, light, and the amount of rain influence the shape of roofs, the size of windows, and the thickness of walls. Even materials that seem very durable, such as marble and bronze, are not immune to nature. Air pollution has also impacted works exposed to the elements. The recent cleaning of many cathedrals, including Notre Dame in Paris, revealed the original light-colored stone concealed under centuries of dirt and dust.

Making art, however, is perceived to be mostly an indoor activity. There are exceptions, such as *plein air* artists (landscape artists who paint outdoors) or sculptors, whose studios have an outside space. Most art materials are very sensitive and would be severely damaged if exposed to the elements. Variations in humidity, excessive temperatures, and bright light are extremely detrimental to art. To protect works from "aging," modern art institutions have created climate-controlled environments. Some contemporary artists have questioned the artifici-

ality of these interiors and challenged the "immortality" of masterpieces by using unstable and perishable materials.

Dialogues between the Environment and Art

One of the most frequent interactions between the environment and art is the subject matter. The landscape has been widely depicted in art. Artists have reflected upon their surroundings in a variety of realistic, idyllic, or conceptualized depictions. For the French artist Paul Cézanne (1839–1906) the environment was a source of artistic innovation. Using Mont Sainte-Victoire, a mountain near Avignon, France, as his subject in a series of paintings, the artist developed an analytical method of representing space. His rigorous arrangement of rectangular shapes forms a basic framework that lies beneath superficial appearances. In these paintings a house is a cube-like shape devoid of windows, doors, and most details. This visual simplification, enhanced by a restrained palette, derives from careful observations and conceptual analysis. Cézanne's innovative representations had significant influence on Cubism and modern art.

Van Gogh often reflected upon nature in his work. The intensity with which he painted fields, trees, flowers, and hills highlights the artist's interest in this subject. His "obsession" with finding the perfect "starry night" suggests that he thought of his surroundings on a cosmic scale. He eventually found the celestial inspiration and his passionate nocturnal portrayal is now a famous work of art (see "The Anatomy of a Work of Art").

Nature is both beautiful and powerful in *The Great Wave at Kanagawa* (*ca.*1831–1833; Figure 2.2), by Katsushika Hokusai (1760–1849). A huge wave is shown engulfing a group of boats, creating a sense of uneasiness, but the majestic Mount Fuji in the distance provides a subtle calming effect. The clear lines and palette, contrasted with energetic shapes, underline the mysterious dynamics of nature.

In Native American, Asian, and African cultures the environment is also intertwined with art in performances, sand paintings, rock art, Zen gardens, and the tea ceremony. In recent decades artists have also more directly connected nature with art. Earthworks, environmental art, process art, and other innovative methods have questioned the basic tenets of the Western tradition. Walter De Maria's (b. 1935) *Lightning Field* (1977; Figure 2.3) exemplifies the visual results and ramifications of this dialogue. This artwork, set in the desert of New Mexico in the United States, comprises a meticulous arrangement of stainless-steel poles which attract electricity and contribute to the creation of a stunning light show. The menacing skies are not painted; the spectacular natural event *is* the work of art.

De Maria challenges traditional formats of both making and displaying art. The artist manipulates the interaction between natural phenomena and the steel poles. But he can neither predict the electric storm nor anticipate the form, shape, and duration of the lightning. What is, then, his role in this brief visual outcome? Furthermore, *Lightning Field* exists as a complete work of art only for a few seconds. It cannot be shown inside a museum or gallery. It cannot be preserved

2.2. Katsushika Hokusai, *The Great Wave at Kanagawa, ca.*1831–1833. Polychrome woodblock print; ink and color on paper, oban, 10 × 15 in. (25.4 × 38.1 cm). Metropolitan Museum of Art, New York. *Photo:* Image copyright © The Metropolitan Museum of Art / Art Resource, New York.

2.3. Walter De Maria, *Lightning Field* (New Mexico), 1977. Permanent earth sculpture, 400 stainless-steel poles arranged in a grid array measuring 1 mile × 1 km, average pole height 20 ft 7 in., pole tips form an even plane. © Dia Art Foundation. *Photo:* John Cliett.

(except through reproductions, which are often erroneously thought to be the art). This is a "mortal" masterpiece. Without labels, frames, and institutional endorsement, it may be difficult to discern art within nature. How should a viewer respond when artists claim nature as *their* art? What are the differences between the Grand Canyon, environmental art, and landscape paintings? These questions and works of art may be valuable starting points to reflect on preconceived ideas about art.

" I don't think art can stand up to nature. "

Walter De Maria[1]

How do these projects compare to similar works from other cultures, such as the *Serpent Mound* discussed earlier? The environment has also influenced the form and content of symbols. (See Chapter 6.)

Materials, Tools, and Technology

Ideas, feelings, and being "inspired" are important but not sufficient to make art. Artists also need to know, among many other things, what materials, tools, and techniques are appropriate and available for a particular project. A keen understanding of these practical issues permits artists to create technically sound works and develop new visual possibilities. A term widely used in connection with materials and techniques is medium (plural: media). Medium is used to identify the specific materials (such as oils, pencil, or marble) and methods (such as painting, ceramics, or sculpture) artists use to convey their ideas. (See Diagram 1 in Appendix 4.) Understanding the properties of materials and their use can substantially enhance the audience's abilities to appreciate art.

Materials and Artistic Values

Western values have established hierarchic differences among artistic traditions based on materials, which have influenced art classification and public taste. Asian paintings are typically made on silk and paper. Jade and ivory have been widely used for sculptures in Asia and South America. Historically, Native American art made extensive use of feathers, beads, and natural fibers; in the Western tradition these materials are mostly associated with the decorative Arts and Crafts Movement. Sculptures are made usually of stone, wood, or metal. Paintings are perceived to be only "oil on canvas."

The Attributes of Materials

The visual outcomes and technical qualities of a work of art are heavily dependent on the materials and techniques used. Therefore artists must be familiar with these, together with a wide range of procedures. However, these skills may be invisible to the viewer. A mastery of the medium and technical accomplishments are not easy to spot. For example, medieval manuscripts are handmade. This includes the beautiful letters and designs, the detailed ornaments and figures, even the elaborate covers and paper. Knowing the meticulous process of making this art allows the viewer, accustomed to the efficiency of computer graphics, to look at and value these manuscripts in a totally new way.

Prior to modern times the preparation processes were lengthy and tedious. Pigments were hand-mixed in artists' studios. Wood panels and canvases were manually primed. Modern conveniences made many of these steps unnecessary. Paints in tubes, prepared canvases, and other art supplies have reduced the time and labor required. These aids have also diminished the need to intimately know materials and techniques, and the consequences of this have become visible. Many modern paintings have deteriorated faster than those from the past. The causes include the use of new materials, unprepared or incorrectly prepared canvases, and not allowing proper drying time before further applications of paint. These technical problems, however, often derive from avant-garde values of newness and change rather than negligence; some contemporary artists want the process of aging to be part of their art and refuse conservation treatments of their works.

It is not only modern artists who have tried to improve or change traditional techniques. History offers rare but very valuable opportunities to understand how materials and techniques influence art-making. The best-known example is Leonardo da Vinci's *The Last Supper* (*ca.*1495–1498). This work, with its breakthrough compositional structure, was an ambitious mural project. The Italian artist, renowned for his interest in experimentation, decided to paint on a dry surface, rather than wet plaster, as the fresco technique required. It did not work. The slow and irreversible deterioration of the fresco began during Leonardo's life and has continued over the centuries. *The Last Supper* has undergone many attempts to be saved through, at times, botched restorations. The unfortunate fate of this work may be an ironic symbol. Technical achievements are, most of the time, invisible in the finished work and therefore go unrecognized.

The choice of materials is dictated not only by specific techniques but also pragmatic factors such as size, weight, transportation, and accessibility and, of course, money. This is often the case with large projects. The architect Frank Gehry (b. 1929) acknowledged that the titanium he needed for his Guggenheim Museum in Bilbao, Spain (1997), was too expensive and so he had to consider another material, which would have had significant implications for the visual aspect of his structure. Fortunately, the price of the metal unexpectedly dropped and Gehry was able to return to his original vision.

The "Purity" of Materials and Mixed Media

There has been a perception in the Western tradition, in particular, that the medium has to be "pure." This approach has practical explanations related to the compatibility of various materials. In general, in the past, mixing materials was limited in the West to mostly decorative arts and crafts. Art materials have been perceived to be passive and transparent. "Realistic art," the American critic Clement Greenberg (1909–1994) stated in an essay, "has disassembled the medium, using art to conceal art."[2]

Many modern artists reacted against this view and purposely made their medium visible. Traces of charcoal and the texture of clay in a work of art have prompted both critics and spectators to consider these works "unfinished." An important step in changing this position, although not the first, was the Cubist collage. Developed in the early twentieth century by the ongoing dialogue between Pablo Picasso and Georges Braque (1882–1963), collage (whose meaning derives from the French word *coller*, to glue) dismissed the homogeneity of the medium. *Still Life with Tenora* (1913; Color Plate 4), by Braque, is an example of mixed media. The artist placed on the same surface paint, charcoal, colored paper, and newsprint. In this, and other Cubist collages, reality is hinted at through fragments, some of which are actual wallpaper and newsprint. Reality is no longer simulated; it is now included in the work of art. This novel, and, to some, unsettling juxtaposition led to new directions in art such as assemblage and installations. (See Chapter 8.)

I think the idea of a "finished" picture is a fiction.

Barnett Newman[3]

Materials as Sources for Meaning

Many modern artists have turned materials from passive means of expression into the focal meaning of their art. The more inclusive contemporary global dialogues have played a significant role in this change. Sara Bates's (b. 1944) series *Honoring* (1997), comprising a geometric design arranged on the floor, does not appear to be anything more than an abstract work. The circular shape is suggestive of Native American symbols. On closer examination it becomes evident that the installation consists of natural materials: corn, beans, stones, and branches. The artist collects, assembles, and later recycles natural resources. The materials and processes involved aim to reinforce, visually and conceptually, connections to her Native American tradition.

 For other artists, materials are a way of reflecting on the practices of art. The colorful natural flowers Jeff Koons used in his *Puppy* (1992) change the perception and meaning of this work. The subject of this colossal sculpture, a cuddly little dog, is intentionally unusual. This giant topiary has links to both the monumental statues and landscape design tradition exemplified by the gardens at Versailles, France. The unexpected floral arrangement forces the viewers to pose several questions. What is the role of the artist? Did he select the flowers? How are they watered? How long would this sculpture last? But more importantly: How is this work different from the "Chia Pet" (a popular ceramic planter in the form of an animal whose "fur" grows from chia seeds) sold in stores? What makes Koons's sculpture better than scores of cute animals growing as topiaries on lawns? This line of inquiry would not be possible had the artist used stone or bronze. What do you think about this work? What is your reaction to it?

 The African American artist Faith Ringgold (b. 1930) also employs materials to enhance the meaning of her art. Her work *Dancing at the Louvre* (1991), an interpretative view of the gallery in the museum which displays *Mona Lisa* and other works by Leonardo da Vinci is, like many of her works, similar to a quilt. However, this is no longer a functional object. Ringgold uses the medium to initiate reflections. Viewers have to confront their preconceived ideas about "fine" and "decorative" arts, masterpieces, and museums. The inventive reinterpretation of the famous paintings (all representations of women) in a mixed medium, with many gender and cultural ramifications, boldly questions biases in art and art history. The materials reinforce the significance of the quilt in the African American tradition and highlight the limited role of women in art.

“ I am a painter who works in the quilt medium. ”

Faith Ringgold[4]

The Chinese American artist Xu Bing (b. 1955) also transforms conventional media into innovative displays. His installation *A Book from the Sky* (1987–1991) is based on traditional Chinese calligraphy. The unusual displays of scrolls, some hanging from the ceiling, with ambiguous connections to expected formats, unsettle the viewer. The text adds to the confusion. It is not, as may appear, in an Asian language, but in an "invented" alphabet: in essence, it is a graphic design.

Meret Oppenheim (1913–1985) was also interested in how the medium can alter and redirect meanings. Her work *Object (Fur Breakfast)* (1936; Color Plate 5) is nothing more than a cup, saucer, and spoon, with one exception: they are all wrapped in fur. This unusual natural covering renders the objects unusable. It also prompts a series of thoughts about the meaning of the work, ranging from fashion and gender roles to archaic and modern identities. The visual tease challenges and entices viewers to fantasize, even if only for a split second, about using the cup.

Transforming the ordinary into a conceptual inquiry about art is at the core of this work.

Materials have meanings in architecture as well. Two examples from the late nineteenth century, the Brooklyn Bridge (1870–1883) and the Eiffel Tower (1889), illustrate this point. The impressive span of the bridge was possible partly because of the use of steel-wire cable. The lace-like steel structure of the Eiffel Tower, erected 986 feet into the air, was also possible because of the material, a form of wrought iron, and technical achievements of the time. These structures express effectively and overwhelmingly the emerging modern dialogue between the individual and technology.

There are many more instances where artists use the medium as part of their message, rather than solely as a means of expression.

> Do materials have an impact on how you look at art? If you had to create a work of art, how would you use materials to emphasize your idea?

"Unusual" Art Materials

There are plenty of preconceived ideas about what materials are adequate for art. Artists, particularly contemporary ones, have not been deterred by these views. They have explored diverse resources that have surprised and discomfited audiences. Lard, soap, candy, and biological materials, sometimes linked to the artists, have also been used. There are many examples. The American artist Ed Ruscha (b. 1937) included chocolate in his 1970 installation, appropriately entitled *Chocolate Room*. The smell coming from the brownish wallpaper surprised viewers. It was chocolate, not paint! Yet many of those shocked by the material enjoy this odor and admire chocolate figurines in other environments.

The British artist Damien Hirst (1965–) has included in his works sharks, pigs, and cows and displayed them in cases filled with formaldehyde. For his 2007 exhibition, *Superstition*, the artist used thousands of butterflies to simulate stained glass. These visually impressive images, such as *Aubade, Crown of Glory* (2006), have shocked audiences within and outside the art world. However, no one has objected to similar displays in natural history museums. On the contrary, exhibits of animals preserved chemically or by taxidermy have been praised for their educational value. Is it the specificity of institutional environments or the viewing expectations of the public that create different reactions to similar exhibits? Hirst's art contemplates mortality from more than one perspective. The death of the animals and butterflies is heightened by the temporality and fragility of the art created with them.

On the surface it appears that this kind of art aims only to shock. But are these contemporary works different from scores of admired still lifes that depict dead rabbits, fish, and birds? Why can soap and sausages, lard and lipstick, and fish and meat be represented but not used in art? In other traditions, the use of animal or biological products would not appear beyond the norm. In fact, Ruscha's chocolate project could be loosely and conceptually compared to the Japanese tea ceremony. Animal skin has been used not only in Native American, Asian, or African art, but also Western art. The pages of medieval manuscripts, glues, and binding

solutions were made from animal products. Why is the use of animals acceptable as an invisible medium, but not when it is a noticeable component of the work of art? What do you think about these works and the materials they employ?

> I wanted people to think about themselves, about their lives, about their own mortality.

Damien Hirst[5]

The fundamental elements of our life and planet – light, fire, water, and air – do not fare any better when they are used as art materials. Their impermanency is perceived incompatible with art. How can a work of art be made of materials that are ephemeral and unstable? This is one of the reasons De Maria's *Lightning Field* (Figure 2.3) disturbs many viewers. Yet, light is a crucial visual and conceptual element, among others, in medieval and Baroque religious art. With all the significant differences, a sense of awe permeates both the interior of churches illuminated by the sun and De Maria's work. This connection may reveal profound spiritual and even cosmic reflections and meanings in De Maria's art.

Found Objects

Another common practice in contemporary art is to use objects created for other purposes. Duchamp's *Fountain* (1917; Figure 0.2) is an early example. Some artists conceal or alter the found objects in their art. The contemporary artist Long-Bin Chen (b. 1964), for example, seems to create sculptures with stone or wood. When we look more carefully at his work the deception is exposed: the beautifully carved figures are made of used telephone directories and magazines. The artist's intention to surprise viewers is also linked to his reflections on cultural values and natural resources.

In today's society "re-purposing" materials is a statement about art and the environment.

Look around you: what object would you use to create art, and what meaning would you like to get across?

The Body as Art Material

Western tradition has somewhat separated art from life. "Wherever art appears, life disappears,"[6] the French artist Francis Picabia (1879–1953) said. Performance art transforms the artist's body into a material that is literally "alive." This dual role, art-maker and art object, has been difficult for viewers to accept. Furthermore, the inclusion of the audience and other elements in some works can make those who are accustomed to a passive art experience feel uncomfortable.

Performance has been a component of African, Asian, and Native American cultures for centuries, but it was considered a novelty in twentieth-century Western art. Avant-garde movements such as Futurism and Dada used it to break away from traditional art objects and concepts. Contemporary artists have reflected in performances about cultural empowerment, gender identity, and control over the body. Yoko Ono (b. 1933) explored the boundaries between private and public spaces in her *Cut Piece*, first performed in 1964. The performance entailed the artist's request to have her clothing cut by the audience. Unprecedented interactions between spectators and artist were part of this work. A sense of uneasiness and even fear grew with the development of the event. The shifting position of power and control created a heightened state of anxiety. The changing reaction of the audience was an important component of the performance.

How would you react if you were the artist? How would you react if you were in the audience?

The American artist James Luna explores comparable issues in his *Artifact Piece* (Figure 2.1). The artist's placement in a display case, as if he were an object in a museum, startles audiences, who expect to see an object, not a real person. Luna's Native American heritage, visible among other things in the connotations of sand paintings, is seminal to this work. The artist reflects in this tranquil performance on representation and identity in art. The attached notes mimic didactic labels in format and purpose and give us information about his life and ties to Native American tradition. The word *artifact* used in the title highlights the hierarchic values defined by cultural contexts and endorsed by museum practices.

Equally difficult to accept, if not more so, is the notion of the body as a "canvas." Tattoos, validated as art for centuries in many traditions, are finding a place in contemporary culture, as both artistic expressions and personal statements. These visual expressions imprinted, often permanently, on the body, make this art both long-lasting and directly connected to life. Contemporary artists, such as the French Orlan (b. 1947), have created an even more intimate link between art and the body. Some of her works have been labeled "carnal art." Over the years the artist has undergone a series of medical procedures on her face and body, based on art-historical and cultural models. Orlan's personal transformations are comments on cultural identities and artistic values. Her recent "hybrid" works include altered digital photography. In these images the artist personifies ideals from pre-Columbian, African, and other cultures to expose and critique stereotypes (for example, Color Plate 17; see the illustrations and further discussion in Chapter 9.)

The fusion between artist and the work of art, discussed in Chapter 1, is, in these examples, both literal and complete. The artist *is* the work of art. But many viewers and even some experts have been skeptical about the value of these artistic practices. Materials are not merely vehicles of expression. They may be determining factors in defining art and establishing its meanings. Their "appropriateness"

is demarcated within culture. Even when their use is disturbing, materials can prompt valuable reflections about art.

Tools and Technology

To use materials efficiently artists need a variety of tools, implements, and instruments. The specificity of the works determines the tools artists need. Some of them, such as brushes, palettes, and easels, are familiar to the general public. Others, such as burins and fine chisels, are highly specialized instruments, used in printmaking and sculpture, respectively. Some of the tools, such as hammers and nails, are common household items. Power tools and industrial materials are among the many non-traditional supplies contemporary artists use. Nowadays artists are more likely to shop at home-improvement rather than art-supply stores.

The Artist's Studio

The size and set-up of an artist's studio reflect the specificity of art-making processes and the materials and tools used. A painter would likely need an easel, a storage system for the works, and a convenient way to access paints and brushes. A ceramic studio must include storage areas for glazes and clay and a safe placement of the kiln. Sculptors require an elaborate set-up for their studio because they use a variety of tools and materials. Practical elements such as the width of doors and height of ceilings are important when planning large projects. To avoid the restrictions imposed by the space of their studios, artists have come up with ingenious solutions, such as making independent components that are later assembled into one large work. Artists must also consider issues related to safety, noise, insurance, ventilation, fire hazards, and other regulations which may impact on and limit their activities.

Art studios may give some indications about artists' personality and their creative process. Some are orderly and meticulously arranged. Others lack a systematic layout. A sculptor's studio may look like a factory, with heavy machinery and power tools. When artists have many assistants, their studio may look like an art school. Artists are usually very protective of their workplace; few allow the public to visit their studios. Even fewer would make art in front of visitors. Some contemporary artists have, however, opened up their studios to organized periodic tours.

In the past technology played a secondary, supportive role in art-making. In recent times it has become a significant primary tool. Printmaking, photography, and more recently new media have been based on a variety of new technologies. There is, however, an inherent distrust of the value of art created with the help

of a "machine." The perception is that the tools, cameras, or computers are doing all the work.

Should purchasing prepared canvases, paint in tubes, and commercial brushes diminish the role of a painter?

Technology offers both opportunities and challenges. New forms of expression require the development of new guidelines and rules. Printmaking is a good example. This technology, which made possible the creation of multiple identical images, was brought to Europe from China, and became more widely used in the fifteenth century. Because they were no longer "one-of-a kind," prints were cheaper than paintings. They were also easier to make, sell, and transport. These qualities made prints a perfect vehicle for spreading art and ideas to broad, diverse, and distant audiences.

Printmaking involves a wide range of techniques, materials, tools, and procedures, which required new practices and terminology. (See Diagram 6 in Appendix 4.) Prints are produced in *editions*. This term identifies the number of works printed from the same plate. Each print has two numbers marked in pencil: one is the total number of the edition, the other the number of the print. For example, the numbers 12/250 on a print means that it is the twelfth out of an edition of 250. The first prints are often considered to be of higher technical quality. Artists' proofs precede the edition and are marked A/P; these prints may be very valuable because they are fewer and may reveal, in some cases, the artist's working process. The number of possible prints varies depending on the techniques and materials used. Plates can be re-used if they are not destroyed. These practices are unethical, may even be illegal, and can also create complicated artistic and financial issues.

Photography was an even greater cultural challenge. After its invention in 1839, it quickly became a popular and highly trusted tool. Photographs have been and continue to be perceived as "truth" because of their ability to create images that convincingly replicate reality. However, interpretation and subjectivity are as much a part of photography as they are of painting or sculpture. The subject, composition, and angle are among the many elements artists, not the camera, select and decide upon. Moreover, technical issues like exposure, settings, and the printing process add more possibilities for the artist's interpretations. There are also significant distortions inherent to photography. First, like paintings, photographs represent a three-dimensional environment on a two-dimensional surface. Second, sepia and black-and-white photography are obvious alterations of reality. Third, the scale is compromised and even may be erased. Digital photography has added ambiguities to the processes of recording reality and transforming it into an image. Programs can substantially modify and even delete the steps taken in creating digital images.

Rapid advancements in technology can make new-media works appear "dated." And yet, with all this broad access and development, the unique attributes of contemporary technology have yet to be fully explored by artists.

Other Resources: Knowledge and Information

There is an erroneous assumption that art comes mainly from passionate senti-ments and uncontrollable urges. Art is neither purely intuitive nor solely a craft. Feeling and thinking are constantly intertwined in the art-making process. To effectively communicate thoughts, emotions, and reflections through lines, colors, and shapes requires not only tools and materials, but also knowledge and informa-tion. Artists' knowledge and ideas derive from personal interests and broader contextual issues.

There are numerous sources that influence artists. Art history is one of them. In the past artists have not only studied but also copied works of art as a manda-tory component of their training. Familiarity with artistic developments from the past and present informs and inspires artists. Many artists have used art history as a muse and source for critical reflections. Robert Colescott (1925–2009) is one of them. The African American artist reinterpreted masterpieces with added com-mentaries. His painting *Demoiselles d' Alabama* (1985), a play on Picasso's *Les Demoiselles d'Avignon* (1907; Color Plate 16), considers the role and perception of African culture in modern art. Picasso also used art history as a source of inspira-tion. His works include reinterpretations of Velásquez's *Las Meninas* (1656; Figure 1.1), and Édouard Manet's *Déjeuner sur l'herbe* (1863).

A personal interest in literature, philosophy, and music also informs an artist's creative path. An example is Tim Hawkinson's (b. 1960) installation at the J. Paul Getty Museum, *Überorgan* (2007). This monumental work, with a sophisticated electronic process and a score 250 feet long, based on a mixture of hymns and pop music, reflects the artist's training and intimate knowledge of music and digital technology. Many other disciplines outside the humanities inform artists and shape their art in practical and conceptual ways. Knowledge of chemistry helps artists develop new ways of using pigments, glazes, and other materials. Geometry and mathematics are necessary for the use of perspective, proportions, and other measurements. Knowledge of anatomy and science is essential to understand and depict the body. Architecture is directly affected by physics and engineering, so that structures are not only to be pleasing to the eye, but also sound. Travel can also have a significant influence. Contact with different cultures, environments, and customs can inspire artists. Their trips to North Africa, for example, had a major impact on the French artists Eugène Delacroix (1798–1863) and Henri Matisse (1869–1954).

The web project *The New Five-Foot Shelf* (2004), by Allen Ruppersberg (b. 1944), reveals the artist's physical and conceptual creative space in an inventive and inter-active way, and exposes the multiple sources that inspire him. Literature, philoso-phy, and music, reflecting the artist's knowledge, interests, and influences, are displayed and connected by the viewer.

Many artists have expanded their creativity to other fields. Michelangelo was also a poet. The Italian theorist Leon Battista Alberti wrote a book on painting

and one on the family. The German artist Albrecht Dürer (1471–1528) wrote about geometry and perspective. Leonardo da Vinci reflected on a wide range of topics, including anatomy and engineering. In the modern period narrow specialization discouraged interdisciplinary approaches. Today, however, postmodern artists are finding innovative cross-disciplinary resources to inform their creativity and art. They include film projects, theoretical texts on art, and books for children.

As in other professions, artists continue to stay informed about their field and other disciplines beyond their formative years and college education. Their art may display stylistic consistency, but may also reflect a constant growth which stems from continuously acquiring knowledge and developing ideas. They also contribute to culture by giving lectures, talks, and workshops, serving as mentors and engaging in other activities that benefit the public and future generations of artists.

Summary

This chapter uncovered multiple practical and cognitive factors that affect the process of making art. Specific elements such as the environment, materials, even climate and location, contribute to and, at times, even determine the outcome of the art. Artists' visions and their art are also influenced by their knowledge.

Luna uses innovative materials in *Artifact Piece* to create meanings. The artist, however, is influenced by and reflects on many other issues. Multiculturalism, museum studies, cultural identities, and history are among the factors that inform and define his work. The context in which art is made plays a significant role in art-making processes. Politics, religion, moral values, social concerns, and other contextual factors affect artists and their creativity. The specific way in which these elements are intertwined with the creative process is discussed in the next chapter.

> What would you be most concerned with if you were an artist? What is the most valuable information you have learned in this chapter? What would affect your art appreciation in the future?

Notes

1. Walter De Maria, "On the Importance of Natural Disasters" (1960), quoted in Stiles and Selz, *Theories and Documents*, p. 527.
2. Clement Greenberg, "Modernist Painting," in Frascina and Harrison, *Modern Art and Modernism*, p. 6.
3. Barnett Newman, quoted in Gayford and Wright, *Art Writing*, p. 337.
4. Faith Ringgold, "Interview with Eleanor Flomenhaft," in Slatkin, *Voices of Women Artists*. p. 322.
5. Damien Hirst, court report, quoted in Gayford and Wright, *Art Writing*, p. 116.
6. Francis Picabia, quoted in Dawn Ades, "Dada and Surrealism," in Stangos, *Concepts of Modern Art from Fauvism to Postmodernism*, p. 113.

3
Context

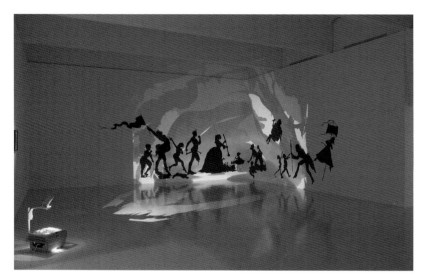

3.1. Kara Walker, *Darkytown Rebellion*, 2001. Cut paper and projection on wall, 180 × 396 in. (457.2 × 1005.8 cm). Installation view: Kara Walker: My Complement, My Enemy, My Oppressor, My Love, Walker Art Center, Minneapolis, 2007 (caption provided by the gallery). *Photo:* Dave Sweeney. Courtesy of Sikkema Jenkins & Co., New York.

Darkytown Rebellion (2001; Figure 3.1), by Kara Walker (b. 1969), is rooted in a series of issues connected to African American history. Here, as in many other of her works, the figures are only silhouettes, which interact with viewers' shadows, creating a vast and dynamic tableau. These depersonalized, opaque forms symbolize and critique stereotyping and marginalization. Walker also comments on the role gender, race, and other social issues have in African American history. These

The Art of Understanding Art, First Edition. Irina D. Costache.
© 2012 Blackwell Publishing Ltd. Published 2012 by Blackwell Publishing Ltd.

visual representations and narratives reflecting on the American South and its past are influenced and informed by diverse contextual elements.

Context is the wide range of external factors, circumstances, events, and elements in which art is created. The terms context and environment have a somewhat similar meaning. In general, environment refers to natural factors, background situations, specific settings, and existing moods. Contextual elements are active conditions that more directly interact with and affect society. The term context can refer to the overall framework of a period or a particular aspect of it. "The context of the Italian High Renaissance" refers to multiple elements of the early sixteenth century such as history, political issues, culture, ideas, and religion. In contrast, "the religious context of the Italian High Renaissance" is focused on this specific factor. The influence of contextual elements varies from one period and culture to another. Some elements, such as history and politics, have a broader impact. Others are specific to particular eras. The distinctions between contextual factors and personal knowledge can be sometimes difficult to determine.

Art is not created in isolation. Understanding how the context affects artists can substantially enhance the appreciation of art. This chapter discusses several contextual elements; the entries are grouped into three sections and listed alphabetically to avoid an implied hierarchy. Many of these elements are closely interconnected and influence one another; for example, the religious context can have an impact on moral and cultural values. Historical and political events can significantly change cultural concerns, moral and social views, and even artistic taste. The separation of specific contextual elements in the discussion below is for analytical purposes. Examples presented in one section may be influenced by multiple contextual factors. However, to avoid confusion and overload of information, only one contextual element is examined.

Cultural Context

The cultural context has a strong impact on the creation of art. Most artists are actively engaged with diverse aspects of culture and society and maintain a sustained level of interaction with the art world. Philosophical ideas, scientific discoveries, and personal friendships affect artists and their work. Even those who work alone in their studios are not detached from their cultural context. Many would consider Van Gogh a recluse. Yet he was keenly aware of the artistic ideas of the late nineteenth century.

Artistic Context

The artistic norms and taste of a period have a great influence on artists. These factors vary drastically in different cultures and time periods. Artists have been influenced and inspired by both individual works and the broad artistic context. In the past, lack of effective communication made it difficult for trends to easily

circulate across regions, and even less, across continents. Enduring values established clear artistic standards which were easy to emulate. Artists, however, had to find a delicate balance between following these norms and developing their unique style.

This becomes evident when looking at art from a specific era. In a gallery of fifteenth-century Florentine paintings it may seem at first impossible to distinguish individual artists. This is because an initial viewing reveals the general characteristics of the period. On a closer, and more attentive examination personal styles emerge. Significant visual differences within the same period have been rare in the past. They can usually be found on side or back panels and in some works created for private use, suggesting that the artistic context has also been an impediment to creativity. The search for deviations from the accepted norms may be one of the most interesting and rewarding experiences for viewers. This "treasure hunt" would expose what contemporaries would have not likely easily accepted.

In previous centuries patrons' taste played a significant role in defining artistic norms. The establishment of art institutions and the emergence of art experts in the modern period have created more transparent and clear criteria. Artistic values are acknowledged through exhibitions, reviews, books, auctions, collections, and other forums. They are also validated by the opinions of critics, art historians, museum professionals, and other specialists. As the artistic context has become more regulated, the need for greater creative freedom has prompted some artists to reject what they perceive to be rigid norms.

Art Organizations, Institutions, and Events

Art organizations, institutions, and events play an important role in shaping artists' visions. Most of them have been established in the last three centuries. Art institutions generate artistic standards, principles, and guidelines that provide a framework for professional credibility and career development.

The French Academy is a well-known example in art history. Established in the mid-seventeenth century, for over two centuries this art institution defined artistic standards in France and even Western Europe. The French Academy launched a system of promoting and supporting artists through exhibitions, the famous Salon, and competitions, such as the prestigious Prix de Rome. Classical tradition was at the core of the Academy. Specific rules and guidelines included a hierarchic list of acceptable subjects, and artists who wanted to gain acclaim had little choice but to follow the rules of the Academy. A similar rigid approach was at the core of the academies established at the Chinese regal courts during the Ming and Song dynasties. These values were also the basis of influential artistic styles, underlining how institutional taste affects artists and their creativity.

Since the mid-nineteenth century, when alternate paths for art careers became possible, Western artists have rebelled against institutionalized taste and norms. The rebellion against the dominant taste of the French Art Academy is well illustrated by Édouard Manet's art. A comparison of his 1863 painting *Olympia* and

The Birth of Venus (1863) by Alexandre Cabanel (1823–1889) (both now in the Musée d' Orsay, Paris) reveals the novelty of Manet's painting. These works representing a female nude were painted in the same year by two artists living and working in the same city, Paris, and exhibited at the same venue, the Salon, but in different years. Yet, with all these common denominators, the two paintings could not be more different. Cabanel's art closely reflected the views of the French Academy. The depiction of the female nude was veiled by a convenient classical theme, the goddess Venus. Her seductive and inviting pose, along with the dream-like setting, draws in the viewer. Manet, on the other hand, refused to follow what he, and others, considered archaic artistic standards. He painted the nude blunt and direct. The sitter's awareness of her body, empowering pose, and piercing gaze, as well as the hand seemingly concealing her full nudity, but in fact drawing attention to it, shocked audiences. Cabanel's painting received high acclaim, whereas Manet's *Olympia* was ridiculed. (See also Chapter 9.)

With all the difficulties they knew they would encounter, many now well-known modern artists have opted for a similar rebellious path. Their works were accepted and understood only by a small circle of art cognoscenti. This self-marginalization was not easy, but it created the very influential context of the avant-garde, which had a significant influence on developments in modern art.

What are the defining elements of today's artistic context? Technology, multi-culturalism, the mass media, and popular culture are some of them. Global culture and instant communication have made it possible to access and be aware of multiple artistic standards. The use of a broad range of materials, styles, subjects, sizes, and formats reflects and represents the dynamic and changeable society in which we live. Nonetheless, art institutions and specialists continue to have decisive influences on contemporary artists and artistic values.

What is the role of the audience in all this? Historically, popular taste has had a minor influence on the artistic context. The mechanisms by which the public can express its views and modify artistic values are limited. In addition, artists have been much more responsive to the taste of patrons and institutions and less receptive to the opinions of their audience. Even though in the last 150 years art has been steadily more accessible, the gap between spectators' taste and artists' values has widened. Artists continue to seek validation from experts, not from the audience.

Should artists be concerned with the public's views on art?

Culture, Science, and Ideas

Many aspects of culture have affected artists. Philosophy, literature, music, theater, poetry, film, dance, and fashion, among many other things, play a significant role in the development of artists' views and ideas. There are many examples that confirm the impact these interdisciplinary dialogues have on art. Italian Renaissance artists used ancient and contemporary texts to articulate their interpretation

of the classical tradition. Many works of art of the period confirm a familiarity with Roman mythology and Neoplatonic philosophy. A good example is the painting *The Birth of Venus* (1485), by Sandro Botticelli (1445–1510). The surprising overlapping of classical and Christian symbols effectively visualizes these sources.

The role of the cultural context is also visible in the influence of Confucius and Daoism in Chinese art. The values of order and freedom, respectively, at the core of their views, are visible in portraits and landscapes. In addition, the notion of void, relevant to Daoism, is an important component of Chinese painting. The conceptual platforms of several twentieth-century developments are connected to philosophical and spiritual ideas. For example, the abstract art of Piet Mondrian (1872–1944) is linked to theosophical concepts. There are also close ties between art and literature. The French painter Eugène Delacroix was influenced by the poems of Lord Byron (1788–1824). Images and words are closely connected in many Asian paintings.

Contemporary influences have expanded beyond local or even national contexts. Access to information and the acceptance of different cultures created a new, rich, and diverse set of resources. The art of the African artist El Anatsui (b. 1944) reflects the influences of eclectic traditions. The colors and designs of his remarkable tapestries are based on African textile design, apparently made of soft, rich fibers. The extensive use of gold and its impressive size add to the extraordinary opulence of the work. The ties to the past are marked by the wear and tear which is easily visible from a distance. A closer look reveals the deception at the core of the work. The material is neither fiber nor fabric. Rather, it is an international array of aluminum caps, cans, and other re-purposed materials and containers. El Anatsui's 2007 installation on the façade of the seventeenth-century Palazzo Fortuny in Venice, Italy (Color Plate 6) effectively connected contemporary global concerns with past visual traditions.

Scientific ideas and trends in technology can also influence artists in a variety of ways. In the seventeenth century, for example, artists were interested in the recent discoveries related to optics and light. In the nineteenth century, the French painter Georges Seurat (1859–1891) used the writings on color by the French chemist Michel Eugène Chevreul (1786–1889) to develop his famous Pointillist style. Scientific ideas were also reflected directly or indirectly in works of art. The theory of relativity and the concepts of speed and simultaneity of the early 1900s left a significant imprint on Cubism and Futurism. Freudian theory influenced Surrealist artists.

> ❝ We affirm that the world's magnificence has been enriched by a new beauty: the beauty of speed. ❞
>
> **Futurist Founding Manifesto, 1909**[1]

The intimate cultural *milieu* (a French term that signifies social circle or environment) and dialogues among artists and cultural figures have also shaped artistic views. Numerous portraits of writers, musicians, philosophers, and scientists document these relationships. Letters and other textual accounts confirm the significance of these personal connections.

Historical, Political, and Religious Context

Historical Context and Current Events

The historical, political, and religious context has had a major impact on art. While they are discussed separately here, these factors are often closely intertwined. Specific events and general historical conditions have a significant role in the creative process. The historical context can determine the position of artists, the role of patrons, the demand for projects, and the value of art within society. The purpose and function of art may also be influenced by the specificity of historical environments. History is strongly connected to political, religious, and moral issues.

The historical context has also often been represented in art. Until the nineteenth-century invention of photography, paintings and sculptures were essential visual means of recording history. Scores of works with historical content offer interesting and unique testimonies of past events. Deciphering the historical accuracy can, however, be difficult. For various reasons, these works reflect mostly the views of patrons, and rarely those of artists. The Bayeux Tapestry is an important visual record of the eleventh-century invasion of England by the Normans, but it is presented one-sided, from the conquerors' perspective. The significant variations in the representations of Napoleon (1769–1821), from liberator to anti-war statements and from powerful emperor to a nude Mars (a Roman god), further underline the partiality of historical accounts.

Allegories have been widely used to suggest historical situations and events. Many nineteenth-century Romantic artists, both in Europe and the United States, have used the landscape as a symbol of national identity. Women have often been represented as symbols of liberty, justice, and peace. Eugène Delacroix's painting *Liberty Leading the People* (1830; Color Plate 7) is a symbolic representation of the 1830 revolution. In this case, history has affected the artist in more than one way. The event depicted resulted in the abdication of the king, Charles X, and the painting is visibly supportive of the change. The woman carrying a French flag is emblematic of both freedom and the country. The French government bought the painting, but later, its political message was perceived to be unacceptable to the official view. It was, eventually, displayed in the Louvre later that century. This is a good example of the continuous influence history and politics have on art, even after a work is completed.

History can affect artists on a personal level as well. Wars and other events influence the creativity of those who participated in or witnessed them.

The historical context can also have practical implications. In times of prolonged battles and extensive turmoil, particularly in past centuries, less art was produced. In difficult times there is less money, time, and interest for artistic projects.

In the modern period photography, film, and video rapidly replaced traditional art forms as means of representing history and current events. The ability to capture and present raw and instantaneous images with apparent undeniable objectivity sometimes makes it harder to distinguish between art and journalism. The photographs Walker Evans (1903–1975) created for the US Farm Security Administration (FSA) during the Great Depression underscore these difficulties. *Allie Mae Burroughs, Hale County, Alabama* (1936), an iconic image from this project, is now discussed in art-history books and exhibited in museums. *Are these photographs works of art or memorable visual documents? What do you think?*

Current events have been depicted more often in the last two centuries, when artists have been able to express their views. These works often reflect the social and political ramifications of such events.

A picture is a tissue of quotations drawn from the innumerable centers of cultures.

Sherrie Levine[2]

Political Context

The political context is closely intertwined with historical elements. It has a significant, and at times, determining, impact on the art-making process. In the past art appears to have consistently endorsed the predominant political power. This one-sided representation should not suggest that artists have been always supportive of governments. Rather, it underlines that the political context can restrict and suppress artists' free expression. In many cultures and periods, openly presenting dissenting visions would have endangered the fate of both artists and art. What artists and architects thought about the political context has remained, in most cases, a mystery.

The impact of the political context is particularly visible in projects with great significance, such as architectural ensembles. A variety of official buildings have been created with a clear understanding of their symbolic value. This concern has been at the core of the layout and design of scores of palaces and fortresses. Many familiar examples from the history of world art have this dual role. The creativity of the artists and architects who designed the Palace of Versailles was not driven by personal beliefs or feelings. Rather, their goal was to create a structure whose beauty and layout would evoke the emerging power of seventeenth-century

3.2. The "Forbidden City" (imperial palace), Beijing, China, aerial view. *Photo:* © View Stock/ Alamy.

France and its king, Louis XIV (1638–1715). Even the exquisite arrangement and order of the surrounding gardens are statements of power and control.

Half the world away, the impressive Forbidden City (1406–1420), in Beijing, China (Figure 3.2), has the same symbolism. The intricate arrangement of private and public spaces aims to heighten the power of the emperor. This is underlined by the distinctions between inner and outer courts visible in the plan of the architectural ensemble. Furthermore, walls, gates, and towers isolate the structure from the city. Its overwhelming presence emphasizes the authority of the ruler. In ancient cultures political might was often marked by dramatic and often oversized statues of lions and other real or mythical creatures, strategically placed at the entrances of palaces and fortresses.

The political environment influences in particular the creation of official portraits. These works aim to represent an idealized image in either narrative or symbolic form. The well-known portrait of Louis XIV by the French artist Hyacinthe Rigaud (1659–1743) presents the king with a sense of authority highlighted and supported by rich fabrics, fur, and the symbols of the French monarchy (the fleur-de-lis and the colors blue and gold).

These visual conventions are used in many cultures and time periods. For example, in Benin, Africa, the rulers, called *oba*, were also represented in strict and formal sculptures. These sculptures reflected political and divine power through symbols such as necklaces and headdresses. The brass plaque *Equestrian*

3.3. *Equestrian Oba and Attendants*, 1550–1680. Brass, H19 7/16 × W16½ × D4½ in. (49.5 × 41.9 × 11.4 cm). Metropolitan Museum of Art, New York. *Photo:* Image copyright © The Metropolitan Museum of Art/Art Resource, New York.

Oba and Attendants (1550–1680; Figure 3.3) is one of many that decorated the royal palace. As in similar works, this portrait represents the *oba* surrounded and protected by members of his court. The consistent central placement of the ruler, his significantly larger size, and elaborate headdress confirm his identity and reinforce his authority. The durability of the material used further emphasizes his role and power.

In few and rare cases, artists have abandoned imposed rigidity and made their creative presence visible. The portrait *Charles IV and his Family* (1801) is a unique, non-idealized royal representation painted by the Spanish artist Francisco de Goya (1746–1828).

Are you familiar with architectural structures or portraits that reveal the political power of a particular period or ruler or government entity?

Most modern artists had greater artistic freedom and thus more opportunities to expose their political views. They became aware of the political power of their art and the value of their artistic autonomy. Pablo Picasso created *Guernica* (1937) in France. The painting is the artist's response to the devastating bombing of the small Spanish town of Guernica in 1937. It was created for and exhibited in the Spanish Pavilion of the International Exposition held in Paris in the same year. In Spain, the fascist regime would have severely limited the artist's creativity, as Picasso was well aware. Consequently, he refused to show this painting in Spain under Franco's repressive rule. It was only in 1981, after the death of the dictator, that *Guernica* was finally exhibited in Picasso's native country. This was almost half a century after it was painted and eight years after the artist's death.

Dictatorial regimes and repressive political environments have consistently suppressed artists' vision and have limited dissenting opinions. Censorship and other forms of artistic and personal repression have prompted artists to develop underground movements and, when possible, leave their home countries. But, as history has demonstrated, these choices were not always available. In repressive regimes, artists could lose not only their creative freedom, but also their lives. (See also "Propaganda Art" in Chapter 4.)

"Degenerate" Art

The infamous *Degenerate Art* exhibition, organized in Germany in 1937, is an example of how dictatorial regimes censored free artistic expression and imposed their views. Held in Munich for four months, this exhibition subsequently traveled to cities all over Germany. The over 600 paintings and sculptures displayed, mostly by noted avant-garde artists such as Emil Nolde (1867–1956), Ernst Ludwig Kirchner (1880–1938), Max Beckmann (1884–1950), and Vassily Kandinsky (1866–1944), had been previously removed from various institutions, in a campaign of expunging modern art from public view. The purpose of the show was to demonstrate not only that modern art had no merit but that it was also capable of undermining the political status quo and thus was detrimental to German culture. This indoctrination was achieved through abundant textual and visual material, often overpowering the works, which discredited the artists on a personal and professional level, and denigrated the art. Not only the art, but also the artists were also perceived to be dangerous to society. Therefore, considerable personal and creative restrictions were imposed on them, with major repercussions on their lives and careers. Some artists were able to leave the country; others changed their styles, but others stopped making art altogether. In 1994 the Los Angeles County Museum of Art re-created this exhibition to inform new audiences about the extreme cultural policies and methods used by the Nazi regime and their correlations to the historical and political context.

Religious Context

The religious context has influenced both the visual and conceptual aspects of an astonishing number of works of art throughout history. Strong ties between art, religion, and political life have contributed, at least in part, to the enduring continuity of some artistic developments. It has triggered and shaped the development of architectural structures, artistic forms, visual programs, and symbolic representations. The colorful light diffused by the stained glass in Gothic cathedrals and the decorative flatness of illuminated manuscripts intentionally created visual effects beyond material life. The purpose of this visual effect was spiritual, not aesthetic.

Religion also limited artists' creativity. Architects and artists asked to create religious works had to observe strict guidelines which might not have coincided with their views. There are also those whose religious belief inspired their creativity. This includes, among others, thousands of monks in Europe and Tibet who produced manuscripts and sand paintings. Similarly, in Native American culture artistic concerns are often intertwined with spiritual needs.

Religious architecture has been directly affected by ritual practices. Indian stupas, Christian churches, Greek temples, and Islamic mosques have astonishing engineering and memorable designs. Their primary function, however, is to accommodate religious services and convey spiritual meanings. The impressive upward-moving shape of many religious structures has been possible due to technical advancements. The purpose of their height is, however, spiritual: they create closeness to Heaven. Some Gothic cathedrals are over 300 feet tall, including the towers.

Images played a crucial role in disseminating religious ideas to largely illiterate audiences. Manuscripts, paintings, and sculptures have not been supplements to, but, in most instances, substitutes for textual information. The canons of religious representations are visible in the consistent narratives, compositional structures, color schemes, and symbols. These rigorously observed guidelines made it easier to effectively convey religious messages. Once an indispensable vehicle for spiritual instruction, many religious works are now part of the world's artistic patrimony. Some of them have been removed from their original locations and are viewed in the neutral space of museums. This secular environment involuntarily conceals the belief systems that generated their creation and curtails viewers' understanding of their meaning.

Disruptions in religious ideas and institutions have direct consequences on artists and their art. This was reflected in the sixteenth century when art and artists were affected by the split in the Western Church. The Protestant Reformation, followed by the Catholic Counter-Reformation, developed rigid principles for art. The power of the Inquisition to approve religious works of art further restricted artists' creativity. The famous questioning of the sixteenth-century Venetian artist Paolo Veronese (1528–1588) for his representations in *The Last Supper* (1573), is a perfect illustration. In a surprisingly bold move, the artist decided not to change the work, just the title. He renamed it *Feast in the House of Levi*, a reference to an earlier biblical story that included secular figures, which was one of the objections of the Inquisition.

In modern times, the predominance of the secular environment has allowed artists to bring a more personal angle into religious works. However, artists continued to follow religious guidelines when working on commissions. Outside religious patronage some artists, particularly in contemporary times, have overtly dismissed and even attacked familiar spiritual figures, symbols, themes, and images. Their works have offended some viewers and generated heated debates from both secular and religious forums. They have also raised important questions about freedom of expression and the audience's input into the production of art.

Societal Context

Artists are part of society. Even if they appear to live outside its norms, artists are affected by it. Some of them have used their art to articulate their objections to

the rules and values imposed by society; others have affirmed existing standards and norms. Everyday life, the mass media, morals, and societal issues have influenced artists and the art-making processes.

Everyday Life

Daily life has influenced and inspired artists. Some have represented ordinary objects, such as food and flowers, or depicted domestic scenes. Others have focused on their environments. Life in the city was a favorite subject for the Impressionists, as well as the twentieth-century German Expressionists and Italian Futurists. The hustle and bustle of train stations and cafés, trams and malls, and theaters and streets were the favorite themes of these groups, even though their art had divergent perspectives and meanings. More recently, Pop artists have depicted everyday life, this time seen through the lens of the mass media.

Outside Western tradition, artists have been inspired by both aesthetic values and utilitarian needs. Native American painted fabric and animal skin are part of ceremonial clothes. In Japan, screens have both practical as well as decorative purposes.

What aspect of everyday life would inspire you most?

> " He will be truly a painter, *the* painter who will know how to draw out of our daily life its epic aspect . . . "
>
> **Charles Baudelaire**[3]

The Mass Media

Since the invention of photography in the nineteenth century, the role of the mass media in art has grown steadily. Photography, film, video, television, and advertising have been for many contemporary artists important sources of inspiration, means of expression, and outlets for disseminating their projects. The art of the Japanese artist Takashi Murakami (b. 1962) illustrates the strong influence of both everyday life and the mass media. His work, inspired by television and animation, is also linked to Louis Vuitton, the well-known French fashion house. The complicated relationships established by these dialogues were heightened by the unexpected inclusion of a Louis Vuitton boutique inside the space of his recent museum exhibitions.

The newest addition to the mass media, the web, has established a novel context with growing implications for artists. It has become a vital place for artists to find new ideas, display and sell their art, and connect with fellow artists and the

audience. These unprecedented possibilities have transformed existing artistic models and substantially redefined all stages of creativity. (See Chapter 5.)

The mass media can also substantially influence the public attitude to art. The focus on shocking works and artists' eccentric behavior may create an inaccurate, one-sided view. Artists may not directly respond to or even be affected by audiences' opinion or media coverage. However, this negative perception may deter some individuals from pursuing an artistic career or prevent artists from creating audacious works of art.

Moral Values

Even though moral values affect art and artists, it is difficult in most cases to establish whose values are reflected: those of the artists, patrons, or time period. Fearing a negative reception of their work, artists might conceal their views if they clashed with the norms of society. In particular, moral values have affected the representation of the human figure. Art has reinforced gender roles and social status. Men have been portrayed mostly strong and with a sense of public identity and purpose. In contrast, and in tune with past societal values, the representations of women have focused on their appearances, such as clothing, hairstyles, and jewelry, private spaces, and domestic roles.

Artists who tried to change the image of women paid a high price. The self-confidence apparent in John Singer Sargent's (1856–1925) portrait *Madame X* (1884) (the Metropolitan Museum of Art) and Manet's *Olympia* (1863), discussed earlier, was not expected of nineteenth-century women. The public and critics were stunned by these images. Madame "X", an American woman from New Orleans married to a French banker, is portrayed in profile, avoiding the public's gaze. The intensity of her black dress highlights her pale skin and lack of jewelry and adds to her sensuality. Her poise suggests a sense of control and self-identity. This representation was, however, not well received by the audience. The negative response to Sargent's portrait prompted him to leave France and go to Britain.

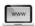

Women artists of the period, like Mary Cassatt (1844–1926), reflected with subtlety on issues of gender and moral values. Her painting *In the Loge* (1878) (Museum of Fine Arts, Boston) represents a familiar Impressionist theme: the theater. In contrast to other paintings, which usually represent a couple or a group, Cassatt presents the woman alone. The artist highlights society's condemnation of such behavior in a discreet and clever way: in the background a man stares through his binoculars at the woman, not the stage. This painting may also have self-reflective connotations: Cassatt was a single woman in a milieu with strong gender biases.

Nowhere are moral values more evident and more overtly at odds with artistic concerns than in the representation of the nude. In certain cultures this subject is either inappropriate or represented in stylized form. In the Western tradition, however, the imitation of reality made the nude a complicated issue. Women, in keeping with moral expectations, have often been used to symbolize chastity and virtue. Paradoxically, they were generally represented as seductive, sensual, and also naked.

Artists have been aware of the impact moral values play on their art when representing the female nude. This is well illustrated by the popular nineteenth-century sculpture *The Greek Slave* (1844). To avoid a negative reaction the artist, Hiram Powers (1805–1873), linked his portrayal of the young female nude to the Greek War of Independence (1821–1832). To make sure this connection was clear, the information was available to the public in a brochure. The text described the statue as a representation of a Greek woman being sold, as a result of the war, as a slave.

Classicism, allegories, and even biblical stories have also been used to create a sense of appropriateness of the subject. Scores of nudes disguised as Venus and allegorical figures, as in Delacroix's *Liberty Leading the People* have been painted and sculpted in Western art for centuries. Seductive poses are well concealed by a fantasy-like atmosphere and the seriousness of the subject matter. How do these nude figures inform viewers about classicism and liberty? There are significant gender differences in the representation of the nude. It would be hard to imagine Delacroix's work portraying a partially exposed male about to lose his pants as a symbolic heroic figure. In recent decades viewers, artists, and specialists have become aware and critical of the way women have been represented in art.

Contemporary artists have more overtly expressed their disagreement over societal moral values. Crossing these boundaries, however, can offend many. Robert Mapplethorpe's (1946–1989) explicit photographs and Karen Finley's (b. 1956) performances made headlines in the late twentieth century because they challenged moral norms. Recently, the sculpture of the British artist Marc Quinn (b. 1964) has confirmed the continuous and complicated dialogue between moral values and art. His sculpture of Alison Lapper (2004), an artist born with severe physical disabilities and represented when eight months' pregnant, was on display in Trafalgar Square for 18 months from 2005. The placement of the statue certainly contributed to its controversy. Comments questioned the subject's appropriateness for this public location with significant historical symbolism. (See "Location" in Chapter 2.)

Some of the outrage focused on Lapper's nudity and pregnancy and overlooked the beautiful marble work with its subtle links to much-admired Greek and Roman sculptures and the overall meaning of the statue. Unlike Powers, neither artist placed a statement on site. However, they did provide commentaries online and in interviews. The response to this sculpture reveals that intolerances still exist, even when cultures celebrate diversity and differences.

Would this reaction affect other artists? What do you think?

Social Context

In the past art reflected mostly the social views of patrons. Art has marginalized and even excluded many national, ethnic, and social groups. Certain issues important to society have also been absent. Illnesses, disabilities, and other societal concerns were extremely rarely depicted until the nineteenth century. Modern

and contemporary artists, however, have been able to voice their opinions. One of the reasons why Manet's *Olympia* was rejected had to do with its exposure of prostitution as a social reality. Furthermore, the maid represented in the painting reflects on issues of class and racial stereotyping of the period. Manet was not alone in his commentaries. The social environment specific to nineteenth-century urban life inspired many Impressionist and Post-Impressionist artists, including Edgar Degas (1834–1917) and, later, Henri de Toulouse-Lautrec (1864–1901). Many of their paintings critically reflect the less glamorized environment of salons, bars, parks, and workspaces. Most audiences at the time preferred to ignore these realities and continued to admire Cabanel's escapist art.

Contemporary artists have become actively engaged in and influenced by social issues. Race, gender, and crime have been significant sources of reflections for artists in recent decades. Andy Warhol's (1928–1987) *Electric Chair* series (1963–1973) powerfully evokes the impact of this subject. The works of Kara Walker are visibly informed by racial and gender stereotypes (Figure 3.1). Her art has been consistently based on these issues. The broad contextual references and the interactive element, which here places spectators literally in midst of her narrative, engage the audience in reflecting about the events depicted.

Many contemporary artists have strived not only to reflect societal concerns, but also to develop social events to connect with the public. Graffiti artists may have the strongest creative ties to the social context. They also have strong and undeniable connections to the earliest form of artistic expression within a community: cave paintings. The multiple negative social implications associated with graffiti make them difficult to accept as art, even with the recent scholarly interest in this topic.

Should artists be concerned with and involved in social issues?

Summary

How would you define your contextual environment? What factor(s) are more relevant/influential? Which one would most likely affect you if you were an artist?

Context is a crucial component of the art-making process. External circumstances can significantly influence the final outcome of the work. They may, as discussed here, not only alter artists' creative directions, but also prevent them from making art altogether. The impact of specific contextual elements varies across time and cultures and is important to understanding how art was made.

What specific contextual element discussed in this chapter were you most interested in? *Which one do you think mostly affects contemporary artists?*

Notes

1. F.T. Marinetti, "The Founding and Manifesto of Futurism" (1909), quoted in Apollonio, *Futurist Manifestos*, p. 21.

2. Sherrie Levine, "Five Comments (1980–85)" (1981), quoted in Stiles and Selz, *Theories and Documents*, p. 379.

3. Charles Baudelaire, "Review of Salon of 1845,"quoted in Blunden and Blunden, *Impressionist and Impressionism*, p. 23.

Conclusion to Part One

The first part of the book outlined and discussed the most significant factors, institutions, and individuals that contribute to the art-making process. It has become evident that a work of art is affected and influenced by a wide range of factors. The multiple decisions artists make when creating art range from selecting materials to fulfilling patrons' requests.

Making art is a crucial but only a first step in a long and complicated journey. To become known, a work of art has to circulate in culture. Kara Walker's *Darkytown Rebellion* (2001) was included in the exhibition My Complement, My Enemy, My Oppressor, My Love, held at several museums in the United States and overseas. This and other works of art have been widely disseminated through a variety of venues and in diverse print and digital formats that have contributed to inform specialists and spectators about her art.

The second part of this book, Disseminating Art, examines the way in which original art and reproductions are made available to both experts and the public. The next two chapters expose the diverse means of disseminating art in contemporary society and reflect on their role and impact on the public's appreciation of art.

Note to the reader: The contextual elements that affect art-making are also relevant to the analytical process. To avoid unnecessary duplication of information they are not extensively discussed in the Original Context section in Chapter 7.

What do you think are the most significant factors that affect art-making? Which would have the most impact on your way of looking at art?

Part Two

Disseminating Art

Once created, art begins a long and sinuous journey of circulation through culture. During this period art interacts with multiple and diverse factors which affect its visibility in society and influence its artistic and financial value. In many instances this process also disconnects art from its initial purpose, location, and intentions. The methods of disseminating art vary significantly in different time periods and cultures. In the past art has often been created for specific religious and political purposes. Its dissemination was limited and preset. Numerous works made under patronage were kept in private spaces with limited or no public access. Modern educational concerns have been responsible for establishing a variety of forums for exhibiting and spreading original art. Art is even more effectively made available to the public in the form of print or digital reproductions. The circulation of art is intertwined not only with artistic values but also economic issues. The following chapters examine influential institutions such as museums and galleries and reflect on the dialogues between art and business. Next, the discussion considers the dissemination of art through the mass media and popular culture, and concludes with a brief overview of today's art world.

The Art of Understanding Art, First Edition. Irina D. Costache.
© 2012 Blackwell Publishing Ltd. Published 2012 by Blackwell Publishing Ltd.

4

The Dissemination of Original Art

In the photograph *Musée d' Orsay, 2, Paris* (1989; Figure 4.1), and other similar works, the contemporary German artist Thomas Struth (b. 1954) reflects on the role of museums in disseminating art and educating the public. The Musée d' Orsay, in Paris, is housed in a renovated building, originally a nineteenth-century train station. The art displayed here includes many works initially rejected from official exhibitions whose values at the time, both artistic and financial, were derisory. Today, they are masterpieces of the modern era. The museum and its collection are now on the "must-do" list for most visitors to the French capital. Struth's photograph comments, directly and indirectly, on the role museums, collectors, and the market have in disseminating art and determining its artistic and financial values. These issues are discussed in this chapter.

Institutions

Museums

Since their inception museums have been a respected and trusted measurement of artistic

4.1. Thomas Struth, *Musée d'Orsay 2, Paris*, 1989. C-print, 224 × 183 cm. Courtesy Marian Goodman Gallery, New York/Paris.

The Art of Understanding Art, First Edition. Irina D. Costache.
© 2012 Blackwell Publishing Ltd. Published 2012 by Blackwell Publishing Ltd.

accomplishment. This seminal public art institution has a relatively short history. Its emergence is rooted in the cultural and social changes of the eighteenth century. The identity of museums is closely related to the beginnings of art history as an independent discipline. (See Chapter 8.) The foundation of many private and public museums around the world was and still is based on or connected to large private or public collections. These originating sources, sometimes included in the name of the museum, have contributed to their prestige. Terms such as national, state, county, and city have also played a significant role in validating the leading cultural and civic positions of museums. The impressive titles have solidified the public's confidence in these institutions. However, they may have also created the erroneous impression that museums are either for experts or highly educated and mature audiences.

Contrary to this perception, museums are concerned with providing, if possible, a meaningful experience to all their visitors. This is not easy. People of different backgrounds, traditions, and cultures with diverse tastes, expectations, and views frequent these institutions. Large museums such as the Met (Metropolitan Museum of Art) in New York, the Louvre in Paris, and the National Gallery in London have up to several millions of visitors a year. There are many concerns that come with this kind of attendance. A primary goal is to make art relevant to all: children from San Francisco and Beijing, elderly people from Buenos Aires and Melbourne, and young adults from Nairobi and Stockholm. Protecting art is another important issue. Vandalism and theft, although fortunately not widespread, certainly happen. Art institutions must be vigilant and impose preventive rules to avoid damage to their collections.

Even though the visitor's experience is a top priority, museums have broader concerns that are mostly unknown to the public. Their mission includes the exhibition, preservation, interpretation, and acquisition of works of art. What do all these activities mean? *Exhibition* refers to the presentation and dissemination of the museum collections through various exhibition programs. *Preservation* denotes the need to safeguard the works of art. *Interpretation* implies the responsibility to thoroughly analyze the works and share these findings. *Acquisition* indicates the preoccupation with expanding museums' collections; in other words, buying more art or accepting donations. *Education,* another significant component of the mission of museums, entails the development of programs for the public. In addition, museums have departments concerned with communications, including electronic media, development, security, and public relations.

Most museum activities take place "behind the scenes." An astonishing number of professionals, including directors, curators, administrators, educators, conservators, and designers, as well as architects, market analysts, communications specialists, registrars, security guards, and insurance agents are among those involved in the decision-making processes. Most of their work is invisible to the public. What visitors see in the galleries of museums is a carefully planned "final performance." This is not unusual. The work that goes into making a book, movie, or television show is also concealed in the finished product.

The works of art displayed in museums have a high artistic and financial value. Viewers are aware of this. What makes a work of art worth millions is difficult, however, to ascertain by looking at it or reading its label. How do museums know they get "their money's worth"? The differences between a masterpiece and a mediocre work may be obvious to art specialists, but not to museumgoers. Museums usually show only the best works of their collections. The others are kept in storage. This makes it harder for viewers to understand the distinctions between "good" and "great" art. Concerns about security have been the main reason for the restricted access to these areas. Many museums, in the United States and other countries – including the Met, the Brooklyn Museum, the Yale Center for British Art, and the National Gallery in London, to mention only a few – have found innovative ways to offer a glimpse into this private space. The Luce Foundation Center for American Art at the Smithsonian American Art Museum, for example, recently opened up its entire storage area to the public. This "open study / storage facility" includes 3,500 art objects that can be examined by visitors. Museums are also posting their collections, including art not on display, online. This is a slow process, as optimal digital images and accurate information can take a substantial amount of time to generate.

There is another little-known aspect of museum practice that could puzzle audiences. Museums remove works of art from their collections. The process is called deaccession. Why would museums deaccess art? Does it mean the art is bad? Why would anyone want these works? Deaccession is a very complicated and often controversial process. Museums deaccess art they perceive, for one reason or another, as no longer fitting their mission and institutional profile. The sales of these works contribute to the development of the museums' collections and programs. The Met has posted its deaccessioning policies on the web. At the top of the list is "lack of relevancy of a work of art to the collection."

Since the late 1990s, museums have undergone substantial changes in order to develop stronger dialogues with their audiences. Visiting museums can be an exhausting experience, substantially different from most everyday activities. Furthermore, unexplained exorbitant prices and high artistic values, vigilant guards and protective devices, limited places to rest, and an implied code of conduct intimidate many visitors. These reactions are the opposite of museums' intentions: their goal is to create a user-friendly environment that is both educational and enjoyable. In fact, many of those initially apprehensive about their visit would agree that most museums have a welcoming atmosphere and the experience of seeing original art is an opportunity not to be missed.

The discussion below explains some of museums' organizational concerns, procedures, and rules. This information will make your next museum visit not only more comfortable, but also more interesting.

Would you rather visit a museum or go to see a movie? Why?

Museums display art from diverse cultures and periods. For example, the Museum of Fine Arts in Boston includes art from Africa, the Americas, Asia, Oceania, and Europe. In addition to more traditional media such as painting, sculpture, and prints, the collections comprise textile, fashion arts, and musical

instruments. Museums with a variety of collections are called encyclopedic. Many institutions, such as the Asian Art Museum in San Francisco, focus only on art from a particular area. Others collect art from specific time periods. The number of works of art varies from tens of thousands, for large museums such as the Louvre in Paris, to less than a few thousand for smaller institutions. Regardless of size or the cultures represented, museums display only a small sample of world art.

Museums address contemporary audiences and convey, even when showing art from the past, current artistic values. They also have to consider practical issues such as ticket sales, parking facilities, and visitor access. Therefore, museums constantly update their spaces, exhibits, and programs to create an environment that reflects current museum practices and art-historical scholarship, while effectively serving the public.

The first thing we see when visiting a museum is its architectural structure. Some museums use older buildings retrofitted for this purpose. The initial structure of the Louvre dates back to the twelfth century, but it has been modified several times over the years, including the latest addition, the glass pyramid (1989) by the architect I.M. Pei (b. 1917). Other structures, such as the Philadelphia Museum of Art and the Detroit Institute of Arts, were built in the early twentieth century expressly for this function. Both museums were established in the late nineteenth century, in 1876 and 1885, respectively.

Even when the architectural structures are developed for this purpose only a small portion of the art displayed "matches" the building. Older buildings may display contemporary art and new buildings house art from the past. The structures of the Picasso Museum in Barcelona are several centuries old. In contrast, the Kimbell Art Museum in Fort Worth, Texas, whose collection includes works from the Renaissance, is a restrained modernist structure designed in 1972 by the architect Louis Kahn (1901–1974). These visual and chronological discrepancies underline the complicated nature of museums' identity. On the one hand they project a sense of timelessness and endurance. On the other they are continuously redefined by experts' knowledge and audience's needs. These elements are even more evident inside museums.

In the entrance area or hallways leading to the exhibition space visitors will notice plaques, sometimes covering entire walls, listing donors, benefactors, and other contributors to the museum. This information should not be ignored: it reveals an important aspect of museum practices. The public can determine local, national and, at times, international support for the specific institution. The amount of money donated is rarely listed, but there is an easy way to figure out who are the more generous donors. The bigger the font and the closer to the top of the list the name is, the more support those individuals or institutions have given. Look at this list next time you visit a museum. You may be surprised by some of the donors included . For example, did you know that the Norton family (the maker of the Norton antivirus software program) is a major supporter of the museums and arts?

Museums aim to present their collections in a clear and orderly manner. The arrangement of art in museums and galleries also reflects the norms and taste of the time. The painting *Gallery of the Louvre* (1831–1833; Color Plate 8), by the American artist Samuel Morse (1791–1872), shows that art in the past was displayed very differently from today. It was hung in close proximity and covered the entire wall. It should be noted that this painting shows the style of exhibiting art, but it is not an accurate rendering of a gallery in the Louvre.

What do you perceive to be the most significant differences between the way art is displayed in Struth's work and Morse's? Which one do you prefer? How would you organize a museum?

To help visitors feel comfortable as they navigate through the space, museums create a "narrative," a story that unfolds logically and appeals to diverse audiences. Through its narrative museums inform the public about artistic values and, as a result, shape their appreciation for art. The decisive criteria in this layout are chronology, geography, national context, and media. Art is usually organized by period and geographical area. Additional factors that affect the arrangement include art-historical information, the expertise of professionals, and the specificity of the museum's collections.

The museum visit should not be a dry, didactic, classroom experience. Therefore, the story of art is narrated in subtle ways through carefully planned room order and itineraries listed in guides and maps. These convenient tools facilitate and enhance the educational value of the visit. They may also, unwillingly, because of the predictable path, diminish personal discovery and experience. For example, visitors following suggested tours or eager to see recommended works may, and usually do, ignore or miss other galleries and works of art.

Patterns of looking and subsequent appreciation of art are also influenced by the décor of the rooms. Some museums, such as the Uffizi Galleries in Florence, the Isabella Gardner in Boston, and the Frick Collection in New York, have preserved, fully or partially, the original interior designs. The art exhibited often blends with the elaborate decorations. This interference may confuse viewers accustomed to pale-colored walls and ample space between works. Equally disturbing to some are the refurbished structures such as the Massachusetts Museum of Contemporary Art (MASS MoCA), a restored nineteenth-century factory, and the Musée d' Orsay in Paris, mentioned above (Figure 4.1). New structures have also adopted this industrial look. Many interior and exterior elements of the Centre Pompidou in Paris, designed in the 1970s by Renzo Piano (b. 1937) and Richard Rogers (b. 1933), are exposed and color-coded. How should viewers look at works exhibited next to pipes, tubes, and valves? Should art be seen in a neutral space, isolated from other visual distractions?

How does the surrounding space affect your way of looking at and appreciating art?

Inside museum galleries the criteria for displaying art is based on the artist, or group of artists, time period, geographical area, and style. The immediate juxtaposition of the works also takes into account size, subject matter, medium, specific visual features, and other subjective and objective elements. The presentation may link artists who did not know each other and never thought that their works would be exhibited together, or even wanted this to happen. Curators, who are responsible for arranging the art, make these decisions based on current museum practices, as well as their views and knowledge. The appearance of coherence and continuity conceals the numerous steps involved in this final arrangement. Finding the connections between works of art in a gallery may be an extremely valuable exercise in understanding artistic values and museum practices.

The physical placement of art inside galleries is somewhat predictable. Paintings and other two-dimensional works are usually hung on walls. Sculptures are placed on pedestals. Smaller works are presented on shelves or in cases and, if required, specially designed structures. Large or artistically significant three-dimensional works, decorative objects, and sculptures are often placed in the center of the gallery. These customary presentations, highlighted by spotlights, create a habit of looking only at certain areas. Changes in these arrangements surprise viewers. Carl Andre's work, discussed below, is a case in point.

After locating a work of art in a gallery, visitors look for its label. Labels include the title, artist, and date. Many of them give extensive additional information related to the subject matter, patronage, and other pertinent elements. Many specialists, including curators and educators, decide on the format, size, colors, and content of labels. This information can substantially enhance viewers' knowledge about the art and museums. For example, the inventory number includes the year the work entered the museum collection. This could reveal the collecting interests of the institution at a particular time. Furthermore, labels may disclose if the acquisition is a donation, promised gift, or loan. Some labels state "anonymous gift." Many, however, identify the individuals and institutions that have contributed to purchasing the work of art.

Labels add a significant educational value to museum visits. They can unwillingly also reduce the visual impact of art. Opinions about the work of art are often based on the textual information rather than visual observations. Museums have been aware of this and have recently experimented with innovative strategies. Some institutions have removed all labels. Others list only the name of the artist, date, and title of the work. Additional information is available on handouts, no longer affixed next to the work, giving visitors more flexibility to look at art on their own.

Museums have developed and adopted many other aids, such as audio tours and a variety of experimental electronic gadgets that enhance the educational experience of the visit. These modern devices have added information about art, and their benefits cannot be disputed. However, the amplified reliance on experts' advice and views has also the potential of restraining personal encounters with art. It is literally seeing art with someone else's eyes and mind.

" The work of art is born anew in us. "

Johannes Itten[1]

Another major concern for museums is the preservation of their art. Conservation procedures usually take place in specialized laboratories, out of public view. (See Chapter 6.) Recently, some museums have made these processes more accessible to visitors. The renovated Smithsonian American Art Museum in Washington, DC has allowed viewers to observe conservators at work through large glass walls. The Brera Museum in Milan, Italy, has placed a conservation studio within the galleries. The Walters Art Museum in Baltimore is also planning to offer the public the opportunity not only to see conservators at work but also ask them questions. Other museums have found innovative methods of informing the audience about their conservation efforts and practices. These projects are very valuable and one may wonder why there are so few of them. The answer is simple: they are very costly. Besides construction and security costs, even a simple question-and-answer session means less time to work on conservation projects.

Preservation and conservation issues have affected and, in many cases, determined the display of art and the set-up of the gallery space. The need to control temperature, humidity, and light has required the installation of a variety of specialized instruments. In older buildings they can be often spotted in the galleries. In newer, or recently renovated ones, they have been incorporated into the structure. Works on paper, which are very sensitive to light, are stored in archival boxes. When exhibited they are displayed in cases, under glass, and in rooms with limited illumination. Frames, pedestals, protective glass, and other materials in direct contact with the art are also part of conservation concerns. In areas where floods, earthquakes, and other natural disasters may occur, museums and conservators develop additional precautionary measures to protect their collections.

One of the most memorable and feared features of the museum visit is the "do not touch" warning. In some cases cords, alarms, and other devices prevent viewers from coming too close to the art. The need to impose a distance, usually 12 inches, between visitors and the artworks is more than justified. These necessary protective measures, however, particularly when carelessly enforced or misunderstood, can make the visit unpleasant. Explaining their role and implementation at the outset would put the public at ease. Museums are aware of the temptation to touch art. Some institutions have come up with educational programs to address this issue. They include demonstrations of making art and, in some cases, allowing the public to touch objects created specifically for this purpose.

Since the 1980s, museums have undergone numerous changes in their institutional identity and presentation. These modifications, prompted in part by arthistorical and theoretical analysis, can be seen not only in museum practices but also architectural structures. New buildings such as the Guggenheim in Bilbao, Spain, designed by Frank Gehry, and the Denver Art Museum, by Daniel Libeskind

4.2. Atrium at the National Museum of the American Indian, Washington, DC, interior view, 2009. © MICHAEL REYNOLDS/epa/Corbis.

(b. 1946), expose these changes. Decades earlier, the Guggenheim Museum in New York, by Frank Lloyd Wright (1867–1959), was one of the first innovative exhibition spaces. These structures have introduced an architecture of irregular forms, breaking the mold of the expected rectangular walls and linear arrangement of artworks, and at the same time disrupting the monotonous museum visit.

Until recently, most museum practices were based on Western needs and models. The National Museum of the American Indian, the recent addition to the Smithsonian Institution, has introduced a new angle. Created in consultation with several Native American designers and architects, including Johnpaul Jones, Ramona Sakiestewa, Donna House, and the Native American Design Collaborative, the museum reflects in architectural design and organizational structure the specific identities of this artistic tradition (Figure 4.2). References to cosmology and spaces for performances, essential to Native American cultures, have replaced pedestals and frames and have transformed visitors' experience.

Artists have questioned the mission and practices of museums. In the early twentieth century Pablo Picasso and the German Expressionist Emil Nolde, among others, were troubled and displeased with the role and artistic standards of these institutions. They describe them as "lies"[2] and "vast collections."[3] The Italian Futurists were even more outspoken. Their founding text of 1909 questioned the purpose of these institutions: "[W]hat is there to see in an old picture . . . ?" the artists stated, claiming that "Museums [are] cemeteries."[4]

Contemporary artists have used creative ways to critique museums' practices. Many sculptures by the American artist Carl Andre (b. 1935) are a flat surface on the floor. The artist forces viewers, accustomed to seeing sculpture on a pedestal, at eye level, or above, to almost walk on his sculpture. Andre's encouragement to step on his art is also a clever experiential commentary on the "do not touch" museum policies. Larry Bell (b. 1939) also questions existing display formats. The shape and material of his sculptures emulate the base to the point of merging them into one. Is this a tall sculpture or large pedestal? It is difficult to distinguish between the two. This play reflects on the substantial artistic, visual, and financial distinctions museums, as well as the public, make between the pedestal and the sculpture it supports.

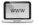

How should one look at plinths, frames, and other display devices?

Frames and Pedestals

Frames and pedestals are an integral component of looking at art. They have a dual purpose: to protect the art and to highlight it, setting it apart from the environment. The design, colors, and shapes of frames play a significant role in the way a painting is perceived. Frames focus viewers' attention on the work, while keeping a visual connection to it. Imagine *Mona Lisa* with a heavily decorated frame painted in red and gold. Would you be able to focus on the work, let alone admire the subtle details?

Unfortunately many period frames have been lost, damaged, or destroyed over time. When the original frame is not available, it is substituted with either a replica or another period frame. Sometimes frames are reconstructed using remnants of materials from the period. In many institutions frame specialists, conservators, and curators consult together on the type of frames to be used. Even though many contemporary paintings do not use frames, they continue to be important for other works, including drawings and photographs.

Pedestals are used to display and emphasize a three-dimensional work by elevating it to a comfortable level for the viewers to look at it. Pedestals are made of durable materials, often similar, if not identical, to those used in the sculptures. Just as with frames, there is a delicate balance between continuity in style and a distinction between the work of art and its support. Plinths are also used to enhance the significance of large sculptures. The resistance to Rodin's low base for the *Burghers of Calais* (see Chapter 1) underlines the role of pedestals in viewing art.

Frames and pedestals are usually not included in reproductions, adding to the incomplete view of art in this format. For some artists, such as Constantin Brancusi, who intentionally made pedestals part of his works, this practice limits a full understanding of his sculptures.

Other artists, such as Fred Wilson (b. 1954), have examined the connections between museums' selection criteria and cultural values. His project *Mining the Museum* (1992) used the museum collection to create a series of installations that reflect on institutional practices and their implications. In this exhibition, held at the Maryland Historical Society in Baltimore, Maryland, Wilson reflected on exclusions, biases, and stereotypes. Using objects and materials that were in storage and reversing or changing expected norms, such as placing the figures with their backs to the viewers (Color Plate 9), or using pedestals below eye level, the artist invites audiences to critically examine the influential role of the museum in defining art and reflecting cultural values.

The group of women artists called the Guerrilla Girls has also critiqued the gender bias inherent in the collecting and display practices of museums. Their

1989 poster contrasts the number of women artists in the Met (5 percent) to the frequency of their representation as nudes (85 percent). The text recognizes women's presence mostly as subjects, not authors, and suggests, as an ironic "punch line," that they need to undress to be in the museum.

Despite this criticism, museums have strived to disseminate new artistic ideas and values, particularly through temporary exhibitions. More than a decade before the Guerilla Girls, in 1976, the Los Angeles County Museum of Art organized a show entitled *Women Artists 1550–1950*. The museum invited the art historians Linda Nochlin, the author of the seminal article "Why Have There Been No Great Women Artists?" (published in the January 1971 issue of *ARTnews*), and Ann Sutherland Harris to organize this exhibition. The theme of the article and show, women and art, was little known at the time. Informing the public about new research, emerging artistic values, and lesser-known artists and trends is an important component of the mission and programs of museums.

Museums also use exhibitions to boost their image, attendance, and finances. The themes of these crowd-pleasers, called "blockbuster shows," include Van Gogh, Monet, Impressionism, and Tutankhamen. These exhibitions require advance booking, generate long lines, and provide substantial revenues for the museums.

In contrast to these popular themes, museums of contemporary art display works that are often controversial and difficult for the public to understand. While the institutions, by their very nature, offer a certain "guarantee," many spectators are skeptical about the merit and meaning of the art exhibited. This response is evident from the low attendance figures. There are also exceptions. For example, the shows of the contemporary Japanese artist Murakami, held at the Museum of Contemporary Art in Los Angeles (2007/8) and later at Brooklyn Museum of Art in New York (2008), were very well attended.

Museums have a significant influence on the careers of artists, critics, dealers, art historians, and collectors. They also affect artistic as well as financial values and, in the process, shape viewers' perceptions and appreciation of art.

How and why do you visit a museum? What do you expect your experience to be like?

How to Visit a Museum

There are no "ideal" ways of visiting a museum. However, here are some suggestions that might help make your experience more enjoyable and informative.

- From the outset, keep in mind that no matter how small a museum might be it is very likely (if not a certainty) that you will not be able to examine all the art in depth. Knowing this may take some pressure off.

- Where to start and what to see? Get a map and other material available in order to get an overview of the museum, the type of art, exhibitions, special events, and tours.
- Select a few galleries or exhibitions that catch your attention.
- In addition to "must see" works, try to discover new ones.
- Don't just follow the paths suggested in the guides.
- If you get an audio tour, look at works of art not included in the program or look at the works first and listen to the experts' comments afterwards.
- If there are particular works or types of art you dislike or do not understand, look at one or two of them. Maybe the original or the information in the museum will change your opinion.
- Don't worry about how you react to art or the amount of time you spend looking at it.
- Avoid setting yourself very specific goals, in terms of time or number of works, but if you do, be flexible.
- When you get tired or bored, take a break.
- A good museum experience is an "incomplete" one, prompting you to return.
- While you are in the museum also look around you and reflect on the entire experience. What do you like? What would you change?
- If you have suggestions or comments, share them with the museum. Your comments will be appreciated.

Collections and Foundations

In addition to museums, collections are important venues for showing art. Some private collections may be either inaccessible or have very limited public admission. Others, like the Peggy Guggenheim Collection in Venice, have regular visiting schedules. Some collections were established decades, even centuries ago. Others have been set up recently and are still being developed. The art in private collections reflects the taste and interest of their owners; some may prefer art from the past, while others may favor modern art. Collections are often focused on particular cultures, periods, and groups of artists.

Certain collectors create foundations to support the arts through grants and other forms of sponsorship. For example, the Chicago-based Terra Foundation for American Art has a program of grants. In Los Angeles, Eli Broad, an important collector of contemporary art, has supported, through his foundation, many cultural and educational institutions in the area. Boards, comprising art experts and other members of the community, including the owners, govern foundations and collections. They often work or consult with dealers, art historians, and other art specialists.

Private collections are sometimes exhibited in museums. This is a unique opportunity to see art otherwise not available to the public. There are many examples. One of them was the 2003 exhibition held at the Met, "A Very Private Collection: Janice H. Levin's Impressionist Pictures." This show included over thirty paintings by famous late nineteenth-century artists from the collector's New York residence.

The connection between private collections and museums has been and continues to be very strong. Many recently established institutions, including the Getty Museum in Los Angeles and the Ludwig Museum in Cologne, Germany, to mention only two, were initially private collections. Many collectors donate their art to museums. To recognize these substantial gifts museums name galleries and buildings after these benefactors. Next time you visit a museum, look for this information. It will help you understand how the art world works. (See also "Today's Art World" in Chapter 5.)

Galleries

The main places for seeing and buying modern and contemporary art are galleries. Some of them are for-profit businesses; others are non-profit. The directors, who often own the gallery, make most of the decisions. Galleries select art from a pool submitted by various artists; only a relatively small portion of the art received by galleries is accepted and subsequently exhibited. Most art galleries have free admission and do not require a reservation or invitation for their opening receptions. The location, exhibition schedule, artists represented, and openings are listed in a variety of local newspapers, specialized journals, and magazines; nearly all of them have a web presence. But even with this "open invitation" visitors feel intimidated by the art displayed and the austere space. For a variety of reasons, including restrictions imposed by commercial galleries, some artists have established their own venues for exhibitions.

Unlike museums, most galleries do not affix labels to the wall. Usually, there is only a number next to the artwork. The front desk has handouts with information about artists, art and, most of the time, the selling price. Art that has been sold is frequently marked with a dot on this list. Sometimes there are many dots; other times there are none. The materials, prices, sizes, dates, and other information available on these lists shed light on the art exhibited, gallery practices, and the mechanism of the art world.

Most viewers think that modern art is complicated and hard to understand. Artists have made little effort to reach out to the public. Viewers must take their share of blame for perpetuating this gap, as few visitors spend sufficient time looking at contemporary art. Even fewer ask questions. How can new art be accepted and appreciated when the public barely looks at it? The often exorbitant prices for works of art that few understand and even fewer value further alienate the public. (See also "Modern Art and the Audience" in Chapter 9).

There is neither an ideal guide nor a "one size fits all" method of looking at art in a gallery. Before you form an opinion take some time to look at the art, read

the information, and ask questions. Most galleries will be eager to tell you more about their exhibitions. Keep in mind from the outset that the art that confuses most has been, paradoxically, created by contemporary artists. These artists live in the same context with the rest of society. They might be on Facebook. They watch television and go to the movies. There must be something in their art that connects with viewers. Reflect critically about what you see: does the show relate to today's culture? Could you identify some of the factors that influenced the artists and their work? Is there anything that catches your attention? How is the art made? What is it made of? Is there something that makes you uncomfortable: materials, subject, format? Why? Did you expect something else? Use other issues discussed in this book.

> " I want my work to be accessible to all different people…My pieces are not complete without the audience. "
>
> **James Luna**[5]

Do you visit galleries? What is the question you would most likely ask in a gallery?

What is the question you would really want to ask, but do not dare to?

Exchanges between galleries in different countries and continents have also increased in the last decades. These forums play an increasing role in enriching the public's knowledge and appreciation of art. Artists have come to realize that they are now part of a global community and, to compete effectively, that they need to remain informed of the latest trends.

International Art Exhibitions and Fairs

An important new way of disseminating art is through international exhibitions and fairs. There is an abundance of these around the world. Some of the most influential include the Venice Biennale in Italy, Documenta in Germany, the São Paolo Art Biennial in Brazil, and the Whitney Biennial in the United States. Their focus is mainly modern and contemporary art. The Venice Biennale, established in 1895, is the oldest. It comprises many national pavilions and additional venues for displaying mostly contemporary art. The exhibition takes place every two years (with some rare exceptions) and is open usually from early June to mid-October. The São Paolo Art Biennial, established in 1951, the second oldest, includes entries from national and international modern and contemporary artists. Documenta, founded in

(Continued)

1955 in Kassel, is another important international exhibition. It is now organized every five years and lasts for 100 days during the summer. In the United States, the Whitney Biennial, established in 1932, considered an important leader in the art world, shows American contemporary art.

Numerous new international exhibitions established around the world in cities such as Istanbul, Melbourne, and Shanghai have further enhanced the global artistic dialogue.

Art fairs, such as Art Basel, held in Switzerland and Miami, the ARCO (Arte Contemporáneo en España), in Madrid, Spain, and the FIAC (Foire Internationale d'Art Contemporain) in Paris, established in the second half of the twentieth century, have added to this worldwide artistic exchange. Hundreds of international galleries attend these fairs to show and, in this case also sell art.

Academic-Affiliated Art Institutions

Many colleges and universities own and administer galleries and museums. Some have large collections. For example, the Harvard Art Museums comprise three institutions, and include over 250,000 objects from various cultures. The Yale University Art Gallery has diverse collections of over 185,000 works including Van Gogh's famous painting *The Night Café* (1888). Other universities and colleges have smaller, but nonetheless valuable collections. The programs of university museums and galleries are fueled by the innovative ideas of the academic environment. They often present cutting-edge exhibitions and lesser-known types of art, cultures, and artists. The first feminist art program was established in the 1970s by the American artist Judy Chicago (b. 1939) at the California State University, Fresno, and a year later, at the California Institute of the Arts (CalArts). In 1972, while a faculty member at this art school, she developed, together with Miriam Schapiro (b. 1923) and about twenty other artists and art students, her renowned project *Womanhouse* (1972). This exhibition marked a milestone in the history of feminist art. The project used a large house in Hollywood, California, where the artists, exclusively women, used individual spaces to creatively reflect on the concept of "home." Social, gender, and personal commentaries permeated this vast installation.

University galleries play a critical role in the creation and dissemination of site-specific works, video, electronic, and multimedia art projects, often too expensive and technically complicated for artists to make on their own. The Rice University Gallery in Houston, Texas, for example, focuses solely on installation art. The gallery also provides financial support for the projects it selects. While nearly all museums and galleries, including the ones mentioned above, seek sponsorship outside academic institutions, they usually do not sell the art exhibited.

The academic environment continues to have a significant impact on new generations of artists, art historians, and audiences through lectures and publications. Their role is discussed in the next chapter.

Art previously kept in isolated palaces for viewing by a privileged few is now available to a mass audience. It is therefore ironic that art institutions struggle with low attendance and lack of interest. It is even more surprising that contemporary audiences respond better to art created in the past than to works made by their peers. Many technically savvy users would rather see paintings by Claude Monet than Gerhard Richter (b. 1932), a contemporary painter whose name few would even recognize. Even more would rush to see a Tutankhamen exhibition (pay a high price for a ticket and stay in line, maybe for hours), rather than visit an innovative electronic art exhibition at their local college or gallery (with low or no admission charges and no waiting).

Which show would you choose? Why?

Beyond Institutional Walls

Alternative Spaces

Art is also displayed in places not connected to museums or galleries such as malls, hotels, libraries, offices, movie theaters, restaurants, department stores and parks. The lack of institutional validation may and often does reduce the significance of the works displayed. For example, if several famous works from the Met were exhibited in a hotel lobby without the audience's knowledge, most people would assume they were copies. Few of those who would carefully examine them in the museum would even look at them. The reverse is also true. Art ignored in a mall would be intensely scrutinized in an established gallery.

There are many ways of showing and seeing art in contemporary culture. Fairs, studio tours, and outdoor exhibitions have opened up new possibilities for artists to present their art. While the quality of the art displayed may vary, these venues are great opportunities for the public to observe art in more informal settings.

A lot of art has been created, particularly in recent times, without a pre-planned place for its display. It is not easy to determine if there is an ideal place to show and look at art.

What do you think: is there a "best" place to see art? Are there inappropriate locations for exhibiting art?

Public Art

Many works of art have been and continue to be created for public display. Before museums and galleries were established, art was seen mostly in churches and public buildings, as well as in the form of outdoor sculptures, wall paintings, and architectural structures. Examples from the past abound. The famous Mayan and Egyptian pyramids and scores of other religious and secular works are viewed outside institutional walls. In some parts of the world large areas and even entire cities are literally outdoor museums. Cities such as Cuzco in Peru, the site

of the ancient Inca capital, and the ancient Roman city of Pompeii, are considered world monuments and are carefully preserved.

Public art also signifies works created with different forms of civic or governmental support. These funds facilitate the creation of large projects such as murals and sculptural ensembles that become an integral part of communities around the world. Some of the art created for public spaces is identified with plaques, isolating barriers, and monumental pedestals. Many cities and states earmark a percentage of their budget, usually 1 percent or less, for support of the arts. National, local, and regional councils, committees, and organizations also support a variety of public projects.

A public project that has drawn significant attention in the late twentieth century is *The Great Wall of Los Angeles* (1976–; Color Plate 10), created by the artist Judith Baca (b. 1946) in collaboration with hundreds of young volunteers, many artists, and scholars. The mural depicts the multicultural history of Los Angeles from prehistoric times to 1960. At 2440 feet, it is the longest mural in the world. Several constituencies, including state and city funds, supported this project. There are proposals to further extend the mural to incorporate the recent history of the city.

Some public art such as graffiti is created without support or even permission from the city or community. Banksy (b. 1974), an elusive British artist, whose identity is intentionally shrouded in mystery, has used both real and virtual public space to disseminate his art. The street murals he has created have been posted on various sites, and their "viral" spread quickly gained him recognition. Not only unauthorized public art projects, but also approved ones can spark controversy. The fate of Richard Serra's (b. 1939) *Tilted Arc* (created in 1981, removed in 1989) is a case in point. Substantial disagreement over either aesthetic or fiscal issues will continue. These dialogues are, however, beneficial because they engage audiences to reflect about art as part of daily life.

Should public funds be used for art? Should restrictions be imposed on artists working on these projects? What should they be and why?

Propaganda Art

In certain political environments art has been used for propaganda purposes. These works were disseminated to indoctrinate audiences with political, religious, and social agendas. Large monuments and smaller works were spread through traditional means such as galleries and museums and also displayed outdoors. Often reproductions and multiples, such as posters, prints, and photographs, are favored because they are more effective in reaching the public. This type of art has to get the message across in a straightforward manner, without confusing subtleties and nuances. Therefore realistic art and narrative subjects are preferred over abstraction and intricate allegorical representations.

Even though the influence of a political regime may be short-lived, propaganda reaches a wide audience and can significantly affect the creation, definition, and

appreciation of art during that period. Many works were created and circulated for this purpose in twentieth-century totalitarian regimes. Even though impressive in size and quantity, most of these works have been destroyed after rulers have been toppled, underlining their narrow and specific purpose as well as their questionable artistic value. (See "Historical, Religious, and Political Context" in Chapter 3.)

What do you think is the most effective form of disseminating original art?

Art and Business

Art and business are strongly connected in the process of disseminating art. The notion that art is "pure" and artists are detached from monetary concerns is naïve and unrealistic. Financial issues have been, and continue to be in most, if not all, cultural, political, and social contexts a preoccupation for artists, patrons, and institutions. To make, exhibit, analyze, preserve, disseminate, and promote art requires money. Art scholarship, institutional values, collectors' taste, and the art market are closely intertwined.

The Art Market and other Financial Matters

The process of selling art and numerous financial concerns are closely intertwined with the dissemination process. In the past most art went directly from the artists' studio to their patrons. In modern times art dealers, collectors, curators, and other specialists play a crucial role in multiple artistic and business matters. The art market may be primarily concerned with prices but it is based on and influenced by artistic merit. Art sells for a variety of reasons: it is appealing, it may be a good investment, it is hard to get, or it might be trendy at the time. Auction houses are a major venue for selling art and play a significant role in the dissemination process. Many were established centuries ago. The most famous of these are Sotheby's, founded in 1744, and Christie's, established in 1766. Today these auction houses have offices around the world. In addition to art they sell real estate, jewelry, and even wine.

Sometimes the works of art are publicly displayed a few days before the auctions. This is a unique and little-known opportunity to see art that may come from and go to a private collection. Most auction houses publish illustrated catalogues and post on their websites information about prices, art-historical analysis, bibliographical sources, and provenance. There are even video clips with expert evaluations of the art market. It is truly an unprecedented possibility to see art from private collections and understand the mechanism of the art market. The record $53.9 million for Van Gogh's *Irises* (1890), the highest price paid for a painting at the time, reflects, among other things, the popularity and appreciation of his work by late twentieth-century audiences. The work of art was sold to a private buyer at Christie's in 1989, and subsequently resold by the same auction house to

the Getty Museum. This record has since been broken in more recent sales. Who buys art at auction? Museums, galleries, corporations, dealers, and collectors are among the buyers. Individuals and institutions can opt to bid publicly or anonymously, in person, by telephone, and now electronically.

Art is also sold in certain galleries and by a variety of professionals. Those representing contemporary artists are concerned with both artistic issues and marketability, thus playing an influential role in the art world. The prices of art include a commission, which can be 50 percent and even higher. This amount can be a significant incentive for galleries and dealers to show artists who are in demand and command higher prices. Galleries, collectors, and dealers have elaborate and (most of the time) confidential contractual agreements with artists. Gallery directors, dealers, and collectors may express interest in particular styles, types of art, or artists. For example, an artist may have "a waiting list" of buyers. Collectors may reserve the right to purchase works even before they are completed. Even though they are not commissioned works, collectors' expectations may influence both artists' creativity and the financial value of their work.

Financial issues are central to other aspects of the dissemination process and have an impact on what the public sees and learns to appreciate. Decisions about acquiring art, organizing exhibitions, and developing private and public collections are based on both artistic and business criteria. Art institutions closely monitor the purchases of works of art. These activities are supervised and approved by boards, directors, and advisory committees, creating a system of checks and balances to prevent the abuse of funds. Even museums with substantial resources must consider budgetary issues when buying art or organizing shows. An art exhibition considered valuable from an art-historical and educational point of view, but not financially sound, is likely not to be taken any further. Art exhibited in major museums and by artists with critical acclaim sells for higher prices. Changing artistic values and new analytical perspectives directly affect art sales.

New media is not immune to business concerns. Even though it appears that electronic devices are within everybody's reach, multimedia projects are expensive to produce, maintain, and exhibit. Few institutions and artists are able to afford their creation. Consequently these exhibitions are rare. This has curtailed viewers' ability to see, understand, and appreciate this new art. Financial issues have also affected the reproduction of art in books, videos, DVDs, and films.

As has become evident, a sound business plan is, along with artistic merit, a significant filtering element in the dissemination of art.

Should art be separated from financial matters? How could this be achieved?

Art Patrons, Collectors, Dealers, and Sponsors

A wide range of individuals and institutions are involved not only in supporting the creation of art but also its dissemination. These partnerships have significant

impact on exhibitions and acquisitions. Collectors' interest in specific art or artists may influence their support for exhibition programs. Similarly, corporate sponsors may limit their patronage to art that better emulates their institutional image. These issues affect shows as well as awards and grants, and can have further consequences for art, art history, and artists.

Museums and exhibitions acknowledge most of the financial contributions on banners, labels, and other printed material. These sources can be instrumental in understanding the dissemination process. Would artists or art institutions accept donations from sponsors whose vision or identity clashed with theirs? Probably not. By the same token, patrons are very likely not to subsidize exhibitions or art they do not approve.

What kind of art would your community support?

Artists and Business

Artists have been preoccupied with financial issues both in the past and today. The letters discussed in Chapter 7 reveal the close attention some artists have paid to the business aspects of their profession. In the past, patronage provided financial support and some sort of "job security" for many artists (See "Artists and Patrons" in Chapter 1.) Its role has substantially diminished and changed in recent times. The notion of "the starving artist," a modern myth, coincided with the decline in patronage and reflects the financial difficulties artists can encounter without this support. This terminology has also been fueled by the false perception that artists are neither interested in making, nor in having, money. Certainly, artists are not solely preoccupied with their financial success. But they understand that the making of art requires money, and sometimes substantial amounts of it, for creative and living purposes.

Contemporary artists have been more engaged in their careers. Many have effectively balanced their creativity with a solid marketing strategy and have been actively involved in the dissemination and promotion of their work. "I wanted to be an Art Businessman or a Business Artist,"[6] Warhol stated. Jeff Koons, who had experience in the financial world, stated that he "enjoy[s] the seduction of the sale."[7]

There is also the notion that art sells for high prices only after an artist's death. There is some economic truth in this. Once an item can no longer be produced its value may increase. But there are plenty of exceptions. Some modern artists, such as Picasso, were financially well off for most of their careers. Furthermore, many works of art by living artists from around the world have recently been sold for millions of dollars. These enticing sums should not suggest that all living artists have financial success. Many of them continue to have difficulties selling their art at significantly lower prices. Most need to find other means of supporting their art and living expenses. (See also Chapter 1.)

Summary

The dissemination of original art is a carefully orchestrated decision-making process involving many institutions and a variety of experts. A work of art is never seen in a vacuum. Where, what, and how art is displayed affects an audience's knowledge and appreciation.

Struth's *Musée d' Orsay, 2, Paris* (1989; Figure 4.1) is a photograph, a fundamental method of creating reproductions. Many works of art are, as here in this text, disseminated not as originals but as print or electronic replicas. The images viewed in lectures, presentations, and films and on the web, toys, and ties, have significantly augmented the possibilities of spreading and seeing art. The specific venues and implications of these new formats and means are discussed in the next chapter.

What did you discover in this chapter about art and its dissemination that surprised you most? Where do you expect to see art?

Notes

1. Johannes Itten, "Analyses of the Old Masters," quoted in Harrison and Wood (eds), *Art in Theory, 1900–2000*, p. 304.
2. Pablo Picasso, *Conversation* (1935), an interview with Daniel-Henry Kahnweiler, quoted in Chipp, *Theories*, p. 272.
3. Emil Nolde, "On Primitive Art," quoted in Harrison and Wood (eds), *Art in Theory, 1900–2000,* p. 97.
4. F. T. Marinetti, "The Founding and Manifesto of Futurism" (1909), quoted in Apollonio, *Futurist Manifestos*, p. 22.
5. James Luna, interview with Julia Barnes Mandle, quoted in Stiles and Selz, *Theories and Documents*, p. 802–3.
6. Andy Warhol, in "Philosophy of Andy Warhol," quoted in Stiles and Selz, *Theories and Documents*, p. 342.
7. Jeff Koons, in "Full Fathom Five" (1998), quoted in Stiles and Selz, *Theories and Documents*, p. 381.

5

The Dissemination of Art through Reproductions, and Other Issues

Publications, Presentations, and Lectures

In her work *"I shop therefore I am"* (1990; Figure 5.1), Barbara Kruger (b. 1945) uses advertising strategies to reflect on and question gender stereotypes. The minimalism of the intertwined text and image effectively focuses the viewer's gaze. The play on "I think therefore I am" – the statement by the seventeenth-century French philosopher René Descartes (1596–1650) which became an essential concept of Western rationalism – aims to suggest biased views of women and their identities. This is further underscored by the small and delicate hand holding the written sign (whose form is reminiscent of a credit card). This version of the work is printed on a paper bag, similar to those used in markets, and part of a multiple edition. The materials, text, and multiplicity of the works intentionally blur the distinctions between art and popular culture. There are also tote bags and other functional objects printed with this image sold in stores, not displayed in museums, and made of more durable material than this work of art. Kruger creates these ambiguities to reflect on contemporary means of disseminating art and images and their impact on distinguishing and establishing artistic values. These issues are examined in this chapter.

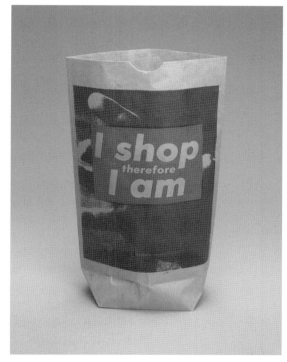

5.1. Barbara Kruger, *"I shop therefore I am,"* 1990. Photolithograph on paper shopping bag. Composition: 12 3/8 × 9 13/16 in. (31.5 × 25 cm); sheet (bag): 17 5/16 × 10 3/4 × 4 3/16 in. (43.9 × 27.3 × 10.7 cm). Museum of Modern Art, New York, SC233.1996. © Barbara Kruger. Courtesy Mary Boone Gallery, New York. Digital Image © The Museum of Modern Art/Licensed by SCALA / Art Resource, NY

The Art of Understanding Art, First Edition. Irina D. Costache.
© 2012 Blackwell Publishing Ltd. Published 2012 by Blackwell Publishing Ltd.

Copies, replicas, and reproductions have been a significant form of spreading art, particularly in the modern period. More art is seen today as a print or digital copy than in its original form. This chapter examines multiple forms of reproductions and discusses their influence on understanding art. It concludes with a brief summary of the "art world."

Publications, Presentations, and Lectures

Publications and lectures are important forms of art dissemination. Studies published in hard-copy format remain the most trusted vehicle for delivering scholarship within the discipline. Books and articles are heavily dependent on documentation and research; reviews and essays have a more opinionated angle. Oral presentations, such as lectures, talks, and courses, inform us about art and shape the views of both experts and the general public.

Books, Catalogues, and Periodicals
(Articles, Essays, and Reviews)

Publications continue to be the principal way of sharing knowledge about art, particularly among scholars. There is an abundance of literature on art. The topics of these texts have a dual role: they reflect current values and simultaneously validate them. For example, studies on Aztec architecture suggest that the theme is valued by contemporary culture. The dissemination of these findings helps to solidify knowledge about the topic discussed and underlines its importance to the history of art. Publications range from books to journals and from newspaper articles to e-books and e-journals.

In general, scholarly publications are written for specialized audiences. These studies are published as books, exhibition catalogues, and articles. Some have broad topics, such as Impressionism, that could be of interest to a wider audience. Others focus on very specific and narrow issues relevant to only a small circle of specialists. The points of view and interpretations developed in scholarly works are based on extensive research and documentation. As in other disciplines, a book may be a lengthy study written by one author, or an anthology comprising shorter texts by one or several scholars. Many articles are published in specialized journals, some of which are available only to members of art organizations. These writings are often the first steps art historians take toward examining particular issues, which later become the subject of a lengthier study, usually a book. Many articles and books are peer-reviewed. This means that a group of experts in the field assess their value and recommend them for publication. Essays are more informal reflections supported by research without the level of documentation expected in a book or article.

Many exhibitions held in museums have a catalogue. Only a few galleries have extensive publications for their shows. Catalogues inform us about familiar art as well as more obscure periods, styles, and artists. These abundantly illustrated texts

Art Reviews

Exhibition reviews are a significant resource in understanding how artistic values are assigned. These writings, based on personal views guided by art-historical knowledge, can have a huge impact on art. Most of them address a large and diverse readership. These essays are sometimes no longer than a few paragraphs, but they can make or break artists, institutions, exhibitions, and projects. Excerpts from Albert Wolff's 1876 review of the Impressionist exhibition in the French newspaper *Le Figaro* reveal the highly opinionated angle and even personal attacks of these writings: "Here is a new disaster. Five or six lunatics, one of them a woman, a group of unfortunate creatures . . . have met to exhibit their works. . . . A frightful spectacle of human vanity working itself up to the point of dementia."[1]

There are also many positive opinions published in newspapers, journals, and magazines. The number of reviews is relatively small in comparison to the number of exhibitions. Electronic media have added valuable publishing venues such as blogs, websites, and e-journals, many with innovative, interactive possibilities.

include essays as well as scholarly research, which can be of interest to both specialist and general audiences.

Trends and values in art and culture affect the themes and topics of publications. The proliferation of books about women artists and diverse artistic traditions reflects the recent interest in feminism and multiculturalism. These topics were rare before the 1960s because of limited interest. Since then scholarly interest in these issues has prompted many studies and scores of reproductions, which have informed experts as well as broad audiences.

Art books are expensive due to the high costs involved in clearing copyright and printing. However, anyone interested in consulting these texts does not need to purchase them. Many books, catalogues, and periodicals are available in libraries, making this form of dissemination efficient and inexpensive. Many texts are also now available online. All publications share an important common denominator often neglected by the reader: they represent the author's point of view. This should not imply that these accounts should not be trusted. Rather, these texts present specialists' unique interpretations, derived from their research, knowledge, and creative thinking. (See Part Four, Interpreting Art.)

Lectures, Courses, and Presentations

Universities, colleges, art schools, and the educational departments of museums play a vital role in disseminating art. (See Chapter 4.) In addition to exhibitions,

what is taught, discussed, and presented in these institutions gives substantial weight to defining and validating the notion of art. The methodologies and content of art courses define what art is for a broad segment of the college population. Until the 1980s few women artists were included in introductory art-history courses. In fact, the public was hardly aware of the existence of women artists, with the exception of a few, including the American Mary Cassatt and Georgia O'Keeffe (1887–1986). Today the art survey includes, among others, the seventeenth-century artists Artemisia Gentileschi (1593–1653) and Judith Leyster (1609–1660), the eighteenth-century Angelica Kauffmann (1741–1807), and the nineteenth-century Rosa Bonheur (1822–1899). Moreover, introductory courses and texts have expanded their examination beyond familiar Western developments.

Some of the defining figures of Postmodernism, such as the influential French philosopher Jacques Derrida (1930–2004) and the artists Mary Kelly (b. 1941) and John Baldessari (b. 1931), to mention only a few, have all been, and some still are, connected, mainly as faculty, to educational institutions. Their views, disseminated in lectures, courses, and critiques, have influenced artists and art historians. Museum lectures, professional meetings, and discussions with artists and experts inform specialists as well as the public, and shape their views on art.

The Mass Media

The mass media have substantially modified the circulation of art. The Internet and an array of new media gadgets are widely trusted tools. The abundance of videos, CDs, and DVDs has augmented information about famous as well as obscure artists, cultures, styles, and periods. In addition, the dialogues between art and popular culture and electronic communication have engaged viewers in novel and unexpected ways. These new means have redefined the way art is viewed, understood, and valued.

Films, Documentaries, and DVDs

Nowadays art is widely disseminated via the mass media. The appeal of film, video, and DVDs can influence the public's views on art. Since its beginnings, film has had significant links to painting and photography. The cinematic works of artists such as Salvador Dali (1904–1989), Fernand Léger (1881–1955), Man Ray (1890–1976), Andy Warhol, and more recently Matthew Barney (b. 1967) and Julian Schnabel (b. 1951), confirm these continuous connections. The avant-garde 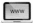 film *Ballet Méchanique* (1924), by the French artist Léger and the American film-maker Dudley Murphy (1897–1968), effectively suggests Cubist concepts. The repetitive movements of mechanized forms and the abstracted fragments evoke and exemplify modern rhythms many artists, including Léger, aim to achieve with traditional media. Even though experimental films are not easy to understand and even less easy to enjoy, moving images are more effective in introducing viewers to modern art and avant-garde ideas.

Art has also had a presence in documentaries and films. Documentaries have an educational purpose. They are often developed by universities and museums and presented by renowned faculty and scholars. These programs play a significant role in informing us about familiar artists as well as lesser-known art. They may also demystify artists' celebrity façade. In films and documentaries art and artists come alive.

Although films use documents in the script, they can also have a strong fictional component. The artists depicted on screen include Michelangelo, Van Gogh, Picasso, Toulouse-Lautrec, Kahlo, Pollock, Gentileschi, and Goya. Movies portray artists as temperamental, unstable, capricious, and outside the norms of society. There are plenty of artists with stable lives who are integrated into the social and moral fabric of society. Those portrayed in films, however, are mostly poor, with tormented lives, and afflicted by diseases or addictions that eventually lead to their untimely death. But death, the audience is reminded time and again, will finally bring them fame. Many viewers would like to have a Van Gogh painting, but not his life!

Have you seen any of these movies? What is your opinion about their portrayal of art and artists? If you were a filmmaker, what artist would you portray in a film?

Television also contributes to the dissemination of art. Many shows developed by various television channels and networks have valuable educational content. Series on the A&E, Biography, and History channels have explored the art and lives of many artists and artistic developments. The television series hosted by the art critic Robert Hughes, *The Shock of the New* (about modern art) and *American Visions* (the history of American art), developed in the 1980s and late 1990s, are good examples. Recently, very innovative shows with valuable educational content have connected contemporary art with other aspects of life. The PBS series *Art: 21*, which premiered in 2001 and had five seasons after that, presented an innovative survey of contemporary art in America, organized around themes such as identity, memory, and structures. The episodes include interviews, studio visits, and discussions with over eighty artists. The hosts of the program are familiar figures interested in the arts, but not scholars. Among them are the actor Steve Martin, the tennis player John McEnroe, and the comedian David Allen Grier. In 2005, the Sundance channel launched a new show called *Iconoclasts*, featuring interviews that "pair" two well-known figures from diverse fields. The inclusion of artists in this series further connected art with the larger cultural discourse. In the first season the designer Tom Ford interviewed the artist Jeff Koons. More recently, the artist Ed Ruscha was in conversation with the designer Stella McCartney, and another episode connected the American artist Chuck Close (b. 1940) with the illusionist David Blaine.

What television show with art content would you develop?

The Web

The web has become a major player in art dissemination. Institutional and personal websites, webcams, art for sale, and image databanks and encyclopedias are some of the numerous forums available in cyberspace. More recently video-posting, podcastings, blogs, and scores of devices and programs have added multiple possibilities for art to become a vast online presence. Some of these new forms of dissemination have challenged, and even dismissed, the value of traditional venues and institutions. Others are so new that neither the experts nor the public know exactly what to think about them. The growing demand for access to information 24 hours a day has prompted museums, galleries, and other art institutions to include new forms of electronic communication in their programs.

From internationally recognized museums to small-town galleries, the number of websites created by art institutions could be in the millions and is continuously rising. This broad access makes the process of looking at art more complicated. How can one select? Which art is better? Where should one look first?

Many museums around the world have developed comprehensive websites with abundant visual and textual information. Some spectators are so in awe of these novel additions that they may prefer the website to the museum visit. Not all institutions have ample virtual tours, extensive educational resources, and substantial art-historical information. This is mainly for financial and technical reasons. To build and maintain large websites with updated information is expensive. These emerging hierarchic cyber-differences have the potential to influence the way original art is perceived and valued by the public. A museum website with minimal information and no images may erroneously suggest that the art is not worth seeing.

The need to have a cyber-presence has prompted museum professionals and other art specialists to pose important, but yet unresolved questions. What is the purpose of museums' websites? Are they advertisements for the institution? Or is their goal to provide supplementary information to enhance a visit to the museum? Could websites become, in time, a convenient substitute for seeing the originals? After all, it is possible, via cyberspace, to visit the Louvre in Paris, the Met in New York, the British Museum in London, and the Museum of Modern Art in Mexico City on the same day, even within the same hour.

The web dissemination of art from "bricks-and-mortar" institutions has significant additional implications. Art on a screen establishes a new, unprecedented, personal link with the viewer. The long-term consequences for art appreciation have yet to be fully evaluated. The computer transforms the barriers between art and viewer imposed by museums into a limited, but unique interaction. Rather than being admonished by guards, intimidated by their surroundings, or forced to follow an imposed path, cyber museumgoers can click on, look at, and react to (reproductions of) art on their own terms.

Features provided by museums and computer software further personalize this experience. Spectators can look at more than one work simultaneously, connect

works of art from different rooms, even different museums, zoom in, add music, and even create an archive. New electronic tools are emerging every day. Information and images downloaded to mobile devices and lectures and videos delivered as podcasts are among them. Unlike in a gallery, looking at art online can be easily interrupted and intertwined with checking your email, ordering pizza, buying movie tickets, and drinking coffee. Without institutional restrictions and regulations, cyber-visitors can tune in and out as they please. There is an unprecedented freedom in cyber-museum visits. To look at masterpieces at any time, day or night, you no longer need to have a vast collection of books. You can find them online.

These novelties can, however, affect the way audiences approach art in real life. The rules of galleries and museums may appear unreasonable and excessive in contrast to the autonomous web experience. The uniqueness of original art, overtly highlighted by these institutions, reinforces the value of visiting real museums over their cyber-counterpart. But are the websites suggesting this? Are they able to attract visitors? Are they able to convey the value of seeing original art?

What do you like about museums' websites? How do they compare to your museum experience?

Established museums and galleries offer validation for both the art and information on their websites. Not all sites have the same level of credibility. Anyone can display art or post their opinions online. Individuals, galleries, and a variety of companies use the web also to sell both originals and reproductions. There is an eclectic and overwhelming selection of art in cyberspace. How can one make sense of all this? What is good art? Whose opinion should be trusted? This extraordinary opportunity to examine art without predetermined values allows viewers to look and react as they please. However, the uncertainty as to whether the reactions are "correct" may curtail this valuable learning process.

Contemporary artists have quickly understood the enormous possibilities and value of a web presence. Both established and emerging artists have used this medium to enhance the traditional ways of displaying and selling art. Artists' websites include statements, personal reflections, informal photographs, videos, and other features, which can establish unprecedented interactions with global audiences. With a computer and Internet connection, an artist from South Africa can communicate with viewers in Norway, and Japanese artists could discuss their art with students in the United States.

This novel realm of communications will continue to significantly redefine the art world in the future. The presence of art beyond "bricks-and-mortar" institutions and accredited specialists raises significant questions, but also enhances the audience's role in this new open space of art dissemination.

What is your opinion about art and the web?

Do you have certain criteria when searching for art information or images? How do you know the information is accurate? If a book has one date for an artist and

the web another, which of the two sources do you think is right? Which one would you trust, and why? Libraries offer excellent tools to evaluate web resources. (See also the textbox "How to Use Online Resources" in Chapter 7.)

When you think about it, department stores are kind of like museums.

Andy Warhol[2]

Art and Popular Culture

The increasing dialogues between art and popular culture have complex ramifications in the dissemination, reception, and appreciation of art. There is a wide range of possibilities to create reproductions in modern culture. New tools have facilitated their circulation outside traditional institutions, venues, and environments. Using art reproductions for advertising has become widespread. Reproductions of scores of masterpieces have been placed on a variety of objects and products unrelated to the artists' intentions or the art's purpose. These endorsements may be even considered offensive in comparison with their original function and meaning. Most of these reproductions are used without the artists' consent, impossible to obtain because most of them are dead. This raises important questions about the "abuse" of art and artists' control over their work. Copyright, discussed in the next section, has been specifically developed to protect the intellectual property and rights of artists.

Do you think art should be used to advertise products? Are certain works or products inappropriate? Should the original function or meaning of the work be considered?

The ambiguous dialogue between art and popular culture is highlighted by several examples. A recent advertisement for Campbell's soup reversed Andy Warhol's appropriation by using the artist's now famous work. Numerous contemporary artists, including Warhol, have created designs for Absolut Vodka. Kruger deliberately incorporates advertising modalities in her work (Figure 5.1). *Viva la Vida*, the 2008 album by the band Coldplay, has a double connection to art. One of Frida Kahlo's paintings inspired the title, while the cover uses Delacroix's *Liberty Leading the People* (1830; Color Plate 7). The international success of the CD disseminated this nineteenth-century painting more effectively than any art venue. As a consequence, many would connect the image to the music and album rather than an art-historical context.

In addition to advertisements, masterpieces have been reproduced on napkins and cups, bags and teapots, and scarves and jewelry. The painting *The Scream* (1893), by Edvard Munch (1863–1944), is better known from variations circulating in popular culture than art history. There are more objects printed with

Michelangelo's famous *Creation of Adam* in the Sistine Chapel than the number of paintings in the vast Vatican collection. Museums and other institutions housing art have facilitated and endorsed the reproduction of revered masterpieces on mundane items that can be purchased in their stores on site and online. One can buy a mug and admire the famous classical sculpture *Venus de Milo*, or purchase a watch inspired by Jacques-Louis David's (1748–1825) painting *Bonaparte Crossing the Alps at Grand-Saint Bernard* (1800), but never see the originals.

Recently museums and large galleries have also developed objects specifically created for some exhibitions. These are sold in temporary satellite stores strategically placed so that visitors do not miss them when leaving the show. These art-inspired articles have contributed in novel ways to the dissemination of lesser-known art and artists. Banners displayed outdoors to advertise exhibitions have also been included in the inventories of museum stores. This has further complicated the dialogue between art and advertising. Some museums sell the entire banner, while others have used them to make bags and totes. These sales have supplemented museums' budgets and contributed to the development of their programs. Visitors have responded very enthusiastically to these mementoes of their museum experience.

Why would viewers want to wear Mona Lisa around their necks or on their T-shirts? Why would they want to take home a smaller version of Degas's Ballerina? *Would you purchase such objects? Why?*

The dissemination of these objects can also have a significant role in art appreciation. Umbrellas, T-shirts, pens, and bags are visible to a much wider audience. They could, to a certain extent, be also educational and informative. On the other hand, encountering art first as a functional object may dramatically change viewers' perception of it. How would those seeing a Monet first while wiping their mouth with a napkin react when seeing the originals? Even the rules of no touching can be shocking and disappointing for those used to carrying "Monet" bags and "Van Gogh" umbrellas.

Some specialists have ignored and even dismissed these recent connections between art and everyday life. Terms such as "pop" have been used to distinguish art from manifestations perceived to have lower value. In contrast, others have argued that these dialogues are essential to contemporary art and cultural identity and have focused their research on these topics.

These links have also been exposed in several exhibitions. They include *High and Low: Modern Art and Popular Culture* (Museum of Modern Art, New York, 1991), *Star Wars: The Magic of Myth* (Brooklyn Museum, New York, 2002), *Once Upon a Time: Walt Disney* (Grand Palais, Paris, 2006), and the recent Tim Burton exhibitions (Museum of Modern Art, New York, 2010 and Los Angeles County Museum of Art, 2011). These shows reflect and confirm the diverse contemporary visual world in which art is created, disseminated, and interpreted.

Copyright

Popular culture and reproductions have introduced a new, highly important and, at times, controversial issue: copyright. The Internet has further complicated this topic, through easy downloads of texts, images, and music. To be able to reproduce works in books, on napkins, or online one must have permission or the copyright of that material. Copyright laws are very complex and they may be different in various countries. Their purpose, however, is similar: to protect authors' intellectual property and financial benefits. Copyright is limited to a specific number of years after the artist's death. After that period expires, art enters the public domain. While this may suggest that an enormous amount of art could be in this category, this is not the case.

Works housed in museums and even in religious structures may sometimes require the consent of the institution for reproductions. Architecture, public art, and monuments are usually in the public domain (out of copyright). Artists' families may also hold copyright, and this can often trigger substantial problems for the dissemination of art. Permissions to use copyright material can be obtained for a fee, which can be very high and have conditional use. This is one of the reasons why art books are expensive. Because copyright is linked to money, family members can grant permission to the highest bidder and favor a textile company over a research project. They may also refuse to give permission to an author if they disagree with their art analysis.

Copyright is included in many modern artists' contracts and gives artists not only royalties and advances but also some control over the use of their work. In

Do you know when online visual and textual information has copyright restrictions?

some cases artists sell their copyright to companies, institutions, or individuals who then own the right to publish and use these works. Similar copyright laws apply to the web. The fact that something is online does not mean that it is in the public domain.

Rights of reproduction are an important component of the dissemination process. They can determine how and when art is accessed, displayed, and published. Copyright laws have special provisions for educational purposes and scholarly use.

Should all material be free to use? Think about your answer from the artists' point of view, as well.

Today's Art World

Modern viewers usually see art within a space that has been designated for this purpose. The displays and presentations disconnect the works, particularly older ones, from their original context. This process of separation, called decontextualization, affects the way spectators see, react to, and understand art. Modern viewers would respond differently to a fifteenth-century work than contemporary audi-

ences. A wide range of experts, institutions, and guidelines are involved in the processes of presenting art to the public. Together they form the "art world."

> ❝ Art is not made for anybody and is, at the same time, for everybody. ❞
>
> **Piet Mondrian**[3]

The Decontextualization of Art

Art is often seen miles away from where it was created and displayed. Furthermore, some artworks displayed in museums are only fragments detached from the structures and ensembles to which they once belonged. This separation from the original context, which, as discussed in Chapter 3, plays an important role in making and analyzing art, can reduce and even alter the information available about the work of art. Decontextualization thus affects not only how art is viewed but also how it is interpreted, as this process may be more difficult and, at times, inaccurate.

Could viewers grasp the full significance of an Assyrian relief in the Louvre when the work of art is only a fragment disconnected from the palace where it was once placed? Even when works are exhibited in an institution located in close proximity to the site the connections may not be immediately visible. Could audiences fully comprehend Mayan representation by looking at a sculpture displayed in a museum, isolated from its architectural setting? Its exact placement within the temple and connections to other elements, are difficult to reconstruct. The systematic decontextualization of art through its dissemination makes precise information about its whereabouts an essential necessity. It also underlines the significant role art institutions have in informing and educating the public about these issues.

Decontextualization is inherent to reproductions. Not only the surroundings but also frames and pedestals are, most of the time, excluded from these images. Even with accompanying information, this limited view can substantially reduce the ability to get an accurate understanding of the art. (See also "The Physical Condition of the Work of Art" and "Originals and Reproductions" in Chapter 6, and the textbox "Frames and Pedestals" in Chapter 4.)

Popular culture has further distanced art from its original context. At times the new environment has become so closely intertwined with the image that a process of recontextualization takes place. This means that the work of art is connected first to its new, not original, context. For example, the cover of *Viva la Vida*, discussed above, has recontextualized Delacroix's painting. Those who have seen it first as a CD cover will connect the painting to the album and the music, not to its original author and context: Delacroix and nineteenth-century French art.

Recontextualization is a widespread phenomenon in digital reproductions and electronic dissemination.

There are many more subtleties and issues related to decontextualization not addressed in this introductory text. Even when the physical environment remains intact, contextual factors, as well as the audience, change with time. New tastes, values, and views affect the reception and response to art.

Original Context and Contemporary Times

The response to art is based on a number of objective and subjective factors. These include knowledge, taste, values, and tradition, as well as gender, education, emotions, and many more. Most art in the world today was created in past centuries for audiences that differed substantially from contemporary ones. Yet art from the past continues to surprise, engage, and intrigue modern spectators. It is, however, impossible to respond to art in the same way as the original audience. This should not suggest that art from previous centuries cannot be fully understood or valued. Rather, it underlines that art is appreciated on terms compatible with contemporary culture. Today's viewers think, speak, and behave very differently not only from Renaissance but also early twentieth-century audiences. They know a great deal more about themselves and the world. It would be impossible for anyone in the twenty-first century to respond to, experience, and look at art in the same way as someone from the 1500s or even the 1950s.

Even if the original function is known, some artworks with specific religious, political, and civic roles may no longer be viewed in the same way. Much religious art is now displayed in museums where its original purpose is neither relevant nor visible. Even in religious structures visitors may look at art with a secular detachment.

Many works of art from the past have become so familiar that it is hard to fathom how they were perceived in their original context.

What was it like to see Michelangelo's monumental depiction of a male nude displayed in a public piazza in early sixteenth-century Florence? Could anyone looking at the Eiffel Tower and the Brooklyn Bridge today experience the same awe the nineteenth-century audience had for these works? How did viewers in ancient Mayan civilizations react to their pyramids? What was the initial reaction of the Romans to the Pantheon? How did the native population view the statues from the Easter Islands when they were created?

Modern audiences cannot re-create the original visual and emotional impact of these still impressive and overwhelming monuments. How would viewers respond a century from now to Koons's *Puppy*, or Warhol's *Campbell's Soup Cans*?

Which contemporary work do you think will impress viewers decades and even centuries from now?

"The Art World"

Art is usually presented as an isolated object singled out on a wall, pedestal, book, or screen. This resting place is at the end of a long and winding voyage, with many twists and unexpected turns. The journey of a work of art is influenced and defined by scores of individuals, institutions, relationships, and many other factors. The term "art world" is discussed here as a "working notion," not a definition. It refers mainly to professionals and processes relevant today which have been developed in the last three centuries as art has become validated by experts and specialized institutions. The purpose is to help clarify the mechanisms through which art becomes accessible and visible. This is neither an objective process nor a fully predictable one.

An important component of the "art world" is its inherent subjectivity. Many spectators are unaware of it. This, however, should not suggest anything troubling; rather it simply acknowledges the role of the individuals involved in the art world. Knowledge, education, and taste, as well as personal, professional, and business connections and interests, affect the art world. Moreover, cultural, social, and political concerns can substantially contribute to the way art is created, exhibited, examined, interpreted, and defined. Museums may organize or cancel a show based on new views on art. Collectors can influence gallery and museum acquisitions. Curators develop shows based on their knowledge and taste. Dealers, collectors, and museums decide what to buy, exhibit, or promote based on what they consider to be "good" art. Similarly, art historians include in their books, courses, and lectures the works of art they believe are most valuable. This selective process influences what is taught and, in the end, what is seen, perceived, and valued as art. Many decisions are also based on financial concerns, market values, and personal choices. This web of somewhat invisible, yet influential dynamics of the art world has been decisive in defining art. (Appendix 1, The Art World, more specifically outlines some of the most significant participants in this critical and crucial path.)

Summary

Reproductions have generated new ways of disseminating art. Print and digital replicas have facilitated broad access to art in novel forms and unexpected places. From books to films and from websites to napkins, art circulates today in innovative ways and interacts with viewers outside formal art institutions and environments. These novel formats have prompted the creation of copyright laws and have brought about unexpected reflections about the decontextualization of art. Barbara Kruger's work *"I shop therefore I am"* reveals some of the issues that arise when art, reproductions, and popular culture are closely intertwined.

In what specific ways have reproductions affected your way of looking at art? Where have you seen art reproduced? What was the most unexpected or unusual venue or place? Have

they influenced your knowledge or appreciation of art? Do you look at art differently based on where you saw it first? In what novel ways would you propose to disseminate art in today's culture? Where would you like to see art?

Notes

1. Albert Wolff, in *Le Figaro*, quoted in Blunden and Blunden, *Impressionist and Impressionism*, pp. 110–11.
2. Andy Warhol, in *America*, 1985, quoted in Stiles and Selz, *Theories and Documents*, p. 344.
3. Piet Mondrian, "Plastic Art and Pure Plastic Art," in Harrison and Wood (eds), *Art in Theory, 1900–2000,* p. 389.

Conclusion to Part Two

The dissemination of art plays a vital role in informing the public and shaping its understanding of art. Institutions and specialists affect audiences' perception of art. There is still much debate about what are the most appropriate venues and effective ways to display and spread art. The dissemination process is closely intertwined with changing artistic values as well as art-historical research. To understand why certain works are more visible and valuable than others requires a comprehensive evaluation of art.

Part Three of this book is concerned with the analysis of art. Many of the factors that influence the process of creating and disseminating art, discussed in Parts One and Two, contribute to a comprehensive art analysis. To understand art requires the examination and study of multiple visual and textual resources and the use of specific procedures. These issues are discussed in the following chapters.

Part Three

Analyzing Art

The analysis of art is informed and supported by a wide range of resources. This process requires attentive viewing, critical thinking, and meticulous study. A first step is a careful examination of the work of art. Rigorous gathering of visual and textual information follows. Art-historical research can take days, months, even years. Viewers do not need the same level of expertise and research to appreciate art. To value and enjoy art requires time and reflection. Familiarity with the experts' tools and methods will substantially enhance spectators' ability to understand art. The visual and textual resources experts use in analyzing art are discussed in the next two chapters. The last chapter in this section, Chapter 8, examines the roots of art classification and presents an overview of art categories.

The Art of Understanding Art, First Edition. Irina D. Costache.
© 2012 Blackwell Publishing Ltd. Published 2012 by Blackwell Publishing Ltd.

6
Visual Resources Used to Analyze Art

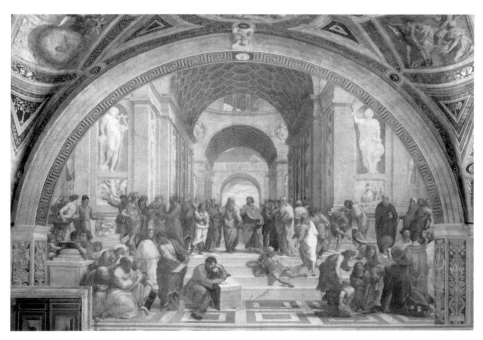

6.1. Raphael (Raffaello Sanzio), *The School of Athens*, *ca.*1510–1512. Fresco, Stanza della Segnatura, Stanze di Raffaello, Vatican Palace, Vatican City State. *Photo:* Scala/Art Resource, New York.

The starting point for art analysis is the work of art. The painting *The School of Athens* (*ca.*1510–1512; Figure 6.1), by the Italian Renaissance artist Raffaello Sanzio (1483–1520), better known as Raphael, represents several figures grouped together. They are gathered in a space suggesting the interior of an architectural structure. The elliptically shaped composition gives viewers a subtle entrance

The Art of Understanding Art, First Edition. Irina D. Costache.
© 2012 Blackwell Publishing Ltd. Published 2012 by Blackwell Publishing Ltd.

into the painting and allows them to move their gaze slowly to observe each element. The entire image is harmoniously balanced. The use of perspective highlights the architecture and, together with the two figures in the center, creates a sense of depth. Light further heightens the illusion of a three-dimensional space.

To understand this, and other works of art, requires the examination of many visual sources. These issues are discussed in this chapter. Some of the resources here are relevant only to experts; many are also available to the public. The chapter is divided into two sections. The first presents the form and content of art. The second discusses artists' "body of work" and reflects on the role drawings, archeological discoveries, and symbols have in visual analysis. This part is arranged alphabetically to avoid the suggestion of a prioritized list or step-by-step process.

The Work of Art (references in parentheses are to the diagrams in Appendix 4)

Form and Content (Diagram 1)

Form and content are the basic components of any work of art. Their careful examination is an important starting point in visual analysis. In some cases, the condition of a work, conservation, and scientific tools may provide additional information. Form includes the *elements of design*, which are arranged, based on *principles of design*, to create a composition. These terms and concepts have often been defined within Western tradition. Below is a brief discussion of how artists have used form to heighten ideas and meanings in their art. The content refers to the specific subject, general theme, and other elements. The subject matter is a description of the particular focus of the work. Together with other factors, form and content contribute to understanding the meaning of art. (This is discussed in Part Four, Interpreting Art.) Basic definitions of all these terms are included in Appendix 4. (More information is included on the website.)

Form: Elements of Design (Diagrams 2 and 3)
Elements of design are the means employed by artists to express their ideas. They are critical to the overall visual aspects and play a significant role in viewers' response to art. They include *line, color, space, shapes, light, texture, pattern,* and *time and motion*.

Line. The line is the most basic element of visual expression, which often defines objects and forms. Artists have used lines not only for descriptive purposes. For the Italian artist Piero Manzoni (1933–1963), the line had symbolical meaning. Between 1959 and 1961 the artist created several works, known as *Lines*, comprising a container with a roll of paper with a line drawn on it placed inside. The length of both the paper and the line varies. One such work was *Line of Infinite Length* (1960–). The mysterious and unattainable existence of the line, inside a box, invisible to viewers, gives this basic formal element a philosophical dimension.

> **" "** A line is a living wonder. **" "**
> **Vassily Kandinsky**[1]

Color. Color is mostly associated with painting. It is, however, also widely used in sculptures, works made of glass, photography, architecture, ceramics, fiber arts, and so on. Color has often been used to emulate reality. To the great surprise and disbelief of modern audiences, Greek sculptures were painted to make them appear more lifelike. Some medieval sculptures were colored to heighten the intensity of the religious subject. In contrast, Picasso suppressed color in *Guernica* (1937) to visually amplify the death and destruction depicted. The disturbing, distorted forms and lines augment the intense drama of the event. (See "Historical, Political, and Religious Context" in Chapter 3 for a discussion of this painting.) Color attracts viewers. In a gallery, visitors are drawn to paintings, often ignoring the other works on display.

Space. In art, space underscores the three-dimensional quality of our environment. In sculpture, mass represents the solid, three-dimensional part of art. Mass is also called positive space, in contrast to the negative space, or void, i.e., the air around the sculpture, architecture, or monument. The nineteenth-century sculptor Auguste Rodin (see "Patronage" in Chapter 1) was one of the first artists to think of sculpture as an intertwining of mass and void, rather than a monolithic presence.

Shapes are outlined and marked by lines. They can have geometric, organic, or free forms. Overlapping shapes can create a sense of depth in two-dimensional art.

In two-dimensional art, perspective is the mechanism which permits artists to create the illusion of a three-dimensional space on a surface. The different kinds of *linear perspective* have specific and strict rules. *Atmospheric perspective* is based on the effect the air (atmosphere) has on perceiving objects closer to the viewer so that they appear more colorful and better defined than those in the background. Another way of defining space is a view from above, called a *bird's-eye view*. This representation is used in many Japanese prints. Such prints, such as *The Great Wave at Kanagawa* (ca.1831–1833) by Hokusai (Figure 2.2), had a strong influence on late nineteenth-century art, and French Impressionism in particular. Space can also be defined, as in Indian and Egyptian art, by codified arrangements of figures and shapes. *Foreshortening* is another means of creating the illusion of depth by depicting objects abruptly receding into space.

The surface of a two-dimensional work is called a picture plane. It is composed of a foreground (the area closest to the viewer), middle ground, and background.

Contemporary art and culture have added a new and complex dimension to space: *virtual space.* Virtual space may exist both as a surface, the screen, and as a conceptual, intangible, and invisible multidimensional realm with unlimited boundaries and unprecedented interactivity.

Light. The play between light and dark defines space and volume. Together with other elements, it creates the illusion of the actual world in two- and

three-dimensional art. For example, in *The School of Athens* (Figure 6.1), the use of light contributes to the three-dimensional definition of the architecture and the overall sense of space of the scene. The term *modeling* is used to explain how an artist uses the material to obtain a three-dimensional quality. In two-dimensional art the term defines the transition between light and dark. *Chiaroscuro* (Italian for "light/dark") is the balance between light and dark. Light also helps to underline the differences between mass and void in three-dimensional works.

Light can be used to enhance the content of the work or suggest ideas. The seventeenth-century Baroque period is especially known for its diverse use of light effects to enhance dramatic aspects, religious fervor, and emotions. *Tenebroso*, or *tenebrism*, specific to this period, defines an intense contrast between light and dark.

There are many other ways in which light has been incorporated in art. The mesmerizing effects of stained glass are only visible in daylight and when seen from the inside. In contemporary times artists have found innovative methods of including light in their works. *Lightning Field* (1977), by Walter De Maria (b. 1935) (Figure 2.3), integrated and manipulated natural lightning effects. In contrast, artists such as Dan Flavin (1933–1996) use artificial light as their medium. His minimalist fluorescent sculptures and installations are abstract, yet the light they diffuse creates an extraordinary poetic environment. The neon light may be ordinary, but the visual outcome is a spectacular realm that engulfs the spectator.

Texture is related to the visual properties of art materials. There are two types of texture: *actual* and *implied*. Actual texture is the real quality of the surface and materials used. Implied texture is the suggestion, illusion, or appearance of a certain surface or material. In addition to the visual impact, texture can play a significant role in the interpretation of art. A smooth surface may be perceived as a sign of a "finished work."

Pattern is a repetition of a formal element. Patterns have been widely used in art. They are often perceived to be just a decorative embellishment with no significance. The contemporary group Pattern and Decoration has made a point of transforming pattern into a meaningful visual component of their art. Artists in this movement, such as Miriam Schapiro, reflect in their work the gender issues associated with patterns and decorative arts. Patterns are also an essential feature of quilts. The nineteenth-century *Crazy Quilt* (1889; Color Plate 11) demonstrates idiosyncratic ways of using this formal element to create extraordinary and, for the time, unexpected innovative modern designs. The historical and artistic sources of quilts, as well as their influence on art and culture, have been re-examined since the late 1990s.

Time and Motion. The representation of time and motion has its limitations in traditional media. In the past, artists depicted these elements using light, creating a mysterious space, and presenting an impending or interrupted development. The body and individual gestures were also used to suggest time and motion. Three types of motion can be identified: *implied* motion (the representation of a movement in static form), *apparent* motion (the suggestion or illusion of movement, through repetition or succession), and *actual* motion (real movement is part of the work, such as in kinetic and mobile sculptures).

Modern artists influenced and informed by scientific knowledge and philosophical views have found innovative ways of depicting time and motion. The Italian Futurists represented time speed, and dynamic movements through abstracted shapes, forms, and lines. A succession of events and the repetition of the same theme have also been used to suggest temporality. For example, the well-known series of the Rouen cathedral and haystacks by Claude Monet (1840–1926) represent the respective subject matter in different seasons, weather conditions, and time of day. This visual "reiteration" implies, particularly when the paintings are viewed together, the passage of time. Action painting, process and environmental art, and new media have developed novel ways of presenting and reflecting on time and motion in art.

Form: Principles of Design (Diagram 4)
The arrangement of formal elements creates a composition. This organization is based on prevailing rules, or guidelines, called *principles of design*. These include *balance*, *scale and proportion*, *unity and variety*, and *focal point*.

Balance. Balance is the visual equality or equilibrium between various parts of a composition. Compositions can have symmetrical balance when they have very similar or even identical parts along a central and usually vertical axis. An asymmetrical balance is achieved when various parts are distributed differently along the axis. Balance can be used to highlight certain aspects of the work and influence the viewer's response. In the High Renaissance compositions were based on rigorous mathematical formulas that reflected the rationalism of the period. Later, in the Baroque period, which favored more emotion in art, the composition was literally "distorted" to produce a sense of "non-equilibrium" which heightened audiences' reactions.

Scale and Proportion. Scale refers to the size of an object in relationship to its original dimensions, or another object. This is difficult to grasp in reproductions, particularly if they have no comparative element. The scale of Ron Mueck's (b. 1958) sculpture *Boy* (1999) becomes apparent only when the sculpture is seen within the gallery space. Scale is at the core of this stunning representation. Hovering over the perplexed audience, this "giant" little boy looks both in charge and terrified. His piercing gaze and crouching position generate an ambiguous message: should viewers be touched or threatened by his size? The realism suggested by the materials used augments the visual power of this memorable sculpture.

Proportions refer to the relationships of various parts to the whole. In Classical antiquity proportions were based on strict mathematical measurements. These norms, revived in the Renaissance, are seen in scores of paintings, sculptures, and architectural structures.

Size determines an object,
but scale determines art.

Robert Smithson[2]

Unity and Variety. A work of art is expected to come together as a whole, a unit. Unity is the coherence of a composition derived from a consistency of forms, colors, shapes, and patterns. Variety disrupts the unity. These terms are defined and understood within specific cultural environments. Postmodernism has dismissed formal unity, replacing it with eclecticism. Artists have juxtaposed references from a wide range of visual and textual sources, making the connections both recognizable and cryptic. This dissonance could be called a "postmodern unity."

Focal Point. A composition has a focal point of attention. This is usually emphasized so that the viewer will pay particular attention to that area, usually the essence of the work. The focal point of a portrait is likely to be the face, rather than the background. In official portraits other elements with symbolic value may also be included.

Content: Subject Matter and Themes (Diagram 5)

The content of a work of art is a significant element of any comprehensive analysis. It may give information about the time period and contextual elements, and help, if necessary, in attributions. The overall theme, specific subject matter, and even title are important for understanding the meaning of the work. There are many recurring themes in art, such as love, nature, death, and so on. The subject matter is more focused on a particular aspect. The title confirms the theme or subject, or both, and may help further clarify the time period. For example, nature is a theme, landscape is a subject matter, and *View from Mount Holyoke, Northampton, Massachusetts, after a Thunderstorm – The Oxbow* (Color Plate 12) is a title.

But things are not that simple: first, not everything depicted in a work, even if realistic, can be identified and, most importantly, explained. Secondly, many artists, particularly in the past, did not use titles for their art. They were added later. These modern readings of the images can be erroneous. Also, at times, visual aspects may not amount to a comprehensible story or subject matter. Titles may change to reflect new interpretations. Finally, neither the descriptive components nor subject matter can accurately define the meaning or significance of a work of art. Depending on other elements in the work, a painting representing a woman could be the representation of a person, a religious figure, or an allegory.

Neither form and content nor titles can fully explain a work of art. This is well exemplified by *The School of Athens* (Figure 6.1). Can you figure out what this painting is about based solely on this information? To understand this, and other works of art, requires research into many more sources, discussed in the following sections and the next chapter.

How do you look at art? What do you notice first?

The Physical Condition of the Work of Art

Physical characteristics such as weight, size, and material provide basic data about a work of art. This information can be valuable in understanding art. Large works

are more likely to be for public viewing or commissioned by wealthy patrons. On the other hand, monumental works created by artists known to produce small-scale art may suggest an unusual purpose or meaning, and even pose questions about the authorship. Irregular and unusual shapes may also disclose the function and significance of artworks.

Materials reveal specific techniques and processes used by artists, periods, and traditions. Knowledge about these issues helps confirm or question the authenticity of artworks. Any deviation from these documented facts would raise doubts about the art. For example, if an ancient Mayan textile had synthetic fibers or a Raphael fresco included acrylics, neither works could be authentic, as these materials were only available much later.

Many works of art are not in optimal condition. Time, war, and natural disasters can leave visible and irreversible marks on art. Damage can also be inflicted carelessly or intentionally on works for religious, political, and even personal reasons, including financial gain. Attentive examination can disclose valuable and, sometimes, unexpected facts about the artwork, its history and context. (See the textbox below.) The present state of many historical sites, including the Greek temple, the Parthenon (450 BCE), are due in part to past vandalism, negligence, and indifference. Today rails, shields, and alarms prevent such abuse, but many sites still require attention. The deteriorating condition of monuments suggests either lack of funds or interest in their preservation, or both.

Over time, many works of art have been removed from their original locations in architectural structures, burial sites, palaces, and private houses, and in some cases have been forcibly dismantled and scattered throughout the world. It is not unusual to find dispersed components of the same work of art displayed in different locations.

The Condition of a Work of Art

A recent exhibition at the J. Paul Getty Museum presented such a case. *Hunting on the Lagoon* (1490–1495), a painting from the museum's collection by the Italian Vittore Carpaccio (1460–1525), was exhibited together with another work by the same artist: *Two Venetian Ladies on a Terrace* (*ca.*1490), from the Correr Museum in Venice. Recent research proved that these two works had been part of the same panel. The separation occurred before the nineteenth century, when this work was cut in half. The two paintings show very different subjects which become connected when the two panels are seen together. The lower part represents two women sitting on a balcony; the upper panel is a landscape, originally the background of the work. It is presumed that these two panels represent only a portion of a larger work.

Accurate observations of the condition of art can only be made when looking at and analyzing originals.

Originals and Reproductions

Where can original art be found? Artists' studios and private collections are often off limits to the public and sometimes even to experts. Art is usually displayed in museums, galleries, architectural structures, and other public and private venues. Seeing originals is an extremely valuable experience that cannot be replicated. Size, forms, colors, proportions, brushstrokes, glazes, and textures are easier to appreciate when looking at original art. Moreover, the three-dimensional quality of architecture, sculptures, ceramics, and many other works can only be fully understood in real life.

Even though there are many possibilities for seeing original art, museum field trips and other first-hand experiences are limited, for practical reasons. Art today is viewed mostly in the form of reproductions. Reproductions have been, and still are, the essential mode of learning about the values of original art. This applies to all levels of research and teaching, from undergraduate papers to published books and from introductory courses to graduate seminars. These modern tools have contributed to the development of art history as a discipline, have enhanced art education, and have played a significant role in spreading art. (See Chapter 5.) Even museums use reproductions to attract visitors to see original art. In 2005 the Philadelphia Museum of Art displayed on its entrance steps a huge replica of Salvador Dali's self-portrait, an unusual, but effective visual invitation to the exhibition.

Most viewers and even experts see many works of art first as a reproduction. In fact, galleries and art dealers routinely request artists to submit slides or electronic images so they can review their work. Some collectors also use the convenience of digital media to stay informed about art.

There is an abundance of reproductions in a variety of media and formats circulating in today's visually oriented society. In the past these replicas were produced by specialized companies in conjunction with art institutions and organizations. In contrast, digital media permit anyone with a camera and web connection to post art on many public forums. Typing the title of well-known works or artists into a search engine would result in hundreds of thousands, even millions, of results in less than a few seconds. Many of these are contemporary variations and personalized plays on famous works. Seeing art first as a distorted reproduction can change how the original is perceived later on.

There are significant differences between originals and reproductions, with enormous implications for the evaluation and appreciation of art. The technology used for slides, book illustrations, and electronic media can substantially alter colors, textures, and proportions and erase the three-dimensional quality of artworks. Many electronic reproductions are adjusted without ever seeing the originals. New tools, such as "zoom," used by many museums, have gone overboard in

their desire to parallel originals, offering views that are not possible with the naked eye. These impressive details are, in a certain way, also distortions of the original.

The artificial brightness of the computer screen affects the color palette and flattens the image. (Flattening is a feature in the program used for adjusting electronic reproductions.) The similar size and format of the images projected create a monotonous sameness that overshadows the uniqueness of the original. The actual dimensions of the work are not easy to grasp in reproductions. Statues and paintings that appear larger than life may be miniatures in reality. Even if captions inform us about size, proportions, texture, and materials, these visual presentations create false expectations.

Reproductions not only distort the work of art but also decontextualize it. (See also Chapter 5.) Paintings, prints, sculptures, and vases are projected onto a screen or pasted into books in isolated, rectangular shapes. Where are they from? Reproductions from museums may be closer to the original, but the detachment is twofold: they disconnect art from both the museum space and the original context. Another significant alteration in reproductions is the elimination of frames and pedestals. In a museum, unframed art would seem unfinished, and sculptures without pedestals would give the gallery the appearance of being in the process of installing a show.

> What do you think about the role of frames or pedestals in looking at art?

(See the textbox "Frames and Pedestals" in Chapter 4.)

What are the most significant differences between originals and reproductions? To answer this question, select a work from your local museum's or gallery's website and then go to see it in real life. Did the original meet your visual expectations?

Even new media are distorted in reproductions. Web projects, multimedia installations, and videos can be copied onto DVDs, CDs, and other electronic formats. The programs, screens, and projectors used for delivering them can, however, alter the images. Viewing large video installations on television or computer screens is not comparable to experiencing the original works. Furthermore, still images of these projects are an incomplete view of the art.

Reproductions modify the identity of originals, but they can also add valuable information. For example, art which is difficult to access can be easier to examine in reproductions. Videos, webcams, and virtual tours have given us new and more comprehensive ways of seeing and understanding art. Reproductions, however, cannot replace the experience of seeing art in person. What is important to consider is that these "surrogates" are essential in defining art and developing the artistic taste of contemporary audiences. Seeing art mostly in reproductions and on electronic screens, in particular, will create unrealistic expectations that may affect the way originals will be appreciated in the future.

The Preservation and Conservation of Art

Many works of art created in past centuries are in need of preservation, conservation, and restoration. *Preservation* refers to the measures needed to protect art.

Climate and light control in museums is part of preservation. *Conservation* means a treatment to repair existing damage and prevent further deterioration. *Restoration* implies additions that are made to bring (or restore) an object close to its original visual conditions. Contemporary conservation processes are guided by strict ethical rules. Art conservation is highly scientific; specialists must be familiar with art history, various art techniques and materials, and science, chemistry in particular.

A widely used conservation treatment is the removal of the superficial layers of dirt, which over the years conceal the original paint, often without damaging it. This cleaning process can result in striking visual changes. Many works have undergone conservation treatments, including cleaning, but none has been more disputed than the Sistine Chapel. To the surprise of the audience, and even some scholars, bold colors and powerful forms emerged from beneath more than 450 years of dust and dirt. The cleaned frescoes revealed connections to Michelangelo's sculptural work that were previously concealed under delicate grays and subtle forms. The uproar that ensued was not over the practice of conservation, even though many still believe that the frescoes were repainted. They were not. The scholarly disagreement stemmed from the discrepancies between the way the famous work had been seen in modern times and the unexpected original vision of the artist. The distrust generated by these discrepancies confirms that changes to established visual norms are not easily accepted, even in art.

Older oil paintings are usually covered with varnish, a transparent protective coat, which has yellowed over time. The cleaning process involves the removal of this layer and the application of new varnish. Many works undergo this treatment. The visual results have been as startling as in the Sistine Chapel. How would art historians and the public react if the varnish on *Mona Lisa* were to be removed to reveal more intense and brighter colors?

Conservators have to balance preservation concerns with the need to present art in a pleasing way. In the past, restorations have altered damaged works to make them more appealing to viewers. Contemporary conservation still uses a process called *inpainting*. However, this procedure is subject to strict ethical rules. Inpainting can be done only to areas where the original layer of paint has been damaged or lost, the materials must be removable and reversible, and large areas are usually covered with a neutral color. Even with all these precautions there is a level of deceit, as most inpainted areas are not easy to identify.

These additions are neither used nor acceptable for all artworks. For example, it would be unconceivable to add arms and legs to familiar Greek and Roman statues. (This practice was more common in the past, and it is still used in some cases today.) Spectators who admire ancient marble torsos would, however, question the value of either a statue becoming a collection of scattered fragments after the restorations have been removed, or a portrait painting missing most of the facial features. These responses confirm that art appreciation is influenced by established cultural patterns of viewing.

What do you think about art conservation? Should art be left to decay? How much intervention is appropriate?

If art from the past raises many difficult questions about its preservation, modern art has introduced even more difficult challenges. New materials, ephemeral techniques, hybrid forms, and unstable pigments are among the issues that have complicated the work of conservators. Many modern artworks have been placed on the priority list for immediate conservation. Detailed and fascinating information about specific art-conservation projects has been posted on many museum websites, including those of MoMA in New York and the Van Gogh Museum in Amsterdam. New media have brought additional concerns for conservators. These issues need to be addressed immediately to avoid the disastrous losses such as those suffered by early cinematography.

Art conservation can be a valuable source of new reflections on art analysis, which until recently was accessible almost exclusively to experts. An abundance of information in museums or on websites offers the public the opportunity to learn about this lesser-known aspect of art.

Scientific Tools

Art specialists also have access to information from scientific sources such as X-rays, infrared lights, and other methods of testing. These examinations expose layers of paint invisible in the final work and help art historians to better understand the creative process and history of a particular work or artist. An X-ray on a Van Gogh landscape at the Norton Simon Museum in Pasadena, California, uncovered a different composition the artist had painted underneath. The museum has made this discovery public and displayed the photograph of this finding next to the painting. These findings generate valuable questions such as: Why did the artist abandon the project before completion and paint another one on top of it?

These tests, performed by specialists to establish the condition of art, are particularly helpful when certain aspects of a work appear suspicious. Some of them are used to authenticate works of art by identifying the age of materials. Even with the advances of today's science some results can be inconclusive. Without scientific and textual documentation, the burden of demonstrating the authenticity of art rests on visual evaluations. This has been at the core of the debate related to the famous ancient Greek kouros (representation of a nude youth) in the Getty Museum. Neither scientific tests nor examinations and research by reputable specialists could conclusively authenticate the sculpture. It is now displayed with a unique and unexpected label: "Greek, about 530 BCE, or modern forgery."

Even though the work of art is essential in the analytical process, other visual resources inform this as well.

Visual Documentation and Research

In addition to examining the work of art, experts use a wide range of other visual resources. The "body of work" provides a comprehensive understanding of an

artist's entire career. The examination of the artistic context is another important component of research. Drawings, photographs, new discoveries, symbols, and other visual resources can add valuable information about a period, artist, and work of art.

Artists' "Body of Work" (*Oeuvre*)

One of the first steps in examining a work of art is to establish its authorship based on the visual elements available: signature and date. Unfortunately, most art has neither been signed nor dated. The absence of a signature, or a recognizable one, puts a further burden on careful assessments of the work and other resources. Once the author and date are known, visual examination can focus on understanding its relationship to what experts call an artist's entire "body of work." This term (*oeuvre* in French) defines the totality of works representative of the overall conceptual and visual approach of an artist. The body of work helps experts answer questions such as: Is this an early or later work? How does it compare with other works of art by the same artist? Are the formal elements typical of the artist's style and specific date? Does the work of art represent a recurring theme, style, or subject, or is it new? Specialists well acquainted with an artist's body of work can sometimes recognize his or her unique style based on as little as the form, shape, and intensity of lines or brushstrokes. An artist's development, creative path, and "body of work" are affected by the artistic context and by many other factors. Visual analysis needs to take these elements into account.

Artistic and Visual Context of the Time

The artistic context influences artists in many ways, including the use of formal elements. The predominant formal aspects create a *style* specific to a certain period, geographical area, or artist. Art experts are familiar with the general visual characteristics of different eras and artists, in particular those they study. Style, themes, formats, shapes, materials, and sizes contribute to positioning the work of art within its time frame and establish connections with the general trends of the period. Visual analysis is also concerned with identifying the innovative directions of the artist and works examined. In modern times avant-garde artists developed innovative visual directions that intentionally clashed with the artistic norms of the period. Any analysis must look at both the visual context against which these artists rebelled and the one in which their art was accepted.

The influence artists and artistic periods have on contemporary or later developments are also important to visual analysis. The artist Jean Charlot (1898–1979)[λ] interpreted Mayan culture in his work. Greek sculptures served as a model for Roman artists. There are times when works of art appear visually disconnected from their immediate artistic context. To better understand these deviations art historians use many other sources to support their research and analysis.

> " We are to remember, in the first place that
> the arrangement of colours and lines is
> an art analogous to the composition
> of music, and entirely independent of
> the representation of facts. "
>
> **John Ruskin**[3]

Drawings, Architectural Plans, and other Visual Resources

Many works of art from the past are either no longer complete or have been destroyed over time. Therefore, other visual sources such as reconstructive drawings, plans, and scale models either from the period or based on documents and descriptions are used to inform the analytical process. More recently, photography has become an important way of documenting art. Its role is particularly valuable when works are stolen, lost, or destroyed.

Artists' sketches and drawings are also important for visual analysis. Created for personal use with less concern for norms, rules, and public reception, these works can substantially enhance the understanding of art, artists, and even periods. Preparatory drawings for large projects, called *modelli* (Italian for "models"), are very valuable in assessing the various stages and development of a project. They can also shed some light on the artist's creative journey. Andy Warhol's early drawings and sketches reveal a subtlety and sensibility in complete contrast with his later famous works. The innovative vision of the Italian architect Antonio Sant'Elia (1888–1916) had an influence on later twentieth-century developments. However, it is in his drawings that his ideas can be seen, as none of his projects have ever been built.

New Art / Archaeological Discoveries

A great deal of knowledge about art from the past has been based on fairly recent discoveries. Cave paintings were discovered in Europe less than 200 years ago. Ancient Egyptian writing was deciphered in the early nineteenth century, thus revamping this entire field of study as an abundance of material became available for interpretation. Tutankhamen's tomb was discovered in 1922.

New findings can be valuable sources for art-historical analysis. For example, the terracotta soldiers (210 BCE) were discovered in China in 1974. This impressive site, comprising an astonishing number of life-size sculptures estimated to be in the thousands, continues to be excavated (Figure 6.2). The statues, which represent the army of the First Emperor of China, were buried in close proximity to his mausoleum. In addition to historical information, these works shed new light on the Chinese sculpture tradition, patronage, political life, and the arts, as well as techniques, materials, and art-making during that period. These, and other newly

6.2. Ancient terracotta soldiers, Xi'an, Shaanxi Province, People's Republic of China, 3rd century BCE. *Photo:* O. Louis Mazzatenta / National Geographic Stock.

discovered works, might also add or change information about other works of art, open up new areas of research, and redefine the story of art.

Symbols in Art

Symbols have been widely used in art throughout history. Their meaning is closely connected to their immediate context. Examples from contemporary culture, which uses a complex system of signs and symbols, will help clarify how they function. A red light stops people from crossing a street, but would be ignored if it were placed in the middle of a forest. Similarly, in a computer store no one would mistake the Apple symbol for a dietary suggestion. The same sign would be interpreted differently in a supermarket's produce section. Many logos are easily understood across the globe: the McDonald's® arches, the sign for wool and cotton, the Nike® swoosh, to name only a few. Symbols can be misinterpreted in different contexts. The Target® logo may be perceived as a symbol for hunting or target practice by those unfamiliar with the store.

Most symbols are explained in books, making deciphering them much easier. Symbols used in cultures with limited documentation may be more difficult and, in some cases, even impossible to decipher today. This is the case with some symbols used in medieval Europe and pre-Columbian art.

Religious representations make extensive use of symbols. Their consistent use and extensive textual material available make it easier to identify most religious attributes and symbols. For example, the lily, garden, and shell are symbols used in the representation of the Virgin Mary. In addition to symbols, religious images

use *attributes*. Attributes are specific objects connected to the life or death of various figures. They help identify the religious characters and narrative. The attributes of the Roman god Mercury are his winged sandals. St Peter's attribute is a set of keys.

Some symbols have comparable cross-cultural significance. The sun is a symbol of life in many cultures. The skull is a recognizable symbol of death. The lion is perceived as a sign of power, even in areas where this animal is not indigenous. Many symbols, however, are intimately linked to their surroundings. Bamboo, lotus, and ginseng are widely used in Asia, where they grow. At other times, symbols representing the same thing have different meanings. In the modern Western tradition, the snake is mostly linked to biblical stories. For the ancient Romans, it was a symbol of healing; the double-snake sign is still used by many pharmacies around the world. The Egyptian and pre-Columbian cultures feared, revered, and worshiped the serpent. Its representation in these cultures therefore has complex symbolism linked to royalty, earth, life, and even death.

Colors, metals, shapes, forms, and numbers also have symbolic meaning. Gold, due to its rarity and durability, is often associated with gods, power, and royalty. The close relationship between symbols and their context is well illustrated by pre-Columbian art. Mayan rulers are represented by intricate designs and symbols. But without significant knowledge of the culture, it would be impossible to understand their meanings. Symbols from Western culture may not be easy to decipher outside their immediate original context, either. Van Eyck's *Portrait of Giovanni(?) Arnolfini and His Wife* (1434; Color Plate 3) is a case in point. The painting uses many religious and secular symbols to highlight spiritual and social values and the financial status of the couple. Modern audiences may not realize why the couple have removed their shoes (they are standing on holy ground), or what the significance is of the burning candle (the presence of God) and the dog (fidelity). What viewers notice reflects today's customs, values, and concerns: the woman is wearing a green, not a white dress, and she appears pregnant.

> How would you transform Van Eyck's work into a contemporary wedding portrait? What symbols would best represent today's culture and values?

Summary

There are many visual elements relevant to art analysis. The work of art is an important starting point. Valuable information may also come from many other sources, such as conservation, reproductions, symbols, and new discoveries.

What do you perceive to be the most important elements of visual analysis? What do you look at first? What else would you like to know about a work of art?

A comprehensive analysis of *The School of Athens* requires the consultation of many other resources. The title of this work states that it is about a school in the

capital of Greece. But this not the case. The figures are older and the setting does not appear to be a school. The architectural details suggest some similarities to the interior of St. Peter's Basilica in Rome. What is this work about? The title, visual examination of the work, and other resources do not fully answer this question. The painting is an allegory of philosophy, a fictional gathering of "minds" from antiquity and the Renaissance. But this information cannot be found in the image alone. To establish the meaning of this fresco, and other artworks, requires the consultation of additional resources. Primary and secondary textual sources are indispensable components of art research. These, and other supportive elements crucial to a comprehensive analysis, are discussed in the next chapter.

Notes

1. Vassily Kandinsky, quoted in Gayford and Wright, *Art Writing*, p. 349.
2. Robert Smithson, "The Spiral Jetty" (1972), in Stiles and Selz, *Theories and Documents*, p. 533.
3. John Ruskin (1853), quoted in Gayford and Wright, *Art Writing*, p. 357.

7
Textual and Other Resources Used to Analyze Art

7.1. Artemisia Gentileschi, *Venus and Cupid, ca.*1625–1630. Oil on canvas, 38 × 56.625 in. (96.52 × 143.83 cm). Virginia Museum of Fine Arts, Richmond. *Photo:* Katherine Wetzel © Virginia Museum of Fine Arts.

Venus and Cupid (*ca.*1625–1630; Figure 7.1), by the seventeenth-century Italian artist Artemisia Gentileschi (1593–1653), represents a widely depicted classical subject, Venus. The depiction of this subject and of a nude by a woman artist is unique for this period. To analyze this work it is necessary, in addition to the visual sources discussed in the previous chapter, to use many other resources. Primary and secondary textual material such as letters, documents, and writings by and about the artist are among them. This painting was acquired by the Virginia

The Art of Understanding Art, First Edition. Irina D. Costache.
© 2012 Blackwell Publishing Ltd. Published 2012 by Blackwell Publishing Ltd.

Museum of Fine Art in 2001. Information about provenance and exhibitions may also inform the analysis. Furthermore, Gentileschi's current fame is due to changing views in art history, specifically, contemporary interests in women artists. Comparative approaches have also contributed to further knowledge about Gentileschi and other artists.

This chapter presents the way various textual resources and art-historical methods inform and support art analysis. The material is organized into four sections. The first two deal with primary and secondary textual resources. The third section is an overview of other sources, including art exhibitions, online information, and popular culture. The chapter concludes with a discussion of comparisons, a widely employed method in art analysis.

The resources discussed in this chapter are neither always available nor relevant to all analytical concerns. The order within sections is alphabetical, to avoid the suggestion of a hierarchy or procedural sequence.

Primary Textual Sources

Primary sources are original documents and published material presented in a fairly "raw" form. Archival material is documentation in its original form. Many primary sources have been published. These materials, such as the letters of Van Gogh, usually include explanatory texts and, as in this case, may be translated. A variety of textual sources can be useful to art analysis. General historical documents, as well as artists' letters, can provide valuable information. Provenance, discussed at the end of this section, is a lesser-known yet very important form of documentation. Its purpose is to prove the whereabouts of a work of art. This information is widely used to detect and avoid fraud, fakes, and other crimes in the art world.

Archival Material

Documents are important resources that can help to establish the original context of a work of art. A wide range of legal, historical, and financial records can be valuable primary sources. Contracts, purchases of art materials, marriage licenses, birth certificates, personal papers, art prices, inventories, and many other documents can provide significant information about the specific circumstances in which art was created. These documents can reveal relationships with patrons, clauses in contracts, the number of apprentices, practices within artists' studios, and many other facts relevant to the art analysis. There are numerous original records that have not yet been examined, and many that have not been published. This material is housed in archives and special collections, which are often connected to libraries and museums. Archives may be public or private, and can be managed by secular or religious bodies. Their missions vary, based on the profile of their collections and their administrative, scholarly, and educational

concerns. The Smithsonian Archives of American Art and the Vatican Archives, both institutions with impressive holdings, reflect this diversity. There are many other institutions around the world with valuable collections.

Private archives belonging to artists, art historians, dealers, and collectors can be particularly interesting. Many have been donated and opened up to the public for research and educational purposes. However, access to consult original documents is often limited to scholars in the field and other professionals, and many restrictions imposed by archives are due to concerns for fragile documents. It is also true that private archives can limit researchers' access to their holdings and prevent fair and complete research. The reasons for this can be subjective and may include disagreements with scholars' point of view. High fees requested by owners to publish archival material might also prevent specialists from using these resources. Consulting material in areas that are hard to access and countries that limit scholarly work can be outright impossible. Additionally, in some instances archival research may also require knowledge of foreign languages.

Electronic media have facilitated scholarly and public access to archival sources. Many institutions around the world have developed websites with extensive information about their holdings. This material, which until only a few years ago could be consulted only on site, can help viewers better understand the behind-the-scenes story of art.

Artists' Letters, Notes, and Statements

For many spectators the voice of the artist is a mandatory component of art analysis. Many artists record their thoughts in notes, letters, journals, and statements. These writings offer an unparalleled insight into their creative processes and provide a unique perspective on their artistic journeys. Numerous texts which were intended for a private and limited audience have been published and even posted online. They reveal the sophisticated and effective communications skills of many artists. The candor, professionalism, and business approach of these texts may surprise modern audiences' preconceived views.

The notes of Leonardo da Vinci reflect on a variety of subjects, ranging from engineering to architecture and from anatomy to painting, and are intertwined, often without any apparent connection, with drawings, sketches, and diagrams. What makes these texts so intriguing is the format. Leonardo wrote from right to left and in reverse, as if the text were reflected in a mirror. Over time the pages were dispersed and their original chronology partially lost. This made deciphering and interpreting them both challenging and exciting. Leonardo's notes are now divided into ten manuscripts called codices, named after the collections and collectors to which they belong. All the notebooks have been published and translated into many languages, and the content has been carefully examined and most of it explained. The manuscripts reveal substantially more information about Leonardo's art and thoughts than the few paintings he created. Many of the pages are now available online.

Equally impressive is Van Gogh's correspondence. The artist wrote an astonishing number of letters, over 800, mostly addressed to his brother Theo. These writings reveal Van Gogh's thought processes and passionate creativity. In a letter of 1882 he states: "But still, in my work I see an echo of what struck me, I see that nature has told me something, has spoken to me and I have written it in shorthand."[1]

The artist comes across as thoughtful and knowledgeable, a striking contrast to how he is perceived. This copious correspondence has been translated in print and electronic formats.

Artists' letters reveal financial concerns and personal struggles readers may not expect. Several examples will illustrate this point. In a series of letters from 1639 to his patron Constantijn Huygens, the Dutch Baroque artist Rembrandt discusses the paintings he was commissioned to create, their delivery, and payment for them in a style that is courteous, eloquent, and firm. The passion with which Rembrandt writes about his art is evident. "[F]or in these two pictures the deepest and most lifelike emotion has been observed (and rendered)." (The paintings he is referring to are *The Entombment of Christ* (*ca.*1636–1639) and *The Resurrection of Christ* (*ca.* 1635–1639.) His reflections may also be perceived, in this context, as a "sales pitch." Rembrandt was keenly aware of the business aspect of his profession. In the same letter he refers to his work, in a detached way. "I shall send along, as a token of gratitude, a piece measuring ten feet in length and eight in height which you will prize in your house."[2]

Rembrandt was not the only artist who had difficulties with his patrons. The letters of Artemisia Gentileschi, an Italian artist who was his contemporary, show her extraordinary professionalism and sophisticated business skills. Her sense of self-confidence as an individual and artist permeates her correspondence. Gentileschi was aware that gender influences artistic and financial values. In a letter from 1649 to Don Antonio Ruffo, who also bought several Rembrandt paintings, she states: "I was paid one hundred scudi per figure . . . [w]hether this is due to [my] merit or luck Your Most Illustrious Lordship . . . will [be the best] judge," and adds: "because a woman's name raises doubts until her work is seen."[3] The firm tone and self-confidence reveals Gentileschi's ability to overcome the personal tragedy that marked her early life.

One of the most interesting letters is the one she wrote to the renowned Italian astronomer Galileo Galilei (1564–1642), asking him to intervene on her behalf to secure the payment from Grand Duke Cosimo for two of her paintings. The artist's connections with important figures of the time help modern viewers understand her representation of female nudes discussed later in this chapter.

The letters of the American artists Mary Cassatt (1844–1926) and Georgia O' Keeffe (1887–1986) also underline their sense of artistic purpose and direction. In a letter in which she rejects an award given to her by the Pennsylvania Academy of Fine Arts, Cassatt explains her decision with clarity: "Of course it is gratifying to know that a picture of mine was selected for a special honor." The artist states and later adds: "I, who belong to the founders of the Independent Exhibitions, must stick to my principles, our principles, which were, no jury, no medals,

awards."[4] Similarly, in a 1945 letter O'Keeffe subtly, but also forcefully, acknowledges her role in American art: "I think," the artist writes, "that what I have done is something rather unique in my time and that I am one of the few who gives our country any voice of its own."[5]

Artists' diaries, notes, and essays have sometimes been published as books. The American photographer and supporter of modern art, Alfred Stieglitz (1864–1946), reflected on this new art form in many texts. His essays and notes were published as a book in 2005. Other examples include *Notes of a Painter* by the French artist Henri Matisse, published in 1908 and *Concerning the Spiritual in Art*, by the German Expressionist artist Vassily Kandinsky, published in 1912. These books continue to be printed and read.

Many modern artists have written formal texts, some called manifestos, to define the general direction of their art. The Italian Futurist artists produced more than a hundred manifestos and texts ranging in topics from painting and sculpture to food and fashion. These writings were published in journals, newspapers, magazines, and as leaflets. Written statements have been widely used by contemporary artists to explain either their overall artistic vision, or specific works. This practice is encouraged and taught in art schools, but the response of the audiences to these texts is mixed. Some perceive this material key to understanding art. To others they are a confirmation that the art cannot stand on its own.

> " I was interested in ideas – not merely in visual products. I wanted to put painting once again at the service of the mind. "
>
> **Marcel Duchamp**[6]

Contemporary artists have also presented their views in lectures, interviews, essays, and a variety of novel formats. Emails, text and voice messages, and other virtual public forums have all but replaced letters and journals. Many artists have sophisticated websites with blogs, chats and, nowadays, Facebook and Twitter accounts. These new possibilities allow the audience, not just specialists, to be informed and to engage in meaningful dialogues with artists. But there is a potential problem with these exciting electronic platforms. Unlike tangible documents, emails and other electronic textual, visual, and audio materials may be, and often are, deleted. Even when they are saved, digital media's endurance over time is still unknown. This raises important questions about how many contemporary art records might be available in the future.

The documentation discussed in this section refers to Western tradition. As art and art history become more inclusive, additional texts and documents from other cultures will be translated and made available to broad audiences. This information would further a broader evaluation of artists' practices around the globe and across time.

For many viewers the voice of the artist is an essential element in art appreciation. Understanding artists' intentions is an important, but not always determining factor in art analysis.

Provenance

If you were an artist, how would you record your thoughts? What would you like to communicate to the audience about your art?

Provenance traces the history of a work of art to prove its ownership and location, going back, if possible, to its creation. Lapses in this documentation can generate suspicions about the origins or the recent whereabouts of a work. Provenance is an important tool in authenticating works of art and finding missing, looted, or stolen art. It is, however, not always easy to track down these documents. Historical circumstances, natural disasters, political environments, the passage of time, and many other factors contribute to the erasure of this important paper trail. In the past, many works of art have been taken from their original locations and moved to other countries and even continents. Wars and lack of ethical guidelines made this practice both possible and acceptable.

Today, provenance is a major concern for museums around the world. Many art institutions have posted information about the origins of their collections and provenance projects they are involved in, as well as governing ethical guidelines and policies. Museums, collections, and other organizations around the world work together to locate and return looted art. Provenance has been essential in identifying artworks confiscated by the Nazi regime and securing their return to the rightful owners.

Recently, provenance has brought forth new concerns regarding acquisitions of works with ambiguous documentation, illegally excavated or fraudulently smuggled out of a country. The decision of prominent museums to return artworks to their country of origin has made front-page news more than once in this century. The issues of art ownership and location have enormous ramifications that cannot be easily resolved.

Provenance may be of greater interest to specialists. But as this information becomes available online it might be also a valuable source for viewers to better understand the practices that govern museums, dealers, and collectors. Art is clearly much more than just a nice painting on a wall.

Secondary Textual Sources

Primary sources are neither always available nor required by all analyses. Secondary sources, texts that present information with an interpretative angle, are widely used in research. They include an author's analysis of a topic, or significantly annotated archival material. Information about the past is often based on secondary sources, such as history books, not original documents.

Which sources are more important for art analysis? This depends on the research concerns and approaches of specialists. Some experts argue that understanding the original context is essential. Others claim that contemporary methods and issues are the defining factors. In any case, a thorough consultation of art-historical texts from both past and present is important to any comprehensive analysis. Most of these resources are available to the general public. However, viewers do not need to conduct in-depth research to understand and enjoy art.

Art-Historical Literature

A comprehensive bibliography is a starting point and significant component of research. There is an abundance of art-historical literature (in other words, texts about art) published in journals, magazines, newspapers, and books, and now online as well. Depending on the topic, the bibliography may vary from a few articles to thousands of texts; proficiency in different languages may be necessary in some cases. As discussed earlier in this chapter, electronic media have facilitated access to libraries, archives, and museums around the world. The full text of numerous books and articles is available online, sometimes free of charge. Electronic access has made research easier, but it has also increased the expectations of constant updates in the field. The amount of information available can make the research process longer, more tedious and, some would argue, more interesting. It can be a daunting task. Researching a work of art from the past is likely to include material from that period, if available, as well as more recent texts. The extensive use of cross-cultural and chronological references in contemporary art has made it necessary to examine texts related to diverse cultures and periods.

Many art-historical texts are written for specialists. New critical and theoretical analyses, in particular, use philosophical terminology and concepts that can be difficult for the general public to understand. However, plenty of textual sources are available to give the public meaningful information about broad aspects of art.

Original Context and History

Because contextual elements affect the creation of art (see Chapter 3), they are also relevant to analysis. History, religion, political life, and many other factors provide valuable information about art's original function and meaning. For example, Egyptian art during the Amarna Period of the New Kingdom has unique stylistic features. In contrast to previous centuries, the art created during this very short period shows emotions, has exaggerated forms, and uses deeper relief with more expressive lines. These artistic changes are directly linked to the political and religious reforms of Akhenaten (1353–1336 BCE). The relief *Akhenaten and His Family* (*ca.*1345 BCE; Figure 7.2) reflects these dramatic visual changes. Instead of the linear and rigid style of previous centuries, this, and other works from the Amarna Period, use expressive lines whose thickness varies to reinforce space and

7.2. *Akhenaten and His Family* (with his wife Nefertiti and their three daughters under the rays of Aton), 18th dynasty, *ca.*1345 BCE. Painted limestone relief from Akhenaten (Tell-el-Amarna), Egypt, 32.5 × 39 cm. Aegyptisches Museum, Staatliche Museen, Berlin. *Photo:* Bildarchiv Preussischer Kulturbesitz / Art Resource, New York.

form. In addition, the work reveals new religious values instituted by the pharaoh, such as the worship of Aten, the sun disk. The most surprising element is the emphasis on life, which is unusual in Egyptian art, whose focus is mostly on the afterlife. The pharaoh and his wife are presented as a couple with tender emotions for each other. Without information about the history and religion of the period this work cannot be fully understood.

Historical circumstances can affect art and artists in a variety of ways. Therefore, in some cases, the analysis may need to consider both the specific conditions in which art was created and the personal experiences of the artists in that context.

For example, the Dada movement was influenced by the historical context of the 1910s and World War I. Outside these conditions the art may appear superficial and irrelevant.

Does your field of study interact with art?

Art analysis may also include research fields in the humanities or sciences that have influenced art-making.

Today's Art History, Criticism, and Context

Art analysis is strongly influenced by contemporary values. New information and methodologies affect specialists' perspectives, focus their attention on particular periods or artists, and expand knowledge in the field. Recent theoretical develop-

ments have triggered novel methods of examining art. Psychoanalysis and gender studies, for example, have focused on aspects of identity. One of the most influential and valuable recent additions to art analysis has been the inclusion of artistic traditions outside the Western world. Global views brought forth artistic norms that were previously marginalized and neglected, and triggered revisions in Western art. These cross-cultural values have also broadened the notion of art.

New directions question accepted norms and propose new points of view and novel ways of understanding art. (See also Chapter 10.)

" Art and work and art and life are very connected . . . "

Eva Hesse[7]

Additional Resources for Research

Art Institutions and Exhibitions

Museum collections, exhibitions, and acquisitions reflect current artistic values. Therefore they can be helpful sources in understanding art. Even practical issues such as the location and arrangement of the art within an institution can shed light on museums' views and values. An artwork placed in a central and visible space suggests that it is considered more important than those displayed in a dark hallway. The changing layout of art within museums can be extremely informative in understanding shifting artistic views.

The topics of exhibitions are strongly linked to art-historical research. Recent findings, new methods, and innovative perspectives inform the themes and designs of these shows. In turn, they give us information about directions in art at a given time. For example, an overview of recent exhibitions at major museums around the world would expose current art-historical trends. Museums' acquisitions can also be effective tools in examining what is considered art in a specific context. Nowadays, these artworks, which reflect both museums' vision and contemporary values, are often displayed in small exhibitions or posted online.

Online and Other Sources

The web has become a widely used resource for art information and research. In addition to museums, archives, and libraries artists have also used this new tool to expose their ideas and work. Online social networks have added new venues for artists to exhibit and discuss their works and have augmented the information about art.

Using Online Resources (a Basic Guide to Avoiding Mistakes)

Libraries provide sound databases and valuable guides for using online resources. Here are some basic common-sense rules for avoiding online research mistakes:

- Use sites sponsored or developed by known art institutions, organizations, and individuals with established credentials.
- Use links on their sites.
- Always check the institution where the art is located.
- Use personal websites of established living artists.
- Check the webmaster/institution if the website is for artists from the past.
- Always check a site's home page.
- Check the date of the last update and the credentials of the webmaster (if available).
- Do not use the top 3–5 sites that come up when you search for a topic/ artist. They may not be the best sources for research/scholarly information.
- Make sure the site is not selling reproductions of the work/artist you research.
- Be aware that sites that use fictional accounts, such as novels or motion pictures, may not contain accurate information.
- When using information from an educational site, check the institution. If you are in college, you do not want to use information for or by elementary school students.
- Use caution when using information from sites concerned with tourism, or those that include multiple topics.

Many other sources may be useful and informative. Exhibition surveys, viewers' comments, and attendance statistics reveal the public's interest in a particular topic, artist, or period. Book sales may reveal the popularity of certain topics; even books that may not be scholarly in approach may be beneficial in understanding art. Dan Brown's book *The Da Vinci Code* (2003) is a case in point. While this is a fictional text, its links to art history have sparked a renewed interest in the art and culture of the period. A series of innovative art-historical activities, including some organized by the Louvre, have used the popularity of the book to educate audiences about art.

Popular culture and the mass media have played a significant role in spreading art beyond museums and galleries. Films, toys, and games may contribute to understanding the ramifications of art in contemporary culture. This material has

created a "secondary" world of art which, directly or indirectly, affects originals, their analysis, and interpretation. The dialogues between art and popular culture are discussed in Chapter 5.

Comparisons

"Conventional" Art Comparisons

Comparisons are widely used pedagogical and research tools. Their purpose is to expose specific trends, characteristics, and influences by highlighting similarities and differences between works of art, artists, and artistic periods. This method is mostly limited to reproductions. Comparisons easily achieved in a presentation would be difficult and in most cases impossible in real life. The juxtaposition of originals is curtailed by practical factors such as location, size, transportation, and cost. This is particularly true for sculpture and architecture.

Comparisons are used to confirm a point of view or clarify a particular inquiry. They may also lead to new information and analyses, as evident in the examples below. The starting point is usually a work of art that generates comments such as "looks like" and "similar to."

This "visual brainstorming," derived from knowledge and experience, contributes to planning formal comparisons. Defining criteria is an important part of the process. Criteria used in comparisons include: subject matter, time period, and style. In addition to visual elements, this method of analysis is informed by many other factors, including history, contemporary values, and patronage.

How do comparisons work? The case study discussed below will help you to understand the process and its value. (The examples are used for didactical purposes and do not include a full range of information and research. Furthermore, because of their purpose in this text they have not been triggered by a particular analytic inquiry.)

The comparisons use as a starting point the painting *View from Mount Holyoke, Northampton, Massachusetts, after a Thunderstorm – The Oxbow* (1836; Color Plate 12), by the artist Thomas Cole (1801–1848). Cole is considered the founder of the Hudson River School, an American art movement concerned with the representation of nature and landscape. Many of his works depict an awe-inspiring nature both in an emotional and rational way.

This painting is a representation of an area in New England around the Connecticut River. An impressive vista overlooks a valley of orderly farmland which signals a human presence. The foreground is a stark and unexpected contrast: a wild and raw nature. The sky, which occupies more than half of the upper part of the canvas, underlines these differences. The wilderness is seen under dark, menacing clouds. The rest of the landscape is covered by unexpected brighter and bluer skies. A small detail in the central lower part of the foreground, hard to see at first, adds a new dimension: it is the artist at work. While the landscape is

site-specific (it depicts an actual place), it has symbolic undertones with broad ramifications. At the dawn of the industrial age this painting is a commentary on nature being altered by human interaction. It also carries, as did other landscapes of the period, national connotations further explored by nineteenth-century American artists.

There are numerous possibilities for comparisons, presented below. In an actual analysis only those relevant would be used. (The order in which they are presented here is not indicative of any ranking; this is also not an exhaustive list.)

Using the subject matter as the main criterion, the comparisons could focus on a variety of related issues such as: (1) the significance of the landscape in general; (2) the role of the individual in an awe-inspiring nature; (3) untamed vs. domesticated nature; (4) parallels between nature and human nature; (5) landscape and symbolism; and (6) nature/landscape and the sublime.

The painting could be compared to a variety of artworks.

1. One comparison could include Cole's other works with similar subject matter. It could focus on earlier works, more concerned with a pristine and untamed nature, or later works, or use both periods. These comparisons would reveal the significance and particularities of this work within Cole's artistic development. This examination could also establish particular changes and influences.

2. Another comparison could juxtapose Cole's painting with other American landscapes of the period. These comparisons would aim to find the singularities of Cole's art, as well as its visual and conceptual connections to the artistic era. Because the artist is considered to have a founding role in American landscape painting, these comparisons would reveal the novel directions and influences his works establish.

3. Other comparisons may be broader in scope and include landscape painting from other countries. The choice is wide open, as this was a popular subject during the Romantic period (the late eighteenth and early nineteenth centuries).[λ] These comparisons could examine a wide range of issues related to the subject. They would position Cole's painting within a large artistic and historical context, and would reveal the connections between American and European art and artists of the period. Many Romantic artists and works of art could be included here: the British J.M.W. Turner (1775–1851), John Constable (1776–1837), and George Stubbs (1724–1806), and the German Caspar David Friedrich (1774–1840) are among them.

Rather than using landscapes by Turner or Constable, which have more overt connections with Cole, the example here will include George Stubbs's painting *Horse Devoured by a Lion* (1763; Color Plate 13). These somewhat visually distinct works are connected by their reflections on nature. Stubbs's work depicts a violent scene in the wild: a horse (a symbol of domestication) being attacked by a lion (a symbol of the wild). A dark and mysterious environment enhances the drama and heightens the graphic intensity of the impending outcome. Can the awe-inspiring, yet terrifying, raw forces overpower rationalism?

In Cole's painting, untamed nature confronts the viewer with its accurate foreground representation. The serene vistas of the farmland and blue sky have a reassuring and calming effect. Some may argue that Cole presents nature as threatening but also manageable. Others may see the storm as a sign of nature's undeniable power. Many landscape artists of the period, including Cole, have reflected with nostalgia about nature and saw modern life disrupting its inner balance. Which one will prevail here?

What do you think about these two works and their depiction of nature? What other elements could be relevant to this comparison?

4. This painting, as well as others by Cole, could be compared to earlier representations of the subject, such as seventeenth-century Dutch landscape art. This comparison would demonstrate, among other possible issues, artistic influences and establish the role of this subject in art.

Other criteria could focus on technique, color, style, and even size. These formal elements could be added to the comparisons discussed above to establish each artist's stylistic patterns, compositional structures, particular palette, and specific brushstrokes. They may reveal a particular size and format either artist liked to use. Stubbs uses a dramatically focused contrast and earthy colors. His palette is almost monochromatic. Cole's choice of colors is also fairly restrained; in the foreground there are dark hues and tones, but gradual transitions appease clashing oppositions. There are many more formal elements that could be compared. Can you see other similarities and differences between these two paintings?

The comparisons could expand to reflect on Cole's influences in nineteenth-century American art. They could focus on Frederic Church (1826–1900), who, together with other artists, continued and solidified the landscape tradition in the later part of the century. These comparisons would reveal changes in representation and symbolism. Formal elements could also be included to reveal new styles of painting.

Comparisons could also include much later works. An interesting one would be the painting *The Oxbow: After Church, After Cole, Flooded (Flooded River for the Matriarchs E. & A. Mongan) Green Light* (2000), by the contemporary American artist Stephen Hannock (b. 1951). This work has recently been acquired by the Metropolitan Museum of Art in New York, where Cole's painting is also displayed. The view is seen from the same vantage point, as Hannock pays homage to the nineteenth-century artist. He also reflects on nature, the tradition of landscape painting, the environment, and the individual and nature. What conclusion would you draw from this comparison? What elements would you focus on? One comparison could reflect on the use of appropriation in contemporary art discussed in Chapter 1. Comparisons are not limited to the same media. Cole's landscape could be compared to the same subject represented in prints and the emerging new medium, photography.

The less evident the comparative criteria and links between works, the more interesting the comparisons and interpretation of art can be. The visual and

conceptual connections formed through comparisons can be particularly instrumental in explaining art that is either controversial or difficult to understand. For example, *The Oxbow* could be compared to environmental art of the late twentieth century, such as *Lightning Field* (1977) by De Maria (Chapter 2, Figure 2.3) and, *The Gates* (1979–2005) by Christo (b. 1935) and Jeanne-Claude (1935–2009), and *Spiral Jetty* (1970) by Robert Smithson (1938–1973), discussed in Chapter 8. In these works the representation of nature has been replaced with an active engagement with it. The dialogue between individual and nature is not portrayed. It is inherent to the work and manifested through the artists' creative process and the viewers' experience. These comparisons may help viewers understand these and other earthworks as a contemporary reflection on landscape and the sublime. What other conclusions would you draw from these comparisons? (See more comparative possibilities in the following sections.)

Another set of comparisons could use gender identity as a criterion. How do women artists depict this subject matter? The search for appropriate artworks will disclose the limited number of landscapes painted by women. The best example would be the paintings of Georgia O' Keeffe, who lived almost a century after Cole. The results of this comparison may lead to a comprehensive analysis related to gender and landscape. Are women artists depicting the landscape differently? Why did so few women artists use this subject in the nineteenth century when it was so popular? Or has their art been forgotten?

Yet another criterion for comparison is self-representation. The specific ways in which the artist portrays him- or herself immersed in nature could generate interesting reflections about self-identity in general, and within the cultural and historical context in particular. What are the similarities and differences between this self-representation and the ones discussed in Chapter 1?

A real artist is only a vehicle for those things that are passing through him. . . . The explanation is left to the observer (and supposedly the critics).

Keith Haring[8]

These last examples underline how this method connects diverse works and, in the process, redirects the analysis.

Comparative approaches are particularly instrumental in analyzing lesser-known art. Because many women artists have been marginalized until recently, the works of the seventeenth-century artist Artemisia Gentileschi were not well known in the past. Her painting *Venus and Cupid* (1625–1630; Figure 7.1) is a stunning and unique representation for the period of the female nude by a woman artist. The body is stark and plain. The intense blue of the bed cover enhances her pale skin. Her head rests on a pillow, face up and eyes closed. There is no interaction with the viewer. Female nudes were usually painted by male artists for male patrons. Comparisons to these representations during this era, the Baroque, would highlight the

novel way in which a woman artist depicts the female body. An element that would become apparent is a different sense of identity and sensuality.

The striking innovation of Gentileschi's work would become even more evident when compared to later works. Specifically, juxtaposing Gentileschi's work to Manet's *Olympia* (1863; discussed in Chapter 3) would reveal some similarities in the representation of the body: the strong and startling presence, reinforced by the flat, pale, and outlined form, rejects facile sensuality and objectification. The selection of *Olympia* is not without significance. This nineteenth-century work critiques the seductive depiction of the nude in Western art. The comparison underlines that more than two centuries earlier Gentileschi, a woman artist, had questioned the norms of representation of the female nude. Other comparisons may consider modern women artists such as the German Paula Modersohn-Becker (1876–1907), the French Suzanne Valadon (1865–1938), and the American Alice Neel (1900–1984), who have represented a nude female, often themselves. Neel's powerful self-representation, unclothed, at the age of 80, would make a very interesting comparison with Gentileschi's work. It would further expose the way women represented their bodies and reflect on their identities and in various historical and cultural eras.

Even well-known works such as *Mona Lisa* (1503–1505), a painting that has mesmerized scores of audiences, may reveal new elements in comparative analysis. When juxtaposed with portraits of women from previous decades, Leonardo's work appears unusual for several reasons. The artist has eliminated the fancy jewelry, elaborate clothes, and complicated hairstyle predominant in most Italian Renaissance portraits of women. He has also freed the sitter from the spatial constraints visible in these works. The unexpected piercing gaze exchanged with scores of viewers and the quiet sense of control define the sitter as an individual. This is unusual for a Renaissance portrait of a woman and, one could argue, much more intriguing than her fascinating smile. A comparison with other portraits of women and self-portraits by the few female artists of the period, such as the later Sofonisba Anguissola, discussed in Chapter 1, may further help us to look at this famous work from a new perspective. (See also the discussion in Chapter 9.) Another criterion could focus on *Mona Lisa's* modern fame. The comparisons could include works by Marcel Duchamp and Andy Warhol, and scores of images from popular culture that have used this famous painting.

Comparisons are, along with many other sources, valuable tools in establishing the time period, style, and even authorship for works of art with scarce or no documentation. As evident in the examples above, visual elements are essential in comparisons but additional resources, discussed in this and the previous chapter, are equally relevant to this process.

Cross-Chronological and Cross-Cultural Comparisons

Comparisons have been widely used in art history, particularly in outlining the differences between various styles and artistic eras. They tend to be limited to

the same cultures, erroneously suggesting that art develops in a linear and isolated manner. There are some exceptions: the comparison of Japanese prints to Impressionist and Post-Impressionist art and the comparisons of African masks and sculptures to early twentieth-century art, Cubism and German Expressionism in particular. These juxtapositions, however, have been mainly concerned with outlining visual elements and reinforcing differences between artistic traditions.

Contemporary global awareness requires new and broader cross-cultural evaluations. The Renaissance, the Baroque, and Impressionism could be more extensively compared to developments in other continents. What was considered art in Asia when the Sistine Chapel was made? What was the influence of the Baroque in the Americas? These broader, cross-cultural comparative approaches would introduce new perspectives, give a more rounded understanding of various artistic traditions, reveal unknown and neglected influences, and expand the definition of art.

For example, Cole's painting could also be compared to the representation of the landscape in other continents and cultures. These comparisons could include art from the past, such as Egyptian and Etruscan tomb paintings that represent nature. They could also focus on nineteenth-century landscape as represented in Japanese prints. This comparison would be particularly interesting, as these prints had significant influence on later nineteenth-century Western art. Another comparison could include *Serpent Mound*, an ancient Native American monument in Ohio, intimately connected to nature. (See "Environment" in Chapter 2.) These comparisons would highlight the diverse significance, meaning, and representation of the subject in different cultures and artistic environments. There are many more possibilities. Can you think of some?

Art materials, techniques, and tools could also be valuable criteria in these cross-cultural comparisons. They would reveal the idiosyncrasies of different artistic practices and traditions, and by positioning art within a global cultural environment, enrich the appreciation of art.

Visual Culture and Interdisciplinary Comparisons

Since the late 1990s images from other disciplines, popular culture, and everyday life have been more often included in visual analysis. Some of these comparisons are necessary because artists have used these sources in their work. Others aim to understand how art is affected by visual culture. Connecting masterpieces to popular and utilitarian objects is offensive to some viewers and art specialists. As disturbing as this link may be to some experts, many viewers first encounter the work of Michelangelo and Monet on a tote or mug, not on a museum or gallery wall. These comparisons recognize the rapidly changing artistic and visual context of the twenty-first century.

Interdisciplinary comparisons are still relatively rare. They are, however, very valuable because they reveal the dialogues art establishes with broader issues in culture and society. These comparisons are essential when other fields contribute

to the works of art. For example, Thomas Cole's work could also be compared to scientific views and various maps and supplemented by economic data, industrial development, and sociological studies. Information about population shift from rural areas to the city, and tools and machinery used to "tame" nature may also be relevant.

Other factors such as fashion, fabric, decorative objects, and furniture can add valuable information about the significance of a particular subject and reveal valuable ties between art and the context of the period.

Summary

A comprehensive art analysis comprises many other visual and textual resources. Online access to archives and libraries has facilitated art research and offered unprecedented opportunities for both specialists and viewers.

The basic information used to identify Gentileschi's work – name, title, date, period, and location – reveals a fundamental order that facilitates and supports art analysis. Art is organized in various categories. These arrangements play a crucial role in accessing art. They also influence how art is defined, viewed, and appreciated. The roots and criteria of art classifications are discussed in the next chapter.

> What specific analytical tools have you discovered in this chapter? Which seem to be more relevant to you? Why? How would you use these tools and information to understand art in the future?

Notes

1. Van Gogh, Letter to Theo, September 3, 1882, in Harrison et al., *Art in Theory, 1815–1900*, p. 945.
2. Rembrandt van Rijn, Letter to Constantijn Huygens, January 12, 1639, in Harrison et al., *Art in Theory, 1648–1815*, p. 251.
3. Artemisia Gentileschi, letter to Don Antonio Ruffo, January 30, 1649, in Slatkin, *Voices of Women Artists*, p. 8.
4. Mary Cassatt, letter to Harrison Morris, March 14, 1904, in Slatkin, *Voices of Women Artists*, p. 141.
5. Georgia O'Keeffe, letter to James Johnson Sweeney, June 11, 1945, quoted in Slatkin, *Voices of Women Artists*, p. 231.
6. Marcel Duchamp, "Painting . . . at the service of the mind" (1946), in Chipp, *Theories*, p. 394.
7. Eva Hesse, interview with Cindy Nemser, in Harrison and Wood (eds.), *Art in Theory, 1900–2000*, p. 902.
8. Keith Haring, "Untitled Statement" (1984), in Stiles and Selz, *Theories and Documents*, pp. 369–70.

8

A Critical Examination of Art Classification

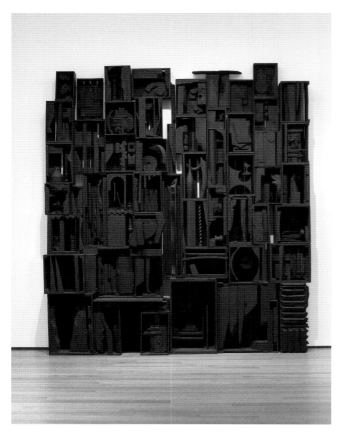

8.1. Louise Nevelson, *Sky Cathedral*, 1958. Assemblage, wood construction painted black, 11 ft 3½ in. × 10 ft ¼ in. × 18 in. Museum of Modern Art, New York. *Photo:* Digital Image © The Museum of Modern Art/Licensed by SCALA/Art Resource, New York.

Sky Cathedral (1958; Figure 8.1) is a work of art that may surprise viewers on close examination. Louise Nevelson (1899–1988) uses mostly remnants from furniture, architectural designs, house lumber, and everyday objects. Is it a sculpture? What category does it fit into? The need to label art and place it in specific "boxes" is an important component of the analytical process for both experts and the general public. *Sky Cathedral* is considered an *assemblage*, a term used to identify works of art that comprise various parts and diverse materials, including ordinary objects. *Assemblage* is part of a comprehensive system of art classification. This chapter considers first the roots of this organizational structure and its relationship to art history and art appreciation. The second part of the chapter is an overview of various art categories. This summary explains the specificity of each group, but it is not intended as a set of rigid definitions.

Reflections on Art Classification

Identifying the Category of "Art"

Contemporary culture has been actively engaged in examining, understanding, and

recognizing art created in various cultures, traditions, and times. Art has become an increasingly complicated and diverse concept. It can be a functional object, an ephemeral manifestation, a decorative work, a philosophical statement, and even an everyday item. Art can be realistic, stylized, abstract, and decorative. The array of materials used and multiple forms it embodies are as vast as the artists' imaginations. Art can be a painting, vase, sculpture, textile, video, or a chair.

> What is more important: technical skills, creative processes, subject matter, or personal statements?

How can art be recognized? What are its essential characteristics? Is it beauty, ideas, or craft? Are there some general guidelines to help facilitate the identification of art objects? How do experts distinguish greatness in art?

> " I am for an art that grows up not knowing it is art at all, an art given the chance of having a starting point of zero. "
>
> **Claes Oldenburg**[1]

In museums and galleries art is highlighted and isolated from its surroundings with directions, labels, frames, pedestals, lights, and other devices. Would the same artworks be identified and equally praised if they were exhibited without institutional validation? If, to use a hypothetical example, *Mona Lisa* were displayed without protective glass, security, or restrictive barriers in the produce section of a market, would shoppers stop and look at it? How many would be able to recognize the original? Stories that make headline news further complicate this issue. "Bought at a garage sale for $3, it was later discovered to be a valuable work of art sold at auction for $1 million." A recent documentary about a painting bought for a few dollars, authenticated and appraised by some as a Pollock worth several millions, is a case in point. How is it possible to discern artistic merit and potential financial value in objects that have not been labeled as art?

Viewers use some general principles to identify and value art. (The list below does not reflect order of priority).

1. Art is perceived to be an object without significant functional purposes, created mainly to be admired. The term art is almost synonymous with painting. Next to painting, sculpture has been perceived as a major form of artistic expression.

2. Artists' involvement in the creative process, their skills and craft are also criteria used to separate art from other ordinary objects. This is easily proven by the answer to this question: Which would be immediately recognized as art: a carefully executed realistic painting or a work made of discarded objects? The immediate answer is: the painting. Few would consider art an object found rather than created by an artist.

3. The medium, closely related to the issues above, also plays a significant role in distinguishing art from other manifestations. Durable materials are perceived as signs of artistic value. Objects made of cardboard, plastic, fur, cork, and so on, are less likely to be accepted right away as works of art. To illustrate this point, imagine two similar figures: one made of bronze, the other of chocolate. Which of the two is more likely to be recognized as art?

4. Themes and subject matter may also help distinguish art from other manifestations. Art is usually expected to deal with serious, important, and enduring themes and issues. Superficial and offensive subjects may raise questions and doubts about a work being called art.

Do you agree with these guidelines? What criteria do you use?

Most of these principles have been challenged by modern and contemporary art. The Conceptual Art movement, for example, as its name suggests, valued concept over object. The artworks include statements, texts, and documentation. Visual aspects were a pretext for igniting a thinking process. For example, *One and Three Chairs* (1965), by Joseph Kosuth (b. 1945), includes a real chair, a photograph of a chair, and the definition of the word "chair." The mix and match of objects, images and text, is, however, not about chairs. Rather it reflects upon reality, representation, and ideas. But the absence of a clear link to existing artistic norms distresses viewers.

As disturbing as it may be to look at texts rather than images, ideas have been at the core of much-admired realistic art from the past. These profound conceptual aspects are overshadowed by the seductive appeal of the quality of illusion. The comfort of seeing familiar objects may reduce art appreciation to passive and superficial experiences limited literally to the surface of the work. To grasp what is going on beyond this superficial layer requires looking at art and thinking about it with an open mind. For example, one could draw some interesting parallels between Kosuth's work and the intricate mixture of annotations and sketches in Leonardo da Vinci's manuscripts.

Artists who have incorporated nature into their art have also challenged these norms. Christo (b. 1935) and Jeanne-Claude's (1935–2009) project, *The Gates* (1979–2005), is an example. This gigantic outdoor installation in New York City's Central Park (2005) closely intertwined nature, technology, and creativity with audience participation. The uncontrollable weather changes produced stunning visual moments. *The Gates* shifts the notion of art from a passively admired work displayed on a wall to an engaging personal experience of intense emotional proportions. The disappointment over its short "life," concerns about cost, and merit of its innovative format continue to polarize audience's opinions about this and other similar projects.

Contemporary innovative artistic models no longer fit many of the criteria discussed above. How does anyone know it is art? What are the new standards? What should art be: an object, an idea, or an experience? For some, art is a purely visual experience. Others look for a thought, while a few believe it has to be an interactive event. *What is more important for you when looking at art: visual appearance or theoretical implications? Or both?*

Understanding past and present art in today's diverse global environment is not easy. Art is defined within specific cultural and chronological circumstances. This process involves a wide range of individuals, institutions, contextual situations, rules, guidelines, and categories. There is both objectivity and subjectivity in assigning artistic values. Even though art ages, it remains visually, generally, the same. Artistic standards, however, change. A work of art dismissed in the past may be perceived valuable in later decades, and vice versa. How would the audience learn about new values?

The Roots of Art Classification

Art classification establishes an order, which partially resolves some of the dilemmas discussed above. This arrangement has created a system of artistic values that has shaped the public's appreciation of art. Since the late eighteenth century, art history has played a significant role in creating disciplinary rules and guidelines, most of which have been disseminated through educational forums and art institutions. Even though writings about art go back to ancient times, the discipline of art history was founded less than three centuries ago. Its identity and characteristics are rooted in and connected to the specificity of the particular period. Classicism was one of these. The German archeologist Johann Joachim Winckelmann (1717–1768), a key figure in the emergence of art history, believed that classical tradition was superior to modern artistic ideas.

Concerns with scientific methods and classification, typical for the Enlightenment, have also left an imprint on this emerging field. The creation of rigid categories as core analytical tools has been one of the immediate results. Their role is still evident today in the basic introduction of an artwork. "This is a painting, an oil on panel, created in the fifteenth-century Italian Renaissance, specifically 1465, by this Florentine artist." Artist, date, artistic period, title, and medium are the common data required in art history, from lower-division courses to scholarly works. These facts usually precede any information or description.

A systematic organizational structure in any field involves both inclusions and exclusions. Art classification was developed within Western norms and reflected the values of this tradition. This view favored paintings and sculptures, recognizable authorship, and provable chronology. Western art was perceived, until recently, to be the standard of high artistic achievement. Consequently, art outside this geographical and cultural boundary was perceived inferior, and even pejoratively labeled "primitive," "barbaric," or "savage."

Neither a rigorous system of classification nor a scientific approach can resolve all the subtleties and particularities of art and its history. What category best fits a work? What criteria should be used? In recent years Postmodernism has exposed limitations and inconsistencies in art classification. These issues have been addressed in many recent critical texts. Revisions of past practices have contributed to understanding the formation of artistic values, and have also contributed to erasing differences between previously segregated and marginalized categories.

Modern and contemporary artists, aware of the confines categories create, have purposely produced art that is difficult to classify. Mixed media, hybrid forms, and ambiguous techniques are not easy to fit into traditional categories. Some artists, like Robert Rauschenberg, have even come up with their own term or category: combine. His 1955 work *Bed* is a good example. Made of real bedding and covered with painterly brushstrokes, which complement and enhance the colors of a quilt, this work is a combination of found object and traditional painting. The vertical display of this work on a wall, like a painting, distinct from the expected horizontal placement of a bed, adds to its ambiguity. The colors and patterns of the bedcover connect with the paint and create a unity that makes this work even more intriguing.

While critical debates about categories go on, classifications remain an important tool that facilitates the analysis and understanding of art. These organized arrangements support art-historical research and help viewers understand art. Few artists, however, are concerned with the specific category their works might fit into. The assessment below includes the definition, criteria, and applications of the most significant art categories. The analysis avoids firm definitions. The discussion aims to expose specificity of art classification and empower readers to examine art without being mainly concerned with identifying its category.

Criteria for Art Classification

A system of classification is an important tool for organizing information and making it accessible. Imagine a telephone book or database arranged in no particular order. On the other hand, you can find something under an unexpected heading. Categories are like "boxes." The formation of these "art boxes" requires decisions about how they should be defined and what should be included.

Classifications appear to have an objective approach, but they have in fact, many subjective components. Various specialists, including art historians, critics, and artists, determine the definition and content of categories. Their views and decisions are influenced by knowledge, values, and taste. To remain valuable tools for art analysis, categories need to be adjusted as changes in art and culture occur. This is not specific solely to art. Many fields, including science, reexamine and update their classification systems.

Chronology, artistic periods, geography, and media are the most commonly used criteria in art categories. Each entry below includes a brief overview, presented as a starting point for reflection and discussion.

Chronology and Artistic Periods

Chronology is a seminal tool for analyzing art. Books, museums, and education follow historical patterns. The inclusion of timelines, whenever possible, underlines the value of examining art as a developmental process. Even though

chronology is an objective criterion, its usage has cultural biases. Time is often perceived through a Western perspective. The precise date of a work of art is of utmost importance in Western art; it seems to be much less relevant for other cultures. Some works are even reproduced without a date. These distinctions have marginalized art from cultures lacking abundant historical documentation.

Chronology alone, however, is rarely used. Geography is also a significant criterion, often linked to another major component of art-historical analyses: artistic period. This term defines developments within a certain time frame that share stylistic, conceptual, and cultural characteristics and are specific to particular countries or geographical areas. The Renaissance is an artistic era. Past artistic periods lasted for over a century. Modern developments such as Impressionism and Cubism, which are called "movements," encompass only a few years and are connected to a group of artists. The term emphasizes the rapid changes of the period.

The transitions from one period to another are subtle and therefore open to debate. The Baroque is specific to the seventeenth century, but many art historians argue that it ends in the eighteenth century. There are only a few instances when specific dates or events mark the beginning or end of an artistic period. Most of the time these dates are based on a series of historical and cultural developments, which may contribute to changes in style.

The names of many artistic periods have been coined by historians and critics, sometimes centuries later. The term "Renaissance," a French word that means rebirth, was introduced in the nineteenth century. Impressionism, Fauvism, and Cubism were initially derogatory labels used by art critics of the period to ridicule these innovative directions. "Gothic" also had negative connotation when it was first used in the Renaissance. The term aimed to devalue the medieval style by linking it to the Goths, a tribe that invaded the late Roman Empire in the fifth century. There was no connection between this medieval art and the much earlier historical event.

Within artistic periods subcategories are used to identify particular developments and facilitate their study. The Renaissance refers to the art created in many Western European countries during the fifteenth and sixteenth centuries. This period can be narrowed down to specific geographical areas: Northern Europe and Italy. Furthermore it can be split based on chronology, the fifteenth century, the Early Renaissance, and the later, sixteenth century, High Renaissance. The Early Renaissance in Italy can also be subdivided into geographical regions of Italy, such as Renaissance in Florence, Mantua, and Milan. It can also be separated in the first half and second half of the century. The subcategory of art in Florence in the first half of the fifteenth century can be further narrowed down by medium: painting in Florence in the first half of the fifteenth century. Subcategories are developed when there is a large amount of art and a great interest in studying it.

Historical and period classifications used in most introductory art-history classes have a clearly defined yet artificial geographical pattern. Recent awareness of artistic traditions outside the Western world has been responsible for important

additions of art from other continents. General art-history texts continue to privilege the moments in which art takes a substantial turn in a new direction, leaving an abundant amount of art for the specialists. Looking at landmarks is an extremely valuable experience, but learning only from masterpieces makes it harder to understand art's subtleties and curtails the ability to look at new works with an open eye and mind.

Media

Media are also widely used as criteria in art classification. Their purpose is twofold. They differentiate between "fine" or "high" and "minor" art. The distinction identifies certain artworks to be of higher artistic significance than others. Media also establish categories based on the materials used. Some media are included in the category of fine arts; others in that of minor arts. Paintings, sculptures, and drawings are fine arts. Tapestries, ceramics, and jewelry are in the minor arts group. Cultural and artistic values as well as personal taste and judgment, all with significant subjective connotations, are at the core of these divisions. These categories, "fine," "high," and "minor," have the greatest impact on how art is viewed and valued. Graphic arts and architecture have functional and commercial purposes, but also many links to the fine arts. Categories such as "self-taught," "folk," and "naïve" include art and artists disconnected from established artistic norms and validated art institutions. "Low art," "popular and visual culture," and "vernacular art" are categories that identify connections to popular taste and daily life. (See Diagrams 1 and 6–8 in Appendix 4 for more information about media.)

Technique is just a means of arriving at a statement.

Jackson Pollock[2]

Fine Art/High Art

The most important and influential classification in art has been the division between fine, or high, art on the one hand and minor, or decorative art on the other. The terminology clearly states the superiority of one over the other. The criteria used for these categories are ambiguous. Media are one of them. Painting is in the fine arts category. Many paintings are oil on canvas. However, a painting on an unstretched piece of fabric used as a banner may be placed in the minor arts category. Sculptures are also fine art. Some sculptures, depending on material and size, may be included in the decorative category. How are these decisions made?

The terms "fine" and "high" designate a superior level of artistic and intellectual or conceptual achievement. A similar, but rarely used term is "plastic art." (Plastic/

plasticity signifies the manipulation, the modeling, of forms.) This category, perceived to be of the highest value, includes mainly works of art with no utilitarian purpose such as painting, drawings, prints, and sculptures; more recently, photography; and a variety of contemporary mixed media. "Fine art" is perceived to have values and meanings that can be appreciated by diverse audiences. It takes a lot of time to conceive, to plan, and to make, and engages artists creatively, intellectually, and physically. These works are to be admired passively and from a distance.

The visual, conceptual, and emotional content of fine art provokes an experience distinct from daily life. Fine art is something "special." The differences between fine and minor arts are determined by knowledge, taste, and values. None of them are absolute standards. A lot of art from the past included by modern specialists in this category was created before the concept of fine arts, or even art, existed. Furthermore, the initial purpose and function of the art may be completely different from today's fine arts standards.

Art institutions have supported and validated the "high" and "fine" categories. Museums of fine arts are perceived to have more valuable collections than decorative arts institutions. The specific qualities of what makes art "fine" and "high" are not overtly disclosed and thus difficult for the public to ascertain. Just as the term "artist" implied until recently a Western male artist, and works by women or from other cultures needed to be identified as such, fine and high art have been perceived as synonymous with the term art. Other artistic manifestations that do not fall into this category are identified with a preceding attribute: "decorative," "minor," "outsider," or "graphic." Until a few decades ago, Western fine art was the essence of art history. The inclusion and discussions of other art have been rare and prompted by necessity.

The "fine arts" categories discussed below have significant subtleties not addressed in this introductory text. (Definitions of the various media can be also found in Diagrams 6–8 in Appendix 4, and on the website.)

How would *you* define fine arts?

Painting, Drawings, Prints, and Sculptures

Painting, drawings, prints, and sculptures form the core of the fine arts category. Their artistic values are measured, defined, and validated by specialists and institutions. Authorship, originality, and authenticity (see the discussion in Chapter 1) are the main criteria for this category. But not all fine art is the same. There are hierarchic distinctions even within this group. "Genius," "master," and "masterpiece" are terms used only for some artists and works of art. The subjectivity of this classification is best visible in the term "little Dutch masters." This label was used until a few decades ago to distinguish, in an obviously derogatory manner, several seventeenth-century painters including Johannes Vermeer (1632–1675), from the "big" masters, such as Rembrandt. This terminology is no longer used, underlining that categories are revised and changed.

8.2. Alfred Stieglitz, *Flatiron Building*, 1902, printed 1903. Metropolitan Museum of Art, New York, 58.577.37. Image copyright © The Metropolitan Museum of Art/Art Resource, New York; © 2011 Georgia O'Keeffe Museum / Artists Rights Society (ARS), New York

Paintings and sculptures are perceived to be more valuable than prints and drawings. This is due in part to the fact that they are usually completed works, made of durable materials and widely exhibited. Drawings have often been a preparatory step for other works. The fragility of the materials, paper in particular, limits their public display. Prints, on the other hand, are not unique, "one-of-a-kind" works.

How many drawings or prints do you know? Is there a famous drawing or print in the history of art, something comparable to *Mona Lisa* or *David*?

How would you define fine arts?

Photography

Photography has only recently been added to the fine arts category due in part to its extensive use in contemporary art. The works created by scores of artists around the globe confirmed the effective visual power of photographs. However, connections with popular culture and everyday life continue to raise suspicions about the status of photography as fine art. (See also "Materials, Tools, and Technology" in Chapter 2.) Furthermore, the identity of the medium, multiple identical images and no clear original, makes it difficult for some to accept photography at parity with painting and sculpture. Photographers have strived to acknowledge the unique interpretative elements of the medium and its seminal role in modern art and culture. The American Alfred Stieglitz was one of them. He initially valued pictorial qualities, as visible in his *Flatiron Building* (1902; Figure 8.2), but later aligned photography more closely with modern forms of representation. His views on art and photography were made visible also in the exhibitions he organized at the New York gallery known as *291* and his work as editor of the journal *Camera Work* (1902–1917).

Mixed Media

Modern artists have intentionally broken away from the rigid definitions and barriers imposed by the "fine art" category and other art classifications. Mixed

media, as the term suggests, is a hybrid form resulting from juxtaposing different techniques and materials. The term includes a variety of possibilities, both two-dimensional (collages, photomontages) and three-dimensional (installations, assemblages). Cubism is credited with introducing mixed media to twentieth-century art. (See also "The 'Purity' of Materials and Mixed Media" in Chapter 2.) Many modern and contemporary artists have widely and very creatively used mixed media in their works.

Assemblage is three-dimensional mixed media, which may include components not created by artists. These so-called "found objects" may be in their full form, or just fragments. Assemblage has been widely used by modern artists to separate their art from traditional sculpture. *Sky Cathedral* (1958; Figure 8.1) by Louise Nevelson is an assemblage made mostly from discarded remnants of furniture. The fragmented wood the artist uses is a metaphor. It suggests, on the one hand, the marginalization of women and on the other their resourcefulness under adverse circumstances.

Installation defines a three-dimensional work that occupies a significant amount of space. Installations are often site-specific, meaning they are created for a particular space and for a limited time. Their impermanency, and the impossibility of being identically re-created, make dating these works more complicated. The ambiguous chronology and fluid format could also be perceived as an artist's rebellion against rigid art categories. Installations are not new artistic forms. They are rooted in diverse historical and cultural contexts. *An Ofrenda for Dolores del Río* (1984; Color Plate 14), an installation by the contemporary American artist Amalia Mesa-Bains (b. 1943), confirms this. This work (dedicated to the Mexican actress famous in the 1940s) is visibly related to altars and offerings. The references to popular-culture memorabilia and private-shrine formats included in this work expose issues of identity and cultural values.

Assemblages and installations have been widely used in other cultures as well as in Western decorative art and crafts.

What do you think about installations as art?

New Media

New media is a convenient "one-size-fits-all" term. It designates, as the word suggests, art created with new means and materials. There is much disagreement among specialists about what should be included in this category, proving once again the subjectivity of art classification. Some consider new media a term that refers solely to art created with digital and electronic technology. Others also include performances, environmental art, earthworks, and process art. New-media art is incompatible with many existing artistic standards, practices, norms, and values. Below is an overview of some subcategories included in new media.

Earthworks, environmental art, and process art are part of the new media category. This art focuses on nature and uses its impermanency as a significant visual and conceptual element. Even though these works seem to reject technology, it is a necessary component in making some of these large projects. In addition to Christo and Jeanne-Claude and De Maria (b. 1935), discussed earlier, the American artist Robert Smithson was also interested in creating art with and within nature. *Spiral Jetty* (1970) is one of his best-known works. The artist knew that eventually the lake would cover his work. It was part of the process and, over time, the work was submerged. Recently, an extensive drought created a remarkable change. The work reemerged from the lake. The natural development produced an astonishing site and confirmed the transitory attributes of this art. In these works time is the main vehicle for visual change, creating a different kind of time-based art.

Performance art is often included in new media. Performances have been central to many cultures outside the Western tradition. They were introduced into Western art in the twentieth century and continue to be used by contemporary artists. (See also "The Body as Art Material" in Chapter 2.)

Time-based art is a term used to define video and other electronic projects that can vary in duration from a few seconds to several hours. These works are rarely seen by the public in their entirety and thus may be easily misunderstood or dismissed. The print reproductions are limited and incomplete views. Looking at a still image from even a five-minute video provides as much information as a square-inch detail from a five-foot painting. Web-based projects require viewers to use sophisticated technology and learn to navigate complicated sites. These factors make many interesting projects simply inaccessible to the public. The lack of tangibility, continuous change, and instantaneous experience require new ways of viewing, examining, and analyzing this art. Some of the artists who have created innovative time-based art include Bill Viola (b. 1951), Francis Alÿs (b. 1959), and Douglas Gordon (b. 1966).

Multimedia

Multimedia, as the word suggests, is an umbrella term defining works that make use of several media. This category includes, but it is not limited to, digital and electronic art. An example of multimedia is Tony Oursler's (b. 1957) recent project *Studio: Seven Months of My Aesthetic Education, (Plus Some) NYC Version* (2005), exhibited the same year at the Metropolitan Museum of Art, New York. His works combine video, installations, found objects, sound, and other media. This project was inspired by and referenced Gustave Courbet's (1819–1877) painting *The Artist's Studio: A real allegory of a seven year phase in my artistic and moral life* (1855). Some multimedia works are comparable to elaborate performing arts shows requiring a huge amount of preparation, large budgets, and generous spaces. These factors limit the number of multimedia projects produced. The diverse materials, techniques, and formats needed intentionally reject classification as a method of defining art.

" What in the end makes the difference between a Brillo box and a work of art consisting of a Brillo box is a certain theory of art. "

Arthur Danto[3]

Graphic Arts

The graphic arts are an eclectic and ambiguous category. Printmaking is considered "fine art." Famous artists such as Rembrandt and Picasso created memorable prints. However, the production of identical images has diminished the artistic and financial worth of printmaking. Graphic and web design are more difficult to classify. They are connected to minor arts and new media, but they also have commercial and practical applications, which have often overshadowed their artistic merit.

The divisions between graphic arts and painting have been blurred in the modern era. The influence of Japanese prints and other artistic styles outside the West played a significant role in this change. This is evident in the art of the French artist Toulouse-Lautrec, known for his posters for the Moulin Rouge, a famous Parisian cabaret. Other modern artists have integrated graphic design in their works by including texts, advertisements, and other elements.

Contemporary culture has brought graphic arts to the forefront of artistic developments. From billboards to product packaging and from advertisements to DVD covers, today's communication is effectively achieved through graphic design. Audiences are more familiar and comfortable with these images than with art, which has prompted specialists and institutions to take notice. In recent years graphic arts have been shown more often in galleries and museums. The exhibition *Masters of American Comics* (2005), organized and held simultaneously at two Los Angeles locations, the Museum of Contemporary Art and the Hammer Museum, was an important validation of artistic manifestations outside the "fine arts." The popularity of the Japanese "superflat movement" founded by Takashi Murakami, inspired by graphic art, animation, and pop culture, has further erased differences between categories.

There is still a long way to go, however, before graphic and web design or animation will be perceived artistically equal to paintings and sculptures.

What do *you* think about this category? What is your opinion about graphic design?

"Minor Arts"

The minor arts category is perceived to have different concerns than the fine arts. Minor arts are focused on decoration, execution, and craftsmanship. Conceptual elements are perceived to be less relevant to these works. Many of them have

functional purposes. Decorative arts, crafts, and applied arts are considered minor arts. Most viewers are familiar with the art included in these categories: ceramics, glass, furniture, and other objects. The Western bias is particularly visible in this classification. Art from other cultures, such as Japanese ceramics, may be placed in this category, even though it is considered "high" and "fine" art in its own tradition.

Decorative Arts

Decorative arts define works made for adornment. Unlike fine arts, decorative arts are usually less concerned with ideas. They are mostly created as an embellishment of various objects. However, the materials used, extent of ornamentation, and even size of some decorative arts can have symbolic meanings.

Decorative arts include furniture, fabrics, costumes, and vases. There are many works that demonstrate the high artistic achievements of this category. Japanese screens are among many other works reflective of the exquisite qualities of decorative arts. The nineteenth-century Art Nouveau and twentieth-century Art Deco movements, as well as individual artists, have highlighted the ambiguous distinctions between fine and decorative arts. The paintings of the artist Tamara de Lempicka (1898–1980), connected to Art Deco, confirm the difficulty and subjectivity of these categories. What category should they be in: fine or decorative art? When does a painting or sculpture become a decorative work? When do tables and chairs become fine art?

Crafts

Crafts is a category that designates works where skills may be more relevant than artistic value. The terminology used segregates the practices and individuals involved in crafts from the fine arts. The individuals who make crafts are called artisans and craftsmen. The fact that they "make" rather than "create" diminishes the intellectual value of their art. Manual labor, not creativity, is perceived to be at the core of crafts.

In the modern period, due to mass production and industrialization, crafts have been in an ambiguous position of having nostalgic ties with the past and benefiting from technological developments. Many contemporary artists have purposely created art that is hard to classify because of the blurred distinctions between minor and fine arts. In what category should Dale Chihuly's (b. 1941) exquisite glass works be: craft, decorative art, or sculpture? Would this be an issue if they were made of marble or bronze?

Architecture

Architecture is a category which is hard to define. On the one hand it is functional, so it does not fit the "fine arts" criteria. On the other hand, it is concerned with aesthetic and conceptual issues. Furthermore, architecture has diverse dialogues with all art categories: fine and minor arts, as well as popular and visual culture.

Paintings, frescoes, furniture, and tapestries are some of the artworks connected to the interior or exterior of architectural structures. In addition, banners, advertisements, and billboards associate architecture with everyday life.

The analyses of architectural works within the context of sculptures and paintings position them on an equal level with fine arts. Architecture is neither a purely practical nor a neutral form. To fully grasp its meaning, architecture needs to be experienced. As with fine arts, symbolism is an important component of many architectural structures. Size, materials, shapes, and forms can all contribute to both function and meaning. For example, Roman architecture aimed to suggest the unity of the empire in subtle ways by using similar structures, forms, designs, and plans.

The impressive steps and overwhelming classical façades of many museums aim to inspire confidence in the institution. The design of the Museum of Contemporary Art in Los Angeles (1986) and the recent addition of the pyramid to the Louvre in Paris in 1989 reversed conventional access to the museums. Instead of going up, audiences had to enter through the lower level. The initial negative reaction to this change had nothing to do with architectural function or beauty. It was the symbolic meaning that discomfited both the public and specialists.

Changes take a long time to materialize in architecture, for many practical reasons. Cost, functionality, and efficiency are among them. Unlike painters and sculptors, avant-garde architects building cutting-edge structures on their own are rare. Antonio Gaudí's (1852–1926) Sagrada Familia (Holy Family) church in Barcelona, left unfinished since the architect's death in 1926, is a strong reminder of the difficulties architects encounter in developing innovative ideas.

Other Categories

The categories discussed in this section are perceived to be outside the norms validated by art specialists and institutions. The art may have popular appeal, but it does not reach the standards of either fine or minor arts. Lack of formal education and dismissal of the "art world" are some of the other factors that place art in these groups. Because of these and other reasons, including links to popular culture, this category is perceived to be less valuable than the fine and minor arts. Some scholars have embraced these categories. Others have questioned their artistic merit.

"Low" Art and Popular Culture

"Low" art and popular culture were initially used to mean the opposite of the high and fine arts. They defined a wide range of art and visual expressions produced for and disseminated to mass audiences. The qualities of these works were perceived to be inferior. However, the meaning of these terms and their use has changed substantially since the late twentieth century. Pop Art is a case in point. The significant dialogues contemporary artists have established with a variety of aspects of popular culture are confirmed by numerous artworks created during this period.

The increased connections between new media and popular culture have made these categories and terms much more difficult to discern from fine arts.

"Outsider" Art

Art included in this category is created outside institutions and the mainstream of art. This category includes self-taught artists whose works do not follow the rules of the art world. This rejection of established norms discloses similarities between outsider art and the avant-garde. Also included in this category is visionary art. Such works often deal with spiritual and apocalyptical issues. An example of outsider art is James Hampton's (1909–1964) *The Throne of the Third Heaven of the Nations Millennium General Assembly* (*ca.*1950–1964; Figure 8.3). This large installation made of found objects, discovered only after the artist's death, reflects his religious views. Today the sculpture is in the collection of the Smithsonian American Art Museum.

Outsider art also includes art created by inmates in asylums. The term *Art Brut* (French for "raw art") was coined in the mid-twentieth century by the French artist Jean Dubuffet (1901–1985), who was fascinated by the purity of these works. His art became increasingly influenced by emotions unfiltered by cultural norms and values. Loosely used, this term could also define graffiti, children's art, and other creations that elude the mainstream.

What do you think about this category? What would you include in it?

8.3. James Hampton, *The Throne of the Third Heaven of the Nations Millennium General Assembly,* *ca.*1950–64. Gold and silver aluminum foil, colored Kraft paper, and plastic sheets over wood, paperboard, and glass. 180 pieces in overall configuration: 10½ × 27 × 14½ ft. Smithsonian American Art Museum, Washington, DC. *Photo:* Smithsonian American Art Museum, Washington, DC/Art Resource, New York.

Naïve and Folk Art

Naïve and folk art includes self-taught artists, whose works are created mostly for personal enjoyment. Some of the criteria overlap with outsider art. This term is also used to describe works that depict reality but do not have strong realistic qualities. Artists or art included in this category rarely cross over into the fine arts. The French artist Henri Rousseau (1844–1910), also known as *Le Douanier* (French for customs officer) because of his profession, is an exception. Picasso admired his art. His works influenced the Surrealist artists. Because of these "fine arts" connections Rousseau is included in many art-history texts, confirming the subjectivity of art categories. His paintings, such as *The Dream* (1910), are visually very appealing because of the intricate fantasy world they depict. The scene is inviting and playful, with subtle and mysterious features that startle viewers.

Folk art has ties to the rural tradition. It often evokes a sense of nostalgia. One such artist, Clementine Hunter (1886–1988), reflects in her works on the life of African Americans in the South. Her visual narrative includes references to family life and social issues, and nature. The defined shapes and subtle balance between intense hues and pastel tones make her work appealing and memorable.

Vernacular Art

This category includes art specific to a region that does not represent the official or prevalent style of the time. It is made by individuals who might have some art training but do not consider themselves artists. This term is often used synonymously with folk or outsider art. In architecture this term identifies structures based on local designs, materials, and systems of building not validated by mainstream architecture. These constructions, built in response to particular environmental or local needs, develop unique and specific systems of building. Igloos and Native American adobe structures are examples of vernacular architecture. Architectural elements, ornamentations, and other designs related to and part of these structures are also included in this category.

Visual and Material Culture

Recently, art-historical and cultural studies have included in their field of inquiry a wide range of visual components, such as advertisements, films, television, and magazines. These forms coexist, compete and, some argue, contribute to a comprehensive and meaningful appreciation of art. Material culture is a term that defines and includes a variety of objects connected with art and culture. The inclusion of visual and material culture in art analysis has become very trendy in the Postmodern era, but its value has been widely debated. Many art historians have criticized these novel directions and perceive them to negatively impact art and its history.

This category may be an art-historical mixed media, a hybrid form of analysis, which visibly rejects traditional classifications, values, and models.

Summary

Art classification is a valuable tool for organizing the vast material that exists in the world today. There are many different criteria used in this process. They include some objective but also many subjective components. Chronology is the most widely used and most objective of all. Media are other criteria used in art classification. Often categories use more than one criterion to create sub-groups. Art classification facilitates access to information. Even though the value of art categories is not disputed, specialists continue to disagree substantially about their role and the criteria used.

Do art categories affect how you look at and value art?

How does art classification compare with systematic organization of knowledge in other fields or your major? How would you organize art?

Notes

1. Claes Oldenburg, "Documents from the Store," in Harrison and Wood (eds), *Art in Theory, 1900–2000*, p. 744.
2. Jackson Pollock, Interview with William Wright, in Harrison and Wood (eds), *Art in Theory, 1900–2000*, p. 586.
3. Arthur Danto, "The Artworld," in Ross, *Art and its Significance*, p. 479.

Conclusion to Part Three

As these chapters have made apparent, there are many resources that support the analysis of art. The work of art is an important starting point that provides indispensable information. Additional visual sources are necessary in the analytic process. Primary and secondary texts are also important. Other information, including provenance, conservation, and art market, adds to a comprehensive understanding of art. Access to visual and textual resources is facilitated by art categories. The system of classification is not only a form of organizing art; it has also affected the way art is valued and perceived.

Specialists, however, are not interested solely in finding information. Their quest is to develop and formulate new interpretations. The interpretation of art is discussed in Part Four, the last in this book. To interpret art requires abundant research material and solid analytical skills, as well as creative and critical looking and thinking. Personal views, cultural factors, and specific methodological directions affect and support art interpretation. Moreover, preconceived ideas, values, and views, contribute to shaping art interpretation. These issues are discussed in the next chapters.

Part Four

Interpreting Art

The purpose of interpretation is to understand the meaning of art. Visual observation, methodical analysis of texts and images, and critical and creative thinking are key to this process. The way art is interpreted changes frequently. Discoveries, novel ideas, and changing tastes can trigger new ways of looking and thinking about art. Even within the same context, specialists may have different interpretations of the same work of art.

Part Four of the book presents criteria, values, and methodologies used in art interpretation. The concern of the following chapters is neither to endorse nor identify an ideal practice. Rather, its purpose is to explain the methods used by specialists and help readers develop their own strategies of looking at and interpreting art. The chapters focus first on preconceived ideas in appreciating art and outline the main characteristics of Modernism and Postmodernism that have influenced contemporary artistic values, norms, and meanings. The discussion in the next chapter presents methodologies used in art interpretations and ends with a case study.

The Art of Understanding Art, First Edition. Irina D. Costache.
© 2012 Blackwell Publishing Ltd. Published 2012 by Blackwell Publishing Ltd.

9

Interpreting Art
Criteria and Values

9.1. Bertrand Lavier, *Giulietta*, 1993. Museum of Modern and Contemporary Art in Strasbourg. *Photo:* Museums of Strasbourg, M. Bertola; © 2011 Artists Rights Society (ARS), New York / ProLitteris, Zürich

"Is this *art*?" is likely to be the first question most viewers would ask when looking at *Giulietta* (1993; Figure 9.1) by the French artist Bertrand Lavier (b. 1949). The work appears to be nothing more than a smashed car, a total loss from both a financial and functional point of view. Why is a damaged car in a museum or art book? What makes it art? What could it possibly mean?

The Art of Understanding Art, First Edition. Irina D. Costache.
© 2012 Blackwell Publishing Ltd. Published 2012 by Blackwell Publishing Ltd.

These questions reveal specific expectations and preconceived ideas about what art is supposed to be. This chapter examines the various criteria used in evaluating art and reflects on the role of Modernism and Postmodernism in these processes. The chapter concludes with an overview of how to begin the process of art interpretation.

Preconceived Ideas about Art

It is impossible even for specialists to immediately understand the full meaning of a work of art. This requires time and information. Because of their knowledge, experts are comfortable in expressing their opinions about art even before they research it. In contrast, the inability to instantly understand a work creates a sense of fear in viewers. In many instances the intentions of the artist become the refuge for appreciating art "correctly."

As discussed in the previous chapters, a significant amount of art admired today was created in past centuries. Its value and meaning is constantly modified. Why is this happening? New visual concerns, ideas, and contexts, among many other factors, contribute to the development of fresh artistic views and prompt scholars to reevaluate the meaning of art. Different perspectives about the same artwork often coexist even in the same time period and culture.

Mona Lisa is a good example. Created over half a millennium ago, this work continues to intrigue both scholars and viewers. There are many interpretations of this painting, including recent ones proposing that it is a self-portrait and others arguing that the sitter's smile might suggest pregnancy or motherhood. In his book *Il soriso di Mona Lisa* ("Mona Lisa's Smile," 2006) Mario Alinei proposes yet another interpretation of this painting. Mona Lisa, the author argues, is a complex metaphor for death. The author acknowledges that his fascination and interest in the painting derive from his memories of his young mother's smile on her deathbed. To demonstrate his point of view and convince the readers of his interpretation, the author rigorously and meticulously examines a wide range of visual elements and textual sources. Some will find his argument interesting, plausible, and convincing. Others will disagree with his view and dismiss this interpretation.

Why it is so difficult to pinpoint the meaning of this and other artworks? What is needed to interpret art? How can viewers form and express their views about art beyond the superficial "I like it" and "I don't like it"?

Visual art, more than music, literature, and film, intimidates spectators. The unexplained, high artistic and financial values of objects protected and revered create an almost sacred realm that deters audiences from expressing their views. Preconceived ideas about art further prevent an open-minded examination. There are plenty of these cherished and firmly held beliefs about artistic values. Most derived from and are based on Western norms. They include:

- Art is expected to be a unique and visually appealing object, with either decorative purposes or an easy-to-understand subject matter.
- Original ideas and images, as long as they are not completely abstract, are essential qualities of art.
- Art should take a long time to make and be the result of the artist's creativity. This process should be impossible, or at least very difficult for the average viewer to duplicate.
- The artist's talent is manifested mostly by the ability to create realistic paintings and sculptures which are perceived to have higher artistic merit than other art.
- The intentions of the artist are essential for understanding art "correctly."
- Good art is made of durable, not perishable materials.
- Older art is more valuable because of its historical significance.
- Preferably, art must provoke a positive, long-lasting, emotional reaction from the viewer.
- Art should be enjoyable, not shocking or offensive.
- Good art is displayed in museums and galleries, not malls or garages.

> What are your preconceived views about art? How do they affect the way you look at and appreciate art?

Based on these criteria, it is not surprising that some of the most popular works of art include *Mona Lisa*, closely followed by Michelangelo's *David* (Figure 10.1). The powerful effect of mimesis (the imitation of reality) has been, and still is for many, the essential criterion for establishing artistic values. The comfort and reassurance of recognizing a face or hand heightened by the illusion of three-dimensional space in *Mona Lisa* and the lifelike representation of *David*, also responsible for the audience's temptation to touch these works, appear to be very important elements in appreciating and understanding art.

These values, part of the artistic conventions brought back from the Classical tradition by the Renaissance, have been relevant in Western art for the last 500 years. The skills of creating the illusion of reality in two- or three-dimensional forms make *Mona Lisa* appear to be not only more appealing but also artistically superior to Picasso's *Les Demoiselles d'Avignon* (1907; Color Plate 16). The modern artist, however, is concerned with *interpreting* rather than *imitating* reality. The immediate reaction to this, and other similar artworks, the familiar *"what is this?,"* confirms that we expect art to replicate reality.

René Magritte's (1898–1967) painting *The Treachery of Images*, better known as *"This is Not a Pipe"* (1929; Figure 9.2), is a strong reminder

9.2. René Magritte, *La Trahison des images (Ceci n'est pas une pipe)* (The Treachery of Images (This is Not a Pipe)), 1929. Oil on canvas, overall 25⅜ × 37 in. (64.45 × 93.98 cm); unframed canvas 23¹¹⁄₁₆ × 31⅞ in., 1½ in. deep, 39⅝ in. diagonal. Los Angeles County Museum of Art, Los Angeles. Digital Image © 2009 Museum Associates/ LACMA / Art Resource, New York; © 2011 C. Herscovici, London / Artists Rights Society (ARS), New York

of these criteria. The immediate response to this painting usually is: "but it *is* a pipe!" Magritte forces viewers to recognize that the pipe is simulated, not the actual item. This is not a pipe: it is a *painting* of a pipe. The playful contradiction between text and image reaffirms that even when art is a convincing illusion it is an interpretation, not a reality. The title further underlines the deceptive component of realistic art. In the end, Leonardo da Vinci's painting is as flat as Picasso's. Even though these artworks were both inspired by reality, they represent the artists' unique visions, which, as this text has shown, are influenced by multiple factors.

The belief that the imitation of reality is a measurement of "good" art derives from Western norms, which, until recently, have been the defining standards. A great deal of art around the world, including many modern and contemporary works, has, however, challenged these views. Audiences, however, continue to search with nostalgia for elements they are familiar and comfortable with and look with skepticism and distrust at works that do not fit these expectations. Art that is not realistic is quickly dismissed. How can art be appreciated and interpreted when it is rejected outright? Its "failure" is usually attributed to an artist's lack of "talent" and "craft." The drawings of numerous artists, including Picasso and Matisse, confirm that the cause for the visual changes in modern art must be elsewhere. What triggered new developments in art?

Modern Art and the Audience

The significant recent changes in art are the result of a number of factors which go back to the late eighteenth and early nineteenth centuries. Substantial scientific, political, and social developments on the one hand and the decreased role of religious, royal, and private patronage on the other, have profoundly affected the creative environment. Lack of stable commissions and employment meant both financial insecurity and the freedom to create with little restraint. In the first half of the nineteenth century, the emergence of photography – a medium able to produce images of reality with unprecedented efficiency and accuracy – further liberated artists' creativity. These, and other developments of the period, were incentives for many artists to search for new visual forms of expression. However, neither the institutions nor the public were eager to embrace new art and continued to value realistic artworks with links to the past.

The Salon des Refusés, an exhibition of works rejected from the influential official Salon of 1863, together with many other cultural and artistic events of the period, marked a turning point in modern art. That year the exhibition's jury did not accept a large number of works of art. To demonstrate the validity of the selection criteria, a decision was reached (supported by the Emperor Napoleon III) to open an alternative space, next to the official one, for the display of the works excluded from the annual exhibition. It was an unprecedented opportunity for the spectators to see what was considered to be "bad" art. The audience

responded with laughter and ridicule to over 2,000 works displayed, including the now famous *Déjeuner sur l'Herbe* (1863), by Édouard Manet (now in the Musée d'Orsay). The subject, a picnic in a park, and the startling juxtaposition of the female nude with fully dressed men, were shocking. Equally disturbing were novel qualities: the influence of photography and Japanese prints (visible in the lack of modeling of the body and clear outlines). The element that puzzled and shocked most viewers was the blunt, direct, and confident gaze of the nude woman in the foreground.

Even though misunderstood by the audience and most critics and discouraged by the reception of their art, artists with innovative ideas were convinced of the value of their views. Avant-garde artists such as Monet, Van Gogh, Matisse, and Picasso, to name only a few, continued to pursue their visual journeys. Their art became increasingly more difficult to understand outside a small circle of colleagues. Puzzled by an art they did not comprehend, audiences continued to favor realistic works. Cubism, Surrealism, Abstract Expressionism, and other avant-garde developments of the last 150 years unfolded independent of public taste and acceptance. Few outside the art world inner circles were either immediately informed or affected by these trends. The term "modern art" acquired negative connotations: it was perceived to be "shocking," "outside the norms," and "difficult to understand." (See also Chapters 1 and 3 and the discussion below on Modernism.)

These developments have profoundly affected the public's knowledge, appreciation, and interpretation of art. Three representations of women by artists from the same country, but from different centuries, confirm this point. Admiration for the nineteenth-century *Portrait of the Comtesse d' Haussonville* (1845; Color Plate 15), by Jean Auguste Dominique Ingres (1780–1867), quickly turns into puzzlement when examining Picasso's *Les Demoiselles d'Avignon* (1907; Color Plate 16). The viewer's response may even change to anger when looking at the self-portraits by the contemporary artist Orlan (Color Plate 17).

Ingres's portrait is meticulously detailed. The elegant pose and soft gaze of the woman and the carefully depicted objects make the painting come alive. Picasso's representation is stylized and simplified. The restrained palette and ambiguous background distance the image from reality. The violent, dark outlines of the bodies and the lack of modeling reinforce the medium and the two-dimensional quality of the canvas. This work, influenced by African masks (see the faces of the two figures on the right), reflects on past art (the nude, still-life, and so on) but projects a novel set of artistic values.

Orlan's self-images take the subject a step further. Her work is literally her body and face, transformed by several instances of plastic surgery. More recently, she added digitally manipulated photographs derived from cross-cultural identities and representations of women. These works, entitled *Self-Hybridizations* (1994–), directly reflect on various ideals in art and cultures around the world and across time. Without replicating specific works, the series refers to African, Native American, and pre-Columbian artistic traditions. The Mayan sculpture (Figure 9.3) has

9.3. Human head, classic Maya Period, *ca.*300–900. Carved stone, covered with wax and painted in cream, yellow, blue, rose, red, and black, classic period Maya. Honduras, Copán Department. Courtesy, National Museum of the American Indian, Smithsonian Institution, Washington, DC. *Photo:* Ernest Amoroso.

What do you think? Which of these works would you prefer, and why? Do you consider realistic works "better"? Why?

clearly defined, yet stylized facial features rigorously framed by the rounded shapes of the headdress and ornaments. In *Refiguration/ Self-Hybridation #17* (1998), Orlan mixes technology with reality and uses the visual characteristics of these sculptures to transform herself into a "pre-Colombian portrait." The suggestions of eroded stone heighten the sense of authenticity and history. The blonde hair, contrasted with the intense purple background (reminiscent of Warhol's *Marilyn Monroe* (1962)), brings this image back into the present. The unusual *hybridizations* surprise the audience and prompt reflections on perceptions of ideals and cultural identity. (See also the discussion about Orlan in "The Body as Art Material" in Chapter 2.)

If viewers were asked to select what they consider the best work, the painting by Ingres will win by a wide margin. The realism of the figure and her surroundings makes the painting easy to understand. Secondly, the ability of the artist to create the lifelike representation enhances the appreciation of the painting. *Les Demoiselles* would likely be second. It is visually too complicated, the bodies are distorted, and the entire image appears disjointed and difficult to understand. Orlan is very likely to provoke discussions, but few would even consider her work "art."

Artistic Values and Art Appreciation

Modern art appears to many viewers as unusual, complicated, and most of all "unrealistic." This is not, however, a new visual approach. Western medieval stained glass, to use only one example, also used distorted forms, exaggerated shapes, and bold colors to express ideas and feelings. Viewers of the time were textually illiterate, but had a high level of visual literacy. They were able to decipher complicated images that visualized spirituality without imitating reality.

Modern Western society has put an emphasis on rationalism and knowledge over sensory experiences and shifted from visual to textual literacy. The definition of an individual based on the motto "I think, (not *I feel*), therefore I am" and scores of scientific norms over the centuries have solidified these characteristics. They have also contributed to enhancing the audience's desire for images that emulate

the logic of the world and diminished the merit of visuality defined outside and independent of this realm.

To a twenty-first-century reader living in a global culture the immense consequences of a show in Paris and the one-sided emphasis on Western developments may seem blown out of all proportion. They are not. As we said earlier, until recently Western art was perceived to have universal values, considered superior to other artistic traditions. Even if modern art rejected Classicism and looked at African and Japanese art, it continued to define itself within Western values isolated from significant cross-cultural exchanges. It is only since the mid-1980s that art has been consistently analyzed in a more inclusive context. These cross-cultural perspectives have exposed novel visual possibilities and rearranged artistic norms and values.

A comprehensive global view is not easily achieved. It requires time before exposure to other artistic traditions can become inherent to art appreciation, but the art world and audiences are rapidly moving in this direction. The confined purpose and taste of the Western academies and the nineteenth-century Paris Salon have been replaced by a growing number of international art exhibitions held in different continents. New venues have facilitated an unprecedented exchange of trends and ideas outside the limitations of galleries and museums. This new context has neither diminished nor discarded the value of Ingres's portrait. Instead, it has revealed that no matter how famous, valuable, or meaningful an artwork might be it represents only one of many visual and conceptual possibilities. And yet, with all the astounding artistic innovation and diversity of the last century, many avant-garde works, including Picasso's *Les Demoiselles d'Avignon* or the abstract paintings by Jackson Pollock, are still perceived by many viewers to be "cutting-edge."

Nothing is at the same time both new born and perfect.

Leon Battista Alberti[1]

What influences the way audiences and experts look at, define, respond to, and interpret art? Two recent developments, Modernism and Postmodernism, have established the essential standards for art appreciation. Modernism includes artistic and cultural movements from the mid-nineteenth century until approximately the 1970s. Postmodernism began in the last decades of the twentieth century. This period witnessed the emergence and expenditure of several fundamental art institutions and practices, including the museum, the art market, art education, and creative freedom. These cultural eras have complicated identities. The discussion below focuses only on some of the general characteristics specific to the developments they comprise. There are many more issues, subtleties, and meanings to Modernism and Postmodernism not addressed in this introductory text.

Modernism

Modernism defines specific cultural and artistic developments (called movements) from about the mid-nineteenth century to the second half of the twentieth century. Issues specific to the identity of modern culture and life, such as technology, simultaneity, fragmentation, speed, and others, were also at the core of Modernist art. The avant-garde is a key concept during this period. Novel ideas and styles prompted the emergence of new artistic movements, which consistently rejected past values, Classicism in particular, as well as prevailing artistic values and norms, and proposed bold new directions that clashed with the status quo. The length of these movements varied, but they were relatively short (a few years, maybe decades) in comparison to earlier artistic eras. Their names – Impressionism, Cubism, Surrealism – usually derive from and reflect their styles and ideas. The succession of these so-called "isms" has a linear, historical progression.

An important element of Modernism is the self-referential nature of the art created. Instead of reflecting "reality," Modernist art and artists searched for an innovative visual vocabulary detached from and independent of reality. The core values established by Modernism, some of which are discussed below, have affected the views of art institutions and consequently the public. They also paved the way for late twentieth-century art. There are many particularities and subtleties not discussed here. Modernism continues to be the topic of intense scrutiny and debate among experts in search for a full understanding of its identity and relationships to Postmodernism.

The entries are listed alphabetically to avoid an implied hierarchy.

The Avant-Garde

The notion of the avant-garde is central to Modernism. This term defines an artist, artistic movement, or particular work. Picasso is an avant-garde artist. His painting *Les Demoiselles d'Avignon* (1907; Color Plate 16) is an avant-garde work. Cubism is an avant-garde movement. The avant-garde rejects the past and tradition and introduces new visual and conceptual expressions that are ahead of their time. Originality is essential to the avant-garde. At the outset, however, few can understand the merit of these unique visions, and thus avant-garde art is initially rejected. With time, art loses its boldness and becomes absorbed by mainstream culture.

Impressionism was an avant-garde movement. Initially this art was rejected because of its novelty. Its shock value dissipated with time and today Impressionism is one of the best known and most liked art movements. Even before the public accepted Impressionism, other avant-garde artists, the Post-Impressionists, proposed new artistic visions. This path continued into the twentieth century. This succession of avant-garde artists and movements emulates the paradigm of progress, an essential ingredient of modern culture.

The notion of the avant-garde is synonymous with "cutting-edge" and, within culture, functions in a very similar way to fashion. New fashion is first presented in showrooms in New York, Paris, Milan, and London. The designs are very bold. After a few months the new trends are sold in high-end boutiques. As they gain wider acceptance they can be found in department stores. When they are sold at discount outlets they are no longer cutting-edge. This process can take a couple of years. Even before new fashions are absorbed by mainstream culture, other innovative designs are introduced. A similar pattern applies to the avant-garde in art. It is an ongoing process. (See also the discussion in "Artists and Creators" in Chapter 1.)

"New and improved" are qualities highly valued in everyday life, but not in art. The novelty of avant-garde works makes the audience uncomfortable. This may explain why the public prefers the nineteenth-century portrait by Ingres to those by twentieth-century artists discussed earlier in this chapter.

The Modernist Artist

The characteristics of Modernist artists include an original vision and style and a rebellious attitude toward tradition. Paradoxically, the central role of originality, authorship, and authenticity connects them to the very past they try to dismiss. Placed on a pedestal by an audience who cannot fully understand their work, Modernist artists are perceived to be on a lonely and heroic mission of personal expression. The intimate connections between artists and their work are very important to Modernism and the public's appreciation of art. Picasso and Pollock's paintings may not be widely liked or understood, but their recognizable styles confirm their direct involvement in the creative process. This uniqueness also enhances the mystery of their art. Self–portraits and photographs of artists at work reaffirm this view. (See also "Self-Reflections" in Chapter 1.)

Modernism and Global Traditions

Until recently Modernism was analyzed from a Western perspective. This cultural isolation has also influenced art appreciation. The distinctions made between Cubist collages and a Native American *kachina* doll (the *kachina* is a spiritual being in Native American religion) derive from the pre-established values attributed to their cultural contexts. Both are mixed-media works. Cubism is considered an innovative avant-garde development. In contrast, the Native American works, some created before Cubism, are perceived as interesting artifacts. These hierarchic values, embedded until recently in culture and reinforced by museums, have substantially influenced the views of the public.

Even though other traditions played an important role in the development of modern art, the visual and conceptual identity of these cultures were of little relevance to the artists who used them. The innovative Cubist style Picasso and Braque developed was indebted partially to African sculptures and masks. These

works, displayed at Musée de l'Homme (Museum of Mankind) in Paris, an ethnological museum, not an art gallery, were valued by many modern Western artists for their formal elements. The religious, social, and cultural significance of African art was, however, not taken into account.

Originality and the Original

The concepts original and originality are key to Modernism. They reinforce the value of the artist as the maker of the work and generator of ideas. The style used by Picasso is distinct from the one visible in Magritte's work. These differences highlight their uniqueness. The same is true for art movements: Impressionism differs from Cubism and Dada from Surrealism. Original and originality emphasize the value of art as an authentic, one-of-a-kind object, not a copy or imitation. Innovative ideas, unique styles, and genuine works continue to be essential to the appreciation of art. Although reproductions are used widely to inform us about art, both experts and the public want to see originals. Museums and galleries clearly value them as well. The institutional endorsement of these concepts has influenced their role in the appreciation of art. (See also the discussion in "Originality, Authorship, Authenticity" in Chapter 1.)

> Would you visit a museum that only displays reproductions?

Does the notion of originality affect your views about art?

System of Values

Modernism has a hierarchical system of values. The distinctions between various artistic traditions and between originals and reproductions discussed above are perfect examples. Modernism continued to give priority to paintings and sculptures over other forms of visual expression. Even if artists have experimented with a variety of media that emerged during this period, traditional formats remained the favorite mode of expression. The primary illustrations of Modernism are paintings by Picasso and Pollock and sculptures by Rodin and Balla, not films by Dali or photographs by Evans, even if these examples are included in discussions. These values and views, supported and endorsed by art institutions, have affected public taste. First and foremost, spectators continue to appreciate paintings and sculptures over photography and other new media.

Binary opposition is the term often used to define Modernism's conceptual platform. This concept acknowledges that values are established by exposing differences between opposites (such as "good" and "bad"). For example: "An original painting is considered more valuable than a reproduction of the same work"; "High art is superior to popular culture." Many viewers would agree with these statements. This confirms that these hierarchic values defined in Modernism have significantly shaped popular views on art.

Have these views affected your appreciation of art?

Postmodernism

The prefix "post" indicates that Postmodernism is the period after Modernism. Critics have debated if it is a reaction against Modernism or its late stage. On the one hand, Postmodernism links itself to idiosyncratic elements that emerge in Modernism but defy its core values, such as Marcel Duchamp's ready-made (a dismissal of original and originality) (See also "Appropriations" in Chapter 1.) At the same time, however, Postmodernism questions and even discards the principles of Modernism. Overall, Postmodernism challenges rigid categories and avoids a clear definition. The broad connections to various fields make it even more difficult to grasp its identity.

Postmodernism refuses to give sole primacy to isolated and innovative developments. Rather it validates and embraces a broad range of views and possibilities that compete, interact, and at times contradict one another. Pluralism and differences are valued and exposed. Linear developments and chronological trajectories are rearranged in novel, multilayered paradigms. The past becomes a vast resource used in a non-sequential manner. Postmodernism "revisits" styles, ideas, and periods, but parody and irony are often the mechanisms of these interpretations. Heterogenic diversity and temporal presences are favored over monolithic unity and stable formations. The identity of Postmodernism may be best explained by comparing it to a web search. The endless hyperlinks open up new possibilities, yet never reach a center or end. Postmodernism, it could be argued, is a vast, open field where everything coexists with no preset hierarchic values.

Even though Postmodernism is heavily indebted to theory, some of its main characteristics – multiculturalism, hybrid identities, diversity, repurposing, and others – have permeated society and are familiar to audiences. A variety of objects, gadgets, and behavioral patterns such as hybrid cars, text messaging, recycling and re-purposing, online social networking, or mixing cuisine or fashion from different eras and cultures, exemplify Postmodernism in today's society.

To highlight some significant differences between these two periods the discussion below addresses the same issues presented in the section on Modernism. The entries are arranged alphabetically.

Multiculturalism

A defining aspect of Postmodernism is multiculturalism. Rather than unilaterally using art from other cultures, as Modernism has done, Postmodernism has overtly accepted diverse artistic traditions. New art and artists have revealed visual possibilities and conceptual approaches, which have significantly broadened the definition of art. Academic institutions, museums, and galleries have been key players in informing the general public about the values of multiculturalism in culture. Exhibitions, lectures, and other programs have exposed art from around the world

How is multiculturalism visible in your community and daily life?

and revealed its incredibly rich diversity. Several examples in this text illustrate the visual and conceptual concerns of multiculturalism.

Originality and the Original
(Imitation / Appropriation / Re-purposing)

In contrast to Modernism, Postmodernism dismisses the value of originality / the original. Rather than being rejected, the past is a vast resource for inspiration. Individual stylistic distinctions are also irrelevant to Postmodernism. In fact borrowing, "recycling," and appropriating ideas, styles, and even entire works is a common though highly criticized practice. (See also "Appropriations" in Chapter 1.) Most spectators do not see any merit in this approach and continue to praise Modernist originality.

Ironically, the public is not troubled by similar practices widely used in contemporary movies (remakes and adaptations from sitcoms, comic books, and so on), music (revival of old songs and styles), fashion, and television (reruns and remakes). Can you think of examples in film, music, or fashion that have "recycled" old ideas, styles, and subjects? Postmodernism's use of the past dismisses the core identity of the avant-garde. Terms such as "transavantgarde" and the "new avant-garde" have sporadically been used to define the artists of this period. Originality has also been questioned by Postmodern theory. However, it remains relatively important to artists, and certainly to institutions and the public, who hold on, at least partially, to Modernist concepts.

The Postmodern Artist

Postmodernism has demystified artists' Modernist image. Unlike their Modernist predecessors, they have included and recognized a broad spectrum of gender and cultural identities. Rather than being outcast and isolated, today's artists are actively engaged in the art world. They organize exhibitions, write about art, and are even involved in marketing their works. Postmodernism has also questioned authorship defined through creativity, style, and craft. Many artists, including some of those discussed in this text, have openly acknowledged the use of assistants. Culture, however, continues to recognize these artists as if they are the sole creators of the work. Not surprisingly these ambivalent values confuse the public, who prefer the certitude of Modernist stylistic uniqueness and personal creativity.

System of Values

Postmodernism has blurred hierarchic differences between categories and values. The dominance of Western art has been replaced by multiculturalism and the superiority of high art has been dissipated by visual and material culture. Postmodern art and culture has an inclusive "everything goes" approach, in clear contrast to the rigid, Modernist binary opposition.

The system of values in Postmodernism is comparable to the flatness of a computer screen. The desktop is a unifying platform where viewers (called "users" in this activity) can do a lot of activities almost simultaneously and with no preset priorities. Everything on the screen has a seemingly equal value. This parity changes when users decide to focus on a particular activity. Emailing may become more relevant and the screen may focus on this activity for a while. Later, banking may be the primary concern and the rest of the desktop would become a backdrop. Postmodernism operates in a similar impermanent manner of shifting positions and meanings. This approach favors constant hybridization over Modernism's purity and unity.

The easy transitions between windows and files is empowering when using a computer, but intimidating and confusing when looking at art. The mixture of values has become part of daily life and this openness is a positive element. The lack of clear standards has made it more difficult to distinguish art. Who can easily understand current artistic values when layers of glass protect some artworks while others are displayed on the street corner, and when some works cannot be touched while others can be worn? It should therefore not come as a surprise that the Modernist hierarchic approach, with its clear distinctions between "good" and "bad" and "art" and "not art," continues to be, even in this Postmodern era, the preferred model and standard for evaluating and understanding art.

Interpreting Art: Getting Started

Understanding Images

Even if certain artistic values and norms are embedded in culture, understanding a work of art is not easy. It takes time and know-how. Art interpretation is not a compilation of information available about a work of art or an entire period. Rather, it is a thoughtful analytical reflection aimed at bringing forth a new perspective. The strategies used by specialists to interpret art are neither widely known nor readily available to the public. But experts and artists should not be the only ones who understand art! The notion that only elite, educated, and older audiences can fully appreciate art is, unfortunately, still shared by some spectators and even some artists and specialists. This assumption, along with other issues discussed earlier, inhibits spectators' interpretation of art and prompts them to seek and rely solely on experts' views.

And yet the public routinely interprets complex visual messages circulating in contemporary culture. Unlike art, they are intertwined with everyday life and they do not intimidate the public. Wide arrays of visual elements communicate the benefits of new toothpastes, promote charity concerts, and introduce new fashions. These images do a lot more than sell products: they provide information about moral values, gender roles, habits, and other issues. They are effective because viewers can easily decipher their meanings. This becomes evident with advertisements from the past. These images appear "dated," not necessarily

because of the products, but because of the style, values, and fashion represented. When looking at an advertisement for the same brand of jeans from the 1970s and one from today, viewers would immediately notice the differences in hairstyle and makeup, as well as suggested moral values, gender relations, body image, and sense of identity. The responses to billboards, posters, and other visual announcements are expected to differ based on personal taste, gender, knowledge, and many other elements, but they can neither be fully planned nor controlled.

The interpretation of art is very similar to the process of decoding advertisements. This critical thinking process is based on the delicate balance between objective facts and subjective views. Visual literacy plays an important role in finding meanings and interpreting art.

A valuable and effective approach to enhance visual literacy is to look for and find meanings not only in art, but also in the visual components of everyday life. The shapes of clouds and the colors of a sunset, the rhythm of the yellow lines on the highway, and the smile of a relative in an old picture can each trigger a variety of responses, ranging from emotions and nostalgia to amazement and revelation. Unlike art, these encounters have no labels and preassigned values, allowing viewers to interpret them without the concern of missing something, or not doing it "right." It is a great starting point to reduce the fear of "being wrong" when looking at art. (See the "Art of the Week" assignment in Appendix 2.) Visual literacy and consequently art appreciation would also substantially benefit from "full immersion." This process, somewhat similar to learning a new language, would entail looking at all kinds of images, including art, focusing on visual aspects and less on information. Understanding the meanings of images requires practice and attentive examination.

Looking at and Interpreting Art

Looking at and interpreting art are based on intertwined visual, experiential, and cognitive elements. There are no "one-size-fits-all" formulas that could be memorized and applied to all circumstances and works. In addition to the subtleties of artworks, the individuals examining them, be it the general public or specialists, will add their own subjectivity. Looking at art is informal. In contrast, interpretation is a rigorous process in which analysis is combined with critical and creative thinking. An opinion about *Mona Lisa* may state that she represents the sixteenth-century vision of independent women. An interpretation arguing this same point will have to demonstrate this through research and visual analysis. Alinei's book discussed earlier in this chapter is a good example.

Visual examination is the first step in forming an opinion on and interpreting art. The next phase intertwines, gathering basic information about the artwork with viewers' experiences. Opinions are also affected by education, gender, cultural values, and other factors. Visual literacy and knowledge about art are essential in forming opinions. It is for this reason that experts are more comfortable stating

their point of view than the general public. Viewers may lack specialists' vast art background, but they also have an edge over them. They look at art with a fresh eye and their responses are not biased or influenced by existing disciplinary norms. This allows them to find novel meanings in art. A "clean visual slate" is close to impossible for an expert to achieve even when looking at new art.

Art interpretation starts with an opinion. To become an interpretation, informal comments must be backed up by extensive research and analysis, presented in a plausible argument, articulated in logical manner, and supported by visual and textual documentation. Both opinions and interpretations represent a point of view. Opinions are speculative. Interpretations are persuasive.

A specific example, the sculpture *Giulietta* (1993; Figure 9.1) by Bertrand Lavier, illustrates the steps used to formulate an opinion and develop an interpretation. First, one would look at the work. The visual encounter with art is never "pure." How viewers respond to art is determined by many factors, including personal characteristics (such as taste, age, education, and gender), knowledge, and experience, as well as preconceived ideas. In this case many would dismiss the work outright because "a damaged car could not be art." To be able to understand and enjoy new artistic expressions it is necessary to discard rigid values, surpass preconceived ideas, and look with an open eye and mind.

Taking time to observe this sculpture would slowly reveal intricate components and possible meanings. A visual examination would include the shape, form, and color of the car. The next steps would be to gather information about this installation and link the work to personal experience and knowledge. Various elements of this sculpture may trigger a series of different thoughts, reflections, and questions. The artwork is a real car, fairly new, but damaged beyond repair. The color red, widely used for sport cars, may have some added significance. What could it symbolize: blood, death, or the reverse, life?

Other reflections would be directed to the implied accident. What happened? Why and how was it damaged? Was it a tragic accident? Were the passengers hurt? The passion modern individuals have for their cars and the speed with which they drive lead, at times, to deadly consequences. Is this sculpture a symbol of modern, fast-paced life? On the other hand, the car could be symbolic of human inventiveness, but also acknowledge the limitations of one's power. The control the individual feels while driving can be easily and abruptly interrupted, a reminder of human vulnerability. One may connect this sculpture to a later well-publicized event: the accident in which Princess Diana lost her life.

The make and model may also be significant. The Alfa-Romeo Giulietta is a popular Italian sports car. Could this work of art have moralizing meanings? Is it about youth, speed, fame, and a "drive fast, die young" commentary? The play on the two names, Romeo and Guilietta/Juliet, has familiar historical and literary ramifications. Is it a modern end to the tragic love story?

Gender may be another issue relevant to this sculpture in more than one way. Those familiar with Italian and French could reflect on the fact that the word "car" has the feminine gender in these languages. In addition, this car has a woman's

name. A whole new set of issues could derive from these observations. Could the car also signify or question women's independence in modern society?

Comparisons to works of art with similar subjects or apparent meanings would contribute to further understand this work. They could focus on the representation of the train, a symbol of modern mobility in nineteenth-century art. Other comparisons might include artworks concerned with cars, speed, and modern life. Such examples could include the series of paintings *Speed* (1913) by the Italian Futurist artist Giacomo Balla (1871–1958), in which he reflected on technology, cars, and modern culture. More recent examples could include *Long-term Parking* (1982), by Arman (1928–2005), *Citroen DS* (1993) by Gabriel Orozco (b. 1962), and *Low-rider* (1999), by Rubén Ortiz Torres (b. 1964), to name only a few. Those who do not believe that an ordinary automobile could be a work of art may want to view the series of BMW cars painted by famous contemporary artists including Andy Warhol, Roy Lichtenstein (1923-1997) and, recently, Jeff Koons.

> **What examples would you use to further reflect upon and understand this sculpture?**

Finally, one may be interested figuring out how and why a damaged car becomes art. Some of the issues and questions would include references to the artist's creativity and intentions. How was this work made? Did the artist damage the car or did he find it in this condition? Was the artist commissioned to create this work? Was the artist involved in a major car accident? Is this his car? Did he own a similar one? Does he drive? Others may inquire about the mechanisms of the art world. Why is this work considered art? Why is it in a gallery? What gallery or museum is it in? How was the transition between a wrecked car and art made? Who and what were involved? Who designated this work as art? Who reviewed the show? Is it art? What is art?

> " Conceptual art is made to engage the mind of the viewer rather than his eye or emotions. "
>
> **Sol LeWitt**[2]

> **What is your opinion about this work? What do you think this work is about?**

After more careful observations and reflections, Lavier's *Giulietta* may trigger a wide range of opinions. Can you think of one we have not yet discussed?

To establish a credible interpretation experts would have to develop and present a coherent argument supported by visual and textual research and analysis. After a comprehensive visual examination they would look at other works by the artist and other contemporary works with similar visual or theoretical concerns. The research would also include books written about or by the artist, reviews of his exhibitions, essays about his work, the artist's statements, interviews, and so on. Biographical information might also contribute to understanding the meaning of this artwork. Web resources could add materials not available in print. Other sources might include patronage, issues

related to the automaker, information about buyers of this car, speed limitations, accident statistics, and traffic rules. Information about the museums, exhibitions, and other venues where this work of art has been exhibited would also add to the interpretation of this sculpture.

There is ample information leading to many potential interpretations of this work alone. What is more important in interpreting art: the creative process, artists' intentions, artists' lives, patrons, or materials? Should one concentrate on forms, colors, and shapes, or on the institutions displaying art? How about the subject matter or the context of the time? How can one select what is more relevant? How can one interpret art when so many issues appear to be equally important and relevant? How can specialists arrive at a conclusive meaning? What path do they take?

Art experts usually specialize in and focus on particular periods or artists. When searching for meaning in art they also select a specific aspect of the work they are more interested in. In this case one interpretation may focus on the name of the car and the gender issues implied in the work. Another may be concerned with the significance of technology in modern culture, while another could concentrate on the meaning of found objects as art. The direction of the research would allow specialists to select the issues and elements they need and decide on the method they will use.

Summary

Interpretation is a final step in the journey of art. To facilitate and focus their interpretations, specialists use different methodologies. The selection of a particular direction and method is based on the scope of the research as well as individual knowledge, taste, gender, education, and other subjective and objective criteria.

There are many different perspectives from which a work of art could be looked at and analyzed. Lavier's work illustrates the diverse reflections a single work of art could generate. The next chapter discusses several methodologies used in art interpretation.

Notes

1. Alberti, *On Painting*, p. 98.
2. Sol LeWitt, "Paragraphs on Conceptual Art," in Harrison and Wood (eds), *Art in Theory, 1900–2000*, p. 849.

10
Methodologies of Art

Figure 10.1. Michelangelo Buonarroti, *David*, 1501–1504, frontal view. Accademia, Florence. *Photo:* Alinari/Art Resource, New York.

The Art of Understanding Art, First Edition. Irina D. Costache.
© 2012 Blackwell Publishing Ltd. Published 2012 by Blackwell Publishing Ltd.

The sculpture *David* (1501–1504; Figure 10.1), by the Italian artist Michelangelo, is well known. What is the purpose of this nude representation of a man? Some viewers who admire or recognize the work may assume it is just a representation of a male figure. Other viewers, intrigued by the statue's prominent placement in the city, may think it has links to the city of Florence. Many know of its biblical connections. There is also an abundance of postcards, books, umbrellas, napkins, plates, pens, and even aprons that depict the statue which may puzzle and intrigue many spectators. What is the meaning of this famous work? There are many possible interpretations and they will be discussed later in this chapter.

This first section discusses several methodologies used in art history. Their definitions are a general overview adequate for the introductory level of this book; the complexities of each method can be found in more specialized studies. The second part of the chapter is an exercise that uses various methodologies of interpretation, using *David* as a case study.

Introduction to Art Methodologies

As in other disciplines, methodologies focus the analytical process on a series of issues using a specific set of principles. Experts are not required to adopt particular methods, nor are they obliged to reveal their approaches. Some art historians and critics have used the same methodology for decades. This can make their interpretations not only predictable, but also limited. Others prefer to combine different methods or use new ones. Methodologies can become "trendy" and claim to be more relevant than other approaches. In recent decades, theoretical angles, prevalent in art interpretations, have questioned the value of formalism and connoisseurship.

The same work of art can be examined using a variety of methodologies. The disagreements of specialists over the value of various methodologies and the resulting differences in art interpretations create tension in viewers. These diverse opinions should, however, put the public at ease: they confirm that art interpretation is, even when supported by analysis and documentation, a personal point of view. Many contemporary artists, informed of recent methodologies, often through their education, have incorporated them in their art. Therefore understanding the basics of these methods is essential to deciphering the meaning of their works.

Art specialists differ over the specific practices of each methodology, in particular the recent ones with ties to semiotics. The entries below are listed in alphabetical order, to avoid the suggestion of a ranking. Therefore, some methodologies that are connected, or share some elements, may not be in close proximity.

Biography / Autobiography

This methodology analyzes art intertwined with and as a result of specific events in an artist's life. Its focus is on artistic intentions and creative processes. The Italian

Renaissance architect and theorist Giorgio Vasari (1511–1574) used this approach in his influential book the *Lives of the Painters, Sculptors and Architects*, published in the mid-sixteenth century. Artists' notes, journals, statements, and books help us to understand artists' works and the specificity of the creative process. Artists have also reflected upon their lives in self-portraits. These visual autobiographies offer unique personal perspectives often not available in written form. The self-portraits discussed in Chapter 1 illustrate how these works inform the analytical process.

Biographical methodology requires that links between art and the lives of artists be visible and relevant. A substantial amount of information and documentation must exist to substantiate the relevancy of these connections. Letters, archival material, and documents are used in this interpretation. For example, a biographical interpretation of Mary Cassatt's art would aim to establish connections between her life and the subject matter of her paintings, mostly women and children. It may also connect Cassatt's personal life to her artistic successes and position in art and culture. Biography as a method of analysis may be instrumental in interpreting only certain works by an artist. For example, this method could be used for Picasso's 1930s portraits of women, which are strongly linked to events and people in his life. It would not be as pertinent in interpreting his Cubist paintings, as they are more detached from immediate personal issues. New documentation or analytical perspective can trigger biographical interpretation. The discovery of an artist's letters, journals, or diaries, or documentation about their lives, may shed new light and generate new interpretations.

Obviously, this methodology cannot be used for anonymous works. Also, many artists have created works that are intentionally detached from their everyday struggles, concerns, and preoccupations. By the same token, a biographical inquiry may help clarify if a work of art has a particular connection to the artist's life. Biographical approaches are widely used in films.

Connoisseurship

Connoisseurship combines biography and formal analysis. The term derives from the French word *connaître*, to know. Knowledge in this case is concerned with visual aspects as well as historical information. Connoisseurship is not preoccupied with understanding the meaning of art. Rather, its essential goals are to determine and confirm the author, style, subject matter, and time period. It also aims to demonstrate the artistic qualities and value of art. Connoisseurship is primarily based on broad visual literacy, having a good "eye." However, visual analysis is supported and supplemented by documentation, such as biographical data, historical information, and provenance. Connoisseurs tend to focus on specific periods, styles, and artists. This specialization allows them to have an intimate knowledge of art. The familiarity with particular media, techniques, and subject matter permits them to determine the author of a work based solely on visual appearances. Originality, authorship, and authenticity are at the core of connoisseurship.

This methodology is used in exhibition catalogues, monographs, and books. It is also used in museums and the art market, forming part of the process that establishes attributions and detects fakes. For example, if a drawing by Michelangelo were discovered a connoisseur would be asked to examine the work. The specialist would look at consistencies in lines, forms, materials, and subject matter to establish a connection with other works by the artist. This process of authentication would also include art-historical research and scientific analysis. This methodology has been part of the authentication process of the Getty kouros (see Chapter 6). Connoisseurship was also instrumental in studies and reattribution revealed in the Rembrandt/Not Rembrandt exhibition (see "Attributions and Studio Practices" in Chapter 1). In addition to elements of visual analysis, this method includes issues related to the processes of making art, including specific techniques and materials used by an artist. This methodology requires a level of visual knowledge akin to detective work.

Connoisseurship has been perceived in recent decades to be superficial and elitist. This is due in part to the intuitive and experiential characteristics of this method. It also derives from the fact that in the past connoisseurs were a privileged few who had access to art. Before public institutions were established, art was available mostly in private collections. The first connoisseurs were either art collectors or were closely connected to those who were.

Context

This methodology is concerned with understanding the meaning of art in its original context. The present significance of the work is less relevant to this approach. As discussed in Chapter 8, art may be perceived today in a significantly different way from its original context. (The role of contextual elements is discussed in Chapter 3.) Contextual methodology is primarily concerned with examining the elements, individuals, and circumstances connected to the creation and the initial function of the art. This interpretation may examine a variety of factors or focus on a single aspect, such as patronage. Even in this case other contextual elements, including political aspects and social issues, may be considered, as they are all intertwined. This methodology may help clarify the subject matter, style, and other elements related to the original context.

Contextual interpretations take into account a variety of elements, including history, symbolism, and religious practices. This methodology includes careful examinations of the art and extensive visual comparisons and relies on in-depth research of textual resources. Primary sources, such as contracts and other historical documentation, are particularly important to this methodology. Experts often disagree about the meaning of certain texts, visual aspects, and the original significance of myths and beliefs. Contextual interpretations may be triggered by new information that may lead to a novel interpretation of one work or an entire period. (See the contextual analysis of *David* later in this chapter.)

Art history, as its name implies, is a discipline inherently concerned with evaluating art within a historical context. Therefore this approach is often used in connection with other methodologies. For example, the analysis of women's role as patrons intertwines contextual and feminist methodologies.

Deconstruction

Deconstruction is a recent methodology strongly linked to Postmodern theories. It is used in a variety of cultural studies and in the humanities. Deconstruction examines a wide range of aspects of making, analyzing, and disseminating art. On the one hand it exposes diverse and changing meanings. On the other it discloses the mechanisms that make those meanings possible. Rather than focusing primarily on the work of art in question, deconstructive methods are preoccupied with a series of apparently external factors. Deconstruction challenges core values and validated norms, such as the concept of eternal masterpieces and stable, universal meanings.

Questions asked, but not necessarily answered in a deconstructive interpretation include: Why is this art? Who decided that this is art? Why is this work in this particular exhibition, or reproduced in a book? Who is the author of the book? What works have been excluded in order to include this one? How do present art-history values affect the significance of this work? What kinds of materials have been used? Why? What is the financial value? What does the price reflect? Where has this art been displayed?

These lines of inquiry intentionally sidetrack the analysis not only from the art object, but also from the possibility of arriving at a firm conclusion. This pattern is similar to an Internet search. Deconstruction is a never-ending process which aims to suggest that art has a "slippery," changeable meaning.

The deconstructive analysis of I.M. Pei's (b. 1917) Louvre pyramid (1989) would continuously find new elements and endlessly shift the possible significance of this work. At the beginning the focus could be on the multiculturalism inherent in the architecture, location, and creator. Pei, a Chinese American architect, designed this architectural structure. It is inspired by an ancient Egyptian pyramid, erected against a mixed architectural backdrop, which includes Baroque and later styles and is placed in the heart of the French capital, in front of its famous museum, the Louvre.

The analysis could change direction and focus next on the meaning derived from the relationship between the Eiffel Tower and the pyramids, both marvels of human ingenuity. It is relevant to mention here that the Great Pyramid of Egypt was the highest structure on Earth until 1889, when the Eiffel Tower was built. The examination could change path again, and see more meaning in the link between the Egyptian form and the museum's collections. The inquiry could shift again to reflect on the Egyptian art in the Louvre and the discovery of the Rosetta stone by a lieutenant in Napoleon's army and the implications of the subsequent deciphering of hieroglyphs. Another direction could emerge from the contrasts

between private and public spaces in ancient and modern times. This could lead to an interpretation of Pei's pyramid as a commentary on the role of the museums, multiculturalism, and global dialogues.

This method is distressing to many because it is not interested in finding answers or providing closure. Deconstruction does not lead to "reconstruction." However, these open-ended questions expose, more than any other analysis, a variety of processes, individuals, institutions, and relationships that contribute to the definition and meaning of art. The lack of a clear answer can have a positive impact. Viewers may be less intimidated and feel more comfortable in forming and expressing their opinions.

Feminism

Feminist issues have become central to broad cultural discussions since the 1980s. This methodology includes social, political, and historical elements. It examines a variety of issues. One concern is to interpret art by women in close connection to the historical circumstances of their creativity. These analyses include education and family life, but also elements such as materials and subject matter. Another purpose of feminist approaches is to disclose the limited participation of women in art and their subsequent marginalization from the history of art. (See also Chapter 1.) These inquiries have been responsible for the recognition of scores of artists such as Artemisia Gentileschi, Frida Kahlo, Angelica Kauffmann, and many others, well known in their own time, who were only recently reinstated to their rightful position in the history of art.

In addition to specific analysis of women's creativity, feminist methodologies have exposed that art is neither neutral nor universal. They have disclosed that the representation of women by male artists and for male patrons has had profound implications in culture. These views have revealed the objectified representations of women and have outlined the differences between the portrayal of men and women. A feminist analysis of two fourth-century BCE Greek sculptures, *Apoxyomenos* ('the Scraper') by Lysippos (active *ca.*370–300 BCE) and *Aphrodite* by Praxiteles (active *ca.*375–340 BCE), would focus on the definition of the body along specific gender lines. Both figures are represented in the nude. Whereas the male figure is a powerful, confident, and rational athlete, the female is sensual, vulnerable, and fragile. How would a woman artist represent this goddess in ancient times? It is impossible to answer this question, because no such works are known to exist. Feminism also examines the way women artists have depicted themselves as individuals and as allegorical figures.

Formalism and Style

Formal analysis is mainly concerned with the examination of the overt descriptive elements, the forms (thus the term formal) of a work of art. This methodology looks at compositional structure, colors, textures, lines, and other visual elements.

This approach gives priority to visual aspects and less to the content and meaning of the artwork. Formalist analysis validates the concept of *art for art's sake*. (The vocabulary and terms used in this analysis can be found in Chapter 6 and Appendix 4.)

Formal analysis is limited to the work of art. Stylistic analysis links the work of art to the general visual characteristics of the period. A stylistic analysis reveals differences between works, often with similar subject matter, to exemplify broad changes in art. This method is widely used in introductory art-history courses. For example, Michelangelo's *David* is compared to the fifteenth-century sculptures of David by Donatello and Andrea del Verrocchio (*ca.*1435–1488). These comparisons reflect on the visual differences in the portrayal of the same subject and highlight the specificity of a period or artist. This method is less concerned with broadly exploring the reasons for these changes. It is used in connoisseurship and often in contextual analysis, and sometimes in theoretical methodologies.

A formal analysis of *Sunrise: Impression* (1872), by Claude Monet, would focus, among other formal aspects, on the painterly qualities, the subdued colors, and visible brushstrokes that overpower linear elements and create an ambiguous, blurred view of the port of Le Havre. A stylistic analysis would look at the formal characteristics of the artist or period. Does this work reflect the style of the period, or is it an isolated case? The interpretation may take into account other works by the avant-garde. Within this visual context Monet's painting reveals a significant, novel style, but also confirms an emerging trend of artistic innovation. The analysis could also include the realist art of Jean-Léon Gérôme (1824–1904) and Alexandre Cabanel, endorsed by the Academy and admired by the public. Monet's art would visibly clash with the style of these artists.

Formal and stylistic elements can add to the meaning and interpretation of art. In today's theory-driven culture, this methodology, like connoisseurship, has taken a back seat. Nonetheless, it continues to be widely used by museums and galleries in catalogues and educational material.

Gender

Gender methodologies have an interdisciplinary approach. The goal is to understand how cultural definitions of gender and sexual orientations affect and influence artists and art. This methodology, linked to feminism and postmodern issues of identity, may include elements from biography, autobiography, deconstruction, and psychoanalysis. These interpretations may look at issues such as subject matter or the suppression of information about an artist's sexual orientation. It has also contributed to a better understanding of how institutional and cultural views of gender affect the creation, analysis, and dissemination of art. This methodology has been instrumental in examining both contemporary and past art. For example, gender methodologies have developed new interpretations of Classical and Renaissance art.

Iconography

Iconographical approaches focus on the content of the work, the subject matter, symbolism, and other elements relevant to its meaning. The term derives from the word "icon" (meaning "image," and also a symbolic or sacred representation). Today the term is also used for computer files and applications. Icon stands for something else, which it represents or symbolizes. The way the term is used may help explain this methodology. Marilyn Monroe was an icon of the 1960s; Michael Jackson has become an icon of popular culture.

This methodology is concerned with deciphering symbols and other visual codes and understanding how they establish meanings. It is also interested in examining the way symbols function within specific cultural and historical environments. Its main attention is the significance of images and visual elements and their connections to other aspects of the period. It is particularly effective and meaningful in interpreting works with known subject matter and recognizable symbols. Iconography uses contextual information and stylistic analysis. It also examines cultural and artistic traditions and their influences. Visual and textual research is very important to this approach. This methodology gives particular attention to those symbols included (and excluded) and how their meanings are defined within the work and time period.

An iconographical analysis of the *Portrait of Giovanni(?) Arnolfini and His Wife* (1434), by Jan van Eyck, would be concerned with deciphering the symbols based on their connection to the time period to understand the meaning of the work. Values and identities are expressed here in visual codes: the dog, a symbol of fidelity; the oranges, a representation of fertility; the expensive clothes, a hint of financial and social status. There are also many religious symbols that underline spiritual and moral values. Many of these visual elements were well understood at the time, but may not be easy for modern viewers to decipher. (See "Symbols in Art" in Chapter 6.)

Iconography can be used to analyze secular and religious works from both the past and present.

Multiculturalism

Multicultural methodologies have been developed since the last quarter of the twentieth century. They are part of broad-culture concerns of incorporating global traditions in critical and historical analyses. Similarly to feminism and gender, multicultural methodology addresses a variety of issues. It examines the identity of cultures and artistic traditions outside the norms of Western art. It is also interested in exposing the one-sided relationships between Western art and other cultures. Interpretations using this method aim to demonstrate the fallacy of the perceived superiority of the West over other traditions and its claim of universal values. Another important component of this methodology has been to

expose artists and art from different cultural environments. Similarly to feminism, multiculturalism has brought marginalized and ignored works of art and artists into the mainstream. This methodology can be used not only for contemporary works, but also as a tool of reflection about past biases in art and culture.

Postcolonialism

Postcolonial methodology more directly reflects on the way Western culture has imposed its views on other traditions. Contemporary artists have used this approach to reveal the unique identity of their cultures and expose these exclusions from the art and art-historical discourse. Some of the new terms which have been introduced are "other," "decentralized" aesthetics, and Eurocentric. They all reflect, in one way or another, the break from the predominant role and hierarchic views of Western tradition. "Other" refers to the exclusion of non-Western traditions from art history. The term non-Western has exclusionary connotations. Decentralized aesthetics reflects the dissolving of the Western artistic hierarchic system. Eurocentrism refers to the central role Western and European cultures played in the history of art. This methodology can be used to interpret many contemporary works concerned with global culture and identities. This approach has been instrumental in shedding new light on artworks from the past. For example, it has been used to reexamine the influences Tahitian culture had on the paintings of the French artist Paul Gauguin (1848–1903), by taking into account his position in the French colony.

Psychoanalysis

Psychoanalytic methodologies are based on theories developed in the twentieth century by Sigmund Freud (1856–1939), Jacques Lacan (1901–1981), and Julia Kristeva (b. 1941), among others. Knowledge of the various schools of psychoanalysis is necessary to be able to apply them to art history. Central to this analytical approach is the unconscious mind and its impact on defining individuals in social and creative contexts. In his analysis of Leonardo's and Michelangelo's art, Freud, one of the first to use this perspective, connects the artists' creativity in the formation of their identity. Psychoanalytic methods examine a wide range of issues, mainly focused on the identity and creativity of the artist. Connections are also made to family relationships, hidden memories, and past, unresolved emotions and trauma.

This methodology may also be concerned with symbols and their significance and relationships to the subconscious. In this case biography and iconography contribute to these interpretations. More recently, psychoanalysis has examined the correlations between art and the viewers' gaze and desire. Psychoanalytical methodologies have been intertwined and connected with feminist theories and gender studies.

Semiotics

Semiotics is a twentieth-century theory of signs developed to better understand methods of communications in various cultures. Signs are part of language. Because spoken language is a concept more familiar to readers it would be easier to use it as an example to explain the basic ideas of semiotics. A sign is composed of two elements: signifier and signified. For example, the word tree: the signifier comprises the letters used in the word, in this case "T R E E"; the signified is the concept the letters define. The sign is the union between the letters and the concept. Semiotics perceives a work of art as a visual sign and art as a language. For example, the "+" (plus sign) is composed of the design *the signifier*, and the concept it represents, *the signified*. Together, the design and concept form the *sign*, which stands for and means something that neither the signifier nor the signified could on their own.

Words by themselves do not have meanings. Their significance is culturally constructed and learned. This becomes clear when one has to memorize words in a foreign language. For example, the French word for tree is *arbre*, but for someone who does not speak the language the word is only a sound with no meaning. The meaning of a word in English may also be unclear when isolated from its context. For example, what does "pop" mean? Pop could be an abbreviation of the word popular, the verb "to pop" (to burst or explode), a reference to a father, or "proof of purchase." Only in a context, a sentence, would the meaning of the word be clear. Similarly, semiotics argues, the meanings of visual signs are defined by context. What does the "+" sign mean? It could be a cross, the plan of a church, the addition symbol, or the representation of an intersection. Furthermore, words acquire or lose meanings owing to changes in culture. The word "Google" has only recently become synonymous with searching the web because of the popularity of the company. Likewise, art may change its meaning in various contextual environments. For example, if Duchamp's *Fountain* (1917; Figure 1.2) were to be placed in a home-repair shop, would the work signify the same as it does in a gallery setting or art-history book? These changes become even more relevant when looking at art in reproductions, as their contextual environment is repeatedly modified.

Signs can be symbolic (an invented abstracted visual convention, as in this case, an intersection), iconic (when the signifier is reminiscent of the signified, for example, a portrait), or indexical (when the signifier is directly connected to the signified, for example, gestures).

Key terms have been replaced in visual analysis: author instead of artist, reader instead of viewer, and text instead of image or work of art. Images are "read" rather than looked at. Semiotics shifts the focus of analysis and interpretation from artists' intentions and original purposes to contemporary contexts and viewers' responses. Art, this methodology argues, is not a timeless masterpiece. Rather, it is continuously redefined by and within new contexts. Semiotics theory has been instrumental in developing structuralism and poststructuralism. These new

directions have further explored the systems that generate and validate meanings in cultures.

Structuralism / Poststructuralism

Structuralism focuses on the "structures" or the mechanisms, such as institutions, that construct and determine artistic meanings and values. Poststructuralism is a more recent development which many associate with deconstruction. This method, derived from structuralism, as its name suggests, is concerned with understanding the multiple systems at play that generate diverse meanings. There are many different views and directions within structuralism and poststructuralism. These methodologies, based on the semiotic concepts of signs and language, often include elements from formalism, iconography, context, and stylistic analysis.

Structuralism has broad concerns with diverse issues. The main focus is not, however, on art objects, but on the surrounding factors that affect their identity, value, and meaning. Overall, structuralism is concerned with what could be called a "microcosm." It focuses on particular areas of research and attention, aiming to establish patterns within systems. Even though context and history are important to structuralism, they are linked to specific analysis and isolated from the wider environment. Structuralist analysis has a detached approach that limits and even excludes the real. A structuralist interpretation may focus on museums (as a source generating artistic meanings) and their role in shaping the notion of art. This analysis may look in depth at museums, their organizational charts, their collecting, exhibiting, and acquiring practices, and how these "structures" affect art. The point of these methodologies is to suggest that meaning is not inherent to the artwork. Rather, it is bestowed upon it from outside systems. These methods are widely used for new media – photography, film, and advertising in particular – because their creation, dissemination, and appreciation involve many components. These methodologies frequently include institutional values, as well as elements from popular culture. They also often employ interdisciplinary comparisons and analyses.

Visual Culture

Visual culture is a field of study and a method used to interpret art. As a method of analysis it is interested in examining art in connection with other forms of visual expression which are not considered art. Its aim is to understand how works of art are redefined within an environment where they coexist and, at times, compete with other images. Many art specialists are not only skeptical but also reluctant to accept, let alone use, this methodology.

Visual culture has clear links to issues related to contemporary times, but it is also used to analyze art from the past. *Mona Lisa* is a good example. A visual culture approach could examine this painting in connection with multiple

contemporary advertisements and objects, as well as the numerous copies by Leonardo's followers. Its aim is to connect art to visual expressions perceived less relevant, such as fashion, furniture design, textiles, and advertising. For example, an analysis of Monet's paintings would include Japanese influences in everyday life and could focus on his dining room, redesigned in a Japanese style, and the artist's famous garden at Giverny. (See also the interpretation of *David* below.)

Art Interpretation: Case Study

This section of the chapter will examine one work of art from various methodological perspectives. The aim of this exercise is to demonstrate how methodologies are used and to show their impact on understanding the meaning of art. Even though the example below uses different methodologies, the analysis, resources, and other elements reflect the author's point of view. Others may reach different conclusions and interpretations, even if they use the same methodologies. The analyses below are not based on full research of the sources listed, but the interpretation is laid out in an abbreviated form, adequate for the didactic purpose of this exercise.

The list of steps used in analyzing and interpreting art below does not aim to suggest a rigid process, or an obligatory order; these stages may be intertwined. The goal of this outline is to help readers better understand the process of interpreting art. Specialists develop their own strategies to analyze and interpret art. They go back and forth, evaluating the information, looking at the art, and reflecting on their point of view before reaching a conclusion.

Elements of art interpretation

1. Visual examination and gathering general information about the work of art.
2. Identification of questions and issues derived from visual examination and general information. (This step establishes the general direction of the analysis and contributes to the selection of an adequate methodology.)
3. Selection of a particular methodology / approach.
4. Selection of appropriate resources for research and analysis.
5. Research and analysis.
6. Interpretation.

Michelangelo, *David* (1501–1504; Figure 10.1)

Visual examination and general information

This famous work represents a standing young male nude. The subject is the biblical battle between David and Goliath, but in this sculpture the artist depicts only

David. Michelangelo is one of the best-known artists of the Italian Renaissance. He was trained in Florence, and his best-known works are the frescoes in the Sistine Chapel, in Rome, and the sculpture *David* discussed here. In addition to being a painter and sculptor, Michelangelo was also an architect.

The sculpture *David* was intended for the cathedral in Florence. When completed in 1504, however, it was placed in Piazza della Signoria in front of the Palazzo Vecchio, the seat of the government, in a secular public space. The statue displayed in the piazza today is a copy. The original, which was deteriorating due to the climate, was moved inside the Accademia galleries in the nineteenth century.

This sculpture has been widely acknowledged as an excellent example of the High Renaissance. The influence of classical tradition and the innovative representation of David as a strong young man are among the elements that make this work memorable and important. The statue represents David in the nude and on an impressive scale: almost 17 feet tall. His body is athletic and alert. He is focused on the upcoming battle with Goliath. The sculpture is seen in reproductions almost exclusively from the front and often without the pedestal, making it hard to appreciate its imposing presence.

Questions and issues derived from visual examination and general information

There are many issues that could lead to different interpretations of this work. One question may be: Why would a major work commissioned for a cathedral be placed in a secular public environment? Was this decision based on civic concerns or practical issues? Was it too difficult or complicated to place the statue where it was originally intended for: on one of the buttresses (a structure built to support the walls) of the cathedral? This line of inquiry would require a *contextual analysis*. The research would lead to an understanding of the significance of this sculpture in early sixteenth-century Florence.

Another set of questions may be related to representation of the body. David is presented as strong and muscular. Is this specific to male representations? How are women represented during this period? Are there sculptures of women in the nude by women artists? This set of questions would prompt a *gender/feminist methodology*. This analysis would reveal, among other things, the role of gender in the Renaissance.

Another line of inquiry and analysis could focus on the abundance of imagery and copies of this famous statue. Games, toys, postcards, and scores of functional objects ranging from underwear to umbrellas have been created in connection with this famous sculpture. How does contemporary culture look at and understand *David* when so many copies exist? These questions would be best answered using the *visual culture* methodology.

Contextual analysis/interpretation

Why was *David* displayed in the piazza?

 Resources that could be used for this analysis (see Chapters 4 and 5):

1. Historical information about the period.
2. Visual and textual information about the artistic context of the time (patronage, artists' studios, practices, and so on).
3. Comparisons to other works (sculptures with the same subject matter, other works by Michelangelo, other outdoor sculptures in Florence).
4. Drawings, prints, and other historical visual sources (images of the piazza and *David*).
5. Artists' letters, statements, and so on (published material).
6. Archival material: documents about this project, contracts, the cost of such endeavors. Researchers may even hope to find a particular document that would shed new light on what prompted this decision.
7. Art-historical literature (articles, books, and so on).
8. Information about materials, costs, techniques, and technologies used at the time.

 Additional sources:

9. Virtual tours and webcams (as a supplement to seeing the original).
10. Websites that, using computer programs, have re-created the intended placement of the sculpture.

What other sources would you add?

 This contextual analysis would focus on patronage. Who was involved in commissioning this project? Secondly, who was involved in making the decision to change the location? Most of this information is available in published sources. In addition, an examination of artworks displayed around the cathedral and in the piazza would contribute to establishing a solid argument. The subject matter is another important element. The role of the Church and city government and issues related to political life in Florence in the early 1500s might also be relevant factors. Was it simply too difficult to place this large marble sculpture that high? These are some of the issues that could be examined.

 The arts were strongly supported in Florence by both religious and civic patronage. Private money contributed to both. The Opera del Duomo (the cathedral works commission, which was administered by the wool guild until the eighteenth century) commissioned this sculpture. When *David* was completed a group of artists was asked to decide where the sculpture should be placed. The decision to display the sculpture in the piazza was prompted partly by the beauty and power of the sculpture. But some technical issues might have also contributed to this:

the sculpture is very narrow from a side viewpoint owing to the block of marble of which it is made. The new placement would have assured a mostly frontal view.

Florence has long perceived the biblical figure of David to be a symbol of the city and the Republic. Michelangelo's *David* had complex meanings attached to it. At that time secular power was restored in Florence after years of turmoil and wars. This included Girolamo Savonarola's (1452–1498) several years of religious leadership and political control that ended with his death. The shift from religious to public setting transforms the statue of David from a biblical representation into a political and civic symbol. It could be concluded, therefore, that the placement of *David* in the foremost public space of the city is an affirmation of the influence and authority of Florence's government.

Gender/feminist interpretation

Resources that could be used for this analysis (these can vary, based on the specific concerns of the specialist):

1. Historical, cultural, and artistic context (including gender-role issues).
2. Comparisons to other works by the artist and other works of the period.
3. Comparisons of gender representation of the period.
4. Artists' letters, statements, and so on.
5. Archival material: documents about women's roles in art and society.
6. Art-historical literature: texts on this sculpture and gender issues in Renaissance art.
7. Feminist and gender theories.
8. Interdisciplinary research: gender issues in Renaissance culture and society.

Other sources:

9. Using a computer program to alter existing works and create new ones to reveal biases in gender representation.

What other sources would you include for this analysis?

What is the significance of *David* from a gender perspective? There are many possibilities of examining this sculpture from this angle, leading to related but slightly different interpretations. Although this is a familiar work, many modern viewers may not feel comfortable with the overt nudity of the statue. Spectators may be intrigued by the fact that the sculpture was commissioned for the cathedral and then displayed in a public place. How did contemporary viewers (men, women, and children) react to this depiction of a nude male body? The interpretation could focus on the gender implications of this representation.

In addition to research of contextual elements and gender roles in Florentine society, visual comparisons would inform this analysis. There are no sculptures of

nude women in this period. Sandro Botticelli depicted the first large-scale realistic representation of the female nude in the painting *The Birth of Venus* (1485). This was almost half a century after Donatello created (in the 1430s) the first freestanding male nude sculpture since antiquity, also a representation of David. The distinction between abstracted two-dimensional media and the lifelike reality of the sculptures implies a subtle, but significant difference. This is further highlighted by the links of both nudes to classical tradition. Botticelli's *Venus* reinforces the meanings attached to Aphrodite, a variation of which inspired this work. Similarly, *David* emulates some of the physical and emotional identity of Greek athletes, as visible in *Apoxyomenos*, discussed above. Furthermore, Botticelli's painting was for a private patron and a limited audience. *David* was a church commission for public viewing.

While Michelangelo represented women in his art, he did not sculpt freestanding female nudes. There is not a single sculpture or even painting by a woman artist representing the female nude until more than a century later. There are also no monumental sculptures of nude women, freestanding and displayed in public in this period. One may even argue that there are no comparable works representing women in the same position of power and control.

The lack of women artists in this period reveals the central role played by men. While the Renaissance is a period of rebirth of individual identity, this sculpture underlines that "individual" does not appear to be a generic term.

Clearly much more research could be done for a formal, lengthy study. This interpretation may conclude that *David* may be a symbol of Florence, but it is not neutral from a gender point of view. The muscular body, emotional control, focus, and self-reliance are gender-specific. There are no representations of women with similar characteristics and certainly not in the nude in a public piazza! *David*, then, is a symbol of male authority and dominance. The statue is a visual confirmation and reinforcement that male power is at the core of government and society in sixteenth-century Florence.

Visual Culture

Resources that could be used for this analysis (these can vary, based on the specific concerns and directions taken):

1. Visual examples of contemporary and past use of this work for other purposes/contexts.
2. Comparisons between "the real" David, the copy, and reproductions.
3. Reproductions (across time and cultures), books, CDs, postcards, and so on.
4. Films and documentaries.
5. Advertisements featuring David.
6. The web.

7. Locations, institutions, and venues that sell, promote, and disseminate objects related to David.
8. Surveys/information about marketing and buyers (if available).
9. Art-historical literature. Texts on the value and meaning of the Renaissance and this sculpture. The meaning of the Renaissance and this work for modern viewers. The value and meaning of "masterpieces" in contemporary culture.
10. Critical texts about visual culture and art and tourism.

This can be a very interesting analysis. *David* is better known through a variety of reproductions, postcards, toys, games, and other objects, than from the original. Has the significance of this sculpture changed due to this abundance of reproductions? This interpretation may also include deconstructive elements. To emphasize the role reproductions have, this analysis may use as a starting point the copy of the statue displayed outside. Few notice the difference. Furthermore, using the material disseminated through stores, online, and other venues, this analysis could focus on: (1) How are the objects inspired by this sculpture used? (2) Who is buying and using these objects (what age group do they belong to, and so on)? and (3) How do these reproductions relate to the original work?

The analysis could also examine how the statue is presented in various reproductions and products. Some focus on its artistic value, others on the nudity, and others on its fame. Few are concerned with the religious story or the significance of the subject and statue for the city. *David*, and for that matter other works used in popular culture, lose some, if not all, of their original meaning. Furthermore, this masterpiece, like many others, has gained wider recognition by being popularized in this manner. Some may find this demeaning and degrading to this sculpture and art in general. Many would state that this is the end of art! Others may see this as a new path to understanding how images circulate in culture. From this perspective, *David* has lost its initial meaning and significance. It is no longer a political and civic symbol of Florence. It has now become a popular international postmodern icon sold in museums and stores around the world.

There are other methodologies that could be used to analyze Michelangelo's David. *Biography* is one of them. An interesting link could be made between the sculpture of *David*, the contemporaneous famous representation of Adam in the Sistine Chapel, and the later self-portrait in the *Last Judgment* (1536–1541). An argument could be made that these images are metaphoric self-representations. The early images of youth and power derive from Neoplatonic philosophy; the later, older Michelangelo is a pious and tormented man. Michelangelo's writings support this interpretation. "Nowhere does God, in his grace, reveal himself to me more clearly than in some lovely human form which I love solely because it is a mirror image of Himself,"[1] he wrote. Later his views changed: "I have let the vanities of the world rob me of the time I had for the contemplation of God."[2]

There are still more methodologies that could also be used to analyze this famous sculpture. An *iconographical* analysis would focus on David and its sym-

bolic significance in Florentine culture. *Structuralism* would be concerned with analyzing, among other things, the systems that have validated this work as a masterpiece. *Stylistic analysis* would focus on the formal elements and their connections to the characteristics of the High Renaissance.

What methodology would you use for *Giulietta* by Lavier, discussed in Chapter 9 (Figure 9.1)?

Here are some suggestions and directions:

- *biography* (the artist's life, possible accidents, loss of family members, friends, and so on)
- *contextual* (artistic context, contemporary life)
- *feminism* (cars as symbols of gender, names of the cars, women artists who used this subject matter)
- *multiculturalism* (the car as a symbol of globalization, environmental issues)
- *visual and material culture*.

Summary

It is evident that different interpretations can significantly change the way a work of art is perceived. The exercises above reveal that the purpose of methodologies is not to find a "correct" answer or interpretation. Rather, their goal and inherent value is their disclosure of the many layers and meanings that coexist within art. Interpretation uncovers many subtleties and hidden particularities that are key to formulating new ways of looking and thinking. This process elucidates why art is created and exposes its past significance and current artistic value. The analysis and subsequent multiple interpretations make art continuously relevant to both specialists and the audience in novel and unexpected ways.

Notes

1. Michelangelo, quoted in Sir Anthony Blunt, "Michelangelo's Views on Art," in Spencer, *Readings in Art History*, p. 76.
2. Spencer, *Readings in Art History*, p. 83.

Conclusion

Art discloses a wealth of information about humanity and civilizations. It speaks of political and religious views and moral and family values and reflects the customs, culture, knowledge, and technology of the period. How many disciplines could claim to provide so much data in such an efficient and beautiful manner? Today art is no longer hidden for the needs, benefits, and pleasures of a few. Works of art from different continents, cultures, and time periods are accessible as originals or reproductions to diverse audiences, regardless of age, education, tradition, ethnicity, income, and taste.

Art connects people and cultures. But to be able to do this art needs to be embraced, not rejected; it has to be enjoyed, not discarded; it should be valued, not ignored.

Imagine life without art: A world without monuments of present or lost cultures, without images of places we do not know or which no longer exist, with no representation of daily life or major events, and no links to societies and traditions that have disappeared. Drab, empty walls, bare public plazas, and plain, simple buildings. No visual memories. No museums or galleries, either. No visual traces of who we were, who we are, and who we might be.

Art exemplifies, illustrates, and represents, but also imagines, envisions, and inspires. Art communicates emotions, thoughts, ideas, and knowledge. Each work of art is a unique and irreplaceable treasure of human existence. Art is a celebration, a commemoration, and a reflection. Art amazes and comforts. It confirms the familiar and exposes the new. Viewers' responses are also diverse. They are enthralled, offended, impressed, shocked, in awe, enraged, enchanted, upset, irritated, impressed, overwhelmed, outraged, delighted, energized, and thrilled.

Art, as this book has demonstrated, is the result of careful preparations, broad dialogues, and significant need. The intricate behind-the-scenes factors that affect

The Art of Understanding Art, First Edition. Irina D. Costache.
© 2012 Blackwell Publishing Ltd. Published 2012 by Blackwell Publishing Ltd.

art from its inception to its interpretation, discussed throughout this text, determine its meaning, value, and position in culture. Art is a fundamental component of human existence and a continuous adventure that reconciles the past with the present and turns recollections into discoveries.

> **❝** [Art is] a revelation, an unexpected and unprecedented resolution of an eternally familiar need. **❞**
>
> **Mark Rothko**[1]

Note

1. Mark Rothko, "The Romantics Were Prompted," 1947, quoted in Chipp, *Theories*, p. 549.

Appendix 1
The Art World

Many individuals, institutions, organizations, and scores of personal and professional relationships contribute to defining what the meaning of art is at a given time. Knowledge and expertise are essential, but many subjective components also influence this process. The purpose of this appendix is to identify some of the key players in the art world and reveal how their operating mechanisms affect what culture labels "art." The list is neither scientific nor exhaustive.

Advisory Board/Art Council/Board of Directors Boards and councils advise institutions on art matters. Sometimes they also have fiduciary duties. The members of these entities include collectors, donors, and benefactors, who may not necessarily be involved in the arts, or have an art education, but they usually have a certain interest in the specific institution, the community, or art in general. Boards and councils make decisions on institutional policies with complex artistic and financial ramifications. Ethical issues related to personal and professional relationships of board members are of great concern to art institutions. Board members usually give financial support to the institution they serve.

Alternative exhibition spaces Some galleries are owned and operated by artists. Most of these spaces continue to have a system of selecting art (committee, jury), but they represent the voice of the artists. Art is also exhibited in malls, stores, movie theaters, cafés, and restaurants, where a wide and diverse audience can see it.

Appraiser Art, like real estate, can be appraised; a work of art is usually appraised each time the ownership or location changes. Appraisers are professionals familiar with art and the art market. The value an appraiser assigns to a work does not guarantee that it would sell at that price. However, that figure can substantially influence and artificially inflate the value of the work and the collection.

The Art of Understanding Art, First Edition. Irina D. Costache.
© 2012 Blackwell Publishing Ltd. Published 2012 by Blackwell Publishing Ltd.

Art and art-history faculty Faculty play a significant role in the art world. They are practicing professionals and their perspective on art influences future generations. The academic environment has been a place for experimentation and faculty have supported and even initiated many new developments in the arts.

Art and art-history organizations/associations Art professional organizations promote the work of their members through publications, exhibitions, and lectures. The various committees who select these works may endorse a certain point of view, methodology, or style that may be trendy or perceived more valuable at the time. The College Art Association (CAA) is the largest art organization in the United States. The art and articles published in its journals and presented at annual conferences influence artists' and scholars' careers.

Art colleges and departments Art colleges, programs, and departments play a seminal role in defining and influencing art. What is taught in the studio and in art-history courses shapes students' art appreciation and affects their creativity.

Art conservator An art conservator is a person specializing in the preservation of art. The role of a conservator is to protect the art, identify its physical condition, and perform treatments, within ethical guidelines, to restore it without compromising its artistic integrity. The way art is conserved determines its visual appearance and thus influences the public's appreciation of art. Technical codes and ethical procedures strictly regulate contemporary conservation processes. One of the professional organizations that establishes these guidelines is the International Institute for Conservation of Historic and Artistic Works (IIC). Training for this discipline can be done in private studios and higher-education institutions.

Art critic The art critic is usually interested in examining contemporary works of art. Critics formulate their opinion based on art-historical knowledge and personal taste but do not use extensive documentation to demonstrate their point of view. Their reviews and judgments can make or break the career of an artist. They also influence collectors, dealers, viewers, and the art market. The reputation of the publications to which they contribute adds to the validity and significance of the art reviews.

Art fairs In today's global culture international art fairs have become an essential exhibition forum and marketplace and a "must" for artists' résumés and gallery activities. At these events artists, experts, and institutions from different continents gather to exhibit art, exchange ideas, and find out about new artistic and financial trends. (See the textbox "International Exhibitions and Fairs" in Chapter 4.)

Art historian Art historians have an influential role in the art world. Their research can substantially change the way art is perceived and evaluated. For example, feminism sparked a great interest in women artists. Scores of books on these and related themes have been published since the 1980s. This has affected museum collections, exhibitions, art courses, and the public's awareness of this issue.

Art-history textbooks The content of textbooks plays a major role in defining the notion of art. The selection of art and the views presented by the analysis reveals how art is perceived at a certain time. A comparison between the 1970 and 2009 editions of the same textbook would show the changes in artistic values and art-historical perspectives during this period.

Art institutes and archives These institutions support specialized research, which is later disseminated through exhibitions, publications, and lectures. The often marginalized, yet important issues these findings introduce can have long-range implications on art and its meaning.

Artist This term is discussed in Chapter 1. Artists can influence one another in the development of their careers. They may try to emulate the style, medium, and ideas of those who have greater critical recognition. Art and artists from the past often influence contemporary artists.

Artist's statement Many contemporary artists explain their art in statements. These texts can help viewers understand complicated artwork. Often they are full of complex theoretical terms that are even more confusing than their art. Statements reflect the artists' intentions and also reveal the conceptual trends of a period.

Art walks and studio tours Since the late 1990s artists have more often opened up their studios to organized public visits. These informal interactions between public and artists have a positive impact on viewers and contribute to a greater appreciation of art. Because artists' participation in these events is usually by invitation or determined competitively by a jury, it is prestigious to be included.

Auction house Auction houses sell art to both institutions and private collectors. The art sold and prices obtained at auctions are closely intertwined with artistic values and art-historical views. The oldest and still most influential auction houses are Christie's and Sotheby's, established in England in the eighteenth century and now with offices all over the world. (See also the discussion in Chapter 4.)

Audience The audience has an important role in the art world. Unfortunately spectators are either unaware of or unwilling to voice their views. Websites of museums, galleries, art institutions, and artists have developed features to allow viewers to communicate their thoughts. Few, however, even when complaining about an art exhibit, use this unprecedented open forum. Could the audience make or break an artist? Could it determine what art a museum will showcase? It is difficult to know for sure. What is certain is that museums and galleries in particular, and also artists, value the public's comments.

Biannual/triannual exhibition A wide range of international exhibitions, held annually or several times during a decade, take place nowadays around the world. Participating in these exhibitions is highly competitive. These forums have expanded and enriched contemporary artistic dialogues and have a growing global influence. Art is not sold at these events.

Collection This term is used to refer to the artworks belonging to a collector. Collections are often named after the person who acquired the art. In recent

years, many prestigious high-profile private collections have become museums and galleries. These changes have an enormous impact on the artists represented in these collections, as well as the dealers, galleries, and art specialists, who sell, display, or write about these works. The term collection also defines a group of works within one institution that share a common denominator. For example: the museum's collection of drawings, or collection of paintings.

Collector A collector is an individual who buys and collects art for their own personal use. They often make their collection available to the public. Sometimes collectors designate part of their collection as "promised gift" to a museum. When purchasing art, collectors may seek the advice of art historians, curators, and other specialists. Collectors concerned with contemporary art can be especially influential. They can affect the career of an artist, as well as have an impact on museums, galleries, dealers, critics, and art historians. The taste and artistic views of major collectors are closely intertwined with the art market, and what is perceived to be "good" art.

Connoisseur An art connoisseur is an individual with extensive visual experience and knowledge. The term derives from the French *connaître*, to know. Connoisseurs use visual elements to determine the author or period of a work of art. Their views are compared to scientific analysis before determining the authenticity of a work of art. As these tests are not available for all materials, connoisseurs still play a significant role in attributions.

Curator A curator has one of the most significant jobs in museums and galleries. The curator literally takes care of the art. The word derives from the verb *curare* which means, in Latin and Italian, "to take care." In large museums curators focus on a particular area of the collections. The duties of a curator include, but are not limited to, overseeing and interpreting the collection, developing and organizing exhibitions, finding and cultivating potential donors, acquiring and deaccessing artworks, and arranging and displaying art in the galleries. The views and knowledge of curators play a crucial role in defining art and shaping the public's taste.

Dealer Art dealers sell, buy, promote, and even display art. They have a very influential role in the art world. Like art historians, dealers usually focus on a period, or specific artists. They may also act as agents for living artists. Art dealers are frequently connected with galleries, and often they are gallery owners or directors. They also have strong ties to museums, auction houses, and collectors.

Exhibition catalogue An exhibition catalogue is a book that documents the show. Catalogues are, however, not neutral. The number and quality of the essays and illustrations they contain, the reputation of the authors, the extent of the bibliographical information, even the number of pages and, of course, the prestige of the publishing houses influence the way the exhibition is perceived. Nowadays catalogues are often published on demand or in electronic format.

Exhibitions Art exhibitions play a crucial role in shaping the definition of art. Their themes reveal art-historical values and concerns of the time. The

reputation of the institution adds to the perceived value of the art show. Exhibitions have highly competitive and comprehensive selective processes, invisible and unknown to most viewers. Exhibitions can last anywhere from a few weeks to several months. Sometimes several institutions and collectors jointly organize a show, which travels to different museums over a longer period. The preparation for large exhibitions may take more than five years. Exhibitions involve a wide range of individuals (curators, artists, collectors, dealers, designers, educators, art historians, security guards, insurance agents, transportation specialists, and many more). During this process complex professional and personal relationships are developed, which may affect the outcome of the exhibition.

Film (art-related films/documentaries/educational videos) As discussed in this book, films about art, both fictional and documentary, influence the popular opinion about art, artists, and the creative process. The documentaries produced by universities and art institutions and hosted by established art experts have a significant role in informing the audience and shaping its appreciation of art.

Gallery A gallery is a space that displays and sells art to the public, and most galleries are for-profit businesses. The reputation of the gallery influences how the art displayed is perceived and valued, which is particularly relevant in contemporary art. (*See also* **Alternative exhibition spaces**, **University galleries and museums, The web**).

Gallery owner/director Gallery owners are often also directors dealing with both artistic and financial matters. In some cases, they also are, or become, collectors or art dealers. Galleries often have contracts with artists and require exclusive representation. These professional relationships can be very complicated from both a financial and creative standpoint. Gallery owners and directors have extensive contacts with collectors, curators, and art critics, as well as the art market, educational institutions, and museums. These dialogues have an impact on the art displayed, collected and even, at times, created.

Lectures, presentations, and art-related talks Educational institutions, usually universities and museums, organize talks, tours, and lectures, often connected to exhibitions, symposia, and conferences. These presentations inform the audience about experts' views on art.

Museum director The director of the museum has an administrative position. He or she may not have an advanced art or art-history degree. In the past artists have served in this position, but it is rare in contemporary times. The director of the museum relies on curators for specific decisions regarding the art collections, exhibitions, publications, and educational programs. Directors often have to report to boards, councils, and trusts. However, their views, taste, and knowledge of art and its history can significantly influence their decisions and thus shape the museum's identity.

Museum education Since the late 1990s the education departments of museums have redefined their dialogue with audiences. New programs have facilitated novel and effective ways of engaging viewers in looking and thinking about art.

Museum/gallery architect/architecture The architects designing museums and galleries are able to shape the experience of the audience. To avoid "art fatigue" (seeing art without a break), architects have found innovative ways to interrupt visits to galleries. This is visible in new museums such as the Guggenheim Museum in Bilbao and the Getty Museum, in Los Angeles, where the traditional linear path has been transformed into fragmented and multidirectional itineraries. A pleasant museum experience has a positive long-term impact on the audience's interest in art. (For all entries related to the museum see also Chapter 4.)

Museum of art Museums remain the most influential institutions in the art world. Museums reinforce the notion that art is a serious matter and contribute to the validation of art historians, critics, and artists as professionals. Museums' collections and exhibitions, as well as their acquisitions and displaying policies, reveal and define what kind of art is valued in culture at a given time. They have enormous influence on art-historical research as well as artists and art education. The criteria used in acquiring or exhibiting art are seldom disclosed to the audience, adding to the intimidation and the authoritative voice of museums.

Museum store In recent years, museums have expanded the space and inventory of their stores. In addition to books, a wide range of art-related objects, ranging from jewelry to posters, are sold by museums. These objects generate significant revenue. They also extend the museum experience and further influence the public's view on art.

Patrons and sponsors In the past most art was commissioned. Therefore patronage played a crucial role in the outcome of a work of art. While artists have become more independent in the modern era, support for the arts is still important. Sponsorship comes nowadays from a wide range of institutions and corporations, which support exhibitions, educational programs, and specific art-related activities. Any form of support implies an accord from both sides. Sponsorship can influence the kind of art museums exhibit or purchase, contributing to the validation of certain works of art and the exclusion of others. (See also Chapter 1.)

Podcast This new feature has quickly entered the art world. Many museums have introduced podcasts for their collections, special exhibitions, and educational programs. Art and art-history courses have followed suit. Because of their wide use podcasts will play a seminal role in art education in the near future. The content of these programs will likely have a major effect on the public's knowledge and appreciation of art.

Publications (books, articles, essays) Publications reinforce what is considered art within culture. For art historians, books continue to be the most valuable accomplishment and the essential measurement of their scholarly achievements. Books, catalogues, and articles about living artists play a crucial role in validating their art and careers. (See also Chapter 5.)

Registrar The registrar is a department within museums and large galleries whose concern is to have a permanently updated inventory of all works of art. The

registrar, also the job title, records exhibition loans and documents even when a work of art is moved within a museum.

Reproductions As discussed in this book, reproductions continue to be the main form of disseminating art in contemporary society. Even though digital images may be quite different from the actual work, auction houses, galleries, museums, and collectors make many decisions based on electronic images. (See also Chapter 6.)

Reviews Exhibition reviews are an essential tool for evaluating art and artists' accomplishments. Even though they express opinions and often reflect immediate responses rather than lengthy analyses, reviews continue to play a major role in artists' careers and the public's perception of art. The credibility of the author and the reputation of the publication add weight to the review. There are very few reviews proportionally to the number of exhibitions.

University galleries and museums There are many museums and art galleries connected to universities and colleges. Their role in the contemporary art world is significant. First, they support art forms that are difficult to create by independent artists, such as multimedia installations and electronic art. Secondly, they develop cutting-edge exhibitions, which reveal new trends, ideas, and marginalized art. Thirdly, they work closely with the academic institutions they are affiliated with to disseminate scholarly research through a variety of public programs. Finally, they play a vital role in the education of both studio and art history majors. These institutions are usually not concerned with selling art. (See also Chapter 4.)

Visual studies Recently this new interdisciplinary program has been established in many universities around the country. Its purpose is to look at art from a more comprehensive angle that includes other disciplines and visual components of culture. While many dispute the validity of these programs and approaches, visual studies position art within a more complex visual context.

The web The web has an increasingly significant role in the art world. Museum websites, art encyclopedias, artists' blogs, virtual tours, and digital reproductions have flooded cyberspace. The Internet and electronic media will have enormous implications in the art world in the years to come.

Appendix 2
Creative Assignments and Writing Projects

Introduction

Art of the Week

The goal of this assignment is to help you develop and formulate your opinion about the meaning of art in various environments. These one-page (or less) essays combine knowledge acquired in class with your interests and taste. Keep your eyes and mind open. Observe colors, forms, movements, light, and so on; reflect about meanings, emotions, and beauty; and then write your personal thoughts. The topic can be a sunset, a hill, an old photo, a cat, or anything you like. The essay has to briefly describe what caught your attention and the impact it had on you.

You do not need to use art-historical sources to support your point! This process of visual and conceptual discovery and reflection will help you develop a more meaningful understanding of art.

Chapter 1

Pretending to Be an Artist or Patron

For this project, you can choose to be a "real" or fictitious artist/architect or patron. You must "invent" a work of art and you must describe its essential visual aspects, which must be compatible with the specific general characteristics of the art of that time and culture. You can include a drawing, painting, or other visual material. The essay can focus on a variety of issues: the creative process, the role of the artist, the request of the patron, and so on. The paper can have creative formats: a personal journal, a letter from a patron, a contract between a patron and an artist, or the thoughts of a future artist working as an apprentice.

The Art of Understanding Art, First Edition. Irina D. Costache.
© 2012 Blackwell Publishing Ltd. Published 2012 by Blackwell Publishing Ltd.

Be creative. Do not forget to specify the culture and time period and to use comparisons to support your argument.

Chapter 2

Found Objects

For this project, you have to choose objects from your environment as well as traditional art materials and/or tools to create a work of art. You also need to write an essay in which you explain why you selected the specific objects, how you are planning to connect them to your ideas, and what you expect the reaction of the audience to be. You may also reflect on the placement of this work. You should use comparisons to other works of art to support your project and ideas.

Chapter 3

Artists from the Past Living Today

Select artists from the past and imagine that they live in the twenty-first century. In your essay, you need to discuss how the new environment would shape their creative process and describe the art they would make. The connections between the artists and contemporary times must be compatible with their original interests and influences, but with a modern twist. For example, Leonardo da Vinci would be creating electronic projects and collaborating with Dan Brown to solve a puzzle from the Renaissance. Or, Van Gogh would be living in Los Angeles, would be interested in Californian landscapes, and would be influenced by Japanese electronic media.

Chapter 4

Donating Art to a Museum

You are planning to buy and donate to a museum of art (select an existing museum) a work from the upcoming auctions at Christie's or Sotheby's. Which artwork would you choose, and why? To answer this question you need to examine the art/collections, departments, exhibitions, and mission statement of the particular museum. Select a work of art that reflects the museum's artistic interest. You may also want to address financial or other concerns/issues. Do you want your donation to be acknowledged or anonymous? Do you want the work of art to be part of educational programs and tours?

Chapter 5

Exhibition on the Web

You have to organize an exhibition on the web in which you invite four different museums to participate. Your exhibition must be linked (conceptually and visually) to the museums you are including, but it can be on an independent site. The general theme of the exhibition is: what, in your opinion, best defines contemporary culture. The exhibition must use art from these various museums and other sources as well as objects from everyday life and popular culture relevant to the show. Your idea must be visually articulated through the art selected and the way the show is organized.

Even though this is a web-based exhibition, you need to reflect about the audience. Who is it for, and why? Why would the museums you have selected participate in this exhibition? What would this exhibition accomplish?

Chapter 6

Discovering a New Work of Art

You have just discovered a new work of art. The circumstances of your discovery are open to your imagination. Your project must describe the essential visual aspects of the art (which must be compatible with the specific general characteristics of that time and culture). If they are not, you must find a plausible argument for their inconsistencies. You have to construct a convincing argument for the form, dimensions, and function of the work and you must connect it to its cultural context through specific comparisons. To add realism to your project you can create artwork or use the computer to produce an image.

The essay should be written for a specific audience: you are sharing your discovery in a letter to your family; you are an archeologist presenting a paper, etc. Be creative!

Chapter 7

Defining New Art

Select an object from your environment that has not yet been defined as art, but which you think should be, and reflect about the specific processes and steps you would take to analyze it and establish its meaning and value. What is this object about? What does it remind you of? What caught your attention? What textual resources would you use? What comparisons could you use? Why do you think it should be art? How does this object compare with established art? How would you argue for its artistic value? Are there any texts you could use?

Chapter 8

A New System of Classifying Art

Create a new system of art classification and, using specific examples of existing works of art, develop a logical argument for its organizational value. The purpose of this assignment is not to challenge the present systems but rather to reflect on the complexity of developing comprehensive categories for art and the inevitability of exclusions. You need to discuss the criteria to be used for the selection and reflect on their objectivity and/or subjectivity and the way they would be applied. You also need to reflect on the consequences your system would have on art. How would the audience react? Would your classification facilitate the public's appreciation of art?

You may want to examine the format of dictionaries, encyclopedias, and other systems of classifying information, both in print and electronic format, to get ideas for this project.

Chapter 9

Criteria for Art Appreciation

Select three works of art with one common denominator (such as subject matter, materials, size, or gender of artist) from different cultures and times. Which do you consider the best work? What are your criteria for evaluating art? What is more important for you in this process? Using your own system of values, identify specific elements in each work selected that you consider essential in qualifying them as art. Also, examine the elements that you perceive to be missing and, therefore, why, in your opinion, the work does not qualify as art. For example, the artist's participation in the creation of the art is important to your evaluation of art.

Chapter 10

Same Art, Different Interpretations

Select a work of art and ask your colleagues, family, and friends what they think about it. Then, using their point of view, analyze the work of art using different methodologies that you think would work best. What do you perceive to be the essential differences in the resulting diverse interpretations? Which one do you prefer? Why? What is the value of looking at and interpreting art from various perspectives?

Conclusion

Art Awareness

For this assignment, you have to create an event/project that will make art more accessible and relevant to a wider audience. You have first to decide why you think art is important and how you could effectively connect with the audience. Below are some questions that will help you develop this project.

- What is your opinion of art?
- What are you trying to get across?
- How do you plan to get your message across?
- What would your project be: an advertisement in a magazine, a television special, part of a cosmetic line?
- Where will your project be: school, store, library, or movie theater?
- Who is your audience?
- Are you going to involve sponsors? If so, who are they, and why would they want to support art and your project?
- What do you want to accomplish with this project?

The essay must include a strong argument for the value of your project and the relevancy of art in contemporary culture.

Appendix 3
Glossary

This section includes brief information about the artists, art critics, philosophers, art periods, terms, and concepts discussed in the text. For more information about these and other terms and artists, consult the Grove Dictionary of Art Online, www.groveart.com (library or individual subscription required), the MoMA Art Terms Index posted on the museum's website, www.moma.org (free), and other sources listed in the Bibliography.

abstract/abstraction. Define both a simplification process and an artwork with limited or no connections to reality. For the latter meaning, *non-representation* and *non-figurative* are also used.

Abstract Expressionism. Influential and internationally recognized American art movement of the 1940s and 1950s concerned with abstracted forms expressing emotional content. Artists include Jackson Pollock and Mark Rothko.

Academic (art/artist). Identifies art which represents the values of academic institutions. In the modern era it is used to distinguish traditional art from avant-garde developments.

Akhenaten (1353–1336 BCE). Egyptian pharaoh during the Amarna Period of the New Kingdom Period (*ca.*1550–1070). Other pharaohs during the New Kingdom include Tutankhamen.

Alberti, Leon Battista (1404–1472). Italian Renaissance architect and theorist whose building and designs are among the primary examples of Classical influence in Renaissance art. His theories were published in several books including *On Painting*, 1436.

Almaraz, Carlos (1941–1989). Mexican American artist, a founding member of Los Four artists' collective, who played a crucial role in creating awareness for Chicano/a art and culture.

Alÿs, Francis (b. 1959). Belgian-born video artist who lives in Mexico City and whose work reflects on the intersections between physical, social, and political

The Art of Understanding Art, First Edition. Irina D. Costache.
© 2012 Blackwell Publishing Ltd. Published 2012 by Blackwell Publishing Ltd.

spaces. He was recently named one of the ten most important contemporary artists (*Newsweek,* June 2011).

Anatsui, El (b. 1944). Ghanaian-born artist who lives in Nigeria. His recent mixed-media works, made with discarded materials, gained international recognition and have been exhibited by major art institutions including the Met and the Venice Biennale. Installation at Palazzo Fortuny, Venice, Italy, 2007.

Andre, Carl (b. 1935). American minimalist sculptor, whose geometric forms articulate a sense of purity and often challenge the expected three-dimensional qualities of sculpture. *144 Pieces of Zinc,* 1967.

Anguissola, Sofonisba (*ca.*1532–1625). Italian Renaissance painter, one of the first women to be recognized as an artist in the early modern period, who worked for almost a decade at the Spanish court. Her body of work and documented dialogues with artists of the period confirm her prominent position in the artistic context. *Bernardino Campi Painting the Portrait of Sofonisba Anguissola, ca.*1550.

Arman (1928–2005). American artist, born in France, whose work consistently reflects on art practices and materials. His large sculptures and installations make extensive use of found objects. *Long-term Parking,* 1982.

Arts and Crafts Movement. Late nineteenth-century movement concerned with the value, aesthetics, and social implications of craftsmanship and preoccupied mostly with the decorative arts, design, and architecture. In contrast to the avant-garde, the past was a visual and conceptual source of inspiration for this movement.

Asco. Los Angeles-based Chicano art collective active from the early 1970s until the mid-1980s, with a seminal role in introducing Chicano/a culture to the art world. The turning point for the group was the realization that in the early 1970s Mexican American artists were not represented in the Los Angeles County Museum of Art. (The word *asco* means "disgust"/"nausea" in Spanish.)

avant-garde. Defines innovative directions in modern art. (See Chapters 1 and 9.)

Baca, Judith, F. (b. 1946). Los Angeles-based American artist and muralist, co-founder of the Social and Public Art Resource Center (SPARC), an organization whose mission is to engage the community in civic art projects. *The Great Wall of Los Angeles,* 1976–.

Baldessari, John (b. 1931). American conceptual artist who intertwines photography, text, and painted shapes to create images that question art practices and norms of representation.

Balla, Giacomo (1871–1958). Italian artist, a founding member of the Futurism, preoccupied with the depiction of speed and motion. He later became interested in geometric forms and decorative designs. *Speed,* 1913.

Banksy (b. 1974). Assumed name of the British graffiti artist who intertwines street art with mainstream practices and mass-media communication. His recent film, *Exit Through the Gift Shop* (2010), documents the strategies of several graffiti artists.

Barney, Matthew (b. 1967). American artist, best known for the *Cremaster Cycle* (1994-2002), a project comprising five films and related artworks, which uses complex symbols to reflect on the construction of cultural norms and biological and sexual differences.

Baroque. Defines the style of the art from the late sixteenth to the early eighteenth centuries. The characteristics of the period include interest in movement, light, and emotions, with significant idiosyncrasies within specific national and religious contexts.

Bates, Sara (b. 1944). American artist whose work reflects visually and conceptually on Native American tradition. *Honoring,* 1997.

Bauhaus (1919–1933). Innovative art and design school in Germany with great influence on twentieth-century art, design, and architecture, established in 1919 in Weimar and closed in 1933 by the Nazi regime. Teachers at the school included famous artists such as Vassily Kandinsky.

Beckmann, Max (1884–1950). German Expressionist artist, whose work was strongly influenced by social and political issues, as well as his experiences in World War I. His art was included in the 1937 Degenerate Art exhibition (see textbox in Chapter 3).

Bell, Larry (b. 1939). American Minimalist artist best known for his simple, geometric sculptures, in particular cubes, made of glass and displayed on see-through pedestals.

Benton, Thomas Hart (1889–1975). American artist, part of the 1930s Regionalist movement, interested in depicting in his paintings and murals life in the United States.

Bernini, Gian Lorenzo (1598–1680). Italian Baroque sculptor and architect, one of the most prolific artists of the period, whose sculptural works render with extraordinary craftsmanship the intense drama, movement, and emotions of the period. *Four Rivers Fountain,* Piazza Navona, 1648–51.

Bonheur, Rosa (1822–1899). French painter internationally recognized for her depiction of animals and her feminist stance.

Botticelli, Sandro (1445–1510). Important Italian Renaissance artist who included in his works elements specific to the period, such as Classical antiquity and Neoplatonic philosophy. *Birth of Venus,* 1485.

Bramante, Donato (1444–1514). One of the most important Italian Renaissance architects who also designed the initial plan for St. Peter's Basilica, Rome, altered in the later sixteenth century to reflect the religious changes of the period.

Brancusi, Constantin (1876–1957). Romanian-born French sculptor, whose simple forms and use of materials contributed to the development of new directions in modern sculpture and influenced many artists, including Carl Andre.

Braque, Georges (1889–1963). French painter, best known for developing, together with Pablo Picasso, the Cubist movement. After being wounded in World War I, he changed his rigid and analytical cubist style and opted for sinuous lines and subdued colors. *Still Life with Tenora,* 1913.

Breton, André (1896–1966). French poet, founder of the Surrealist movement and author of the first *Manifesto of Surrealism* (1924).

Brueghel, Jan, the Elder (1568–1625). Flemish painter, primarily interested in still life and landscapes. *The Garden of Eden with the Fall of Man, ca.*1617.

Cabanel, Alexandre (1823–1889). French academic painter, highly acclaimed during his time. *The Birth of Venus,* 1863.

Campi, Bernardino (1522–1591). Italian painter, active in northern Italy.

Carpaccio, Vittore (1460–1525). Venetian painter whose works include detailed observations of life in his city. *Two Venetian Ladies on a Terrace, ca.*1490. *Hunting on the Lagoon,* 1490–95.

Cassatt, Mary (1844–1926). Important American artist, who was part of the Impressionist circle in Paris. Her paintings, drawings, and prints disclose a personal style based on a keen understanding of avant-garde views as well as Japanese art. She also played an important role in introducing American collectors to Impressionism. *In the Loge,* 1878.

Cézanne, Paul (1839–1906). French Post-Impressionist painter, whose interest in representing the geometric inner structure of reality, rather than its superficial layers, had a strong influence on twentieth-century art, Cubism in particular.

Chardin, Jean-Siméon (1699–1779). French painter known for his still-life and genre scenes. *Still Life with Fish, Vegetables, Gougères, Pots, and Cruets on a Table,* 1769.

Charlot, Jean (1898–1979). French artist, active in Mexico and the United States, associated with the Mexican muralists, who was also interested in printmaking.

Chen, Long-Bin (b. 1964). Chinese artist who uses magazines and other discarded paper goods to create sculptures that appear to be made mostly of stone and other traditional and durable materials.

Chicago, Judy (b. 1939). Influential American artist internationally recognized for her seminal contribution to the development of Feminist Art in the 1970s. Her collaborative installation *The Dinner Party* (1974–79), a celebration of women in history, is a major work of the late twentieth century. *Womanhouse,* 1972.

Chihuly, Dale (b. 1941). American artist known for his exquisite, large and colorful glass sculptures.

Christo (b. 1935) and Jeanne-Claude (1935–2009). Collaborative husband and wife team, whose large-scale projects are created within the natural or built environment. *The Gates,* 1979–2005.

Church, Frederic Edwin (1826–1900). American painter, who further developed the landscape tradition established by Thomas Cole and the Hudson River School.

Classical. Defines ancient Greek and Roman civilizations from approximately 500 BCE to the fourth century CE. Also used to designate the ideals and ideas of these cultures (such as balance and proportions, the central role of the

individual, and the notion that art should be an imitation of reality). The term *classic* also means (1) values that have endured over time; (2) a high level of achievement; and (3) a concise, clear, and balanced visual vocabulary based on general principles.

Cole, Thomas (1801–1848). American landscape painter, one of the most significant figures in the Hudson River School (a term used to define several nineteenth-century artists inspired by nature and its nationalistic symbolism). *View from Mount Holyoke, Northampton, Massachusetts, after a Thunderstorm – The Oxbow*, 1836.

Colescott, Robert (1925–2009). American painter, who uses bold colors and references to art-historical landmarks to critique stereotypes with wit and irony. *Demoiselles d'Alabama*, 1985.

Conceptual Art. A development in the late 1960s and 1970s, with significant influences on later art movements, and concerned primarily with ideas and theoretical issues rather than visual aspects.

Constable, John (1776–1837). One of the most important English landscape artists, who had a significant influence on French nineteenth-century art.

Contemporary (art). The term defines the present time, but it is often used to designate art created as far back as 1950s. It also means coexistence within the same period.

Courbet, Gustave (1819–1877). French painter, a leading artist of Realism, concerned with an objective depiction of reality, whose art and stance against cultural norms and practices influenced many avant-garde artists. *The Artist's Studio: A real allegory of a seven year phase in my artistic and moral life*, 1855.

Cubism. Important twentieth-century art movement developed by Pablo Picasso and Georges Braque starting around 1907, concerned with a novel, and more comprehensive representation of the three-dimensional space on a two-dimensional surface. Cubism influenced many twentieth-century avant-garde movements and artists.

Dada. Avant-garde movement launched in the second decade of the twentieth century, initially in Zurich, Switzerland, which later spread to other European cities as well as New York, that challenged many tenets of Western art and culture.

Dali, Salvador (1904–1989). Well-known Spanish Surrealist painter, who was also interested in film, theater, and photography. *Un Chien Andalou,* 1929.

Daosheng, Guan (1262–1319). Chinese poet and artist, known for her paintings and calligraphy.

David, Jacques-Louis (1748–1825). One of the most important French Neoclassical artists who later became Napoleon's official painter, and who had a significant influence on French and European painting.

Degas, Edouard (1834–1917). Acclaimed French Impressionist artist, best known for his representations of ballerinas and his use of pastels.

De Kooning, Willem (1904–1997). American artist, part of the Abstract Expressionist movement.

Delacroix, Eugène (1798–1863). French Romantic artist whose paintings and theory influenced nineteenth-century artists, including the Impressionists and Post-Impressionists. *Liberty Leading the People*, 1830.

De Maria, Walter (b. 1935). American artist best known for his earthworks. *Lightning Field*, 1977.

Derrida, Jacques (1930–2004). French philosopher whose writings had a great impact on contemporary art and theory.

Donatello (1386–1466). One of the most important Italian Renaissance sculptors whose work, representative of the core characteristics of the period, influenced many artists including Michelangelo.

Dubuffet, Jean (1901–1985). French artist, whose interest in Art Brut ("raw art") – works created by non-professionals and outside the norms, values, and practices of the art world – was also reflected in his paintings.

Duchamp, Marcel (1887–1968). French artist whose bold views and ideas about art influenced many twentieth-century artistic developments, including Conceptual Art and Postmodernism. *Fountain,* 1917.

Dürer, Albrecht (1471–1528). German artist and theorist, renowned for his paintings and widely circulated prints, considered one of the most important contributors to Northern European Renaissance.

Eakins, Thomas (1844–1916). American painter, photographer, and educator whose keen observations of reality balanced with a mastery of light and color made him one of the most important artists of the nineteenth century.

Evans, Walker (1903–1975). American photographer known for his documentary project for the Farm Security Administration (FSA) during the Depression era. *Allie Mae Burroughs, Hale County, Alabama,* 1936.

Fauvism. Early twentieth-century art movement interested in using bold colors and visible brushstrokes, which influenced German Expressionism. The name *fauvism* (in French, *fauves* means wild beasts) was derogatorily given to the movement by an art critic in 1905.

Finley, Karen (b. 1956). American performance artist whose sexually explicit art created controversy in the late 1980s and early 1990s.

Flavin, Dan (1933–1996). American Minimalist artist known for his use of fluorescent light in his sculptures and installations.

Francesca, Piero della (ca.1415–1492). Major Italian Renaissance artist, whose paintings reflect a keen understanding of perspective. He also wrote theoretical texts on geometry and perspective.

French Art Academy. Institution founded in France in 1648 with an influential role in art and culture for over two centuries. It supported official exhibitions, called *salons*.

Freud, Sigmund (1856–1939). Founder of psychoanalysis.

Friedrich, Caspar David (1774–1840). Important German Romantic painter whose novel and unique landscapes represent nature as symbolic and spiritual.

Futurism (Italian Futurism). Twentieth-century avant-garde movement founded in 1909, interested in modern life and technology, whose views were articulated in painting, sculpture, photography, film, and theater, as well as in multiple texts published as manifestos, essays, and even leaflets.

Gamboa, Harry, Jr. (b. 1951). American artist, founding member of Asco, whose work reflects on Chicano identities, experiences, and aesthetics.

Gaudí, Antonio (1852–1926). Spanish architect whose unique style was influenced by modern views and his interest in nature. Sagrada Familia (Holy Family) Church, Barcelona, Spain, 1926–.

Gauguin, Paul (1848–1903). Important and influential Post-Impressionist French artist, whose life in the South Pacific and interest in nature shaped his art and artistic views.

Gehry, Frank (b. 1929). Canadian American architect known for his playful forms and innovative use of materials that defy traditional structures. Guggenheim Museum, Bilbao, Spain, 1997.

Gentileschi, Artemisia (1593–1653). Important Italian Baroque painter, whose recognition and success was unprecedented for a woman during this period. She was able to overcome the traumatic events that marked her early life (she was raped and tortured during the subsequent legal procedures) to become an accomplished artist whose work was commissioned by many important patrons. *Venus and Cupid, ca.*1625–1630.

German Expressionism. Defines several cultural and artistic movements developed in Germany before and after World War I, including *Die Brücke* and *Der Blaue Reiter*.

Gérôme, Jean-Léon (1824–1904). French academic painter.

Gordon, Douglas (b. 1966). Internationally recognized Scottish video artist.

Goya, Francisco de (1746–1828). Important Spanish Romantic artist, known for the portraits created while he was a court painter, but also for his paintings and prints that critically reflect on historical, social, and political issues. *Charles IV and his Family,* 1801.

Greenberg, Clement (1909–1994). An influential American art critic and a strong supporter of Abstract Expressionism and Jackson Pollock.

Gronk (b. 1954). American artist, founding member of the Asco group, whose work includes murals, paintings, and stage designs.

Hampton, James (1909–1964). American folk artist, whose religious-inspired art made of found objects was discovered only after his death. *The Throne of the Third Heaven of the Nations Millennium General Assembly, ca.*1950–64.

Hannock, Stephen (b. 1951). American artist whose work reflects on and celebrates traditional landscape painting. *The Oxbow: After Church, After Cole, Flooded,* 2000.

Hawkinson, Tim (b. 1960). American artist who uses diverse and eclectic materials and tools to create elaborate sculptures and large multimedia installations. *Überorgan,* 2007.

Hirst, Damien (b. 1965). Innovative British artist known for his large installations comprising dead animals preserved in formaldehyde and for a platinum replica of a human skull covered with diamonds. *Aubade, Crown of Glory,* 2006.

Hokusai, Katsushika (1760–1849). Japanese artist whose prints have influenced many nineteenth-century artists, including the Impressionists. *The Great Wave at Kanagawa, ca.*1831–33.

Hunter, Clementine (1886–1988). American folk artist.

Impressionism. Avant-garde art movement developed in the second half of the nineteenth century concerned mostly with depicting landscapes and city life, using a colorful painterly style based on perception and immediate "impression." The movement was influenced by Japanese prints, photography, and color theories of the period. Dismissed initially, Impressionism gained international recognition and left a significant imprint on the development of modern art. Artists in this group include Monet and Degas.

Ingres, Jean Auguste Dominique (1780–1867). French artist known for his rigorously depicted portraits and his rejection of the Romantic style. *Portrait of La Comtesse d' Haussonville,* 1845.

Kahlo, Frida (1907–1954). Mexican artist internationally recognized for her unique style and powerful imagery, as well as her tumultuous marriage to artist Diego Rivera. She has become a role model for many women artists. *Self-Portrait with Cropped Hair,* 1940.

Kahn, Louis (1901–1974). American architect known for his restrained modernist style. Kimbell Art Museum.

Kandinsky, Vassily (1866–1944). Russian-born artist, a key figure in the German Expressionist group *Der Blaue Reiter,* who played an important role in the development of abstraction.

Kauffmann, Angelica (1741–1807). Swiss artist, one of the founding members of the British Royal Academy.

Kelly, Mary (b. 1941). American artist whose work is rooted in Postmodern feminist theories.

Kirchner, Ernst Ludwig (1880–1938). Important German artist, one of the founders of the German Expressionist group *Die Brücke.*

Koons, Jeff (b.1955). American artist, concerned with mundane subjects, popular culture, and mass media, who uses a variety of traditional and innovative materials. *Puppy,* 1992.

Kosuth, Joseph (b. 1945). American Conceptual artist. *One and Three Chairs,* 1965.

Kristeva, Julia (b. 1941). Bulgarian-born French feminist theorist.

Kruger, Barbara (b. 1945). American artist whose work intertwines text and image to emulate advertising and other mass-media strategies.

Lacan, Jacques (1901–1981). French psychoanalyst and philosopher.

Lavier, Bertrand (b. 1949). French artist who intertwines artistic practices with everyday life. *Giulietta,* 1993.

Léger, Fernand (1881–1955). French artist, associated with the Cubist movement, interested in the aesthetics of the machine. *Ballet Méchanique*, 1924.

Lempicka, Tamara de (1898–1980). Polish Art Deco artist known for her precisely stylized and vividly colored portraits with subtle connections to Cubism.

Leonardo da Vinci (1452–1519). Italian Renaissance artist and thinker, one of the most important and influential figures of the era. He is best known for his paintings, but his interests, revealed in notebooks, were vast and diverse, ranging from architecture to optics and from war machines to anatomy. *The Last Supper*, 1495–98; *Mona Lisa*, 1503–05.

Levine, Sherrie (b. 1947). American artist best known for her appropriation of modernist works. *Fountain (After Marcel Duchamp: A.P.)*, 1991.

Leyster, Judith (1609–1660). Dutch painter who depicted mostly genre scenes and portraits; one of the few women artists of the period.

Libeskind, Daniel (b. 1946). Polish-born American architect known for his innovative designs. Denver Art Museum, 2006.

Lichtenstein, Roy (1923–1997). American Pop artist best known for creating paintings that emulate the comic-book style.

Luna, James (b. 1950). American artist whose work reflects on cultural identities and artistic practices. *Artifact Piece*, 1987.

Lyotard, Jean-François (1924–1998). French philosopher whose writings on Postmodernism had a significant influence on contemporary art and theory.

Lysippos (active *ca.*370–300 BCE). One of the most important Greek sculptors of the period.

Magritte, René (1898–1967). Belgian Surrealist artist known for his playful and thought-provoking imagery. *This is Not a Pipe*, 1929.

Manet, Édouard (1832–1883). Important French artist with a seminal role in the development of modern art. His innovative style and subject matter generated much controversy at the time and paved the way for Impressionism and other avant-garde movements. *Déjeuner sur l'herbe*, 1863; *Olympia*, 1863.

Man Ray (1890–1976). American artist associated with Dada and Surrealism who worked mostly in France. He is best known for his photographs and contribution to avant-garde films.

Manzoni, Piero (1933–1963). Italian conceptual artist who mixes traditional practices and media with unusual materials, such as fur and bread. *Line of Infinite Length*, 1960.

Mapplethorpe, Robert (1946–1989). American artist, known for his large, powerful black-and-white photographs. His explicit representations of male nudes generated controversy in the 1980s.

Matisse, Henri (1869–1954). French painter, a leading member of Fauvism, whose work reflects his interest in bold color and defined organic shapes as well as his impressive draftsmanship.

Mesa-Bains, Amalia (b. 1943). American artist who reflects on and exposes the construction of women's identities within social and cultural norms. *An Ofrenda for Dolores Del Río,* 1984.

Michelangelo Buonarroti (1475–1564). Italian sculptor, painter, and architect, one of the most important artists of the Renaissance, best known for his frescoes in the Sistine Chapel in Rome and the sculpture of David in Florence. His architectural projects include work for St. Peter's Basilica in Rome, completed after his death. *David,* 1504; Sistine Chapel, *Creation of Adam,* ceiling, 1508–12; *The Last Judgment,* 1535–41.

mimesis. Signifies the imitation (mimicking) of reality, a focal concern of ancient Greek art, revived in the Renaissance.

Minimalism. Art movement of the 1960s concerned with presenting basic geometric forms that embody essential visual and conceptual elements. Artists include Larry Bell and Carl Andre.

Modern. Defines the time period after 1850 until about the 1960s. *Modernism* and *Modernist* specifically refer to innovative ideas of the period discussed in Chapter 9. Modern (art) is also often used as a synonym for *Contemporary.* Sometimes the term is used for periods that go back to the late eighteenth century (which many experts consider the emergence of the modern world), and even the Renaissance. The term "early" is added to "modern" when referring to the period that goes back to the 1500s. The reason why this term is applied to such broad eras is that many characteristics specific to the modern period are rooted in the Renaissance.

Modersohn-Becker, Paula (1876–1907). German painter and printmaker, whose style is associated with and anticipates Expressionism.

Mondrian, Piet (1872–1944). Dutch artist who developed an abstract style visually defined by vertical and horizontal lines and primary colors and who was conceptually influenced by Theosophy, a complex modern philosophy that synthesizes knowledge and spirituality into an all-inclusive view.

Monet, Claude (1840–1926). One of the most significant and prolific French Impressionist painters whose interest in nature is visible throughout his career. He is best known for his series paintings including those of water lilies, inspired by his garden at Giverny. *Sunrise: Impression,* 1872.

Morse, Samuel F.B. (1791–1872). American painter, also interested in technology and communication, who contributed to the invention of the telegraph and was the creator of Morse code. *Gallery of the Louvre,* 1831–33.

Mueck, Ron (b. 1958). Australian sculptor whose lifelike, oversized sculptures representing the human figure surprise and even discomfit audiences. *Boy,* 1999.

Munch, Edvard (1863–1944). Norwegian artist, whose work influenced Expressionism. *The Scream,* 1893.

Murakami, Takashi (b. 1962). Japanese artist, who, in his work, combines traditional materials and styles with popular culture and mass media.

Neel, Alice (1900–1984). American artist known for her powerful portraits in which the figures and space are defined by colorful shapes and clear contours.

Neoclassicism. Style of the second half of the eighteenth century, influenced by Classical ideas.

Neoplatonic philosophy. A philosophy with ties to Classical antiquity and Christianity specific to the Italian Renaissance. Many artists of the period, including Botticelli and Michelangelo, were familiar with these ideas.

Nevelson, Louise (1899–1988). Russian-born American artist, known for her large-scale abstract sculptures. *Sky Cathedral*, 1958.

Nolde, Emil (1867–1956). An important German Expressionist artist associated with the *Die Brücke* group.

O'Keeffe, Georgia (1887–1986). American painter, one of the most influential women artists of the twentieth century, known for her stylized close-up representations of flowers and her imagery related to New Mexico, where she spent the later part of her life.

Ono, Yoko (b. 1933). Japanese American artist, known for her feminist work and her marriage to John Lennon. *Cut Piece*, 1964.

Oppenheim, Meret (1913–1985). Swiss artist associated with Surrealism, whose work reflects on women and gender differences. *Object (Fur Breakfast)*, 1936.

Orlan (b. 1947). French artist, who uses her body to reflect on ideas of beauty and artistic values. *Refiguration-Self-Hybridation #17*, 1998.

Orozco, Gabriel (b. 1962). Mexican artist, who uses ordinary objects to initiate a dialogue with the audience. *Citroën DS*, 1993.

Ortiz Torres, Rubén (b. 1964). Mexican painter and installation artist, whose art blurs the distinctions between high and low in contemporary culture. *Lowrider*, 1999.

Oursler, Tony (b. 1957). American artist, whose complex multimedia installations include video, sound, found objects, and figures. *Studio: Seven Months of My Aesthetic Education (Plus Some) NYC Version*, 2005.

Pei, I.M. (b. 1917). Chinese American architect internationally recognized for his innovative designs. Louvre pyramid, 1989.

Perspective. A geometrical system of representing space on a two-dimensional surface. (See Chapter 6 and Appendix 4, Diagram 3.)

Piano, Renzo (b. 1937). Italian architect, a significant contributor to Postmodern architecture. Center Pompidou, Paris, 1972–77.

Picabia, Francis (1879–1953). French painter and writer connected to many avant-garde movements, including Dada and Surrealism.

Picasso, Pablo (1881–1973). Spanish artist, active in France, one of the most prolific and influential figures in modern art. Early in his career together with Braque, he developed Cubism, a style that would continue to permeate his work, even though his later paintings also show a Classical influence and a more

painterly approach. In addition to paintings and drawings he also created sculptures, prints, and ceramics. *Les Demoiselles d'Avignon*, 1907. *Guernica,* 1937.

Pollock, Jackson (1912–1956). American painter, one of the most important artists of Abstract Expressionism, known for his innovative processes (painting on the floor and pouring paint from cans) which emphasize the determinant role of inner creativity over external factors.

Post-Impressionism. Defines several avant-garde artists and directions in art in the last two decades of the nineteenth century, derived from and reacting to Impressionism. Artists include Van Gogh, Gauguin, Cézanne, and Seurat.

Powers, Hiram (1805–1873). American Neoclassical sculptor, known for his refined representation of the human figure. *The Greek Slave*, 1844.

Praxiteles (active *ca.*375–340 BCE). One of the best-known and influential Greek sculptors of the period, whose sculpture *Aphrodite of Cnidos* was the first life-size representation of a nude female in this culture.

Puryear, Martin (b. 1941). American sculptor interested in simple, abstracted forms made with extraordinary craftsmanship and a keen understanding of materials.

Quinn, Marc (b. 1964). British sculptor, whose preoccupation with human identity within social and cultural norms is reflected in his choice of materials, scale, and subject matter. *Alison Lapper,* 2004.

Raphael (Raffaello Sanzio) (1483–1520). One of the most important artists of the Italian High Renaissance, known for his exquisite painting style, defined by subtle colors and smooth transitions. His religious subjects, portraits, and famous frescoes in the papal rooms, primary examples of this artistic period, disclose a complex visual and conceptual understanding of Classical tradition and Renaissance values. *The School of Athens, ca.*1510–12.

Rauschenberg, Robert (1925–2008). Very influential American artist associated with the Pop Art movement and internationally recognized for his innovative inclusion of popular culture and ordinary materials in his work. *Bed, 1955.*

Realism. Identifies an art that imitates reality in two- or three-dimensional media (realistic art). Realism (capitalized) is also the name of an artistic movement in mid-nineteenth-century France.

Rembrandt van Rijn (1606–1669). Dutch Baroque artist, whose unique painterly style, heightened by a sophisticated use of light and dark, visible in his paintings as well as etchings, made him one of the most important and influential artists of the period. His work includes numerous portraits and self-portraits and many religious themes. *The Entombment of Christ, ca.*1636–39, *The Resurrection of Christ, ca.* 1635–39.

Renaissance. Defines the cultural period that started in Italy around 1400, subsequently spread to other European countries and lasted until about 1600. The word means "rebirth" in French and it is a reference to the revival of the ideals and ideas of Classical Antiquity during this period. Renaissance art, influenced

by humanism, and in contrast to the Middle Ages, placed an emphasis on the individual and aimed to visually and conceptually intertwine religion, reality, knowledge, reason, and Classical norms. The works and ideas created during this period had a profound influence on the Western tradition and the modern world.

Richter, Gerhard (b. 1932). Prolific German artist internationally acclaimed for both his realist as well as his abstract works.

Rigaud, Hyacinthe (1659–1743). French Baroque painter recognized for his portraits. The most famous work is the portrait of *Louis XIV*, 1701.

Ringgold, Faith (b. 1930). American artist who uses quilts as her medium to reflect on identity, art practices, and cultural norms. *Dancing at the Louvre*, 1991.

Rococo. Style of the early eighteenth century, often called "late Baroque," known for its excessive ornamentation and playful subject matter, more widely used in the decorative arts.

Rodin, Auguste (1840–1917). Important French sculptor whose innovative style and understanding of three-dimensional forms played a significant role in establishing the foundations of modern sculpture. *The Burghers of Calais*, 1884–89.

Rogers, Richard (b. 1933). Internationally acclaimed British architect, whose structures reflect Modernist influences and Postmodernist elements. Centre Pompidou, Paris, 1972–77.

Romanticism. Cultural movement encompassing the late eighteenth and early nineteenth centuries visible in music, art, and literature. Its broad concerns, such as individual emotions and experiences and interest in nature, reflect and are connected to some of the issues facing the emerging modern world.

Rothko, Mark (1903–1970). Latvian-born American artist, a major figure of Abstract Expressionism, whose painterly canvases suggest tranquil meditation.

Rousseau, Henri (1844–1910). French self-taught painter, whose work influenced many avant-garde artists. (Also known as *Le Douanier*, or "customs officer" in French). *The Dream*, 1910.

Rubens, Pieter Paul (1577–1640). Flemish Baroque painter, one of the most important artists of the period, whose unique colorful painterly style and dynamic compositions influenced artists beyond national and chronological boundaries. He was employed by kings as an artist and diplomat. *The Garden of Eden with the Fall of Man*, ca.1617.

Ruppersberg, Allen (b. 1944). Conceptual American artist who uses innovative methods and materials, including text and images, to create novel and unexpected narratives. *The New Five-Foot Shelf*, 2004.

Ruscha, Ed (b. 1937). Important American artist, associated with the Pop Art movement, best known for his simple, stylized urban views, often intertwined with words, signs, and references to the mass media. *Chocolate Room*, 1970.

Sant'Elia, Antonio (1888–1916). Italian architect, member of the Futurist movement, whose innovative drawings and writings have influenced modern architecture.

Sargent, John Singer (1856–1925). Important American painter, who lived mostly in Europe, acclaimed for his large portraits that combined realism with a more informal painterly style. *Madame X,* 1884.

Schapiro, Miriam (b. 1923). American artist, first associated with Abstract Expressionism and later the Pattern and Decoration movement, who uses ordinary objects, such as lace and buttons, to reflect on feminist issues. She collaborated with Judy Chicago on the *Womanhouse* project, 1972.

Schnabel, Julian (b. 1951). American artist, who incorporated broken plates in his early paintings. He has become a successful filmmaker.

Serra, Richard (b. 1939). American artist known for his large metal sculptures, often created for outdoor public spaces. *Tilted Arc,* 1981, removed 1989.

Seurat, Georges (1859–1891). French Post-Impressionist painter, known for his meticulous pointillist style based on contemporary color theories.

Sherman, Cindy (b.1954). American artist whose photographs, in which she becomes unrecognizable in assumed identities, expose and question the role of women in culture, art, and society.

Smithson, Robert (1938–1973). American sculptor and conceptual artist, best known for his earthwork projects. *Spiral Jetty,* 1970.

Stieglitz, Alfred (1864–1946). Important photographer and influential figure in American art, editor of the journal *Camera Work,* 1902–17, director of *Gallery 291,* 1905–17, and a major supporter of modern art. He was married to Georgia O' Keeffe. *Flatiron Building,* 1902.

Struth, Thomas (b. 1954). Important German artist, whose photographs explore a wide range of themes, including family portraits, cityscapes, and museum interiors. *Musée d'Orsay, Paris, 2,* 1989.

Stubbs, George (1724–1806). English artist, known for his paintings of horses. *Horse Devoured by a Lion,* 1763.

Surrealism. Cultural movement linked to Dada, developed in the 1920s by the French poet André Breton, influenced by Freudian theories and whose main concerns included an exploration of dreams, the subconscious, and their relationships to reality. Best known for its accomplishments in the visual arts, painting, photography, and film.

Symbolism. A late nineteenth-century movement, linked to developments in poetry and literature and concerned in the visual arts with mystical views and the symbolic meaning of lines and color.

Toulouse-Lautrec, Henri de (1864–1901). French artist, who depicted cafés, music halls, and other aspects of Parisian life, and is best known for his posters of cabarets.

Turner, Joseph Mallord William (1775–1851). English Romantic landscape artist known for his dramatic and awe-inspiring representations of nature, whose innovative painting style influenced the Impressionists, Monet in particular. The Turner Prize, established in 1984 to recognize new developments in British art, was named after him.

Valadon, Suzanne (1865–1938). French painter, a model for many artists of the period, who gained recognition for her personal style and her representation of female figures.

Valdez, Patssi (b. 1951). American artist, the only woman of the Asco group, whose work reflects on Chicano/a issues and self-identity.

van Eyck, Jan (*ca.*1385–1441). One of the most important Flemish painters of the fifteenth century, known for his attention to detail and ability to represent the effects of light on different materials and surfaces. *Portrait of Giovanni(?) Arnolfini and His Wife*, 1434.

van Gogh, Vincent (1853–1890). Dutch Post-Impressionist painter, one of the most recognized and celebrated artists today. His works include landscapes, still life, and portraits. He is best known for his dynamic brushstrokes and intense colors, visible in the paintings created in the south of France during the last years of his life. *Self Portrait before Easel, Van Gogh's Chair, The Night Café*, all 1888; *The Starry Night*, 1889; *Irises*, 1890.

Vasari, Giorgio (1511–1574). Italian painter, architect, and writer, whose book on artists established an enduring biographical approach in art-historical methodologies.

Velázquez, Diego (1599–1660). Spanish Baroque painter, one of the most important artists of the period, whose keen observation of reality, understanding of light, and painterly style influenced Goya, Manet, and Picasso, among many others. *Las Meninas (The Maids of Honor)*, 1656.

Venus. Roman goddess of love, often represented with Cupid (her son). The Greek equivalent is Aphrodite.

Vermeer, Johannes (1632–1675). Dutch Baroque painter, best known for his meticulously depicted interior scenes and his extraordinary rendering of light.

Veronese, Paolo (1528–1588). Italian Renaissance painter, known for his elaborate compositions, bold chromatic choices, and the illusionistic quality of his paintings and murals. *Feast in the House of Levi (The Last Supper)*, 1573.

Verrocchio, Andrea del (*ca.*1435–1488). Italian sculptor and painter, mostly recognized for his sculptural works, who trained many artists, including Leonardo da Vinci.

Viola, Bill (b. 1951). American video artist whose visually stunning narratives, created with innovative technologies and often involving performers, have poetic and reflective connotations.

Walker, Kara (b. 1969). American installation artist and painter, who reflects on gender, race, and identity, using, among other elements, dark silhouettes outlined against the background. *Darkytown Rebellion*, 2001.

Warhol, Andy (1928–1987). American artist internationally recognized for his role in the Pop Art movement. His use of and references to the mass media and popular culture had significant influence on many cultural developments and shaped the views of many artists. *Campbell's Soup Cans*, 1962; *Gold Marilyn Monroe*, 1962.

Wen Cheng-ming (1470–1559). Important Chinese artist and calligrapher.

West, Benjamin (1738–1820). American artist, active in Britain, known for historical paintings and his role as founding member and later head of the British Royal Academy. *Benjamin Franklin Drawing Electricity From the Sky, ca.*1805.

Western. Defines cultures and societies in particular geographical areas that are derived from, rooted in, or influenced by the classical tradition and its legacies.

Whistler, James McNeill (1834–1903). American painter and printmaker active in England and France, whose work, connected to artistic concerns of the late nineteenth century, also displays an innovative, more abstract painterly style. *Nocturne in Black and Gold: the Falling Rocket*, 1875; *Peacock Room*, 1876–77.

Wilson, Fred (b. 1954). American conceptual artist preoccupied with exposing issues of identity and cultural marginalization, using museums and institutional practices as his medium and object of analysis. *Mining the Museum,* 1992.

Winckelmann, Johann Joachim (1717–1768). German archaeologist whose views on classicism have shaped the foundations of art history.

Wright, Frank Lloyd (1867–1959). American architect, one of the most important and influential figures in twentieth-century architecture.

Xu Bing (b. 1955). Chinese artist who uses language to reflect on cultural values and means of communication. *A Book from the Sky,* 1987–91.

Appendix 4

Diagram 1

The work of art:
the "tools of the trade"

Form

Elements of design
The basic elements used to create a work of art.

Principles of design
The arrangement of formal elements in a work of art.

See other diagrams in this appendix and also Chapter 6.

Form

Medium/Media

Content

Content

Refers to what the work of art is about, what is depicted, and what its meaning might be.

Theme. A recurring broad subject (such as love or nature) represented across time and cultures.

Subject matter. The specific story depicted in a work of art.

Title. The name or brief description that defines a work of art and helps explain its meaning. Many titles of older art have been added later, based on the content of the work.

See other diagrams and also Chapter 6

Medium/Media

The term medium (plural media) has several meanings:

1. The means and methods used by artists to get across their ideas or specific category, such as painting, sculpture, etc.

2. The specific materials used in making art. For example, paint is the medium for painting.

3. Medium is also used as a synonym for the term solvent, or thinner, a liquid used to dilute and mix dry pigments.

See other diagrams in this appendix and Chapter 8 for art classification based on media.

The Art of Understanding Art, First Edition. Irina D. Costache.
© 2012 Blackwell Publishing Ltd. Published 2012 by Blackwell Publishing Ltd.

Diagram 2

Form 1

COLOR

Hue. The purest form of any color of the spectrum/color wheel.

Pigment. The powder that contains the color. Pigments can be natural, mineral, animal, or synthetic.

Saturation. The amount of pure pigment in the color.

Value. The amount of light or dark added to the pigment.

Primary colors (red, yellow, blue).

Secondary colors are formed by mixing two primary colors, e.g., red and yellow = orange. The **color wheel** is divided into two sides: **warm colors** – yellow, orange, and red – and **cool colors** – green, blue, and violet.

Complementary colors are on the exact opposite side of the wheel.

Local color is the color of an object as it appears in reality.

Arbitrary colors are not connected to reality.

Optical color is an effect created by the eye, which mixes small patches of colors placed one next to the other and produces a new one: e.g., blue next to yellow would be seen as green.

Complementary contrast is between two colors opposite each other on the color wheel.

Simultaneous contrast is a visual effect created by a complementary contrast of pure hues.

A palette is a surface used to mix colors. It also defines the colors specific to a work or an artist. A **monochromatic palette** implies the use of only one (mono) color.

Elements of design

Color

Line

Pattern

Space
Texture
Time and Motion

LIGHT

Light is used to create a sense of space in both two- and three-dimensional works.

Value is the amount of light and dark.

Modeling is used to define a process of creating the illusion of volume, using light and shadows or by sculpting a form in clay.

Chiaroscuro is the visible contrast between light and dark, achieved by modeling.

Tenebrism/tenebroso is a strong contrast favored particularly during the Baroque.

Sfumato is a modeling technique where the transition from dark to light is so subtle that no contours are visible.

PATTERN

The repetition of formal elements creates a pattern.

LINE

A line is the trace left on a surface. It can be straight, curved, or free form.

Analytical lines have mathematical precision and present a systematic process.

Contour lines outline exterior shapes and may suggest volume.

Expressive lines have variations in their shape and direction. They are perceived to represent artists' emotional states.

Diagram 3

Form 2

SPACE

Perspective

Perspective is a convention used to represent space on a two-dimensional surface. **Linear perspective** is based on mathematical principles that create the illusion of depth on a picture plane. In *one-point perspective,* the parallel lines that run from the viewer converge in one vanishing point on the horizon line. *Two-point perspective* uses two converging points, each with their own converging lines. **Atmospheric / aerial perspective** refers to the effect the air / atmosphere has on visual perception. Objects and forms closer to the viewer appear to be more defined and have more color, while those further away seem to be less clear and have less contrast and color. **Shape** marks the outline of a two- or three-dimensional form. **Mass** or **positive space** is a form with three-dimensional qualities. **Void** or **negative space** is literally the air around the mass.

Elements of design

Color

Light

Line

Pattern

Space

Texture

Time and Motion

TEXTURE is the visual or tactile quality of a work of art. **Actual or physical texture** is the physical quality of the surface, such as **impasto,** a thick layer of paint. **Implied** or **visual texture** is the suggestion of a material or finish that is not actually there.

TIME AND MOTION

In two- and three-dimensional art time can be represented as a **frozen moment**, a **succession** of developments or in symbolical ways.

Motion can be **suggested** when lines and forms are perceived to "move," **implied** by the repetition of certain forms and shapes, or **actual** when real movement is used, such as in kinetic sculptures.

Diagram 4
Form 3

BALANCE

Balance is the visual equilibrium between various parts of a work of art.
Symmetrical balance is achieved when a composition has similar or identical parts along a central axis. In an **asymmetrical balance**, the two parts are not the same or distributed unevenly along the axis. **Radial balance** is based on a central point from which all parts are distributed.

Principles of design

Balance

Emphasis and Focal Point

Rhythm

Scale and Proportions

Unity and Variety

SCALE AND PROPORTIONS

Scale is size of an object in relationship to its original dimensions, or reality. Proportions refer to the relationships of various parts to the whole.

RHYTHM

The consistent repetition of elements creates a rhythm, which contributes to and enhances unity.

EMPHASIS AND FOCAL POINT

A composition has a focal point of attention, usually the essence of the work, highlighted in some way to draw viewers' attention.

UNITY AND VARIETY

Unity is the consistent use of the same forms, colors, and shapes to create a sense of oneness. Variety is the interruption of this continuity and the introduction of new elements.

Diagram 5
Content

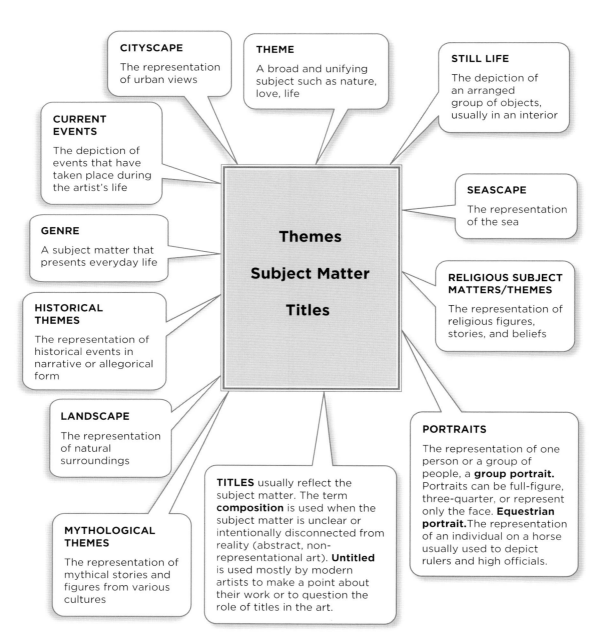

CITYSCAPE
The representation of urban views

THEME
A broad and unifying subject such as nature, love, life

STILL LIFE
The depiction of an arranged group of objects, usually in an interior

CURRENT EVENTS
The depiction of events that have taken place during the artist's life

GENRE
A subject matter that presents everyday life

HISTORICAL THEMES
The representation of historical events in narrative or allegorical form

LANDSCAPE
The representation of natural surroundings

Themes

Subject Matter

Titles

SEASCAPE
The representation of the sea

RELIGIOUS SUBJECT MATTERS/THEMES
The representation of religious figures, stories, and beliefs

PORTRAITS
The representation of one person or a group of people, a **group portrait.** Portraits can be full-figure, three-quarter, or represent only the face. **Equestrian portrait.** The representation of an individual on a horse usually used to depict rulers and high officials.

TITLES usually reflect the subject matter. The term **composition** is used when the subject matter is unclear or intentionally disconnected from reality (abstract, non-representational art). **Untitled** is used mostly by modern artists to make a point about their work or to question the role of titles in the art.

MYTHOLOGICAL THEMES
The representation of mythical stories and figures from various cultures

Diagram 6
Art media 1

DRAWING

Drawings can be: independent works of art, sketches, or supportive material for paintings, sculptures, and other projects. The preparatory drawings for tapestries and frescoes are called **cartoons**. Drawings use **dry media** (**pencil**, **charcoal**, **chalk**, and **pastel**), and **fluid media** (**inks** and **wash** — ink mixed with water). A protective coat of fixative is often sprayed on dry media. The primary support for drawing in modern times is paper.

MOSAIC is a technique that juxtaposes pieces of glass, stone, or tiles, called *tesserae*, to create a design. Mosaics are created for walls, floors, and various objects, as well as three-dimensional works.

FIBER ARTS include works of art that use fabrics and fibers as their primary media. **Tapestry** is a work created by weaving wool, cotton, silk, and other natural and synthetic materials.

PHOTOGRAPHY. A process that uses light to create an image on a surface. Traditional photography employs film to create a *negative*, which, when chemically processed, can be fixed onto a surface and produce a *print*. Multiple prints can be made from one negative. **Digital photography** has eliminated processes and materials specific to traditional photography. There are various categories of photography based on the form or purpose of images, type of equipment, and techniques used. Photography is printed mostly on specially treated paper but also on other materials.

Two-dimensional media
(includes works of art that are primarily two-dimensional)

Drawing
Fiber Arts
Mixed Media
Mosaic
Painting
Photography
Printmaking

MIXED MEDIA is the use of different materials/media in the same work. **Collage** is a work made by pasting different materials. **Photomontage** is a collage of photographs.

PAINTING

A painting is a work of art that uses paint to create images. The paint is applied to a surface called support, and paints are mixed with a solvent. Based on the paint and techniques used, there are several types of painting:
Acrylic: the use of synthetic paint, which can be mixed with water and applied to various supports, including canvas.
Encaustic: an ancient technique using pigments mixed with hot wax.
Fresco: a technique where pigments, mixed usually with water, are applied onto wet plaster. After drying, the paints become literally part of the wall.
Oil painting: the use of pigments mixed with an oil-based binder using solvents (or thinners) applied to wood and other types of panels, and most commonly to canvas.
Tempera: the use of pigments mixed with oil, egg, and water binders applied to a variety of surfaces, including paper, wood, and canvas.
Watercolor: a technique that mixes paint with water, usually applied to paper.

PRINTMAKING is a process of producing multiple similar images.
Relief printing is a printing process where the area around the design to be printed is carved out. The ink, applied with a roller, covers only the raised area of the design. It includes the **woodcut** (a carved-out wood block) and **linocut** (using linoleum).
Intaglio is a process of carving the design into a metal plate. It includes **engraving**, a technique that requires the manual incision of the design onto the plate.
Etching is a similar process, but it uses acid to create the grooves in the metal plate, allowing more visual possibilities. *Drypoint* is similar to engraving, but uses a needle to form ridges, thus creating greater visual variety.
Lithography is a printing technique using stone as the plate. Unlike wood or metal plates, stone could be reused for other works.
Silkscreen is a printing method that uses stencils.

Diagram 7
Art media 2

ARCHITECTURE is an art concerned with creating buildings. (A term also used is "built environment")
Post and lintel is a basic system of building, using two supporting vertical posts on which a horizontal lintel or beam is placed. **Columns** are often used for support.
Arches are curved connections between supporting posts. The best-known types of arches are the **Roman arch** and the **pointed/gothic arch**. The invention of the Roman arch led to the development of **vaults**, **barrel vaults**, and **domes**.
For practical reasons architecture favors durable materials. **Concrete**, invented by the Romans, and **steel and reinforced concrete**, introduced in modern times, have contributed to both the system of building and the visual aspects of structures.
Green/Eco architecture is a contemporary trend reflected in the materials used and the relationship between the building and the environment.

BOOK ARTS
The book is the medium and conceived as a three–dimensional mixed media work of art, which may include text, images, and even electronic media.

Three-dimensional Media
(works of art with three-dimensional elements)

Architecture

Book Arts

Ceramics

Glass Art

Sculpture
Sculpture/Three-dimensional Mixed Media

GLASS ART
This type of art uses glass as its primary medium. Glass-blowing is the process that allows this material, which is soft while hot, to be manipulated into the desired shapes.

SCULPTURE (THREE-DIMENSIONAL MIXED MEDIA)
Assemblage is a three-dimensional work that encompasses a variety of materials, including found objects.
Found objects are works that use everyday objects. Another term is "ready-made."
Installations are temporary works, composed of separate parts arranged in a specific place.
Kinetic (**mobile**) sculptures are works that involve movement, achieved either through a machine or naturally.

CERAMICS are made from clay. There are many different kinds of clay and techniques. Clay is coated with **glaze** before firing. Glazes change their color at high temperatures.
The kiln is a furnace designed for firing clay. The time needed for clay objects to be fired depends on size, method, and glazes, and varies from a few hours to several days.

SCULPTURE
Relief sculpture is connected to a ***two-dimensional surface***. Depending on the differences between the background and the highest protruding area, relief can be **low** (also called **bas-relief**) or **high**.
Freestanding sculpture has a ***full three-dimensional quality*** and can be seen from all sides. A **statue** is a sculpture, usually representing a person, animal, or event.
There are two main **processes** in sculpture:
1 The **subtractive process** involves carving into the material. It is used for stone and wood.
2 The **additive process** means that materials are added to create a sculpture. It has been traditionally used for clay and bronze.

Diagram 8

Art media 3

Body art is an art form where the body is used as support and medium, such as tattoos

Digital media/art is a term that refers to the tools and materials used in art making (e.g. a digital camera) or in the dissemination process (the web, etc.). Artists use digital media for multiple purposes

Performance art includes in the work, in addition to the artist, many eclectic components, and at times involves audience participation

New Media is an umbrella term used to include recent developments in art:

Body Art

Digital Media/Art

Earthworks/ Environmental Art

Multimedia

Performance Art

Time-based Art

Web-based Art

Earthworks and environmental art use nature as their primary medium

Multimedia is a term used for works of art created with a wide variety of materials and media, such as video and electronic art, music, and performance

Time-based art. This term defines a broad range of art, including video, film, and multimedia, where there is a time component in viewing the entire work. **Video art** refers specifically to art created using video as the medium. **Video installations** are works also comprising three-dimensional components. **Animation** uses a variety of processes, including digital media to create "moving images."

Web-based art. This art uses the web for both its dissemination and its creation and is often interactive.

List of Figures and Color Plates

Figures

The Art of Understanding Art, First Edition. Irina D. Costache.
© 2012 Blackwell Publishing Ltd. Published 2012 by Blackwell Publishing Ltd.

Color Plates

Bibliography

Note: more bibliographical entries, particular for online sources, are posted on the book's companion website (http://faculty.csuci.edu/irina.costache/book). The web addresses are current as of the date of publication. If you are unable to access a site, do a web search using the institution's name or the topic as the subject.

General Sources

Berlo, Janet, C., and Phillips, Ruth, B. (1998) *Native North American Art*, Oxford University Press, Oxford and New York.

Chipp, Herschel B., with contributions by Selz, Peter and Taylor, Joshua C. (1968) *Theories of Modern Art: A Source Book by Artists and Critics*, University of California Press, Berkeley and Los Angeles.

Foster, Hal et al. (2004) *Art Since 1900: Modernism, Antimodernism, Postmodernism (2 vols)*, Thames & Hudson, London.

Frascina, Francis and Harrison, Charles (eds) with the assistance of Paul, Deirdre (1982) *Modern Art and Modernism: A Critical Anthology*, Icon Editions, Harper & Row, New York.

Gayford, Martin and Wright, Karen (eds) (1998) *The Grove Book of Art Writing: Brilliant Writing on Art from Pliny the Elder to Damien Hirst*, Grove Press, New York.

Harrison, Charles and Wood, Paul (eds) (2003) *Art in Theory, 1900–2000: An Anthology of Changing Ideas* (new edn), Blackwell, Oxford.

Harrison, Charles, Wood, Paul, and Gaiger, Jason (eds) (1998) *Art in Theory, 1815–1900: An Anthology of Changing Ideas*, Blackwell, Oxford.

Harrison, Charles, Wood, Paul and Gaiger, Jason (eds) (2000) *Art in Theory, 1648–1815: An Anthology of Changing Ideas*, Blackwell, Oxford.

Heartney, Eleanor (2008) *Art & Today*, Phaidon, London.

Hopkins, David (2000) *After Modern Art 1945–2000 (Oxford History of Art series)*, Oxford University Press, Oxford and New York.

Kelen, Emery (ed.) (1990) *Leonardo da Vinci's Advice to Artists*, Running Press, Philadelphia.

Kemp, Martin (2004) *The Oxford History of Western Art*, Oxford University Press, Oxford and New York.

Lucie-Smith, Edward (2003) *The Thames and Hudson Dictionary of Art Terms* (2nd edn) (World of Art series), Thames & Hudson, London.

Lucie-Smith, Edward (2004) *Latin American Art of the 20th Century* (2nd edn) (World of Art series), Thames & Hudson, London.

McArthur, Meher (2005) *The Arts of Asia: Materials, Techniques, Styles*, Thames & Hudson, London.

Onians, John (ed.) (2008) *The Art Atlas*, Abbeville Press, New York and London.

Patton, Sharon F. (1998) *African-American Art*, Oxford University Press, Oxford and New York.

Slatkin, Wendy (1993) *The Voices of Women Artists*, Prentice Hall, Upper Saddle River, NJ.

Spencer, Harold (ed.) (1976) *Readings in Art History*, New York, Charles Scribner's Sons.

Stangos, Nikos (ed.) (1994) *Concepts of Modern Art from Fauvism to Postmodernism (World of Art series)*, Thames & Hudson, London.

Stiles, Kristine and Selz, Peter (eds) (1996) *Theories and Documents of Contemporary Art: A Sourcebook of Artists' Writings*, University of California Press, Berkeley and Los Angeles.

Willett, Frank. (2003) *African Art* (3rd edn) (World of Art series), Thames & Hudson, London.

General Art-History Surveys

Adams, Laurie Schneider (2003) *World View: Topics in Non-Western Art*, McGraw-Hill, New York.

Adams, Laurie Schneider (2010) *Art Across Time* (4th edn), McGraw-Hill, New York.

Arnason, H.H. (2009) *History of Modern Art* (6th edn), Prentice Hall, Upper Saddle River, NJ.

Fineberg, Jonathan (2010) *Art Since 1940* (3rd edn), Prentice Hall, Upper Saddle River, NJ.

Hunter, Sam, Jacobus, John, and Wheeler, Daniel (2004) *Modern Art* (3rd edn), Prentice Hall, Upper Saddle River, NJ.

Janson, Anthony F. (2004) (6th edn), *History of Art*, Prentice Hall, Upper Saddle River, NJ.

Stokstad, Marilyn and Cothren, Michael (2010) *Art History* (4th edn), Prentice Hall, Upper Saddle River, NJ.

Tansev, Richard, Kleiner, Fred S., and De La Croix, Horst (1995), *Gardner's Art Through the Ages* (10th edn), Harcourt, Fort Worth, TX.

For more specialized analyses see, among others, Thames & Hudson's World of Art series and the Oxford History of Art series.

Part One

Selected Suggested Readings

Alberti, Leon Battista (1966) *On Painting*, Yale University Press, New Haven, CT.

Barron, Stephanie (ed.) (1991) *"Degenerate Art": The Fate of the Avant-Garde in Nazi Germany*, Los Angeles County Museum of Art, Los Angeles.

Bell, Julian (2000) *500 Self-Portraits*, Phaidon, London.

Berson, Ruth (ed.) (1996) *The New Painting: Impressionism 1874–1886: Documentation*, Fine Arts Museum of San Francisco, San Francisco, distributed by the University of Washington Press.

Blunden, Maria and Blunden, Godfrey (1980) *Impressionists and Impressionism*, Skira/Rizzoli, Geneva and New York.

Boettger, Suzaan (2004) *Earthworks: Art and the Landscape of the Sixties*, Berkeley and Los Angeles, University of California Press.

Chadwick, Whitney (2007) *Women, Art and Society* (4th edn), Thames & Hudson, London.

Fuga, Antonella (2006) *Artists' Techniques and Materials (Guide to Imagery series)*, Getty Publications, Los Angeles.

Goldberg, Roselee (2001) *Performance Art: From Futurism to the Present* (2nd edn) (World of Art Series), Thames & Hudson, London.

Jacob, Mary Jane and Grabner, Michelle (eds) (2010) *The Studio Reader: On the Space of Artists*, University of Chicago Press, Chicago.

Kastner, Jeffrey and Wallis, Brian (2010) *Land and Environmental Art*, Phaidon, London.

King, Catherine E. (1998) *Renaissance Women Patrons: Wives and Widows in Italy, c. 1300–1550*, Manchester University Press, Manchester.

Lee, Hui-shu (2010) *Empresses, Art, and Agency in Song Dynasty China*, University of Washington Press, Seattle.

Lyons, Albert, S., and Petrucelli, Joseph R. (1997) *Medicine: An Illustrated History*, Harry N. Abrams, New York.

Nelson, Jonathan K. and Zeckhauser, Richard J. (2008) *The Patron's Payoff: Conspicuous Commissions in Italian Renaissance Art*, Princeton University Press, Princeton, NJ.

Rosenblum, Robert and Janson, H.W. (2004) *19th-Century Art* (2nd edn), Prentice Hall, Upper Saddle River, NJ.

Sonnenburg, Hubert von (1995) *Rembrandt/Not Rembrandt: Aspects of Connoisseurship (2 vols.)*, Metropolitan Museum of Art, New York.

Wallace, William E. (2009) *Michelangelo: The Artist, the Man and his Times*, Cambridge University Press, Cambridge.

Weintraub, Linda (2003) *In the Making: Creative Options in Contemporary Art*, D.A.P./Distributed Art Publishers, New York.

Websites/Online Resources

"Videos: Making Art," from the J. Paul Getty Museum: http://www.getty.edu/art/gettyguide/videoCategory?cat=2

Part Two

Selected Suggested Readings

Altshuler, Bruce (ed.) (2008) *Salon to Biennial: Exhibitions that Made Art History*, Vol. 1, 1863–1959, Phaidon, London and New York.

Cuno, James, et al. (2004) *Whose Muse? Art Museums and the Public Trust*, Princeton University Press, Princeton, NJ.

Ganz, Nicholas (2009) *Graffiti World: Street Art from Five Continents* (2nd edn), Abrams, New York.

Hooper-Greenhill, Eilean (1992) *Museums and the Shaping of Knowledge*, Routledge, London and New York.

Hoving, Thomas (1994) *Making the Mummies Dance: Inside the Metropolitan*, Touchstone, New York.

Karraker, Gene D. (2010) *Looking at European Frames: A Guide to Terms, Styles, and Techniques*, Getty Publications, Los Angeles.

Mansfield, Elizabeth (ed.) (2002) *Art History and Its Institutions: Foundations of a Discipline*, Routledge, London and New York.

McClellan, Andrew (2008) *The Art Museum from Boullée to Bilbao*, University of California Press, Berkeley and Los Angeles.

Newhouse, Victoria (1998) *Towards a New Museum*, Monacelli Press, New York.

Pennsylvania Academy of the Fine Arts: 200 Years of Excellence (2005), University of Pennsylvania Press, Philadelphia.

Robertson, Iain and Chong, Derrick (eds) (2008) *The Art Business*, Routledge, New York and London.

Stourton, James (2008) *Great Collectors of Our Time*, Scala, London.

Thea, Carolee (author), Micchelli, Thomas (ed.), Obrist, Hans Ulrich (foreword) (2009) *On Curating: Interviews with Ten International Curators*, D.A.P./Distributed Art Publishers, New York.

Thornton, Sarah (2009) *Seven Days in the Art World*, W.W. Norton & Co., New York.

Weil, Stephen (2002) *Making Museums Matter*, Smithsonian Books, Washington, DC.

Websites and Online Resources

Getty Museum: video gallery includes "Behind the Scenes," "About the Museum" and "Looking at Art": http://www.getty.edu/art/gettyguide/videoGallery

Museum of Modern Art, New York, multimedia projects related to the museum's collection and exhibitions: http://www.moma.org/explore/multimedia

Part Three

Selected Suggested Readings

Apollonio, Umbro (2001) *Futurist Manifestos*, MFA Publications, Boston.

Barasch, Moshe (2000) *Theories of Art (vols. 1–3)*, Routledge, New York and London.

Battistini, Matilde (2005) *Symbols and Allegories in Art*, Getty Publications, Los Angeles.

Crenshaw, Paul (2006) *Rembrandt's Bankruptcy: The Artist, His Patrons, and the Art World in Seventeenth Century Netherlands*, Cambridge University Press, Cambridge.

D'Alleva, Anne (2010) *Look! Art History Fundamentals* (3rd edn), Pearson Prentice Hall, Upper Saddle River, NJ.

Garrard, Mary D. (1991) *Artemisia Gentileschi*, Princeton University Press, Princeton, NJ.

Gill, Sarah (1993) *The Critic Sees, A Guide to Art Criticism* (2nd edn) (revised edn 2010), Kendall/Hunt Publishing Co., Dubuque, IL.

Hall, James (2007) *Dictionary of Subjects and Symbols* (2nd edn), Westview Press, Boulder, CO.

Harris, Jonathan (2006) *Art History: The Key Concepts*, Routledge, New York and London.

Murray, Chris (ed.) (2003) *Key Writers on Art: The Twentieth Century*, Routledge, London and New York.

Pietrangeli, Carlo, et al. (1999) *The Sistine Chapel: A Glorious Restoration*, Abradale Press, New York.

Risatti, Howard (ed.) (1998) *Postmodern Perspectives: Issues in Contemporary Art* (2nd edn), Prentice Hall, Upper Saddle River, NJ.

Ross, Stephen Davis (ed.) (1994) *Art and its Significance: An Anthology of Aesthetic Theory* (3rd edn), State University of New York Press, Albany.

Salisbury, Laney and Sujo, Aly (2009) *Provenance: How a Con Man and a Forger Rewrote the History of Modern Art*, Penguin Press, HC, New York.

Smagula, Howard (ed.) (1991) *Re-Visions, New Perspectives of Art Criticism*, Prentice Hall, Englewood Cliffs, NJ.

Schubert, Karsten and Daniel, McClean (eds) (2002) *Dear Images: Art, Copyright and Culture*, Ridinghouse and Institute of Contemporary Arts, London.

Websites

Van Gogh/conservation (Van Gogh Museum): http://www.vangoghmuseum.nl/blog/slaap-kamergeheimen/en/

Van Gogh's letters: http://www.webexhibits.org/vangogh http://vangoghletters.org/vg/quickguide.html?redirect

Leonardo da Vinci's manuscripts (Museum of Science, Milan, Italy): http://www.museoscienza.org/english/leonardo/manoscritti/

Digitized archival material for American art and artists, including Mary Cassatt's letters (The Archives of American Art): http://www.aaa.si.edu/collections

Georgia O'Keeffe's letters and other archival material (Alfred Stieglitz/Georgia O'Keeffe Archive, Beineke Library, Yale University): http://beinecke.library.yale.edu/digitallibrary/asgo.html

Part Four

Selected Suggested Readings

Adams, Laurie Schneider (1996) *The Methodologies of Art: An Introduction*, Icon Editions (an imprint of HarperCollins), New York.

Barnard, Malcolm (2001) *Approaches to Understanding Visual Culture*, Palgrave Macmillan, New York.

D'Alleva, Anne (2009) *Methods and Theories of Art History*, Laurence King, London.

Edwards, Steve and Wood, Paul (eds) (2004) *Art of the Avant-Garde (Art of the 20th Century series)*, Yale University Press, New Haven, CT and London.

Gaiger, Jason (ed.) (2004) *Frameworks for Modern Art (Art of the 20th Century series)*, Yale University Press, New Haven, CT and London.

Hatt, Michael and Klonk, Charlotte (2006) *Art History: A Critical Introduction to its Methods*, Manchester University Press, Manchester.

Hughes, Robert (1991) *The Shock of the New*, Knopf, New York.

McEnroe, John C., and Pokinski, Deborah F. (eds) (2001) *Critical Perspectives on Art History*, Prentice Hall, Upper Saddle River, NJ.

Minor, Vernon Hyde (2000) *Art History's History* (2nd edn), Prentice Hall, Englewood Cliffs, NJ.

Perry, Gill and Wood, Paul (eds) (2004) *Themes in Contemporary Art (Art of the 20th Century series)*, Yale University Press, New Haven, CT and London.

Sandler, Irving (1997) *Art of the Postmodern Era: From the Late 1960s to the Early 1990s*, Westview Press (Icon Editions), Boulder, CO.

Vasari, Giorgio (2008) *The Lives of the Artists*, Oxford University Press, New York.

Weintraub, Linda (1997) *Art on the Edge and Over: Searching for Art's Meaning in Contemporary Society, 1970s–1990s*, Art Insights/D.A.P. Distributed Art Publishers, New York.

Wood, Paul (ed.) (2004) *Varieties of Modernism (Art of the 20th Century series)*, Yale University Press, New Haven, CT and London.

Films

Selected Films by Artists and Related to Twentieth-Century Art Movements

Anémic cinéma (1926) (dir. Marcel Duchamp)

Ballet mécanique (1923–4) (dir. Fernand Léger and Dudley Murphy)

The Cabinet of Dr. Caligari (1920) (dir. Robert Wiene)

Un Chien Andalou (An Andalusian Dog) (1928) (dir. Luis Buñuel and Salvador Dalí)

Emak-Bakia (Leave me Alone) (1926) (dir. Man Ray)

L'Étoile de mer (Starfish) (1928) (dir. Man Ray)

Manhatta (1921) (dir. Charles Sheeler and Paul Strand)

Optical Poem (1938) (dir. Oskar Fischinger)

Opus I and II (1921 and 1923) (dir. Walter Ruttmann)

Rhythmus 21 (1921) (dir. Hans Richter)

Most films are available online; some are posted on the J. Paul Getty Museum website

Selected Fictional Films (Biographies of Artists)

The Agony and the Ecstasy, 1965 (dir. Carol Reed)

Artemisia, 1998 (dir. Agnès Merlet)

Basquiat, 1996 (dir. Julian Schnabel)

Camille Claudel, 1998 (dir. Bruno Nuytten)

Dreams, 1990 (dir. Akira Kurosawa; segment on Van Gogh)

Frida, 2002 (dir. Julie Taymor)

Girl with a Pearl Earring, 2003 (dir. Peter Webber)

Goya in Bordeaux, 1999 (dir. Carlos Saura)

Lust for Life, 1956 (dir. Vincente Minnelli)

Moulin Rouge, 1952 (dir. John Houston)

Pollock, 2000 (dir. Ed Harris)

Rembrandt, 1936 (dir. Alexander Korda)

Vincent and Theo, 1990 (dir. Robert Altman)

Selected Documentaries

Art 21 (Art in the 21st Century) seasons 1–5 (PBS) (also website, http://www.pbs.org/art21/)

The Rape of Europa, 2006 (dir. Richard Berge and Bonni Cohen)

Who the #$&% Is Jackson Pollock? 2006 (dir Harry Moses)

Websites

Selected Art Auction Houses

Sotheby's: http://www.sothebys.com/
Christie's: http://www.christies.com/

Selected Art-History Resources

A comprehensive source for art historical information, developed by Dr Christopher L.C.E. Witcombe, Professor of Art History: http://witcombe.sbc.edu/ARTHLinks.html
Art Historians' Guide to Movies (a website focused on the inclusion of art/ art history in movies): http://personal1.stthomas.edu/cdeliason/ahgttm.htm

Selected Art Journals

Art in America: http://www.artinamericamagazine.com/
The Art Newspaper: http://www.theartnewspaper.com/
Art Forum: http://www.artforum.com/
Art News: http://www.artnews.com/home/

Selected Art Organizations

College Art Association: http://www.collegeart.org
American Institute for Conservation of Historic and Artistic Works: http://www.conservation-us.org/
Association of American Museums: http://www.aam-us.org/

Concepts, Terms, Timelines

Terms, movements, concepts (developed by the Getty Research Institute): http://www.getty.edu/research/tools/vocabularies/aat/index.html
Timeline (Metropolitan Museum of Art): http://www.metmuseum.org/toah/

Exhibitions, Galleries, and Art Fairs Worldwide (Art Forum)

http://www.artforum.com/guide/

Museums

http://www.artcyclopedia.com/museums.html
Google Art Project (includes several museums with many features including zoom, virtual tours and creating and sharing your personalized art collection): http://www.googleartproject.com/

Index

Note: page numbers in italics denote figures, tables or illustrations

The Art of Understanding Art, First Edition. Irina D. Costache.
© 2012 Blackwell Publishing Ltd. Published 2012 by Blackwell Publishing Ltd.